現實秘境

TOWARDS
MYSTERIOUS
REALITIES

目錄

CONTENTS

策展概念
CURATORIAL STATEMENT

現實秘境

鄭慧華

「現實秘境」是一檔關於重新思索當下亞洲與世界關係的展覽與研討計畫。為期三年的過程裡（2016–2018），共邀請了主要來自亞洲的十六組藝術家、多位策展人及歷史與文化研究者於不同階段共同參與。* 通過他們對特定歷史和生活經驗的關注，以多重時空向度，嘗試以不同視角組構和揭露歷史過往與當下現實之間的關係。

本展中的作品，無論是談論個人經驗還是集體意識，都關係到不同的歷史進程，在政治與社會變革力量的推動或消長狀態下被形塑出的樣貌，宏大至現代國族意識的發生、生存疆界變動，細微至個人生命遭遇與家族歷史。在此之中，展覽特別關注二十世紀後半葉的冷戰過程，檢視那些已被忽略或遺忘了的意識型態與生活價值之爭，在今日如何以超驗的方式漫延和滲透至日常生活裡，並期待以這段穿越了幾個世代的歷史經驗作為主要的反思樞紐，來勾劃另一種認識和敘述現實的途徑。

然而「敘述現實」並不如表面看起來那般容易，因為「現實」往往不是單一的線性因果，更多情況，是多重而複雜的經驗的交互作用 —— 除了我們所描述的地理或物理性的世界，還包含了人的經驗、意識所投射與反映的心靈與精神世界。我們或可將展覽中的個別作品視為「現實的切片」，這些「切片」彼此之間所隱含的各種有形或無形的斷裂、連繫或對話，將為我們鋪述出一幅更深刻的當代亞洲集體心靈圖像。

台灣劇場導演暨文化評論家王墨林曾經說過：當人們面對歷史（考古、文件或紀錄）的時候，其實「時常是用了比較概念化的『記憶』，而不是『歷史』這個有知識生產性的名詞。」那麼何謂「有知識生產性」的歷史？王墨林說，「……常常隔了很久以後，突然有個歷史學家跑出來告訴我們哪一段歷史是假的，我們一直在真真假假的歷史裡面。」面對這樣的狀態，當你不能爭辯哪一段歷史訊息為真時，他認為更重要的，即是去探索和感知那存在歷史中「幽微的心靈活動」[1]。

此外，本展以「亞洲」為核心來進行對現實的再敘述，但為何是「亞洲」？在這裡，「亞洲」不僅關係到地緣政治及文化政治，亦可視為是歷史心靈上的一個問題意識。香港亞洲藝術文獻庫曾於 2013 至 2014 年間，通過藝術實踐、亞洲藝術的典藏研究、檔案整理推動了一個深具意義的計畫，名為「拼湊亞洲」，正如其出版物中的導言所述：「光是『拼湊亞洲』這個命題的不可即，就足以叫人暈頭轉向。……[它] 預設了一個版圖拼湊和整合過程。」[2] 亞洲這個龐大而紛雜多面的概念，是夾帶著數百年來對「他者」的想像投射，以及無數自我辨識的過程，它從來就不是單一而固定的，其認同也並非是理所當然的。

那麼,在這些歷史與文化差異中,又是否存在可以讓我們重新對話與聯繫的方法?印度學者阿希斯·南迪 (Ashis Nandy) 曾提出過,在由現代國家體制與主權所畫下的邊界裡、在消費性和主導性的強勢文化支配下,我們該去思索和追求的,應當是可以超越民族國家、社群、甚至文化本身的「共享自我」(the shared self) [3]。換句話說,僅管亞洲內部有各自殊異的文化、信仰、語言和甚至是刻骨的歷史苦難,然通過開放性的檢視和面對共同的困境,我們將發現仍有許多過程是共存、甚至共享的,這可能也意味著,去認知那些不同經驗中的「共同」(卻隱蔽)的近代歷史,或將會是讓我們辨識出「共享自我」的一個開始。

近年來,亞洲再度成為被高度關注的「議題」,和它在後冷戰的全球化年代裡成為了推動資本市場引擎的一塊豐富燃料的事實息息相關,在此局勢下,亞洲也成為了當今各種國際政治的角力場。這並非歷史的偶然,就在這些看似各個獨立,實則相互牽動的現象此起彼落之際、在新一波政治、經濟與文化競爭與對抗中,昔日「冷戰經驗」也再度浮現其殘影。儘管,這已不再意味著舊日立場鮮明的意識型態對抗或圍堵,但檢視存在於其中的歷史意識「殘餘」,或許可以使我們窺知何以「瞭解亞洲」與「自我表述」近年來再度成為了某種(具危機感的)渴望,或甚至是成為迫切的選擇。

換言之,現代/當代亞洲「觀」(visions) 的形成和歷史經驗不可分割,而從冷戰歷史出發,我們將範圍擴大為戰後至今,若能以製圖學的方法來繪製一張「近現代亞洲心靈地圖」,那即意味著:在被國家權力、政治經濟利益及意識型態戰爭所勾劃而鞏固的圖像之外,還呈現什麼樣的生存與認同意識。最終,通過「現實秘境」這個展覽與研討計畫所想提問的,是關乎每個生存個體又將如何從這些多重而幽微的訊息中獲得更多關於自身未來選擇的洞見。

1 鄭慧華,〈形塑幽微史觀:為失語的歷史找到話語 —— 專訪王墨林〉,《藝術與社會》(台北:台北市立美術館,2009),頁 40–41。

2 《拼湊亞洲》(香港:亞洲藝術文獻庫,2014),頁 9。

3 阿希斯·南迪,〈巫師、蠻夷之地與荒野:論異見之可聞與文明之未來〉,《民族主義、真誠與欺騙》(上海:上海人民出版社,2011),頁 103。

* 由鄭慧華策劃的「現實秘境」展覽與研討計畫共分為三個階段,2016年底由台北立方計劃空間與耿畫廊共同主辦第一階段展覽,邀請十三組藝術家參展。並於展期間舉辦十場工作坊、表演及講座。2017年十二月,立方計劃空間與馬來西亞吉隆坡的Lostgens'當代藝術空間、亞答屋84號圖書館及ILHAM畫廊共同合作第二階段,邀請策劃人許芳慈擔任策劃人,舉辦為期三天的「雙束現實—歷史潛流中的感覺能指」國際論壇。2018年四月,展覽巡迴至韓國首爾總體當代美術館及Space55獨立空間,由鄭慧華與總體美術館策展人申寶瑟共同策劃,增加了藝術家侯俊明的駐地創作〈亞洲人的父親——首爾篇〉等項目。
「現實秘境」參展藝術家包括張乾琦、侯俊明、秦政德、許家維、洪子健、黃大旺及李士傑(台灣)、區秀詒(馬來西亞)、法蘭西斯柯·卡馬丘(哥倫比亞)、普拉賈克塔·波特尼斯(印度)、巴尼·海卡爾(新加坡)、李燎(中國)、曹海準、李京洙、曹東煥、任興淳和玉仁集體(韓國)。
參與論壇的講者除參展藝術家許家維、李士傑及區秀詒外,還包括馬來西亞藝術評論暨策展人孫先勇和李永財、新加坡歷史學者覃炳鑫、策展人林沁怡、馬來西亞文化研究學者魏月萍、蘇穎欣,以及舉辦菲律賓導演約翰·托雷斯的〈人民力量重磅彈:越南玫瑰日記〉影片放映會。

Towards Mysterious Realities

Amy Cheng

Towards Mysterious Realities is a research-based exhibition and seminar project aiming to encourage profound reflection on Asia's relation to the world. This three-year project (2016–2018) not only invited a total of 16 artists/collectives mainly from Asia, but also marked the engagement of many curators, historians and cultural researchers in different phases.* They not only add multiple temporal and spatial dimensions to this exhibition through their concerns over specific pieces of history and life experiences, but also attempt to construct or discover the relationships between historical contexts and current realities from different perspectives.

All the works presented in this exhibition, be they discussions about personal experiences or collective awareness, are linked with different historical trajectories charted by the vicissitudinary political and social forces. They may appear as grand as the rise of modern national consciousness or the re-demarcation of *Lebensraum*, and also as subtle as personal life stories or family histories. In this situation, the exhibition is particularly concerned with the unsettling Cold War experiences throughout the second half of the 20th century, seeking to examine how the previous head-on confrontations over ideologies and values, which have been ignored or consigned to oblivion, lurk in our quotidian existence in a transcendent manner. Besides, this exhibition expects such a historical experience stretching back generations to serve as one of major pivotal points for profound reflections wherefrom we can map out alternative routes to grasp and re-narrate realities.

However, "narrating realities" might not be as easy a task as it sounds, because "realities" are not simply linear causal chains of events occurred here and now, but mostly the interplay of incidences and experiences in various dimensions revolving around the spatial and temporal axes. In addition to the tangible geographical or physical world, realities contain the mental and spiritual world projected and mirrored by human experiences and consciousness. In this sense, we may construe each work in this exhibition as a specific entry point to the realities concerning a given individual or group. The tangible and intangible disconnections and connections among these entry points may thus outline a broader vision of contemporary Asia.

Taiwanese theater director and cultural critic Wang Mo-Lin remarked that people "often employ the more conceptualized term 'memory' rather than 'history,' a noun with intellectual function—the capability of knowledge production—when they are faced with historical material (e.g. archaeological evidence, documents and records)." In this case, what is the history with the capability of knowledge production? Wang continued, "...it was not until after a long time that a historian would alert us to the inauthenticity of a specific piece of history. We have been mired in the history in which the true mingled with the false." As far as Wang is concerned, in the situation that you failed to distinguish the true from the false, what matters is to explore the "subtle mental activities" lurking in history.[1]

The re-narration of realities in this exhibition revolves around Asia. Why Asia? The Asia here is not simply a term of geopolitics and cultural politics, but also a problematique regarding psychic experiences on history. Between 2013 and 2014, the Hong Kong-based Asia Art Archive undertook a meaningful project titled *Mapping Asia* which unfolded itself through engaging with different artistic practices, research on Asian art collections, and archive collating. As stated in the note from the editors of the project's publication, "[t]he title of the third issue of *Field Notes*, 'Mapping Asia,' should be enough to induce an immediate state of dizziness at the sheer impossibility of such a proposition... [which] presupposes a mapping process."[2] Asia is a portmanteau concept involving centuries of imagination about "others" and a ceaseless process of self-identity construction. As a result, we can neither give Asia a single rigid definition, nor take the Asian identity for granted.

1 See "Shaping a Subtle Historical Point of View: Re-orientating the Disorientated History—An Exclusive Interview with Wang Mo-Lin ," in *Art and Society: Introducing Seven Contemporary Artists*, ed. Amy Cheng (Taipei: Taipei Museum of Fine Arts, 2009), pp.40-41.

2 Asia Art Archive, "Mapping Asia," *Field Notes*, issue 3, 2014, p.9.

3 Ashis Nanday, "Shamans, Savages and the Wilderness: On the Audibility of Dissent and the Future of Civilizations" in *Nationalism, Genuine and Spurious—Ashis Nandy Reader* (Chinese-English), eds. Chang Tsong-Zung, Chen Kuan-Hsing, and Gao Shi-Ming (Shanghai: Shanghai People's Publishing House, 2011), p.264 (English original text).

Then, is there any practical method for us to resume the aforementioned dialogues and connections among the *différance* of histories and cultures in Asia? In his article "*Shamans, Savages and the Wilderness: On the Audibility of Dissent and the Future of Civilizations,*" Indian scholar Ashis Nandy argued that we should contemplate and pursue the "shared self" that transcends nation-states, communities, perhaps even cultures themselves, since we are fettered by the demarcations of modern sovereign states and dominated by the mainstream consumer culture nowadays.[3] To put it another way, we may discover many of our parallel or even shared origins and processes through open-minded reflections on the *cul-de-sac* we encounter in the present era, despite Asia's diverse cultures, beliefs, languages, and historical traumas. It also implies that finding out the common (yet veiled) driving forces in modern history that brought us different experiences is perhaps an appropriate departure point for identifying our "shared self."

In recent years, Asia has arisen as an urgent geopolitical issue once more, which is closely related to its post-cold war status as the gasoline and electricity by which the engine of capitalist market is powered throughout the process of neo-liberal globalization. Given the gravity of the situation, Asia has also become an arena for today's international political wrestling. This is by no means a result of historical contingency. While these seemingly independent yet actually interlocked events occurred one after another, the haunting ghost of the "Cold War experiences" was resurrected from the oblivion with this new wave of political, economic and cultural competitions and confrontations. Although it no longer implies the head-on ideological confrontation or containment in the old days, we may conjure up the reason why "re-understanding Asia" and "self-formulation" have become aspirations (with the awareness of crises) or even imperative options in recent years by reviewing these historical "residues."

To put it simply, these modern/contemporary visions of Asia share an indissoluble bond with Asia's historical experiences. Based on a review of the Cold War and post-Cold War history, this exhibition covers a long span from the post-war period to the present. In addition to the

images outlined and reinforced by states' power, politico-economic inter-ests and ideological wars, the state of Asia's survival and identity would be uncovered if we employ cartographic methods to draw a "modern Asian cognitive map." In sum, the ultimate quest of this project is to address the question as to how individuals garner a higher level of insights about their future options from these subtly discernible messages.

* Curated by Amy Cheng, the exhibition and seminar project *Towards Mysterious Realities* proceeded in three stages. Co-organized by TheCube Project Space and TKG+, the first stage was held at the end of 2016, including an exhibition and a series of workshops, performances and lectures.

Produced in December 2017, the second stage was a product of the multilateral collaboration among TheCube Project Space of Taipei, Lostgens' Contemporary Art Space, Rumah Attap Library & Collective, and ILHAM gallery of Kuala Lumpur. Independent curator and culture researcher Hsu Fang-Tze, served as the convener, organized a three-day international symposium: *Reality in Its Double Bind: Emotional Signifiers in the Undercurrents of History*.

In April 2018, *Towards Mysterious Realities* toured to Seoul at the Total Museum of Contemporary Art and Space55, which was co-curated by Amy Cheng and Nathalie Boseul Shin, the chief curator of the Total Museum of Contemporary Art, who collectively organized the second edition of the exhibition and its residency program.

The participating artists in *Towards Mysterious Realities* included Chang Chien-Chi, Hou Chun-Ming, Chin Cheng-Te, Hsu Chia-Wei, James T. Hong, Huang Da-Wang, and Shih-Chieh Ilya Li (Taiwan); Au Sow-Yee (Malaysia); Francisco Camacho (Colombia); Prajakta Potnis (India); Bani Haykal (Singapore); Li Liao (China); Jo Haejun, Lee Kyeongsoo, Jo Donghwan, Im Heung-Soon, and Okin Collective (South Korea).

Apart from Hsu Chia-Wei, Shih-Chieh Ilya Li, and Au Sow-Yee, the speakers of the symposium included art critics/curators Simon Soon and Lee Weng-Choy (Malaysia); historian Thum Ping-Tjin and curator Lim Qin-Yi (Singapore); cultural researchers Ngoi Guat-Peng and Show Ying-Xin (Malaysia); plus a screening of Filipino director John Torres' film — *People Power Bombshell: The Diary of Vietnam Rose*.

藝術家
ARTISTS

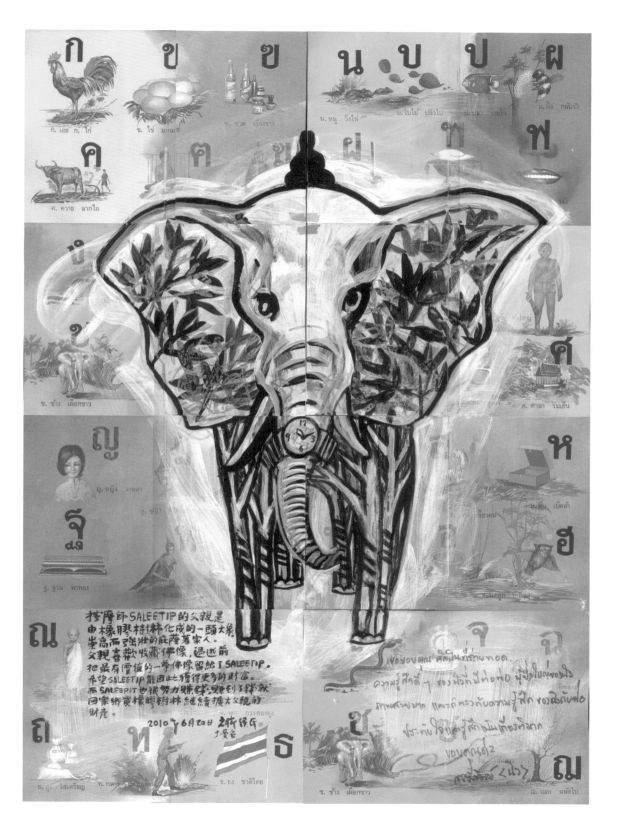

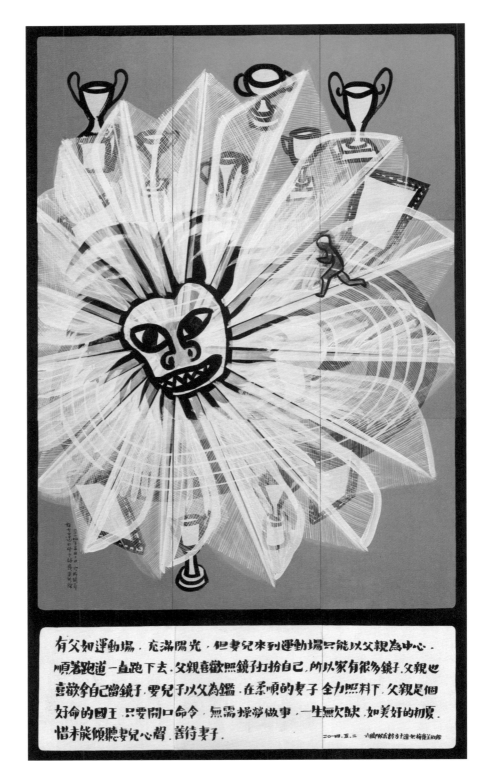

〈亞洲人的父親：嘉義篇－方士達之父〉，壓克力、紙板，203×118 公分，2014
The Asian Father Interview Project: Chiayi—Fung Shih-Da's Father, acrylic and paperboard, 203×118 cm, 2014

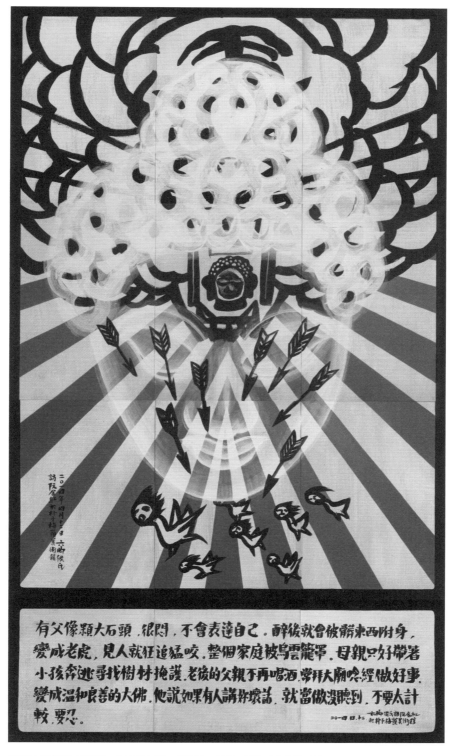

〈亞洲人的父親：嘉義篇―阮金紅之父〉，壓克力、紙板，203×118 公分，2014
The Asian Father Interview Project: Chiayi―Ruan Jing-Hong's Father, acrylic and paperboard, 203×118 cm, 2014

〈亞洲人的父親：首爾篇－有父愛如禾〉，壓克力、紙板，234.3×161.7 公分，2018
The Asian Father Interview Project: Seoul－The Love of the Father is Like the Rice, acrylic and paper board, 234.3×161.7 cm, 2018

〈任大植之父〉，油性蠟筆畫於紙上，75.1×52.1 公分，2018
Im Dae-Sik's Father, oil pastel on paper, 75.1×52.1 cm, 2018

〈任泰俊之父〉，油性蠟筆畫於紙上，75.1×52.1 公分，2018
Im Tae-Jun's Father, oil pastel on paper, 75.1×52.1 cm, 2018

父。祖父二太太所生。獨立早。溫順如駝羊。亦如終日忙著銜枝築壩捕魚的河狸。兒高二與母閒聊「我想彈吉他」。父聽到了。等到兒生日就買了吉他送兒。
兒大一兒童節，父親打電話給兒，只說了兩句話就掛了電話。「匯錢了」，「我愛你」。
兒說郵差父親愛如稻禾。年復一年始終規律不變的工作著，給予資糧。
2018.3.9 首爾 / 原州 禁山侯拜訪任大植

My father is the son of my grandfather's second wife. He has been independent from an early age. My father is as tame as an alpaca, and as busy as a beaver occupied with collecting twigs and branches to build its dam all day long. "I wanna learn to play guitar," I chatted with my mom one day when I was a high school sophomore. My father heard and bought me a guitar as a birthday gift. When I was a freshman in college, my father called me on Children's Day. Leaving no other words than two messages — "the money was remitted to you" and "I love you" — he hung up the phone.
My father is a postman, whose love rivals rice ear. He works regularly year after year, affording me necessary supplies.
Seoul / Wonju, 9th March, 2018, Hou paid Im Dae-Sik a visit.

父不喝酒時有精巧手藝。自製農具。教兒農作。挖防空洞安置家人。
父一生如豐收的秋季。不工作也能有好生活。
兒怕父酒醉。如虎咆嘯罵人。醉倒郊野，子揹父過河。悲傷。子誓此生不沾酒。
子當郵差有收入之後，送給父親的禮物是一瓶好酒。
2018.3.11 首爾 / 原州 禁山侯拜訪任泰俊

My father was a skilled craftsman when he was clean and sober. He made farm implements by himself, and taught me farming. He also built an air-raid shelter to protect his family. My father lived a decent life without having to work. His life bore a strong resemblance to the bumper fall harvest.
I had always dread seeing my father getting drunk and hearing him yelling like a roaring tiger. Every time my father was so drunk that he fell down in the field, I had to carry him on my back and cross the river. Feeling sad about my father's situation, I swore that I would never touch a drop of alcohol.
No sooner did I receive my first salary as a postman, I bought my father a bottle of quality liquor as a gift.
Seoul / Wonju, 11th March, 2018, Hou paid Im Tae-Jun a visit.

〈亞洲人的父親：首爾篇—有父愛如鐘〉，壓克力、紙板，234.3×161.7 公分，2018
The Asian Father Interview Project: Seoul—The Love of the Father is Like a Bell, acrylic and paperboard, 234.3×161.7 cm, 2018

〈元千秀之父〉，油性蠟筆畫於紙上，75.1×52.1 公分，2018
Won Chun-Soo's Father, oil pastel on paper, 75.1×52.1 cm, 2018

〈元光植之父〉，油性蠟筆畫於紙上，75.1×52.1 公分，2018
Won Kwang-Sik's Father, oil pastel on paper, 75.1×52.1 cm,
2018

父如松。做鐘。
終年常綠不變。
父如犀牛。固執。
不聽別人意見。一直往前衝。認為只要工作做好，後續錢財自
然會進來。「不要追錢」。
父如隔壁叔叔。不熟。
兒小時少有互動。兒長，繼家業，父子一起工作，如兩只吱吱
響的木輪，在不圓順中緩慢前進。
2018.3.13 首爾 禁山侯拜訪元千秀

*My father displays as much perseverance in making bells as a
pine tree does in keeping its greenness.*
My father's stubbornness is only rivaled by that of a rhino.
*He is a self-opinionated mover and shaker, who believes that
as long as one gets his job done well, money follows naturally.*
"Let the money chase you, not the other way around," he said.
To me, my father is as strange as the next-door uncle.
We seldom interacted with each other when I was a child.
*I inherited the family business after coming of age. We
work together like two wooden wheels rattling forward
slowly with glitches.*
Seoul, 13th March, 2018, Hou paid Won Chun-Soo a visit.

父。如羊。如柳。
溫和輕盈。
不被強風吹倒折損。
父信任兒子。支持兒子。
從不反對兒子的決定。
兒少小離家。
坦言對父印象不多。覺得自己給父親的，不夠。想對父親說
「對不起」。
父逝多年後，於今兒才感受到父親長年孤獨。
應該給父親找個女朋友的。
2018.3.18 首爾 / 鎮川 禁山侯拜訪元光植

My father was as meek as a sheep, and as gentle as a willow.
*Under the bludgeonings of howling gales, his head was
bloody, but unbowed.*
My father trusted and supported his son.
He never opposed his son's decision.
I left home at my tender age.
To be honest, my memories of my father are quite hazy.
*At the thought of failing to give my father enough care, I
wanna tell him I'm sorry.*
*I did not feel sympathy for my father's long-term loneliness
until years after his death.*
I should've found my father a life companion/girlfriend.
*Seoul/Jincheon, 18th March, 2018, Hou paid Won Kwang-
Sik a visit.*

〈亞洲人的父親：首爾篇 — 有父愛如松〉，壓克力、紙板，234.3×161.7 公分，2018
The Asian Father Interview Project: Seoul—The Love of the Father is Like a Pine, acrylic and paper board, 234.3×161.7 cm, 2018

〈金槿源之父〉，油性蠟筆畫於紙上，75.1×52.1 公分，2018
Kim Keun-Won's Father, oil pastel on paper, 75.1×52.1 cm, 2018

〈金道泳之父〉，油性蠟筆畫於紙上，75.1×52.1 公分，2018
Kim Do-Young's Father, oil pastel on paper, 75.1×52.1 cm, 2018

父聰明如烏鴉。知恩反哺。父穩定如松。虔誠信奉基督。堅定中心。正直。父寬大如海。即使有風浪，亦能因風浪而帶來新的循環。淨化。更新。父力量如雷神勇猛。同時溫暖有愛的能力。
2018.3.4 首爾 / 高陽 禁山侯拜訪金槿源

My father is as clever as a crow. He is grateful and tries to re-pay others for all their favors. My father is as steady as a pine tree. He is a devout Christian with unquestioning faith and a man with high integrity. My father is as magnanimous as the sea. He can channel the rogue waves to create motivation, which results in purification and regeneration. My father is so brave and strong that he rivals Thor, and meanwhile he is warm and capable of love as well.
Seoul/Goyang, 4th March, 2018, Hou paid Kim Keun-Won a visit.

父。虎。家之守護神。嚴格。位要津。正直清廉。父少說愛。兒懼父。但兒仍能感受到父愛。
父。巨樹。孤獨。沈穩。自我犧牲。不說累。不訴苦。大風大浪過一生。
2018.3.4 首爾 / 高陽 禁山侯拜訪金道泳

My father was like a tiger, the patron saint of my family. He held a key post, and followed a strict code of conduct. Honest and incorruptible, he seldom expressed his love verbally. In dread of my father though, I could feel the paternal love from him.
My father was little more than a giant tree, who was lonely but poised. He tended to make self-sacrifice, showing no sign of tiredness and making no complaints. He embraced all his life's vicissitudes without regret.
Seoul/Goyang, 4th March, 2018, Hou paid Kim Do-Young a visit.

曹海準 ＋ 李京洙
曹海準 ＋ 曹東煥
JO HAEJUN & LEE KYEONGSOO
JO HAEJUN & JO DONGHWAN

相信海洋是陸地的船
A Ship Believing the Sea is the Land

複合媒材裝置、素描、影片，2014
Multimedia installation, drawing and video, 2014

曹海準與李京洙的作品來自於曹海準與父親（曹東煥）之間的談話。雖然兩位藝術家使用多種媒介和藝術形式，但他們最常使用的創作手法卻是「紀實素描」。藝術家將父親所講述的奇妙故事以單純的素描手稿描繪出來，父與子之間的關係因此進入到南韓社會的集體記憶裡另外一個完全不同的層面。由於曹海準和父親過去從未實際進行合作，於是他們開始合作拍攝短片〈之間的場景〉（2013），以 1970 年代南韓全羅北道鎮安郡發生的真實事件的口述回憶為基礎所拍攝。影片裡，曹海準與李京洙在群山市美軍基地附近的海埔新生地發現一艘小船。〈相信海洋是陸地的船〉以此作為動機，呈現一艘船置於結構體（底座）被停泊在陸地上的處境。此外，文字、素描和〈之間的場景〉的剪輯片段，企圖生產出關於「多凱比」（Dokkaebi，韓國民間神話的妖怪）的故事、雕塑和影片。

Jo Haejun & Lee Kyeongsoo's work mainly comes out of Jo's conversations with his father, Jo Donghwan. Although the two artists employ a variety of media and artistic formats, their creative output is usually in the form of records named "documentary drawings". As the amazing stories told by Jo's father are narrated through simple writing-drawings, the relationship between a father and his son enters a completely different plane, which is the collective memory of South Korean society. In recent years, Jo Haejun and Jo Donghwan realized that they had not been collaborating on a physical level, which led them to produce a short film titled *Scenes of Between* (2013). The narrative of the film is based on an oral memory about a real event that happened in the 1970s in Jinan in Jeonbuk Province, South Korea. In the film, Jo Haejun and Lee Kyeongsoo discover a small boat in reclaimed land near a U.S. military base in the city of Gunsan. *A Ship Believing the Sea is the Land* (2014) takes the boat as a motive, presenting a situation in which a boat is anchored on land through a structure (plinth) that supports it. In addition, writings, drawings and edited footage of *Scenes of Between* are presented as part of an attempt to produce stories, sculptures and a film about Dokkaebi, a mythical being that appears in Korean folktales.

〈相信海洋是陸地的船〉，影片擷圖
A Ship Believing the Sea is the Land, video still

熊與父親
Bear and Father

單頻道錄像，14'26"，2016
Single-channel video, 14' 26", 2016

這件影像作品以講故事的方式拍攝，內容描述我那位日據時代被徵召到北海道的祖父和他的兒子曹東煥之間「最初與最終的對話」。

在 2015 年末，我父親曹東煥將他與我祖父在北海道的最終對話繪製成素描。由於這些素描極富戲劇張力，我決定和父親一同前往北海道夕張市拍攝一部影片，片中有原始人（父親－曹東煥）和熊（兒子－曹海準）。

到了夕張市，我們抽空前往充滿父親兒時回憶的地方。然而，久遠的記憶被修改且日漸遺忘，七十一年前的陰影已成為混亂的場景。當時被徵召的韓國人所居住的村莊、公共浴室，以及曾作為載運和處理煤礦的龐大的夕張車站，不是消失就是被改建為煤礦博物館。

1942 至 1945 年 —— 韓國獨立運動年間 —— 我父親曾居住於北海道夕張市。2016 年冬天，我和他一同造訪此地，無論在他過去的幼年時光裡，還是眼前的景觀裡，依然鐫刻著痛苦的殖民主義枷鎖。

我們兩人都未曾經歷過自己父親的苦痛，因此我們花了一些時日進行角色替換，猶如死者向生者訴說，使我們得以面對對方的白晝與黑夜。

片中的原始人是父親，即所謂「支配者」的替身。所謂的「亡父的陰影」是刻印在我父親的回憶中的支配者，在此被描述為歷經失敗和挫折的人。而熊則是兒子，作為「被支配者」的角色。畏於殖民政權統治者的威權，試圖保持「生命的希望」的父親為了家庭而犧牲自己。死者的靈魂在此得以體現。

基本上，我想藉由這部影片揭示的是「要比其他政治聲明更容易領會、要比其他政治行動更意味深遠」的事。藉由這段「父親—兒子七十年前的對話」，我們得以再次檢視日本殖民統治期間：太平洋戰爭、徵召、強制勞役、意外事故、襲擊、死亡、歷史上懸而未決的道歉和責任義務、賠償議題……，這些使死者的靈魂難以平撫、失去方向而不斷回返的悲愴歷史問題。在哀悼之外，本片的拍攝是為了傾聽我們上一代用超過七十載的氣息道出衰老且模糊的聲音，像是敲在歷史大門上的回音，那扇門早已封閉，猶如廢棄礦坑的入口，被徹底地遺忘。

This work is a film cinematized in a story-telling style, featuring "the first and the last dialogue" between my grand-father, who was drafted to Hokkaido in Japan during the period of Japanese oc-cupation, and my father, Jo Donghwan.

At the end of 2015, my father transformed his last dialogue with my grandfather in Hokkaido into drawings. Mesmerized by the dramatic tension around these drawings, I decided to head for Yubari, Hokkaido with my father and produce a film there, a film based on the story of a primitive man

(father—Jo Donghwan) and a bear (son—Jo Haejun).

Arriving in Yubari, we found time to revisit the places filled with my father's memories of childhood. However, the shadows of Yubari's past haunting my father for 71 years have become chaotic scenes over the course of time. These places have been largely repurposed, as if his memories were consigned to oblivion. The Korean draftee village, bathhouses, the colossal Yubari station for coal carriage and handling were either disappeared or repurposed into the coal museum.

My father had lived in Yubari between 1942 and 1945 during the Korean Independence Movement. In the winter of 2016, we revisited Yubari only to find that the inscription of the painful colonial past has been engraved, whether in his childhood memories or in the landscape laid out in front of his eyes.

Each of us has never experienced the pains and sufferings that our fathers had endured, ergo we spent days on exchanging our roles, as though the perished victims speak to the survivors, enabling us to face up to each other's joys and sorrows.

The primitive man in the film is a father, an incarnation of the so-called "dominator". For my father, the "shadow of his late father" is a dominator imprinted in his memories and described as a man who experienced failures and frustrations. The bear represents a son, a role of "the dominated". Feeling intimidated by the power of the colonial regime, the father sacrificed his life for his family in order to keep the "beacon of life" aflame. The spirit of the deceased is therefore embodied in this film.

To sum up, what I expect to reveal through this film is the realities "more comprehensible than any other political statements and eventually more meaningful than any other political acts". By virtue of this "father-son dialogue held 70 years ago", we may review the realities during the period of Japanese occupation, such as the Pacific War, the draft, the forced labor, accidents, assaults, death, historically unsettled obligation and official apology, the issue of compensation, and so forth. All these unsolved issues have not only prevented the perished victims from resting in peace but also trapped them in a loop of disorientation and tragic history. In addition to lamentation, this film is dedicated to applying the viewers' ears to the old and feeble voice that our parents' generation muttered under their breath for over seven decades, which sounds like the echo from the great gate of history, a gate as completely sealed and forgotten as an abandoned pit.

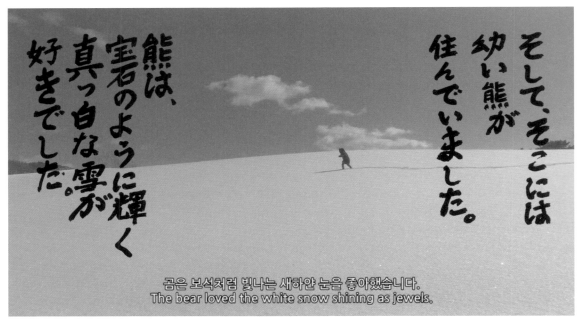

そして、そこには
幼い熊が
住んでいました。

熊は、宝石のように輝く
真っ白な雪が
好きでした。

곰은 보석처럼 빛나는 새하얀 눈을 좋아했습니다.
The bear loved the white snow shining as jewels.

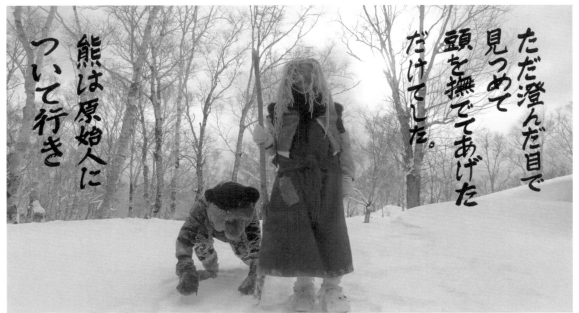

ただ澄んだ目で
見つめて
頭を撫でてあげた
だけでした。

熊は原始人に
ついて行き

〈熊與父親〉，影像擷圖
Bear and Father, video still

美軍與父親
U.S. Army and Father

89 張素描與文字，2002–2009
89 drawings with texts, 2002–2009

生生—父子計畫，2002–2009

開啟我和父親一起創作的契機，是我五歲時在他的雕塑上撒尿的記憶。那件雕塑放置在父親過去任職的學校校園中。那件雕塑的影響來自於 1952 年時，他在第六屆東京—大阪法國當代藝術展海報上第一次見到羅丹〈沈思者〉的圖像。1974 年，「新村運動」正積極展開，為了激勵學生奮發思考學習，他在這年刻了那座中學生的坐姿雕塑。

2002 年三月，我計劃把他的雕塑置放在文學促進組織設立的「新世代韓國當代美術館」中。就在這時，我開始傾聽他談到這件雕塑和海報的事情，然後將他的故事畫成素描，放進展覽。這件作品不僅展現當時韓國現代化與文明體系的落後，也呈現父親在極權下的日常生活、夢想，以及改變這些事情的渴望。我試圖透過他的繪畫與雕塑來展現父親的時代與我的時代之間的關係。

藉由上述的創作方法，我開始可以用客觀的角度來理解他。後來，我對他過去沈重的人生開始感到好奇，在他的家鄉不斷寫信給他。信件往來中，我想要了解更多他日常生活與家務事的細節。談話的展開，是召喚家庭機制中從過去一直進行到現今的各種小故事，以及已癒合的傷痛。我們經過長期的對話，一起回溯他的記憶。我告訴父親，我打算用繪畫加上文字的方式來講這些故事。父親同意後，他開始用這種紀錄形式來述說他的故事。

這些素描講到他的童年經歷：他隨著被徵召到日本北海道的我祖父一同在日本生活了四年；回到家鄉後，1950 年 6 月 25 日爆發韓戰的回憶；鄰居的街談巷議；死於非命的涵義；在釜山的艱困環境下求學；以美術老師的身份在湖南高速公路的通車儀式中展示他設計的人體排字；還有在 1974 年新村運動中創作的雕塑〈讓我們思考和工作〉。

我在這件作品中試圖呈現的不僅是作品本身的圖像或實體，還有父子之間的真實狀態與奇思妙想、圍繞在這些事情的互相理解與合作，和各種複雜的想法與事件的各個面向。

美軍與父親

〈美軍與父親〉包含了八十九份的文件素描，內容描繪我父親曹東煥從 1945 年他 11 歲時，第一次在日本北海道見到美國軍人，到 1959 年服役於美國陸軍附編韓軍（KATUSA）這段期間的所見、所聞和所經歷的歷史。

這件作品的創作過程進行得非常緩慢。當我試著回溯父親的記憶時，有時候會很難具體地傳達他記憶中的事件與場景。我特別注意他在回憶這些往事時的精神狀態，當他以防衛與內省的方式回溯過去的行為時，往往顯得吞吞吐吐，使對話難以順利進行。然而，若對話過程完整，那些在意識深處被遺忘的個人史，以及被隱藏的家族故事，就能夠順利舒展開來。這些素描清楚呈現了上述的事情，不過，有一天我們的對話中觸及了韓戰，現實便開始像是一場意識型態的惡夢。儘管如此，最重要的是，透過讓別人從心理層面介入他個人

的歷史經驗，我父親得以將自己從過去被視覺與聽覺感官經驗所佔據的精神狀態中解放出來。

Life Life—Project for Father and Son, 2002–2009

What started my work with my father was the memory of me pissing on his sculpture when I was five years old. The sculpture is placed in the campus where my father had been employed. He sculpted it under the influence of *Le Penseur* of Rodin, which he first witnessed in 1952 on the poster for the 6eme Tokyo-Osaka Exposition Francais Contemporain. When this sculpture was made in 1974, the New Village Movement was in full bloom. To inspire his students to think and study hard, he made a sculpture of a sitting middle-school student.

By March 2002, I planned to install his sculpture in the pavilion of the Korea Modern Art of New Generation, which was organized by the Literary Work Promotion Organization. I listened to him talk about the story of the sculpture and the poster, and turned it into drawings and presented them in the exhibition. The work demonstrated not only how poor Korea's modernization and civilization system was, but also portrays daily life under a totalitarian regime, as well as my father's dreams and desires to adjust it. Working with his drawings and sculptures, I aimed to draw out the relationship between my times and my fathers' times.

Through the work, I gradually came to understand him in an objective point of view and became interested in his difficult life. From his hometown, I wrote to him incessantly. In our correspondence, I asked for more details on his personal life and family life. The unfolding of our conversation summoned various episodes governed by the family mechanism, reminding me of old traumas that healed. Communicating over an extended period of time, we retraced his memories together. I told father how I desired to retell these stories in the form of drawings accompanied with texts. With his consent, he began to tell his story.

These drawings also talk about his childhood: The memory of the four-year family life that he and my grandfather, who was conscripted to Hokkaido in Japan led. After he returned home, he experienced the break-out of Korean War on June 25th, 1950; memories of gossiping neighbors; the meaning of dying a sudden death; living in Busan and studying in the face of adversity; presenting the card stunt that he designed as an art teacher at the opening ceremony of the Honam Express Way, and sculpting *Let Us Think and Work*, which was made during the New Village Movement in 1974.

What I intend to realize in this work is not only the work itself as an image or object,

but also the real conditions and strange ideas that pass between father and son, the comprehension and cooperation involved in the work, and the complicated thoughts and different aspects surrounding the events.

U.S. Army and Father

U.S. Army and Father is a 89-page series of drawings, documenting the history that my father, Jo Donghwan, has seen, heard, and experienced from he was 11 years old in 1945, to when he had seen an American soldier for the first time at Hokkaido in Japan, and his eventually becoming part of the Korean Augmentation To the United States Army (KATUSA) in 1959.

The work was completed very slowly. While trying to draw on his memories, I sometimes had a hard time concretely expressing his memory of events and situations. I've focused more on his mental state for such subject matter. Likewise, my father's hesitation when he revealed some of his past actions, his introspection, as well as the defensive way in which he justified past actions, made it impossible for conversations about his past go smoothly. However, in this, he showed his individual history and hidden family story to be wrinkles of forgotten consciousness, smoothed out by having a full conversation. The drawings in these series are expressive of that. There

was one time during our conversation that the Korean War is seemed to almost force itself in our conversation, as an ideological nightmare hanging over us. Yet the most important thing is that, through allowing others to understand his feelings and personal history, my father was able to free himself from his past experiences.

1945 年美軍在日本北海道夕張登陸，要來讓日本投降。當時我才小學 3 年級，好奇地跑去圍觀美軍。那時有一位看起來年紀頗大的韓國人走到美軍前面對他說：「喂！大鼻子爺，你老家在哪兒？我是韓國人，老家在全羅道，雖然被強徵到這裡來，但如今戰爭結束，可以回家了，這都是托您們的福啊。所以特地來謝謝您！」美軍鴨子聽雷，不斷反覆地說：「你說啥？」不過圍觀的人幾乎是日本人，既聽不懂英語也聽不懂韓語，臉上滿是驚訝的表情，心想他們竟能流暢對話。

In 1945, the U.S. Army who forced Japan to surrender in WWII also disembarked in Yubari, Hokkaido, Japan. At the time, I was a third grader in elementary school. While I was first looking at the American soldiers curiously, a Korean person who appeared to be quite elderly approached the GIs and said in Korean, "Oy! Look over here! You, the man with the big nose, where are you from? I'm from Korea, and my home iz Jeolla-do and I wuz drufted here, but now that tha war iz over, I can go back home now, thanks to you, so I just wunted to tell you that I am grateful!" The American soldier kept replying "Whatchusay?" in a frustrated manner. On the other hand, most of the spectators were Japanese who spoke neither English nor Korean. They all had fascinated faces, as they assumed that the two were having a successful conversation.

1945 年 8 月 15 日光復後，也有很多美軍卡車頻頻行經我的故鄉井邑。卡車經過時，孩子們就會喊著「哈囉、哈囉」，士兵會丟下口香糖或餅乾。我那時人在日本啊！

After independence on August 15th, 1945, U.S. Army trucks frequently passed by my hometown, Jungeup City. When kids cried "Halo, halo" (meaning "hello"), soldiers threw chewing gums or biscuits to them. At that time, I was in Japan!

大鼻子，吃這個（拳頭）啦！（因為他們什麼都不給，就這樣經過……）
金先生，「這個」是什麼啊？
啊！這手勢是代表著他們在歡迎重要的人。
啊！原來如此呀。

Yankee! Eat shit! (Because they passed by without giving out anything…)
Mr. Kim, what does that mean?
Ah! It means welcoming an important person.
Ah! Okay.

1945 年 10 月，我搭著從日本出發的貨物船，船的裡面用木板改造過（有 3 層），和船上的其他六千人一起回來。

The cargo ship that I took from Japan in October, 1945, transported 6,000 people in the three stories inside of the vessel.

在我的故鄉，有兩位被日本強徵勞動後還生還的人，在 1945 年 8 月 15 日光復後回到家鄉。其中有一位白先生，他被其他沒被強徵的人問道：「美軍 B-29 飛機能夠搭多少人？」白先生回答說：「可以搭幾百人，就算只算飛機翅膀的地方，也能搭上五十人。」現在想起來，實在是個吹破牛皮的謊話。
我當時聽到這席話，想像著機翼上坐著人。

After the Liberation on August 15th, 1945, in our hometown, there were two men who survived even though they were forced to go to Japan for forced labor. One of them was called Mr. Baek. A man from the town asked Mr. Baek how many people can fly in the American aircraft, the B-29. He answered that hundreds of people can fly in it, and fifty more can fly on the wings. But only now do I understand that he was lying. (Although had I lived in Hokkaido, Japan, I never saw an airplane firsthand, so I believed him back then.)
I imagined people sitting on the wing.

韓戰爆發時，軍人因為無法接受完整的訓練就被派上戰場去對抗中共軍，隊員幾乎都會戰死，我哥哥經過九死一生倖存下來，最後才得以休假回家。我們煞有其事的服侍他吃午餐。他飯吃到一半被一旁的鏡子嚇了一跳，伸手就要去抓靠在牆上的槍，我說：「哥，您當兵當到連自己的臉都忘了啊。」他看到鏡子中反射出的自己，誤以為是當時在各地出沒的游擊隊員。

Almost every detachment who did not get enough training was killed in the Korean War. My eldest brother narrowly escaped with his life. He came back home for a vacation at long last. We served him lunch. While he was having lunch, he glanced at the mirror and shocked, instinctively reaching for his gun leaning on the wall. I asked, "Did the war make you forget even your face?" At that time, guerrillas were everywhere in all the provinces and his reflection in a mirror made him mistake himself for a guerrilla.

1950 年 9 月 28 日光復後，共產黨的蠻行也在我們村裡發生。我們家隔壁的里長家住著他二兒子。他們（共產黨）在撤退之際，在我們家後面的桑樹底下，用刀刺了爸爸（村長）的脖子好幾刀，爸爸最後雖然死裡逃生地活了下來，兩個兒子卻屍首分離，屍體在村裡偏遠的山中被發現。（那天晚上從家後面傳來的呻吟聲，令我非常難受。）

After Seoul was reclaimed on September 28th, 1950, an incident took place because of the surviving Communists forces. Our town chief's second son's family was living on the upper floor. When the Communists were withdrawing, they attacked their family. Two sons were found dead with their throats slit on the nearby mountain. Their father was also stabbed in his neck several times in a mulberry field behind my house, but he survived. (On the night of the attack, I couldn't fall asleep because of the moaning.)

據美國救護貧民國的《農產物法》第 480 條，麵粉、奶粉、玉米粉等物資被作為救護食糧自美援而來。多虧這項措施，1950 年 6 月 25 日至 1960 年代初，靠麥梗和艾草充飢的慘澹情勢終於逐漸得到舒緩。
1. 植樹防砂（透過金援）；2. 救護學生；3. 透過教會救護百姓；4. 救護戰爭孤兒

After the passage of Article 480 of the Agricultural Law for the Relief of the Poor Countries, food such as wheat flour, powdered milk, and corn flour was sent to Korea as a form of aid. As such, gradual improvements in the situation took place beginning from June 25th, 1950 until the early 1960s, with a reliance on wheat straw and Asian mugwort to relieve hunger. 1. Erosion control through tree planting, with the use of American funding; 2. Medical care for students; 3. Assistance of the poor by churches; 4. Aid for war orphans

1955 年我在釜山第三港口擔任監察員時，有位故鄉在北邊（北韓）、面目清秀的男學生，據說和我同年。不久之後他因為在軍資倉庫附近閒晃被美軍憲兵發現，逃跑時被射殺了。

This event took place in 1955 when I was working as a cargo inspector at No. 3 Pier in Busan. I got to know a good-looking student the same age as myself whose home was in North Korea. Later, he was loitering around the U.S. Army supplies warehouse when he was found by the U.S. military police and he was shot to death while trying to run away.

這是我被分派到美國陸軍附編韓軍的故事

我被分配到論山訓練所後半期部隊的那一天，每個人都被分派到一張人事紀錄卡。我拿到卡片後發現自己的學歷被誤記為中學畢業，我拿給旁邊的朋友看，正想要馬上到前面要求修正的時候，旁邊的朋友說：「會有好事發生的，就這樣放著不管吧。」我照著他說的辦了。於是不久之後，我就被分派到美國陸軍附編韓軍去了。（在1959年那時，被分派去美國陸軍附編韓軍的大都是小學和中學畢業的人。）

The story of how I got assigned to the KATUSA
I got assigned to a unit in the latter half of the army training camp for recruits in Nonsan. Everyone was supposed to get their personal record card that day, but there was an error on the card that said my highest level of education was middle school. I asked a friend who was next to me whether I should ask the instructors to correct it. However, he said "You'd better leave it because that will be better for you.", and I believed him. A few minutes later, I was assigned to the KATUSA.
(Generally speaking, in 1959, elementary or middle school graduates were assigned to the KATUSA.)

被分派到美國陸軍附編韓軍的第一天，我在八軍團司令部，那是我此生第一次在三層鐵製的軍用床上睡覺，度過了既刺激又幸福的一晚。

The first time I slept on an iron triple bunk bed, on the first day when I was assigned to KATUSA in the No. 8 Headquarters. I felt excited and fortunate to be there at that night.

1959年我被編制到美國陸軍附編韓軍，於是來到京畿道坡州奉日川美軍機甲師團服役，當時吃的第一餐主食是麵包、牛肉、青菜和牛奶，點心是水果和咖啡。當時韓國還處於青黃不接的饑荒時期，吃著這些對我來說過於油膩的食物，令我想起母親和兄弟。

When I had my first meal in the U.S. Armored Division in Bongilchun, Paju, Kyunggi-do after joining the Korean Augmentation to the U.S. Army in 1959, the main dishes were bread, beef, vegetables and milk. Fruit and coffee were served as dessert. In those days, Korea was experiencing food shortages. While eating this oily food, I thought of my mother and brothers.

答覆美軍軍官時，要說「耶，瑟」，但我卻不小心說成「咿，呀」惹得他大發雷霆，連發式的罵我「混帳」，嚇死我了。

When responding to a U.S. officer, I had to say "Yes, sir!", but I said "Ee Yah!" by mistake. The officer got extremely angry and repeated "Goddamn" over and over again. That frightened me.

在站步哨的時候，總會有幾位老婦人挨著鐵絲網說無論有什麼要賣的，她們都能買下來。要說我們在美國陸軍附編韓軍有什麼東西能賣，就是每個月能拿到 30 盒包裝上沒有任何文字和圖片的香菸（美國陸軍附編韓軍的配給品）。因為我不抽菸，所以都拿來賣掉，賺來的錢就當零用錢花用。

When we stood guard, women would approach the barbed wire and ask us to sell something to them. We sold thirty packs of cigarette which had no text and no pictures on the packaging, which were KATUSA rations, and spent the money.

- 美軍的戶外小便池
- 只要在地上挖個洞，填滿鵝卵石，再把周圍遮起來就行了。在這塊區域被過度汙染之前移走。
- 我第一次進到廁所時，對著舒適的木製坐式馬桶嘖嘖稱奇。在 1959 年當時韓國的報紙只有 4 頁，美軍看完放在一旁的報紙竟然有 32 面。不禁讚嘆：真是富裕的國家！
- 以前有位剛被派到美國陸軍附編韓軍的鄉下人，曾經犯過這樣的錯。

- *Outdoor urinals for the U.S. Army*
- *It is just a hole dug up, filled up with pebbles, then later covered up. It should have been moved before it became too dirty.*
- *The first time I entered a toilet, there was a wooden toilet bowl and it was quite comfortable, not to mention a new experience for me. In 1959, we had only a 4-page newspaper in Korea, but there were 32 pages in a newspaper for American soldiers. When I counted the pages, I thought about how the U.S. truly is affluent.*
- *There was a person from the countryside assigned to the KATUSA that made such a mistake.*

1955 年我在釜山第三港口擔任監察員時，有個善良的美軍像是扔棒球一樣，把橘子丟給我要我吃。
我沒打過棒球，平時也沒運動，所以沒接到橘子。
他又丟了第二次，我又沒接到。
那時我覺得好丟臉，一邊責備自己運動神經怎麼這麼遲鈍，一邊把橘子撿起來吃掉。

When I worked as an inspector in the No. 3 Pier in Busan in 1955, a kind U.S. soldier threw me an orange like he was playing baseball.
I had never played the sport and I did not practice any sports usually, so I did not catch that orange.
He tried again, but I again did not catch it.
Feeling ashamed of my poor athletic abilities, I picked up and ate those oranges.

同袍士兵大打出手，他們只是袖手旁觀
1959 年我在美國陸軍附編韓軍服役的時候，第一次看到美軍士兵之間打架的場面，非常驚訝。如果是韓國同袍之間打架，通常都會被勸架，但美國士兵都不勸架，只是在一旁觀戰。被壓在地上的人被抓著脖子，直到無法呼吸、幾乎要死的時候才投降，爭執就這樣結束了。在遙遠的異鄉服役很煎熬了，沒有力氣的人似乎只有被打的份。※ 在韓國有句俗諺說「不可打架！」看來韓國同胞們的確是出身自「東方禮儀之國」。

Standing idly while fellow soldiers fight each other
I was surprised when I first saw American soldiers fight each other while serving in the army as a KATUSA in 1959. It is common for us to stop a fight when our comrades are arguing, but the American GIs were just standing by, merely watching the fight. When the soldier who was knocked down was in danger of suffocating, he surrendered and then the fight ended. It must have been lonely to be so far away from home in a foreign and strange land, but the weak soldier seemed to have no energy left to keep fighting.
** As the Korean saying goes, "Always stop a fight!" I was led to believe we were the people of Dongbangyeuijiguk (the country of courteous people in the East, Korea).*

平時在體育館裡的下士
1960 年 4 月 19 日我從機甲師團退伍，有一位接到八軍團司令部的美軍資深下士，他缺了左手臂。每天我都會在體育館遇到他，我非常喜歡他。

The sergeant in the gym
When I was discharged from the armed division on April 19th, 1960, there was a first sergeant who brought me to the No. 8 Headquarters. He did not have his left arm. I liked him very much because he was a person who I met everyday in the gym.

許家維

HSU CHIA-WEI

回莫村
Huai Mo Village

單頻道錄像，8'20"，2012
Single-channel video, 8'20", 2012

「回莫村計畫」講述 1949 年後一批撤退泰緬邊境的中國軍隊，他們所面臨的多重文化的交錯、不被認可的尷尬身分，以及邊境地區孤軍部隊的故事。這些在分裂歷史陰影下生活的人們，最終產生的是常人所不具有的歧義性。1949 年國共內戰之際，國民黨戰敗後原屬國民黨政府的正規軍由雲南撤退至緬甸，原二十多萬人員抵達緬甸時僅存兩千餘人員。在國際的壓力下，蔣介石指示這支部隊撤回台灣，但事實上則是「明撤暗留」；表面上這支部隊已解散，但私底下仍然保持戰備狀態以圖反攻。這一次形同向國際宣告，「當地軍人」不再有任何行動，以後與中華民國政府無關。因此，他們依然生活在泰鄉，像一群無家可歸的人、沒有任何國籍與正式身份。

1970 年，這支孤軍因生存需要，應泰國軍方要求，出面協助遠征泰共以換取居留權，並確定了孤軍在泰北以傭軍形式長久駐留的必要性。這段期間，許多人也開始種起滿山的罌粟花，並協助毒梟從緬甸運送毒品以改善生計，在過去這裡的毒品產量佔全球產量的百分之八十，成為世界毒品中心。回莫村還有一個特殊的背景，此地大多是情報局的老兵或是家眷，因為在 1970 年代的冷戰架構下，美國政府秘密支持中華民國政府在回莫村成立了情報局，名為「國防部 1920 區光武部隊大陸工作組」，這支情報部隊的主要任務在於監控大陸的共產黨活動。此地成為了一個鮮少人知的情報村。

作品〈回莫村〉關注泰國清邁回莫村的自強之家，創辦人是一位牧師，但同時在冷戰時期，他也秘密地擔任 CIA 情報員，持續了有三十九年的時間，他的身分也點出了這段歷史的源頭及變化的過程。此地從 1980 年代開始成為世界的毒品中心，走私與販賣問題極為嚴重，目前有大約七十位左右的院童，這些孩童的父母親大多是因為販毒或走私毒品而遇害或入獄，因為當地的毒品問題而成為孤兒。

在這件錄像作品中，藝術家邀請這些孩童成為拍攝團隊，與他們共同使用攝影機、錄音設備與燈光等等拍片器材，並且由孩童們親自訪問這位牧師，牧師在影片中娓娓道出作為情報員的過往。藝術家慣有的拍攝手法在本作品中仍在延續：從講故事的人、聽故事的人、到由孩童們組成的拍攝團隊，藝術家站在更為後方的位置，觀察著這一切、探討這個地區複雜的歷史。

Huai Mo Village Project relates the story of remnant troop on the border regions of Thailand and Myanmar (Burma) who face multiple cultural identities and the embarrassment of being of an unrecognized identity. People who live under the specter of history end up producing an ambiguity absent in ordinary people. In 1949, during the Chinese Civil War, the defeat of the KMT resulted in a perilous retreat of the Nationalist army from Yunnan to Myanmar with only 2,000 among 200 thousand soldiers reaching the destination in the end. Due to international pressure, Chiang Kai-Shek instructed the troop to retreat to Taiwan. In

fact, the troop seemed to have disbanded, but in secret they remained in a state of combat preparing for their counterattack. Their actions were like declarations to the world that the "local soldiers" will no longer intervene. They severed all ties with the government of the Republic of China. Therefore, they remained living in this Thai village, like a group of homeless people without any national identification.

In 1970s, in order to sustain themselves in foreign lands and to exchange for the right to abode, the lost troop answered the request of the Thai military in assisting their expedition against the Thai communists, which then determined their prolonged stay as mercenaries in northern Thailand. During this period, many people grew poppies to increase their incomes for a better life, or assisted drug dealers to traffic drugs from Myanmar. The drug production in this region used to account for 80% of the global supply, determining its status as the international drug trade center at the time. Most of the villagers were either former intelligence officers or families. During the Cold War in the 1970s, the American government secretly supported the Republic of China government's return to the Huai Mo Village to establish an intelligence base there, which was referred to as the District 1920 Guangwu Troop Department of Defense Chinese Affairs Team. The main task of the team was to monitor Chinese communist's activities. Now only a few people know about this village.

Huai Mo Village focuses on the Huai Mo Tzu Chiang House in Chiang Rai, Thailand. The founder of this house is a priest who, during the Cold War period, served as a secret informer for the CIA for thirty-nine years. His identity indicates the sources of this period of history and the process of change. Starting from the 1980s, this region has turned into a world drug center facing serious issues of smuggling and trafficking. Currently, there are around 70 children most of whose parents have been killed or jailed due to drugs trafficking or smuggling. Owing to the local drug problems, these kids have become orphans.

In this video work, the artist invited these children to form a filming team and jointly used camera, sound recording equipments, lights, and other filming facilities. Children were able to interview the priest in person and to listen to him tirelessly talking about the past of the Intelligence Bureau. The artist's customary style is extended in this work—the people telling the stories, the people listening to the stories, the filming crew made up of orphans, with the artist standing further back, observing and exploring the complex history of this region.

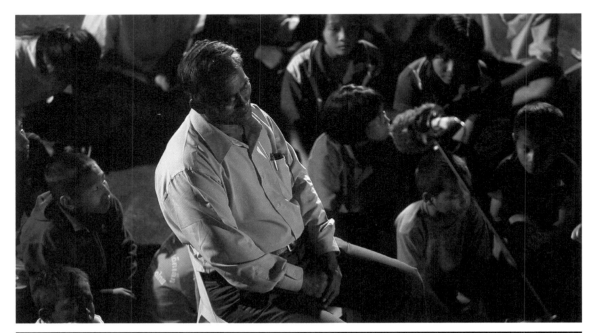

〈回莫村〉，影片擷圖
Huai Mo Village, video still

廢墟情報局
Ruins of the Intelligence Bureau

單頻道錄像，13'30"，2015
Single-channel video, 13'30", 2015

〈廢墟情報局〉是在回莫村的情報局遺址所拍攝而成，情報局原有的房舍已經拆除，現今只遺留下地基，並且由泰國陸軍所管轄。藝術家邀請了目前仍居住在這個區域的情報局老兵參與拍攝，並以此地基作為一個舞台，演出泰國的傳統木偶表演。此外也邀請擔任情報工作三十九年的老情報員（同時也是自強之家院長）錄製這部影片的旁白，同時在錄音室錄製旁白的過程也成為了影片的一部分。

影片從情報局地基上的木偶劇團表演開始，操偶師頭戴黑色面具並身著黑衣進行這場表演。旁白述說著一個遠古的傳說，關於猴子將軍哈努曼（Hanuman）拯救軍隊的故事。這是流傳於東南亞各國的經典神話，在神話中，哈努曼帶領軍隊作戰，最終協助王子回到他當初被驅逐的王國。

旁白描述著這個故事的同時，畫面切換到了錄音室，老情報員正在錄製這段旁白，他看著巨大的投影，一面說著遠古的傳說，一面描述著自己的真實經歷以及這些老兵在回莫村的真實處境，他們並不像神話裡的王子一樣能夠回到自己的王國，事實上這些老兵再也回不去他們的家鄉。當畫面回到了情報局遺址，舞台前聚集了很多觀眾正在觀看木偶劇團的表演，一部分是目前駐守在此的泰國陸軍，另一部分的觀眾則是情報局的老兵，他們全部戴著黑色面具，他們是在歷史洪流之中被遺忘的一群無名之人。影片的最後一幕是錄音室的空景，只有這部影片在錄音室獨自播放著。這是一部結合了神話與現實、紀錄與虛構的電影，並呈現了回莫村複雜的認同、記憶與想像。

Ruins of the Intelligence Bureau was filmed at its historical site in Huai Mo Village. The original building of the Intelligence Bureau does not exist any longer, yet foundation slab, now governed by the Thai army, still remains. The artist invited former intelligence officers, who still live in this area, to participate in filming. The foundation slab was turned into a stage for a traditional Thai puppet show. The narrator in this video is the head of the Huai Mo Tzu Chiang House who served as an intelligence officer for thirty-nine years. The video also reveals the narration recording process.

The video opens with the puppet show upon the grounds of the Intelligence Bureau; the puppeteers are dressed in black and wear black masks. Simultaneously, the narrator recounts an ancient legend about the monkey general Hanuman rescuing the army. This classic myth is well-known amongst the Southeast Asian nations. In this story, Hanuman leads the troop to battle, and helps the prince to return to the kingdom he was exiled from.

While the narrator tells this story, the camera switches to the studio and shows the veteran officer in the middle of recording. He, while looking at a huge projection, recites the myth and describes his own

personal experiences as well as the real situation of other former officers in Huai Mo Village. Unlike the prince in the myth, they are not able to return to their kingdom. In fact, these veterans cannot go back to their home country. When camera cuts back to the site of the Intelligence Bureau, one can see a large audience watching a performance of puppet troupe. Some of the audience currently serve for the Thai army and some are the former informants. All of them wear black masks. They are a group of unknown people who had been forgotten in the tides of history. The final scene of the video reveals an empty recording studio, where only the video is still running. Weaving together folklore and reality, documentary and fiction, this video reveals complex identities, memories and dreams of people in Huai Mo Village.

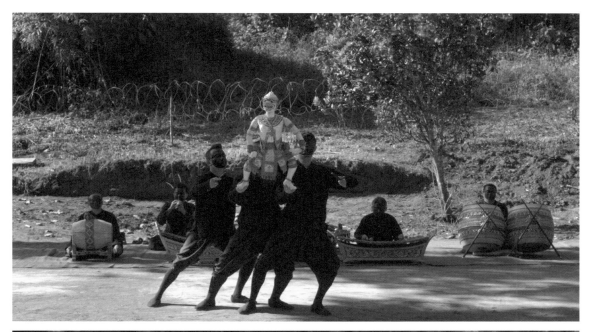

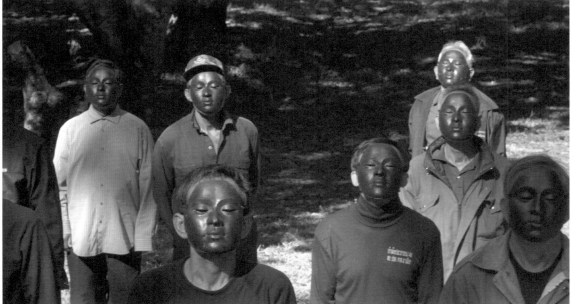

〈廢墟情報局〉，影片擷圖
Ruins of the Intelligence Bureau, video still

普拉賈克塔・波特尼斯
PRAJAKTA POTNIS

廚房辯論
The Kitchen Debate

複合媒材裝置，2014
Multimedia installation, 2014

本作品的標題取自 1959 年 7 月 24 日於莫斯科的索科爾尼基公園所舉辦的「美國博覽會」開幕裡，美國副總統尼克森與蘇聯領導人赫魯雪夫一連串透過口譯者的即席意見交換。在美國博覽會的開幕儀式中，尼克森和赫魯雪夫在展場內的廚房展示區裡，進行了一場關於資本主義與共產主義的激烈辯論。這所謂的「廚房辯論」已成為冷戰時期的著名事件。

普拉賈克塔‧波特尼斯 2014 年在柏林的貝塔寧藝術村駐村期間，重新研究並思索這個特別的事件，同時檢視它對我們這個時代所造成的影響。由於她長期且廣泛地關注日常生活空間中潛在的型塑驅動力，使她立刻為這場廚房辯論所吸引。

她把廚房當成檢視的場域，進一步凝視我們現代生活方式的核心 —— 那間擺放著日常家用裝置的小房間。生活例行家事如洗碗、攪拌、冷凍，她將這些有點乏味的儀式賦予了活力，試圖將其轉化為怪物，讓人聯想到核彈似乎就是在家庭廚房內製造出來。她使用看似基因被改造的花椰菜這類的蔬菜，隱約地指涉了日復一日吞噬我們的毒化生活。

普拉賈克塔‧波特尼斯希望能夠過藝術創作，把這條從過去到當下的脈絡，與自己的脈絡連結在一起。

The title is adopted from a series of impromptu exchanges that transpired (through interpreters) between then U.S. Vice President Richard Nixon and Soviet Premier Nikita Khrushchev at the opening of the American National Exhibition at Sokolniki Park in Moscow on July 24, 1959. During the grand opening ceremony of the American National Exhibition in Moscow, Vice President Richard Nixon and Soviet leader Nikita Khrushchev engaged in a heated debate about capitalism and communism in the midst of a model kitchen set up for the fair. The so-called "kitchen debate" became one of the most famous episodes of the Cold War.

During her residency at the Künstlerhaus Bethanien in 2014, Prajakta Potnis revisited and explored this particular episode, to also examine its repercussions within our present times. Her extensive long-term engagement with the various undercurrents that determine the dynamics of a domestic space instantaneously drew her to the kitchen debate.

By proposing the kitchen as a site of investigation, she proceeds by gazing into the cavities of certain everyday domestic apparatuses central to our modern existence. Animating the daily routine of washing, blending, refrigerating these otherwise mundane rituals, attempt to translate as anomalies to draw references to the

making of a nuclear bomb probably in the ambit of a domestic kitchen. By employing vegetables like the genetically modified cauliflower she subtly tries to hint to the toxic lives that consumes us on a day-to-day basis.

Prajakta Potnis promises to engage through her art making, threads from this past–present to hers.

〈廚房辯論〉，影像擷圖
The Kitchen Debate, video still

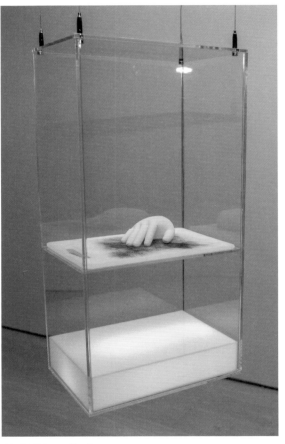

〈廚房辯論〉，展場局部
The Kitchen Debate, installation view

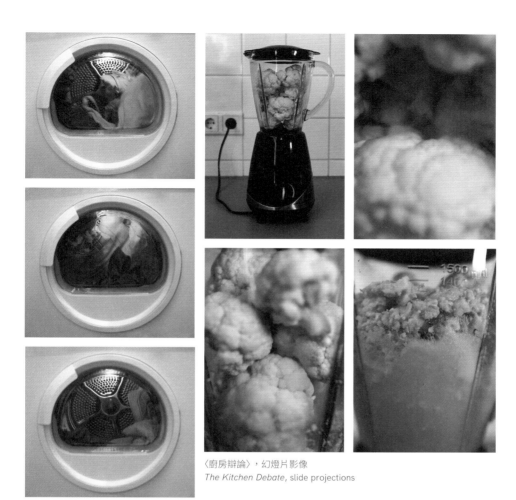

〈廚房辯論〉，幻燈片影像
The Kitchen Debate, slide projections

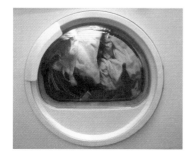

廚房辯論——對話紀錄

*本文件擷取自 https://www.cia.gov/library/readingroom/docs/1959-07-24.pdf

1959 年 7 月 24 日
美國副總統尼克森與蘇聯總理赫魯雪夫，蘇聯莫斯科的美國大使館記錄。

（兩人走進美國博覽會的廚房）

尼克森：我想請你看看這個廚房，我們加州的房子都是這樣。
（尼克森指著洗碗機）

赫魯雪夫：這玩意兒我們也有。

尼克森：這是我們最新的款式，幾千棟房子裡都有這種標準配備。在美國，我們要讓女性的生活過得輕鬆一點……

赫魯雪夫：你們資本主義對女性的看法跟共產主義不一樣。

尼克森：我想，這種對女性的看法是普世的。我們希望讓家庭主婦更輕鬆……

尼克森：這棟房子的價格是一萬四千美元，大多數的美國（二戰老兵）可以用一萬到一萬五千美元買到房子。跟你舉個例子你就懂了。就如你所知，我們的煉鋼工人正在罷工，但任何一個煉鋼工人都買得起這種房子。他們一小時賺三美元，買這棟房子可以分期二十五到三十年，每月付一百元。

赫魯雪夫：我們也有付得起一萬四千美元買房子的煉鋼工人和農夫。你們美國蓋的房子只能住二十年，這樣建商才能繼續賣新房子。我們蓋的房子很堅固，我們的房子是為了子子孫孫蓋的。

尼克森：美國房子的壽命不止二十年，不過，即使如此，過了二十年，很多美國人會想要新房子或新廚房。他們的廚房是要被淘汰的……。美國的系統就是要充分運用新創意和新科技。

赫魯雪夫：這種理論站不住腳。有些東西不會過時。傢俱、裝潢也許會過時，但房子不會。我讀過很多關於美國和美國房子的報導，那些跟這個展覽展出的還有跟你所說的可不太一樣。

尼克森：呃，這個……

赫魯雪夫：希望沒有冒犯到你。

尼克森：我被專家冒犯的經驗豐富。不過，我們聊得很融洽，直來直往。

赫魯雪夫：美國人創造了自以為是的蘇聯人形象，但他們可不像你們想的那樣。你們以為俄羅斯人看到這個展裡的東西就會目瞪口呆嗎？其實俄羅斯人現在蓋的新房子也都有這些設備。

尼克森：是啦，不過……

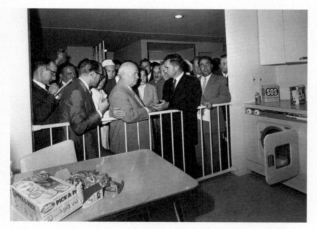

蘇維埃總理赫魯雪夫（中左）與美國副總統尼克森於美國博覽會中的「廚房辯論」，蘇聯莫斯科，1959。
Soviet Premier Nikita Khruschev, U.S. Vice President Richard Nixon, attending American Exhibition resulting in "Kitchen Debate", Moscow, U.S.S.R., 1959.

赫魯雪夫：在俄羅斯，只要你是蘇聯人就可以擁有一棟房子，天生就有居住權……在美國，有錢沒錢將決定你是睡屋裡還是睡街上。但你們還是很敢說我們是共產主義的奴隸。

尼克森：我很欣賞你講話清晰有力……

赫魯雪夫：有力和有智慧是不一樣的。

尼克森：如果你在我們的參議院，會被說是議事搗蛋鬼，你 ——（赫魯雪夫中間插嘴）—— 拼命講還不讓人家講。這個展不是做來讓人震驚的，而是用來讓人感興趣的。我們有一千個建商，蓋出一千種房子，多樣性與選擇的權利，才是最重要的事。我們不會有一個來自政府高層的決定，決定唯一一種房子的模樣。這就是不同之處。

赫魯雪夫：在政治上，我們不可能同意你的看法。例如說，米高揚愛喝很辣的湯，我不愛。但這不代表我們不能合作。

尼克森：你們跟我們學習，我們跟你們學習，一定要有自由的交流。要讓人民有權力選擇房子、選擇湯和選擇想法。

（進入攝影棚時翻譯中斷）

赫魯雪夫：（打趣的口氣）你好像很生氣，好像想跟我打架似的。你還在氣？

尼克森：（打趣的口氣）沒錯！

赫魯雪夫：……尼克森以前是律師啊？可他現在很緊張。

尼克森：對啊（笑），他現在還是（律師）。

某位俄羅斯人：請談談你們對這個展覽的看法？

赫魯雪夫：我看得很清楚，工人沒把事情搞定，展覽亂七八糟……美國人就這點能耐，美國建國幾年了？獨立三百年了？還是一百五十年？水準才這樣。我們建國還沒四十二年，再七年我們就要趕上現在的美國了，之後就會超越美國。等我們超車時，會跟你招手說「嗨」，到那時候，若是你願意，我們還是可以停下來說：「請跟上。」……如果你們想活在資本主義底下，隨你便，那是你們內部的問題，跟我們沒關係。但我為你們感到遺憾，真的，你們不懂。我們早就知道你們是怎麼想事情的。

某位美國人：副總統先生，就你看這個展覽，你覺得它可以打動蘇聯人民嗎？

尼克森：這是非常有效力的展覽，它會讓人們感興趣。像今天很早的時候，我去參觀了市場，市郊的農夫帶著他們的農產品到城裡來賣。我只能說，有非常多的工人、農人等等會很感興趣。因此，從這個觀點來看，我覺得這個展覽應該會相當成功。回到赫魯雪夫先生剛才的評論，我們從他身上學到，原來他們有抓到機會就要即席發表直率演說的傳統。我只能說，你剛才很明確提到的那種競爭，計劃要超越我們，特別是消費商品的生產……如果這種競爭對我們的人民和全世界的人民有好處，我們就一定要允許思想的自由交流。有幾個你們領先的例子 —— 像你們發展的外太空火箭。還有其他的例子，像彩色電視機，我們勝一籌。但為了讓彼此都受益……

赫魯雪夫：（打斷）不對，我們不止火箭超越你們，其他科技也……

尼克森：（接著說）看吧，你們什麼事情都不讓步。

赫魯雪夫：我們都知道美國人很聰明，愚蠢的人民沒法搞出那樣的經濟水準。但你們知道，「我們不用鼻孔打蒼蠅！」這四十二年裡，我們進步很快。

尼克森：你不應該害怕思想。

赫魯雪夫：這是我們講的話，你們才不要害怕思想，我們什麼都不怕……

尼克森：好啊，那我們多多交流思想。這點我們都同意，對吧？

赫魯雪夫：好。（回頭問翻譯）同意什麼？

尼克森：（打斷）一起去看看我們的照片吧。

赫魯雪夫：可以，我同意。但首先我必須要澄清我所同意的內容。我有這個權利吧？我知道我在跟一個優秀的律師打交道，因此，我的立場要非常堅定，這樣我的人民才會認為：「我們的頭兒沒認輸！」

尼克森：沒問題。

赫魯雪夫：你是資本主義的律師，我是共產主義的律師，咱們比一比。

尼克森：我只能說，從你講話的方式和你主導話題的方式看來，你應該會是個好律師。我的意思是：你可以看到這裡有錄影機，可以立即把現在的對話一句不差得傳送出去，這表示傳播的可能性會提高很多。而更好的溝通，可以讓我們學習一些事情，你們也學到事情。因為，畢竟你們什麼都不明白。

赫魯雪夫：如果我什麼都不明白，那你們對共產主義才壓根兒沒搞懂，就只會害怕！而且現在的爭執並不公平，這個設備是你們的，你講英語，我講俄語，你的話會被傳播出、被人們聽到。我對你談到的科學卻不會被翻譯，所以你們的人民聽不到。這並不是公平的狀態。

尼克森：你在蘇聯講的每一句話，我們在美國每天都讀得到……我向你保證，別以為我們美國人讀不到你在這裡說的話。

赫魯雪夫：如果是這樣，我希望你說到做到。你得承諾我……副總統先生，我要你承諾將我的演說都轉成英文並紀錄起來。可以嗎？

尼克森：當然沒問題。同樣的，我也希望我說的每一句話都被錄下，而且翻譯出來，傳播到整個蘇聯。這樣才公平。

（兩人握手，走下講台，持續交談）

The Kitchen Debate—Transcript

* This document is taken from https://www.cia.gov/library/readingroom/docs/1959-07-24.pdf

24th July, 1959
U.S. Vice President Richard Nixon and Soviet Premier Nikita Khrushchev
U.S. Embassy, Moscow, Soviet Union

[Both men enter kitchen in the American exhibit.]

Nixon: I want to show you this kitchen. It is like those of our houses in California. [Nixon points to dishwasher.]

Khrushchev: We have such things.

Nixon: This is our newest model. This is the kind which is built in thousands of units for direct installations in the houses. In America, we like to make life easier for women...

Khrushchev: Your capitalistic attitude toward women does not occur under Communism.

Nixon: I think that this attitude towards women is universal. What we want to do, is make life more easy for our housewives...

Nixon: This house can be bought for $14,000, and most American [veterans from World War II] can buy a home in the bracket of $10,000 to $15,000. Let me give you an example that you can appreciate. Our steel workers as you know, are now on strike. But any steel worker could buy this house. They earn $3 an hour. This house costs about $100 a month to buy on a contract running 25 to 30 years.

Khrushchev: We have steel workers and peasants who can afford to spend $14,000 for a house. Your American houses are built to last only 20 years so builders could sell new houses at the end. We build firmly. We build for our children and grandchildren.

Nixon: American houses last for more than 20 years, but, even so, after twenty years, many Americans want a new house or a new kitchen. Their kitchen is obsolete by that time...The American system is designed to take advantage of new inventions and new techniques.

Khrushchev: This theory does not hold water. Some things never get out of date—houses, for instance, and furniture, furnishings—perhaps—but not houses. I have read much about America and American houses, and I do not think that this is exhibit and what you say is strictly accurate.

Nixon: Well, hum...

Khrushchev: I hope I have not insulted you.

Nixon: I have been insulted by experts. Everything we say [on the other hand] is in good humor. Always speak frankly.

Khrushchev: The Americans have created their own image of the Soviet man. But he is not as you think. You think the Russian people will be dumb-founded to see these things, but the fact is that newly built Russian houses have all this equipment right now.

Nixon: Yes, but...

Khrushchev: In Russia, all you have to do to get a house is to be born in the Soviet Union. You are entitled to housing...In America, if you don't have a dollar you have a right to choose between sleeping in a house or on the pavement. Yet you say we are the slave to Communism.

Nixon: I appreciate that you are very articulate and energetic...

Khrushchev: Energetic is not the same thing as wise.

Nixon: If you were in the Senate, we would call you a filibusterer! You—[Khrushchev interrupts]—do all the talking and don't let anyone else talk. This exhibit was not designed to astound but to interest. Diversity, the right to choose, the fact that we have 1,000 builders building 1,000 different

houses is the most important thing. We don't have one decision made at the top by one government official. This is the difference.

Khrushchev: On politics, we will never agree with you. For instance, Mikoyan likes very peppery soup. I do not. But this does not mean that we do not get along.

Nixon: You can learn from us, and we can learn from you. There must be a free exchange. Let the people choose the kind of house, the kind of soup, the kind of ideas that they want. [Translation lost as both men enter the television recording studio.]

Khrushchev: [In jest] You look very angry, as if you want to fight me. Are you still angry?

Nixon: [In jest] That's right!

Khrushchev: ...and Nixon was once a lawyer? Now he's nervous.

Nixon: Oh yes, [Nixon chuckling] he still is [a lawyer].

Other Russian speaker: Tell us, please, what are your general impressions of the exhibit?

Khrushchev: It's clear to me that the construction workers didn't manage to finish their work and the exhibit still is not put in order...This is what America is capable of, and how long has she existed? 300 years? 150 years of independence and this is her level. We haven't quite reached 42 years, and in another 7 years, we'll be at the level of America, and after that we'll go farther. As we pass you by, we'll wave "hi" to you, and then if you want, we'll stop and say, "please come along behind us." ...If you want to live under capitalism, go ahead, that's your question, an internal matter, it doesn't concern us. We can feel sorry for you, but really, you wouldn't understand. We've already seen how you understand things.

Other U.S speaker: Mr. Vice President, from what you have seen of our exhibition, how do you think it's going to impress the people of the Soviet Union?

Nixon: It's a very effective exhibit, and it's one that will cause a great deal of interest. I might say that this morning, very early in the morning, went down to visit a market, where the farmers from various outskirts of the city bring in their items to sell. I can only say that there was a great deal of interest among these people, who were workers and farmers, etc... I would imagine that the exhibition from that standpoint would, therefore, be a considerable success. As far as Mr. Khrushchev's comments just now, they are in the tradition we learned to expect from him of speaking extemporaneously and frankly whenever he has an opportunity. I can only say that if this competition which you have described so effectively, in which you plan to outstrip us, particularly in the production of consumer goods...If this competition is to do the best for both of our people and for people everywhere, there must be a free exchange of ideas. There are some instances where you may be ahead of us—for example in the development of the thrust of your rockets for the investigation of outer space. There may be some instances, for example, color television, where we're ahead of you. But in order for both of us benefit...

Khrushchev: [interrupting] No, in rockets we've passed you by, and in the technology...

Nixon: [continuing to talk] You see, you never concede anything.

Khrushchev: We always knew that Americans were smart people. Stupid people could not have risen to the economic level that they've reached. But as you know, "we don't beat flies with our nostrils!" In 42 years we've made progress.

Nixon: You must not be afraid of ideas.

Khrushchev: We're saying it is you who must not be afraid of ideas. We're not afraid of anything...

Nixon: Well, then, let's have more exchange of them. We all agree on that, right?

Khrushchev: Good. [Khrushchev turns to translator and asks:] Now, what did I agree on?

Nixon: [interrupts] Now, let's go look at our pictures.

Khrushchev: Yes, I agree. But first I want to clarify what I'm agreeing on. Don't I have that right? I know that I'm dealing with a very good lawyer. Therefore, I want to be unwavering in my miner's girth, so our miners will say, "He's ours and he doesn't give in!"

Nixon: No question about that.

Khrushchev: You're a lawyer of Capitalism, I'm a lawyer for Communism. Let's kiss.

Nixon: All that I can say, from the way you talk and the way you dominate the conversation, you would have made a good lawyer yourself. What I mean is this: Here you can see the type of tape which will transmit this very conversation immediately, and this indicates the possibilities of increasing communication. And this increase in communication, will teach us some things, and you some things, too. Because, after all, you don't know everything.

Khrushchev: If I don't know everything, then you know absolutely nothing about Communism, except for fear! But now the dispute will be on an unequal basis. The apparatus is yours, and you speak English, while I speak Russian. Your words are taped and will be shown and heard. What I say to you about science won't be translated, and so your people won't hear it. These aren't equal conditions.

Nixon: There isn't a day that goes by in the United States when we can't read everything that you say in the Soviet Union...And, I can assure you, never make a statement here that you don't think we read in the United States.

Khrushchev: If that's the way it is, I'm holding you to it. Give me your word...I want you, the Vice President, to give me your word that my speech will also be taped in English. Will it be?

Nixon: Certainly, it will be. And by the same token, everything that I say will be recorded and translated and will be carried all over the Soviet Union. That's a fair bargain.

[Both men shake hands and walk off stage, still talking.]

廚房對話

阿崔伊・古普塔

* 本文原刊載於《Prajakta Potnis— Store in a Cool and Dry Place》，2014。

剪貼簿，加爾各答，約 1950 年，作者的收藏。
（圖片由作者提供）

在 1990 年代，當時正值高中時期的我偶然發現了一本母親在 1950 年代末做的剪貼簿，當時她大約十二、三歲。我還記得自己為這本剪貼簿所著迷，並且深深地感到疑惑。我無法理解的是雜誌上廚房用具和核心家庭的圖像，為何在剪貼簿裡佔據了如此重要的位置？對我們這些在 1970 與 1980 年代末的印度城市裡長大的中產階級小孩來說，諸如電冰箱、吸塵器、電動果汁機和烘焙烤箱，並不是什麼新鮮事。核心家庭同樣不算稀奇，所以都用不著為了保存而花力氣將雜誌頁上光亮的圖片剪貼到簿子裡的私密世界。在當時，剪貼簿被認定是區分母親的世代 ——「午夜之子」，指出生於印度脫離大英帝國統治而獨立的 1947 年的一代，這個名詞也因薩爾曼・魯西迪（Salman Rushdie）1981 年的同名小說而名垂千古 —— 與我等世代之間，無法跨越的鴻溝。鴻溝的兩側似乎不可能溝通。儘管如此，我仍是滿懷好奇地盯著在我衣櫃底層的那本剪貼簿，在後來的二十個年頭，它都被保存在那裡。在更久之後我才了解到，1950 年代末，十二歲的我母親身處的冷戰年代裡，具備完善家電的現代家庭有著多麼崇高的重要地位。

1959 年夏天,「美國博覽會」在莫斯科的索科爾尼基公園開幕,美國副總統尼克森和蘇聯領導人赫魯雪夫之間著名的廚房辯論,就發生於此地。相應的俄羅斯展覽「蘇聯科學、科技與文化展」則在同年初於紐約體育館會議中心舉辦。[1] 後者包下了整棟會議中心的三層樓作為展場,展出世界上第一架人造衛星(史普尼克號)的模型、機械和設備,藉以展現並證明蘇聯於後史達林主義時代的科技進步。特別值得注意的是,展覽中還搭起了一間實際尺寸、家具俱全的三房式公寓,用來向美國觀眾展示蘇聯政府之下的普通公民所享有的舒適居家生活。

隨後,美國就招募了一批聰慧過人的設計師們來對抗蘇聯在展覽中所強調的科學與科技發展。美國在莫斯科舉辦的展覽「美國博覽會」在巴克敏斯特・富勒(Buckminster Fuller)所設計的直徑兩百呎的巨型穹頂建築中拉開序幕。七十八呎高的鍍金結構體在夏日的艷陽中閃爍著光芒,它如克里姆林宮般洋蔥造型的穹頂,在地平線上若隱若現。在穹頂之下,播放的是設計師查爾斯與蕾・伊默斯(Charles and Ray Eames)所拍攝的第一部影片〈美國一瞥〉,影片投影在從天垂下的二十呎乘以三十呎的七面屏幕上,其中概括了美國人典型市井生活的一週。

伊默斯的影片利用了航空技術,以外太空的影像為開始,慢慢拉進到美國郊區的房子,攝影機透過影像的暫時靜止來強調美國人日常生活中的親密行為:最後一口的咖啡、正包裹著午餐盒的女人、親吻妻兒準備動身前往工作的男人、互道再見、孩子們也起身去上學。展場的其他地方,有五百件家用小設備、鍋碗瓢盆掛在模組廚架上,就像是自由市場的皇冠上閃閃發光的珠寶。六房的郊區家屋搭配著最新款的家用電器,以多方位的感官重建出美國生活。

挑起尼克森和赫魯雪夫之間廚房辯論的東西,正是新款惠而浦洗碗機、得力於軍事科技而發明的廚房電器和罐頭食物。[2] 對尼克森來說,這種家庭導向的消費品 —— 似乎無止境地混合了香味、功能、色彩和價格 —— 體現的正是美國公共與私人生活中的核心原則:自由、民主和自由市場經濟。對赫魯雪夫來說,這些都是資本

1　關於後史達林主義蘇聯的討論,參見 Stephen Lovell, *The Shadow of War, Russia and the USSR 1941 to the Present*, West Sussex, U.K. and Malden Mass, 2010。

2　關於辯論的文稿,請參閱 "Encounter", *Newsweek*, August 3. 1959, pp.15-17; "Better to See Once", *Time*, August 3, 1959, pp.12-14。

3 Stephen J. Whitfield, *The Culture of the Cold War*, Baltimore 1991; Karat Ann Marling, *As Seen on TV: The Visual Culture of Everyday Life In the 1950s*, Cambridge, Mass. 1994; Beatriz Colomina, "Enclosed by Images: The Eameses' Multimedia Architecture", *Grey Room*, no.02, Winter 2001, pp.6-29.

4 "MoMA Press Release No. 4, Friday, February 16. 1959" and "MoMA Press Release No.31, Monday, April 13, 1959", MoMA Press Release Archive, Museum of Modern Art, New York; *Design Today in America and Europe*, exhibition catalogue, Museum of Modern Art, New York and National Small Industries Corporation Limited, New Delhi, 1959.

5 關於這段歷史，請參閱 Paul M. McGarr, *The Cold War In South Asia: Britain, the United States and the Indian Subcontinent, 1945–1965*, Cambridge, 2013。

6 關於這段不結盟運動的歷史，請參閱 Vijay Prashad, *The Darker Nations, A Peoples History of the Third World*，New York 2007；Itty Abraham，"From Bandung to NAM: Non-alignment and Indian Foreign Policy. 1947–65", *Commonwealth & Comparative Politics*, vol. 46. no. 2, pp.195-219; Nataša Mišković, Harald Fischer-Tiné, and Nada Boškovska, (eds.), *The Non-Aligned Movement and the Cold War*, Abingdon 2014。

主義邏輯中膚淺、過度和頹廢的象徵。廚房這個勞動、生產與消費的場域，因而被投射在冷戰時期緊張的意識型態地勢圖上。政治意識型態和家庭生活，被緊密地結合在精心規劃的展覽空間之中，當時的展場由美國建築師兼設計師喬治‧尼爾森 (George Nelson) 操刀設計，委任他主掌「美國博覽會」的單位，是當時為了支持冷戰文化外交政策而成立的組織 —— 美國新聞處。這部分的歷史比較為人所知。[3]

較鮮為人知的是，威爾森在當時還同時著手於紐約當代美術館的展覽「今日歐美設計展」(Design Today in America and Europe)，1959 年二月在新德里開幕。[4] 該展在印度巡迴了兩年，最後在 1961 年為艾哈邁達巴德 (Ahmedabad) 新成立的國家設計研究所提供了館內的核心典藏品。無庸置疑的，「今日歐美設計展」當然是美國在冷戰時期的文化外交。事實上，這檔展覽也呈現了由富勒設計的穹頂建築，類似於在莫斯科亮相的那棟建築物，在在證明了這檔展覽與冷戰政治樣板的相關性。根據報導，「今日歐美設計展」在印度吸引數百萬的觀眾，在富勒的穹頂建築外大排長龍，耐心地等待入場。值得注意的是，這座穹頂建築是現代美術館向美國新聞處借來的。

儘管有著某些相似處，但在印度的展覽仍有些許特點使它不同於莫斯科的豪華冷戰大展。獨立後不久，印度就開始透過實施蘇聯式的五年計畫和經濟管制，步上美國式的科技快速發展和工業革新。[5] 就在萬隆會議後僅僅四年的 1955 年，印度政府就要求「今日歐美設計展」至當地巡迴展出。萬隆會議由印度第一任總理賈瓦哈拉爾‧尼赫魯 (Jawaharlal Nehru)、埃及的賈邁勒‧阿卜杜勒‧納瑟 (Gamal Abdel Nasser)、迦納的夸梅‧恩克魯瑪 (Kwame Nkrumah) 和印尼的蘇卡諾 (Sukarno) 所領導，有三十個殖民國、剛獨立的前殖民國在萬隆聚會，目的是聲明拒絕加入東西方的兩個霸權。隨後，受全球超過一半以上人口支持的「不結盟運動」(The Non-Aligned Movement) 便在 1961 年於貝爾格萊德 (Belgrade) 正式展開。[6]

從不結盟的意識型態觀點來看，印度政府希望推動的是設計和工業現代性之間的結盟。1958 年，尼赫魯就委託查爾斯‧伊默斯執掌印度設計的前景報告。伊默斯花費了五個月在印度旅行，最後他建議設立一所永久性的設計研究所。[7] 印度政府於是向紐約現代美術

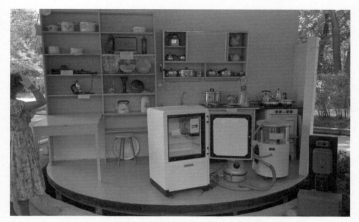

1959 年於蘇聯莫斯科舉辦的臨時俄羅斯展，照片中所展示的蘇聯冰箱與廚房設備，就位於美國博覽會附近。

館提出一檔歐美設計示範展的要求，希望引介歐美設計，計畫性地展開設計研究所的設立。別具象徵意味的是，不結盟國家陣線文學網絡中的重要人物，小說家馬爾克拉吉・阿南德（Mulk Raj Anand）早在 1947 年就對比了印度傳統廚房以及法蘭克福廚房，後者是經典的高性價比廚房，由奧地利建築師瑪格麗特・舒特・理荷絲基（Margarete Schütte-Lihotzky）在 1920 年末基於理性主義原則所設計。[8] 阿南德主張，印度需要自己的法蘭克福廚房。儘管是在冷戰時期不結盟運動的氛圍之下，廚房在這裡也成了後殖民的未來圖像所投射的屏幕。這就是後殖民現代性的烏托邦夢想所承諾的進步、富足和平等。

與尼赫魯和阿南德這樣的大都會人物不同，我十二歲的母親幾乎不可能意識到廚房在她生長的冷戰年代中佔據中心位置。她並不是 1959 年那些在富勒的穹頂建築外的長龍中，等著一瞥歐美設計的觀眾。儘管如此，捲入後殖民烏托邦的現代廚房 —— 展現親密感、休閒生活和效率的理想場所 —— 成為母親多采多姿的慾望場域，她的剪貼簿透露了這種慾望。但是，這種慾望並不全然集中在現代設計及和最新款的電器，事實上，節省勞力的新型家電曾是印度中產階級家庭可望不可及的。此外，在印度的情況下，家務勞動的問題 —— 乃至於省力家電的利弊 —— 必須另外處理，才能留一些討論空間給多樣的經濟和勞動模式。儘管如此，這些電器已成為一個支點，撐起朝向未來的慾望地形圖，對於追求平等的後殖民現代性

7 Charles and Ray Eames, *The India Report*, April 1958, Ahmedabad: National Institute of Design, 1997.

8 Editorial, Mulk Raj Anand, *Marg*, vol. 1, no. 1, 1948, no pagination.

的烏托邦夢想來說，它們是必要的部份。但是，威脅就潛伏在表面之下，一手造成這些危機的那群人也很明白。二戰的科技所引發的恐怖尚未走遠，當時這間由軍事科技所推動的冷戰廚房是個危險的地方。

對於成長於 1970 年代末和 1980 年代的人 —— 包括我自己在內 —— 似乎是不可能真正理解冷戰廚房的情結。因此，我想要透過提出一個小實驗來作為結論：

步驟 1： 煮一顆雞蛋，直到它像彈道飛彈的外殼一樣堅硬，再立刻將它冷凍在冰箱裡。

步驟 2： 一旦雞蛋結凍，就將其放置在有著金屬光澤的微波爐內。微波爐出自是二戰期間雷達實驗的家用小電器之一。

步驟 3： 戴好安全帽，按下烹飪開始鍵。

步驟 4： 等待爆炸的來臨，看著那顆雞蛋變形成蘑菇的形狀，親身經歷急遽升高的室溫。如果感受不到這種效果帶來的恐懼，你就不算是成功地完成這項實驗。

Kitchen Conversations

Atreyee Gupta

* This article was originally published in *Prajakta Potnis—Store in a Cool and Dry Place*, 2014.

Sometime in the 1990s. I came across a scrapbook that my mother had begun in the late 1950s, when she was about twelve or thirteen I was in high school at that time. Remember being enthralled by the discovery. I also recollect being terribly puzzled and could not comprehend why magazine images of kitchen appliances and the nuclear family occupied such a prominent place in the scrapbook. For many of us who grew up in urban middle-class India in the late 1970s and the 1980s, home appliances—the refrigerator, the vacuum cleaner, the electric blender and the baking oven—were not novelties. Nuclear families were not unusual either. Neither merited the labour involved in carefully extracting glossy pictures from the pages of magazines with the intention of repositioning them in the more private world of the scrapbook. At that time, the scrapbook registered as a sign of the seemingly unbridgeable gulf that separated her generation—the "midnight 's children" born in 1947, the year of India's independence from British rule, and immortalized in Salman Rushdie's 1981 novel by the same name—from my own. Across this gulf, conversation seemed impossible. Nonetheless, I was sufficiently intrigued and safely stared the scrapbook at the bottom of my closet, where it remained for the next twenty years. Much later, I realized the paramount importance the modern home, complete with its electronic appliances, had held in the late 1950s Cold War world that my twelve-year-old mother inhabited.

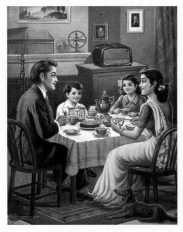

Scrapbook, Kolkata, 1950. Author's collection. (Photo from author)

In the summer of 1959, *the American National Exhibition*, the site of the famous Kitchen Debate between U.S. Vice President Richard Nixon and Soviet leader Nikita Khrushchev, had opened in Sokolniki Park in Moscow. The corresponding Russian show, *the Soviet Exhibition of Sci-*

1 For a discussion on the post-Stalinist Soviet Union, see Stephen Lovell, *The Shadow of War, Russia and the USSR 1941 to the Present*, West Sussex, U.K. and Malden Mass, 2010.

U.S.S.R., Moscow, temporary Russian exhibit 1959. Photograph shows refrigerator and kitchen equipment at a Soviet exhibit that was located next to the American National Exhibition in Moscow.

ence, Technology and Culture, had opened at the Coliseum Convention Center in New York earlier that year.[1] The latter covered all three floors of the Convention Center with models of the world's first artificial satellite (Sputnik), machines and equipment as evidence of the technological advances made in the post-Stalinist Soviet Union. Significantly, a full-scale model of a furnished three-room apartment was also set up to demonstrate to American audiences the domestic comforts enjoyed by the average citizen under the Soviet government.

The United States in turn enlisted some of the most perspicacious designers to counter the technological and scientific emphasis of the Soviet exhibit. In Moscow, *the American National Exhibition* opened in a gigantic geodesic dome designed by Buckminster Fuller. Two hundred feet in diameter, the seventy-eight feet anodized gold structure stood glistening in the summer sun, its atomic contours off set by the onion-shaped domes of the Kremlin looming on the horizon. Inside, the American designers Charles and Ray Eames displayed their first film, *Glimpses of the USA*. Projected on seven twenty-by-thirty-foot screens suspended from the ceiling, the film summarized a typical week in the life of the average American.

Utilizing aviation technology, Eames' film began with images from outer space, slowly moving into the American suburban house, the camera pausing to highlight the intimacy of everyday rituals. The last sips of coffee, women packing lunchboxes, men kissing their wives and the baby, heading off to work, waving goodbye, children leaving for school. Elsewhere, five hundred small appliances, pots and pans dangled from a modular rack, their steel contours gleaming like jewels in a free-market tiara. Fitted with the latest domestic appliances, a six-room suburban house completed this multi-sensorial re-construction of American life.

It is here that the Kitchen Debate between Nixon and Khrushchev erupted over the new RCA Whirlpool robotic dishwasher, electronic kitchen aids powered by military technology and canned food.[2] For Nixon, such home-oriented consumer products with their seemingly limitless combination of flavours, features, colours and cost exemplified the core principles of public and private life in the United States: freedom, democracy and a free-market economy. For Khrushchev, these were signs of the triviality, excess and decadence inherent in the logic of capitalism. The kitchen as the locus of labour, production and consumption was thus projected onto the Cold War's tense ideological terrain. Political ideology and domesticity stood tightly conjoined in the carefully orchestrated exhibition space conceived by the American architect and designer George Nelson, who had been contracted to direct *the American National Exhibition* by the United States Information Agency, an organization established to support Cold War cultural diplomacy. This history is relatively well-known.[3]

What is far lesser known is that Nelson was simultaneously working for New York's MoMA on *Design Today in America and Europe*, an exhibition that opened in New Delhi in February 1959.[4] The exhibition travelled in India for two years and ultimately provided the core collection of the newly established National Institute of Design in Ahmedabad in 1961. Without doubt, *Design Today* was part of America's Cold War cultural diplomacy. The fact that this exhibition also presented a geodesic dome designed by Fuller, similar to the one that had been put up in Moscow, speaks volumes about the exhibition's relevance with in the Cold War's political template. In India, *Design Today* reportedly drew millions of viewers who patiently waited in long queues at the entrance of Fuller's dome. Significantly, this dome had been lent to the MoMA by the United States Information Agency.

2 For transcripts of the debate, see "Encounter", *Newsweek*, August 3. 1959, pp.15-17; "Better to See Once", *Time*, August 3, 1959, pp.12-14.

3 See Stephen J. Whitfield, *The Culture of the Cold War*, Baltimore 1991; Karat Ann Marling, *As Seen on TV: The Visual Culture of Everyday Life In the 1950s*, Cambridge, Mass. 1994; Beatriz Colomina, "Enclosed by Images: The Eameses' Multimedia Architecture", *Grey Room*, no.02, Winter 2001, pp.6-29.

4 "MoMA Press Release No. 4, Friday, February 16. 1959" and "MoMA Press Release No.31, Monday, April 13, 1959", MoMA Press Release Archive, Museum of Modern Art, New York; *Design Today in America and Europe*, exhibition catalogue, Museum of Modern Art, New York and National Small Industries Corporation Limited, New Delhi, 1959.

5 For this history, see Paul M. McGarr, *The Cold War In South Asia: Britain, the United States and the Indian Subcontinent, 1945–1965*, Cambridge, 2013.

6 For a history of the Non Aligned Movement, see Vijay Prashad, *The Darker Nations, A Peoples History of the Third World*, New York 2007; Itty Abraham, "From Bandung to NAM: Non-alignment and Indian Foreign Policy. 1947-65", *Commonwealth & Comparative Politics*, vol. 46. no. 2, pp.195-219; Nataša Mišković, Harald Fischer-Tiné, and Nada Boškovska, (eds.), *The Non- Aligned Movement and the Cold War*, Abingdon 2014.

7 Charles and Ray Eames, *The India Report*, April 1958, Ahmedabad: National Institute of Design, 1997.

8 Editorial, Mulk Raj Anand, *Marg*, vol. 1, no. 1, 1948, no pagination.

In spite of certain similarities, however, there was something about the India exhibition that distinguished it from the Cold War extravaganza in Moscow. Shortly after independence, India had set out on a course of rapid technological and industrial advancement on the U.S. model to be implemented through Soviet style five-year plans and regulated by a controlled economy.[5] *Design Today* had been dispatched to India at the request of the Indian government only four years after the Bandung conference of 1955. Led by India's first Prime Minister Jawaharlal Nehru, Gamal Abdel Nasser of Egypt, Kwame Nkrumah of Ghana and Sukarno of Indonesia, thirty colonized, formerly colonized and newly independent nations had come together in Bandung to explicitly reject the Cold War's seemingly hegemonic West/East binary. The Non-Aligned Movement, which represented more than half of the world's population, was subsequently formalized in Belgrade in 1961.[6]

From this non-aligned ideological vantage point, India desired to set in motion a new alignment between design and industrial modernity. In 1958, Nehru had commissioned Charles Eames to submit a report on the future prospects of Indian design. Eames spent five months travelling in India and recommended the establishment of a permanent institute for design.[7] The government's request to MoMA for an exhibition of exemplary American and European design followed, and plans to set up a design institute proceeded in tandem. Significantly, as early as 1947, the novelist Mulk Raj Anand, an important figure in the literary networks of the non-aligned nations, had contrasted the tradition-Indian kitchen with the Frankfurt Kitchen, a classic cost-effective model kitchen based on rationalist principles designed in the late 1920s by the Austrian architect Margarete Schütte-Lihotzky.[8] India, Anand claimed, needed its own Frankfurt Kitchen. Here too, the kitchen became the surface upon which the image of a post-colonial future was projected, albeit within a Cold War

non-aligned context. This then was the promise of progress, plenitude and equality, the utopian dream of a post-colonial modernity.

Unlike cosmopolitan figures like Nehru and Anand, my twelve-year-old mother was hardly aware of the central place that the kitchen occupied in the Cold War world that she had inherited. She was not one of the people who queued outside the entrance of Fuller's dome in 1959 for a glimpse of European and American design. Nonetheless, privy to the post-colony's utopia, the modern kitchen—the idealized locus of intimacy, leisure, and efficiency—became a site of iridescent desire for my mother, a desire that she articulated in her scrapbook. This desire, however, was not precisely centred on modern design or on the newest range of electronic appliances. Indeed, the latest labour-saving domestic appliances would have been well outside the reach of India's middle-class families. Besides, in the Indian context, the question of domestic labour—and, by extension, the relative virtues of labour-saving domestic appliances—must be addressed differently, leaving latitude for variegated economic and labour patterns. Nonetheless, these very objects became the fulcrum for a future-oriented topography of desire, part and parcel of the utopian dream of an egalitarian post-colonial modernity. Yet threat lurked right beneath the surface and was recognized as such by the many who spun its golden threads. The horrors unleashed by technology during the Second World War were still far too close. Propelled by military technology, the Cold War kitchen was a dangerous place.

For those who grew up in the late 1970s and the 1980s, myself included, the complexity of the Cold War kitchen appears incomprehensible. Thus, I want to conclude by proposing a small experiment:

1. Boil an egg until it is as hard as the shell of a ballistic missile. Freeze it in the refrigerator immediately.
2. Once the egg has frozen, place it inside a shiny steel microwave oven, one of the domestic gadgets that emerged from radar experimentation during the Second World War.
3. Wear a hard hat and press start.
4. Wait for the explosion, watch the egg transform into a mushroom shaped form and experience a sharp rise in room temperature. If you do not feel horrified by the effect, you have not completed the experiment successfully.

張乾琦
CHANG CHIEN-CHI

脱北者
Escape from North Korea

單頻道錄像，5'40"，2009
Single-channel video, 5'40", 2009

1990 年代後期，在一次於兩千三百萬人中至少餓死了一百萬人的嚴重飢荒之後，「脫北者」開始逃離北韓進入中國。他們跨越邊界來到中國躲藏，等待走上一趟極為隱密、危險的逃脫之路，這條所謂的「亞洲的地下鐵路」自華北一路延伸至寮國，跨過湄公河來到泰國，最後才會被遣送至南韓。

這趟不可預期的逃脫旅程可能花上幾個禮拜、幾個月甚至數年。中國警方例行地取締這些企圖跨國逃亡的北韓人。警方的掃蕩行動可一次網羅上百名逃脫者。若在中國或寮國的逃離途中被逮捕，他們會被遣返極權主義的北韓，送入嚴酷的勞改營或是判處死刑。

馬格蘭攝影通訊社的攝影師張乾琦，在 2007 與 2009 年與這些逃亡者同行，記錄下這段黑暗旅程。迄今為止，他仍持續地記錄「脫北者」的困難處境。

The exodus of North Korean defectors into China began in late 1990s after a severe famine that destroyed at least one million of its 23 million people. Once they cross the border to China, they'll be in hiding and waiting to embark on an extremely secretive, dangerous escape route, known as Asia's Underground Railroad from northern China all the way to Laos, crossing Mekong River, to Thailand and finally to South Korea.

The unpredictable journey can take weeks, months or even years. Chinese police routinely hunt for North Koreans attempting to escape cross-country. Police crackdowns can net hundreds of victims. If they are caught while escaping in China and Laos, they will be repatriated to totalitarian North Korea, facing severe labor camps or capital punishment.

Magnum photographer Chang Chien-Chi traveled with the defectors to document the darkest journey in 2007 and 2009. To date, He has continued to document the plight of North Korean defectors.

〈脫北者〉，影片擷圖
Escape from North Korea, video still

非戰之戰
The War that Never Was

單頻道錄像，15'40"，2017
Single-channel video, 15'40", 2017

因為受邀製作展出一部關於台灣和冷戰的影片，某天，我出於好奇向母親詢問她是否知道「冷戰」，她回答我：「那是誰？」

母親出生於 1938 年台灣中部的貧困山區，沒受過什麼教育，在嫁給我父親前後幾乎大半輩子都在工作。台灣所歷經的世界史上第二長的戒嚴（1949 — 1987 年）對她幾乎沒有影響，她一生都僅求溫飽。她告訴我，當時因為村子裡沒有電，在一日田間工作後，她常騎著舊單車到最近的鎮上去為家裡的電池充電。載著我和電池在夜晚回家的路上，她經常不小心跌進污濁的小溪裡。

這部訪談影片主要拍攝我的母親，我擔任訪問者，而我的母親是受訪者。所有的提問都關於她的一生，來自農村、貧苦且未受教育的女孩成為了妻子和五個孩子的母親，直到 2000 年中期，她都仍在炎熱的田間工作、擔任洗衣婦、清潔婦。

這些關於她人生的提問與冷戰期間所發生的歷史事件並列，後者來自匈牙利鐵幕博物館（Iron Curtain Museum）的歷史影像和馬格蘭攝影檔案庫，其間穿插我母親的訪談 —— 她從未聽說過冷戰。

I have been invited to produce a video on Taiwan and Cold War for an exhibition. So out of curiosity, the other day, I asked my mother if she knew what Cold War was and she replied, "who was that?"

My mother, born in 1938, in a poverty-stricken mountainous region in central Taiwan received little education and worked her entire life before and after she was married to my father. Taiwan's second longest martial law (1949 - 1987) in history had little effect on her. Her whole life was merely to work for a meager survival. She told me that back then, there was no electricity in our village and she, after working the whole day on the rice paddy, used to ride an old bicycle to the nearest town to charge a battery for the household electricity. She lost track of how many times she ran into the dirt creek in the dark when coming back with a charged battery and me and in the backseat.

This interview-based video is centered on my mother. I am the interviewer and my mother the interviewee. All the questions are about her life from a rural, poor and uneducated girl to a wife and a mother of five children, working in scorching rice field, later a washer-woman and a domestic cleaner until mid 2000s.

The questions about her life juxtapose with the years when the historical events took place during the Cold War. The latter is done with historical images, from the Iron Curtain Museum in Hungary and Magnum Photos archives intertwined with the interview to my mother who has never heard of Cold War.

〈恐怖面具，台中〉，攝影，銀鹽相紙，88×126.4 公分，2003，藝術家、馬格蘭攝影通訊社及其玫畫廊提供
The Scary Mask, Taichung, photography, silver gelatin print, 88x126.4 cm, 2003, courtesy of the artist, Magnum Photos and Chi-Wen Gallery

〈非戰之戰〉，影片擷圖，藝術家、馬格蘭攝影通訊社及其玖畫廊提供
The War that Never Was, video still, courtesy the artist, Magnum Photos and Chi-Wen Gallery

〈非戰之戰〉，影片擷圖，藝術家、馬格蘭攝影通訊社及其玖畫廊提供
The War that Never Was, video still, courtesy the artist, Magnum Photos and Chi-Wen Gallery

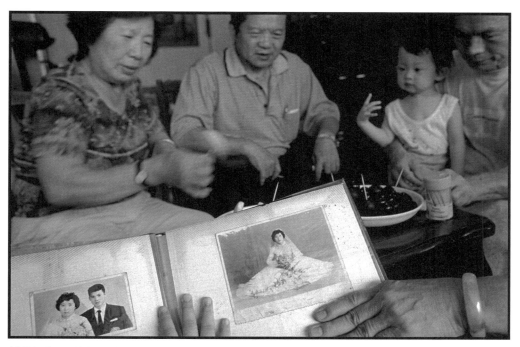

〈非戰之戰〉，影片擷圖，藝術家、馬格蘭攝影通訊社及其玟畫廊提供
The War that Never Was, video still, courtesy the artist, Magnum Photos and Chi-Wen Gallery

〈與父母共乘，台中〉，攝影，銀鹽相紙，88×126.4 公分，2003，藝術家、馬格蘭攝影通訊社及其玟畫廊提供
A Drive with Mother and Father, Taichung, photography, silver gelatin print, 88x126.4 cm, 2003, courtesy the artist, Magnum Photos and Chi-Wen Gallery

你與原子彈

喬治‧歐威爾

* 本文原載於《論壇報》(Tribune)，1945 年 10 月 19 日，為史上第一篇提到「冷戰」的文章。在「非戰之戰 —— 張乾琦個展」中，以文件與聲響裝置展示本文內容。

想想原子彈在未來五年內有多大的可能把我們所有人都炸成碎片，原子彈引起的討論顯然不夠多。現今報章上已經有大量關於質子與中子如何在原子彈中運作的圖表 —— 這對普通人沒什麼幫助 —— 對於原子彈「應該受國際管制」的無用申明也被重申了無數次。但是，一個最急迫卻鮮少被提及的問題是：「大量製造這種玩意兒會有多困難？」。

然而我們 —— 也就是普羅大眾 —— 能夠接收到的總是間接的、二手的資訊，恰好，杜魯門總統也打算繼續掌握某些秘密，而不願意向蘇聯公開。幾個月前，當時原子彈還只是個謠言，一般人相信如何使原子分裂只是物理學家的問題，但是當問題解決之後，一種全新的、毀滅性的武器卻立即成了所有人的問題。（謠言隨即到處流傳，諸如：實驗室裡那些孤僻的瘋子可能會把文明摧毀成碎片，而且就像點燃一撮煙花一樣容易）。

如果謠言成真，整個歷史的走向就會被突然改變，不僅大國和小國不再有區別，國家凌駕於個人的力量也將被大大減弱。不過 ，從杜魯門總統的演說和各種評論看來，原子彈的價格仍然昂貴無比，且它的製造仰賴極大工業力量，因此世界上僅有少數三到四個國家有能力生產原子彈。這點至關重要，因為這表示原子彈的發現，不僅無法反轉歷史，反而只會強化近十年來越來越清楚的趨勢。

文明的歷史在很大程度上就是武器的歷史，特別是在火藥的發現和資產階級推翻封建主義之間的關聯已被反覆提及。雖然毫無疑問的，我也可以提出反例，但是我認為以下的規則仍是普遍適用：在優勢武器越是昂貴而難以製造的時代，就越是一個專制的時代，反之，武器越是便宜且容易製造，老百姓就越能夠握有機會。因此，例如坦克、戰艦和轟炸機本身就是暴政的武器，而步槍、滑膛槍、長弓和手榴彈則是民主的武器。複雜的武器使強者愈強，而簡易的武器 —— 一旦沒有別的法子 —— 則是弱者的力量來源。

民主和民族自決的大時代實際上也就是滑膛槍與步槍的時代。滑膛槍的問世介於燧發槍及火帽的發明之間，是一種非常有效的武器，同時又是如此簡單以至於幾乎可以到處都能生產。它的種種特質，促成了美國和法國的革命，並使人民起義成為一項比現今更嚴肅的志業。自從滑膛槍被改良成後膛式步槍後，它變得相對複雜，但仍然有數十個國家可以生產，價格便宜，且容易走私買賣，屬經濟又實惠的武器。因此，即使

是最落後的國家也總是能有不同的槍源，保加利亞人、阿比西尼亞人、摩洛哥人，甚至是西藏人，才因此能夠為自身的獨立而戰，有時候甚至會取得成功。然而，每當軍事技術有所發展，強化的都是對立於個體的國家，以及對立於落後國家的工業化國家，權力越來越集中於少數核心。1939 年，只有五個國家有能力發起大規模的戰爭，現今只有三個 —— 最後很可能只剩兩個。多年來，這股趨勢顯而易見，甚至在 1914 年以前就已經被少數觀察者指出。要扭轉這種局面，可能的作法是發現一種全新的武器 —— 或者，更廣泛地說，一種戰法 —— 不需要靠高度集中的廠房生產的武器。

從各種癥狀推斷，俄羅斯雖然還沒有解開製造原子彈的秘密，但另一方面，輿論對俄羅斯將在幾年之內開始製造原子彈的共識卻是肯定的。如今，在我們面前的是二或三個駭人的巨獸國家，各都握有足以在幾秒之內摧毀無數人民的武器，世界將被他們所劃分。人們已經大膽假設，這代表更大規模、更血腥的戰爭將要到來，而且終結掉人類的機械文明。但是，假使 —— 而且這是最有可能的發展方向 —— 最後倖存的大國私下達成協議，不再使用原子彈對付彼此呢？假使，他們就只用它來攻佔、脅迫其他那些無法反擊的人呢？如此以來，我們是不是又回到了從前的處境，而唯一的區別是權力更加集中在更少數的人手中，而被壓迫的階級則是更加無望。

當年詹姆斯・伯納姆（James Burnham）出版《管理革命》(The Managerial Revolution)，讓許多美國人認為德國人將成為歐洲戰事中最後的贏家，因此自然而然地假設德國，而非俄羅斯，將主宰整個歐亞大陸，而東亞則由日本稱雄。雖然說這是一次誤判，但並不會影響伯納姆主要的論點。就伯納姆對於新世界的地理景致想像而言，它反而是正在形成的真實狀況。至今，地球表面被越來越明顯的撕裂成三大帝國，每一個帝國都自成一體，與外部隔絕；每一個帝國，都在不同的偽裝之下，為寡頭政治所掌控。雖然劃分國境邊界的爭議不斷，而且還會持續好幾年，三大勢力中最後一個是由中國所主導的東亞，即使還未成真但仍然具有潛力。但是整體走向不僅仍是毫無疑問的，近年來每一項重要的科學發展也都加速著這股趨勢。

曾經有人這樣告訴我們，飛機的問世「廢除了邊界」，但事實上，自從飛機成為一種駭人武器，邊界就再也不能被跨越。曾經我們以為，收音機將有助於國際間的相互理解和合作，但事實上收音機成了將一個國家與另一個國家隔離開來的技術。原子彈掠奪了被剝削階級與人民革命的力量，同時又讓原子彈擁有者享有軍事對等地位。他們誰也無法取得完全的勝利，而更有可能繼續一起統治這個世界。除了緩慢且無法預測的人口改變之外，很難看出這種平衡將如何能被打破。 赫伯特・喬治・威爾斯（H. G. Wells）等人早在四五十年前就警告我們，人類因握有的武器使自己深陷在滅絕的危險之中，隨後如螞蟻或其他群居物種將取代人類。只要看過德國那些被摧毀的城市，任誰都會認為這並非異想天開。儘管如此，從整個世界局勢看來，這幾十年來的趨勢非

但不是向著安那其，反而是走向奴隸制度的回返。我們可能不會全盤崩毀，但會進入一個如同古代奴隸帝國一般穩定得可怕的時代。雖然伯納姆的理論已經被討論得很多了，但很少人注意到它意識型態上的含義，也就是說，如果一個強大的國家與鄰國處於永恆的「冷戰」狀態，那這個國家可能會盛行什麼樣的世界觀、信仰和社會結構。

如果製造原子彈就像製造自行車和鬧鐘一樣便宜和容易，那麼它很有可能陷我們於原始的野蠻狀態之中，但另一方面，也意味著國家主權和高度中央集權的警察狀態的終結。如果 —— 情況比較是如此 —— 它是如戰艦一般稀有且昂貴難以生產的東西，那麼它更有可能會終止大規模戰爭，代價是永無止境「非和平的和平」。

You and the Atomic Bomb

George Orwell

* This essay appeared in the form of document and sound installation in *The War that Never Was— Solo Exhibtion of Chang Chien-Chi*. The essay was originally published in *Tribune* on Oct 19th, 1945, and was the first article in history that mentioned the term "Cold War".

Considering how likely we all are to be blown to pieces by it within the next five years, the atomic bomb has not roused so much discussion as might have been expected. The newspapers have published numerous diagrams, not very helpful to the average man, of protons and neutrons doing their stuff, and there has been much reiteration of the useless statement that the bomb "ought to be put under international control." But curiously little has been said, at any rate in print, about the question that is of most urgent interest to all of us, namely: "How difficult are these things to manufacture?"

Such information as we— that is, the big public—possess on this subject has come to us in a rather indirect way, apropos of President Truman's decision not to hand over certain secrets to the USSR. Some months ago, when the bomb was still only a rumour, there was a widespread belief that splitting the atom was merely a problem for the physicists, and that when they had solved it a new and devastating weapon would be within reach of almost everybody. (At any moment, so the rumour went, some lonely lunatic in a laboratory might blow civilisation to smithereens, as easily as touching off a firework.)

Had that been true, the whole trend of history would have been abruptly altered. The distinction between great states and small states would have been wiped out, and the power of the State over the individual would have been greatly weakened. However, it appears from President Truman's remarks, and various comments that have been made on them, that the bomb is fantastically expensive and that its manufacture demands an enormous industrial effort, such as only three or four countries in the world are capable of making. This point is of cardinal importance, because it may mean that the discovery of the atomic bomb, so far from reversing history, will simply intensify the trends which have been apparent for a dozen years past.

It is a commonplace that the history of civilisation is largely the history of weapons. In particular, the connection between the discovery of gunpowder and the overthrow of feudalism by the bourgeoisie has been pointed out over and over again. And though I have no doubt exceptions can be brought forward, I think the following rule would be found generally true: that ages in which the dominant weapon is expensive or difficult to make will tend to be ages of despotism, whereas when the dominant weapon is cheap and simple, the common people have a chance. Thus, for example, tanks, battleships and bombing planes are inherently tyrannical weapons, while rifles, muskets, long-bows and hand-grenades are inherently democratic weapons. A complex weapon makes the strong stronger, while a simple weapon—so long as there is no answer to it—gives claws to the weak.

The great age of democracy and of national self-determination was the age of the musket and the rifle. After the invention of the flintlock, and before the invention of the percussion cap, the musket was a fairly efficient weapon, and at the same time so simple that it could be produced almost anywhere. Its combination of qualities made possible the success of the American and French revolutions, and made a popular insurrection a more serious business than it could be in our own day. After the musket came the breech-loading rifle. This was a comparatively complex thing, but it could still be produced in scores of countries, and it was cheap, easily smuggled and economical of ammunition. Even the most backward nation could always get hold of rifles from one source or another, so that Boers, Bulgars, Abyssinians, Moroccans—even Tibetans—could put up a fight for their independence, sometimes with success. But thereafter every development in military technique has favoured the State as against the individual, and the industrialised country as against the backward one. There are fewer and fewer foci of power. Already, in 1939, there were only five states capable of waging war on the grand scale, and now there are only three—ultimately, perhaps, only two. This trend has been obvious for years, and was pointed out by a few observers even before 1914. The one thing that might reverse it is the discovery of a weapon—or, to put it more broadly, of a method of fighting—not dependent on huge concentrations of industrial plant.

From various symptoms one can infer that the Russians do not yet possess the secret of making the atomic bomb; on the other hand, the consensus

of opinion seems to be that they will possess it within a few years. So we have before us the prospect of two or three monstrous super-states, each possessed of a weapon by which millions of people can be wiped out in a few seconds, dividing the world between them. It has been rather hastily assumed that this means bigger and bloodier wars, and perhaps an actual end to the machine civilisation. But suppose—and really this the likeliest development—that the surviving great nations make a tacit agreement never to use the atomic bomb against one another? Suppose they only use it, or the threat of it, against people who are unable to retaliate? In that case we are back where we were before, the only difference being that power is concentrated in still fewer hands and that the outlook for subject peoples and oppressed classes is still more hopeless.

When James Burnham wrote *The Managerial Revolution* it seemed probable to many Americans that the Germans would win the European end of the war, and it was therefore natural to assume that Germany and not Russia would dominate the Eurasian land mass, while Japan would remain master of East Asia. This was a miscalculation, but it does not affect the main argument. For Burnham's geographical picture of the new world has turned out to be correct. More and more obviously the surface of the earth is being parceled off into three great empires, each self-contained and cut off from contact with the outer world, and each ruled, under one disguise or another, by a self-elected oligarchy. The haggling as to where the frontiers are to be drawn is still going on, and will continue for some years, and the third of the three super-states—East Asia, dominated by China—is still potential rather than actual. But the general drift is unmistakable, and every scientific discovery of recent years has accelerated it.

We were once told that the aeroplane had "abolished frontiers"; actually it is only since the aeroplane became a serious weapon that frontiers have become definitely impassable. The radio was once expected to promote international understanding and co-operation; it has turned out to be a means of insulating one nation from another. The atomic bomb may complete the process by robbing the exploited classes and peoples of all power to revolt, and at the same time putting the possessors of the bomb on a basis of military equality. Unable to conquer one another, they are likely to continue

ruling the world between them, and it is difficult to see how the balance can be upset except by slow and unpredictable demographic changes.

For forty or fifty years past, Mr. H. G. Wells and others have been warning us that man is in danger of destroying himself with his own weapons, leaving the ants or some other gregarious species to take over. Anyone who has seen the ruined cities of Germany will find this notion at least thinkable. Nevertheless, looking at the world as a whole, the drift for many decades has been not towards anarchy but towards the reimposition of slavery. We may be heading not for general breakdown but for an epoch as horribly stable as the slave empires of antiquity. James Burnham's theory has been much discussed, but few people have yet considered its ideological implications—that is, the kind of world-view, the kind of beliefs, and the social structure that would probably prevail in a state which was at once unconquerable and in a permanent state of "cold war" with its neighbors.

Had the atomic bomb turned out to be something as cheap and easily manufactured as a bicycle or an alarm clock, it might well have plunged us back into barbarism, but it might, on the other hand, have meant the end of national sovereignty and of the highly-centralised police state. If, as seems to be the case, it is a rare and costly object as difficult to produce as a battleship, it is likelier to put an end to large-scale wars at the cost of prolonging indefinitely a "peace that is no peace".

洪 子 健
JAMES T. HONG

一個中國佬的機會
A Chinaman's Chance

雙頻道錄像，12'30"，2015
Dual-channel video, 12'30", 2015

對日本來說，獨島與尖閣群島代表了相反的紛爭。日本向南韓爭奪獨島的主權，反之，日本控制了尖閣群島，但中國和台灣都宣稱擁有其主權。南韓政府並未正式承認獨島主權有爭議，且同樣的，日本也沒有正式承認中國與台灣對於尖閣群島的主權宣稱。數十年來，二者爭議日益加劇，但釣魚台／尖閣群島衝突在近幾年顯得特別險峻，因為它涉及了中國的崛起與美國的重回亞洲。

〈一個中國佬的機會〉於兩地拍攝。一個是南韓治理的群島，名為「獨島」，日本政府則宣稱其名為「竹島」。南韓與日本之間的紛爭其實波及這個小島週圍的海洋 —— 一般稱為日本海，但南韓政府稱其為「東海」。另一個地方是中國東海同有主權爭議的島嶼，中國稱為「釣魚島」，台灣稱為「釣魚台」，日本稱為「尖閣群島」。

For Japan, Dokdo and Senkaku represent conversely polarized disputes. Japan contests South Korea's sovereignty over and administration of Dokdo, whereas it controls the Senkaku Islands, which China and Taiwan both claim as their own. The South Korean government does not officially admit of a sovereignty dispute over Dokdo, and similarly, Japan does not formally recognize China and Taiwan's claims over the Senkaku Islands. Both of these disputes have been festering for decades, but the Diaoyu/Senkaku clash has become more dangerous in recent years as it involves a rising China and an Asian-pivoting United States.

A Chinaman's Chance was shot in two locations. The first is the South Korean administered group of islets called "Dokdo," which the Japanese government also claims and labels "Takeshima." This dispute between South Korea and Japan actually spills into the islets' surrounding ocean, which is commonly called "The Sea of Japan," but which the South Korean government dubs "The East Sea." The second location is the East China Sea group of disputed islands called "Diaoyudao" in China, "Diaoyutai" in Taiwan, and the "Senkaku Islands" in Japan.

〈一個中國佬的機會 — 獨島東側〉，影片擷圖
A Chinaman's Chance—Dokdo East island, video still

〈一個中國佬的機會 — 尖閣群島附近船隻〉，影片擷圖
A Chinaman's Chance—Senkaku boats, video still

台灣大規模毀滅性武器
Taiwan WMD

複合媒材裝置、文件，2012
Multimedia installation and documents, 2012

〈台灣大規模毀滅性武器〉原發表於 2012 台北雙年展，作為其中微型博物館「歷史與怪獸博物館」的核心作品。這個微型博物館以展示於玻璃櫥窗中的多種歷史物件和文檔所組成，因此很容易被認知為檔案庫。〈台灣大規模毀滅性武器〉裡面的每件物品都代表著台灣化學、生物，或者核武器計畫中的一個里程碑。用班雅明的話說，每件物品實際上都「同時是一份野蠻的文檔」。

國際社會已經採取了諸多措施來禁止 WMD（大規模毀滅性武器）或者至少控制其擴散，但是台灣不是該國際社會的官方成員，由於台灣（「中華民國」）是在一種例外情況下，因緊急狀態而誕生的，而 WMD 特別適合這樣的情況和緊急狀態。換言之，在不顧一切的絕望時期，生產這樣的武器具有國家意義。

由於公眾普遍憎惡任何形式的 WMD，任何涉及到這樣的武器或者其運用，都可能引發激烈的爭議或強烈的譴責。典型社會自由主義對於 WMD 的成見與偏見，如核能、化學，或是生物武器，大過於任何對武器的爭議，如武器之自衛功能或是發動戰爭。甚至連一個虛幻的 WMD 都可能具有國際威脅的功能並成為戰爭的起因。不過，核武器依然被視為必要的威懾物，至少它還存在於九個國家的軍械庫中，並且，全世界私下秘密進行的生化武器研發計畫仍繼續得到其政府的支持。儘管存在反對的偏見，WMD 依然有其道理。

Taiwan WMD was originally presented as the centerpiece of *The Museum of the Monster that is History*—a mini museum within the 2012 Taipei Biennial. Composed of various historical objects and documents in vitrines, this mini museum is easily recognized as an archive. Each object represents a milestone in Taiwan's chemical, biological, or nuclear weapons programs. In the language of Walter Benjamin, each object literally "is at the same time a document of barbarism."

The international community has taken steps to ban or at least control the spread of WMD's (weapons of mass destruction), but Taiwan is not officially a part of this international community, and since Taiwan ("The Republic of China") was born as a state of emergency in a state of exception, WMDs are especially well-suited for just such states and just such emergencies. In other words, in times of great desperation, the production of weapons like these makes national sense.

Since the public generally abhors WMD's of any sort, any reference to or application of such weapons would generate vigorous controversy or condemnation. Typical social liberal prejudices and biases surrounding even the idea of WMD's, be they of nuclear,

chemical, or biological origin, probably overdetermine any arguments for their utility as self-defense or to make war. Even a phantasmic WMD can function as an international threat and *casus belli*. And yet, nuclear weapons are still considered an essential deterrent in at least nine national arsenals, and clandestine chemical and biological weapons programs around the world continue to be supported by their respective governments. Despite the prejudices against them, WMD's still make sense.

〈台灣大規模毀滅性武器〉，展場局部
Taiwan WMD, installation view

秦 政 德
CHIN CHENG-TE

美國派
American Pie

藝術家收藏的歷史物件與文件，2016
Historical objects and documents collected by the artist, 2016

台灣解嚴（1987）前後的劇變時代，我剛好正讀著高中，除了親身目睹並經歷了一場場激昂的街頭運動——比如某日放學就遇上「520 農民事件」，也開始對課本外的土地歷史感興趣。透過「黑名單工作室」《抓狂歌》專輯內〈台北帝國〉的歌詞：「穿的是麵粉袋做的短褲」，首先讓我知悉並注意到印有「中美合作」握手標誌的各式各樣品牌麵粉袋。進而順藤摸瓜認識二戰與韓戰後，世界兩大陣營對峙的冷戰格局下，原來美國才是真正實質操控、左右島鍊與台灣的老大哥。

固然可以透過網路或研讀出版品熟稔這段歷史，但不知是否因為從小學習且有志創作之故，我還是喜歡透過雙手身體性地收集「中美合作」種種相關原件的漫長過程，猶如在陽明山求學生活、每每漫步徘徊於美軍眷區，彷彿自導自演著穿越劇，得以想像重返冷戰台灣的時空現場感受體驗……。事實上，若非藉由這些點點滴滴地實物蒐羅、匯聚、整理，不僅對這座島嶼恐怕仍完全無知無感，甚至於根本也不可能會有強烈的創作實踐驅動力量，陸續轉化為諸如〈美國派〉（筆記書）、〈小台正傳〉、〈冷島〉、〈蔣王朝〉、〈美帝國〉等系列的立碑計畫吧！

I was a senior high school student in 1987, seeing the lifting of martial law in Taiwan. In addition to witnessing a wave of public protests in that turbulent period (for instance, I happened to be at the site of the "520 Peasant Movement" one day on my way home from school), I became interested in this island's history deliberately excluded from textbooks. "The pants we wear were made of flour sacks" is part of the lyrics of "Taipei Empire", a song included in the Blacklist Studio's album *Songs of Madness*. It alerted me to the fact that there were flour of different brands with a handshake sign on the sacks, symbolizing the Chinese-American cooperation in that period. Following this clue, I tracked down the bare fact that the United States was the real "Big Brother" who controlled Taiwan and the island chain in the Cold War structure, in its total confrontation with the communist bloc after the Second World War and the Korean War.

Certainly I could grasp this piece of history by collecting information from the Internet or related publications. Somehow, I preferred collecting the original objects of every stripe related to the history of Chinese-American cooperation by hand. I'm not sure whether it was because I aspired to learn and to be an artist at my tender age. As a result, I tended to roam around the American Military Housing when I lived and studied at the Yangming Mountain, as if I was directing and starring a time-travel TV drama, immersing myself in the atmosphere of Cold War Taiwan charged with excitement and tension. As a matter of fact, but for the incremental

collection, accumulation and collation of these material objects, I would be ignorant about and insensitive to everything on this beautiful island as well as lacking the strong motivation to carrying out the series of stele-erection projects such as *American Pie* (a note-book), *The True Story of the Small Taiwan*, *Cold Island*, *The Chiang Dynasty*, and *The American Empire.*

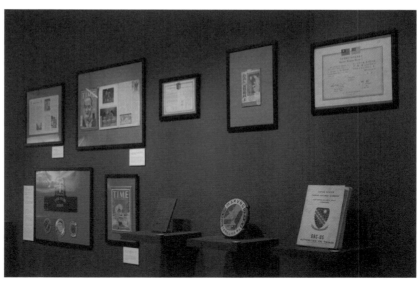

〈美國派〉，展場局部
American Pie, installation view

島鍊

「島鍊」是美國於 1951 年冷戰初期所提出的戰略概念，意欲以軍事支援和政治意識型態串連亞洲東岸諸島，圍堵蘇聯與中國等共產國家的勢力擴張。其中，所謂的「第一島鍊」北起南韓、日本群島、琉球群島，中接台灣，南至菲律賓、大巽他群島。

對於島鍊中央的台灣，二戰結束後，美國就開始以協助中國接收台灣為名，派美軍進駐台灣，負責組織、裝備和訓練國軍。雖然美國曾在 1949 年考慮放棄台灣，但因 1950 年韓戰爆發，美國決定重新扶持孤立於台灣的蔣介石政權，開始提供更大規模的軍事與經濟援助。在美國所派遣的軍事顧問團的支持下，台灣軍事力量大為提升。美援拯救了台灣瀕臨崩潰的政經局勢，也順利造就台灣在軍事、外交與發展策略各方面都必須依賴美國的局面。

1965 年，美國認為台灣經濟已可自立，宣布停止經援。1970 年代，由於美國希望與中國重新建立外交關係，對台軍援也逐步改為軍售，以期在對大陸與對台灣關係之間取得平衡，而對台軍售也為美國帶來大量收益，此狀況一直持續到今日。

The Island Chain

The "Island Chain" is a strategic concept coined by the United States in 1951 during the Cold War. It suggests connecting the islands along the eastern coast of the Asian continent with military support and political ideology as a way to contain communist powers such as the Soviet Union and China. The first island chain is primarily composed of South Korea, Japanese Archipelago, Ryukyu Islands, Taiwan, the Philippines and Greater Sunda Islands.

After the end of World War II, the United States began to make China be recognized Taiwan as the name of a nation and sent its troops to Taiwan located at the center of the first island chain, to organize, equip and train Taiwan's military forces. The U.S. used to consider abandoning Taiwan in 1949. Nevertheless, the outbreak of the Korean War in 1950 forced the U.S. to resume its role in supporting the isolated Chiang Kai-Shek regime and extend its military and economic aid to this island. Under the support of military advisory group dispatched by the United States, Taiwan's military strength has greatly improved. The U.S. aid not only prevented Taiwan from political and economic collapse, but also entailed Taiwan's heavy dependence on the U.S. in terms of military strategy, foreign affairs and development.

The U.S. withdrew its economic aid to Taiwan in 1965 because it believed that Taiwan has become economically full-fledged. In the 1970s, the U.S. redesigned its foreign policy towards establishing diplomatic relations with China's communist government, and ergo gradually replaced its military aid to Taiwan with arms sales, in the hope of striking a balance between its relations to Taiwan and China. The arms sales to Taiwan has also proved to be fairly lucrative for the U.S. down to the present day.

1

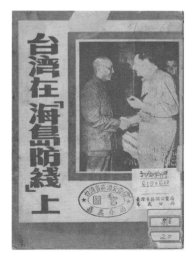

2

3

4

5

6

7

1《台灣在「海島防線」上》
A book titled *Taiwan on the "Line of the Island Chain"*

2《越戰美軍來台 R&R 指南》:「R&R」是美軍俚語,意指「休閒娛樂/搖滾」。
The U.S. R&R Leave Program: "R&R" is U.S. military slang for Rest and Recuperation (or Rest and Relaxtion, Rest and Recreation, Rock and Roll).

3 蔣介石曾十次登上《時代週刊》封面,1955年 4 月 18 日是最後一次。但這期《時代週刊》無法於台灣銷售,甚至不能流通,因為他背後有一面五星旗。
Chiang Kai-Shek had been featured on *TIME* cover for ten times, and the one issued on 18 April 1955 marked his swansong appearance. However, that issue was banned from distribution across Taiwan due to the flag of the People's Republic of China hung behind Chiang.

4 美軍憲兵臂章:越戰期間,在幾個美軍主要的渡假地點,如台北雙城街、台中清路與高雄安賢三路,都有美軍憲兵巡邏。
U.S. Military Police Patch: During the Vietnam War, several resort destinations for the U.S. soldiers on leave (e.g. Shuang-cheng Street in Taipei, Zhong-qing Road in Taichung and An-xian 3rd Road in Kaohsiung) were patrolled by the U.S. Military Police.

5 紀念牌:可能是被發配到台灣離島的美軍收到的紀念品。
A plaque carved with the Chinese characters "Why God treats me this way?" (It might be a souvenir for the U.S. soldiers on the outlying islands of the R.O.C.)

6 美軍艦隊 1996 年台海危機巡弋任務紀念臂章:臂章上描繪了中共於 1996 年 3 月 8 日試射兩枚 M9 飛彈(分別落於基隆與高雄外海)示意圖。
The Patch of the U.S. Naval Fleet Mission for the 1996 Taiwan Strait Crisis. The patch is embroidered with the illustration of China's missile test on 8 March 1996 (China launched two of its M9 missiles, one landed 35 miles off Kaohsiung, Taiwan's biggest port in the south, and another landed 23 miles off Keelung, the second-biggest port in the north).

7 藍星演習紀念臂章:1962 年的「藍星演習」號稱是二戰後最大的兩棲登陸作戰演習,假想中共入侵台灣後的軍事行動。美方自夏威夷等地調動五萬兵力、出動飛機五百架、艦艇一百三十五艘,配合國軍七千人進行五天兩棲登陸演習。
The Patch of the Operation Blue Star: The Operation Blue Star (1962) was recognized as the largest amphibious military exercise in the Western Pacific since the end of the Second World War. In view of the escalating tensions between Communist China and the Chinese Nationalists on Taiwan, the U.S. launched a joint amphibious training operation with the Nationalist Army off the shore of southern Taiwan by assuming the People's Liberation Army as the opposing force. The U.S. deployed a total of 50,000 troops, 500 aircrafts and 135 battleships from Hawaii to participate in the five-day landing operation with another 7,000 troops from the Nationalist Army.

美援

1951 年，因中國共產黨勢力擴張引發韓戰，在此背景下，第一批美援物資運往台灣。美援的項目非常龐雜，包括電力、交通、水泥、造紙、肥料、農產品等，政府機關及公營事業皆是受援對象。美援於 1957 年由原本的贈與性質轉變為贈與和貸款並行，1962 年之後，大部份皆改為貸款。台灣於冷戰時期積欠美國的經濟與軍事貸款於 2004 年全部償清。

The U.S. Aid

The Korean War escalated with the expansion of the Communist Party of China in 1951. Against this background, the U.S. aid to Taiwan came as a portmanteau package. The items included electricity, transportation facilities, cement, paper, fertilizer, agricultural products, and so forth. Governmental agencies and public enterprises were the major recipients. The nature of the U.S. aid had been transformed from *pro donato* to parallel tracks of gift and loan since 1957 and mostly converted to loans since 1962. The full repayments to the U.S. economic and military loans to Taiwan during the Cold War was made by 2004.

中美合作標誌
A logo of Sino-American cooperation

「美國人牌」成藥廣告
"American Brand" modern family medicine

美援期間，美國輸出大量生產過剩的麵粉至台灣，以米食為主的台灣人的飲食習慣因此而有了改變。而當時貧窮的台灣人民食畢麵粉後甚至將麵粉袋改製成衣褲、肚兜（女用內衣）與腰包。
During the U.S. aids period, the U.S. exported large flour surpluses to Taiwan, insofar as to change the dietary habit of Taiwanese whose staple used to be rice. At that time, the impoverished Taiwanese even repurposed these flour bags for clothes, undergarments, and waist packs.

為了處理來自美國的龐大經費和物資,台美共同成立「中國農村復興聯合委員會」推動各種農業發展計畫,其中包括印製大量農業教育手冊。
In order to make proper use of the generous funds and goods from the U.S. aids, Taiwan and the U.S. established the Council for Agricultural Planning and Development as the competent authority to initiate agricultrual projects of all stripes, including printing agriculture education pamphlets in bulk. (left) *A Brief Introduction to Banana Planting*; (middle) *A Brief Introduction to Tilapia Aquaculture in Paddy Fields*; (right) *Pyrethrum Planting*.

明信片
Postcard

麥片袋
Bulgur bag

解放台灣

中共中央於 1949 年提出「解放台灣」作為人民解放軍的任務之一。這個口號至 1978 年為止，一直是中共對台工作的主要方針。

1953 年韓戰結束後，中共認為解決台灣問題的時機已到，在 1954 年發表《解放台灣聯合宣言》，但因美國隨即與台灣簽署《中美共同防禦條約》，使得此計畫的實現困難重重。這段時間為「解放台灣」宣傳的第一波高峰。

第二波宣傳高峰發生為 1970 年代，中共加入聯合國，國際地位提升，「解放台灣」被重新提起，成為文革時期眾多的激昂口號之一。

Liberating Taiwan

In 1949, the Communist Party of China (CPC) declared "liberating Taiwan" as one of the missions of its People's Liberation Army. It was not until 1978 that the slogan "Taiwan must be liberated" cease to be CPC's guiding policy and sacred duty on this island.

Considering the end of the Korean War in 1953, the CPC believed that the time is ripe for solving the Taiwan issue, and hence announced the "Joint Declaration on the Liberation of Taiwan" in 1954. However, the CPC failed to achieve this objective due to the immediate signature of the "Mutual Defense Treaty between the United States of America and the Republic of China." It marked the first peak of the "liberating Taiwan" propaganda.

This propaganda hit its second peak in the 1970s, during which the United Nations accepted the People's Republic of China's application for entry that has greatly improved the latter's international status. The ambition of "liberating Taiwan" was chanted again, and the Chinese Cultural Revolution also carried it as one of its flaming slogans.

傳單
Leaflet: "We must liberate Taiwan."

《青年團員》雜誌
Youth League magazine: "We must liberate Taiwan."

空投傳單
Airborne leaflet: "American imperialism must get out of Taiwan."

空投傳單
Airborne leaflet: "Put down American guns."

傳單
Leaflet: "We must liberate Taiwan."

傳單
Leaflet: "Taiwanese people long for liberation."

《黨的生活》雜誌
Party Life magazine—the group of people marched past waving placards that said "Chinese people must liberate Taiwan."

反攻大陸

蔣介石於 1949 年撤退到台灣後，提出了「一年準備、兩年反攻、三年掃蕩、五年成功」的口號。隨著 1950 年代冷戰格局的成形，美國對「反攻大陸」的態度從懷疑轉為支持。但在中國共產黨政權逐漸穩固並完成核子試爆後，美方再度轉為反對，並開始嚴格限制蔣介石的軍事行動範圍。即使如此，「反攻大陸」與「統一中國」一直是國民黨政權對內鞏固軍心民情的主要口號。冷戰期間，小至書籤、車票，大至壁畫與建築外表，「反攻大陸」與相關的政治宣傳口語充塞於台灣人民生活的各個角落。

直到 1991 年，繼任總統的李登輝宣布結束動員戡亂時期，「反攻大陸」才正式走入歷史。

Recapturing Mainland China

After the Nationalist government's retreat to Taiwan in 1949, Chiang Kai-Shek summed up his plan of recapturing the Mainland China by the slogan "Year 1: prepare, Year 2: recapture, Year 3: mop up the enemy, Year 5: seal the victory." The formation of the Cold War structure in the 1950s prompted the U.S. to change its attitude about "recapturing the Mainland China" from skeptical to buttressing. However, in view of the increased stability of the CPC regime and its success in nuclear test, the U.S. swung back to skepticism over Chiang's aspiration and began to restrict the scope of his military manoeuver. Despite the skepticism of the U.S., the Nationalist government had used "recapturing the Mainland China" and "unifying China" as the patriotic slogans to maintain the domestic morale. During the Cold War period, Taiwanese people's quotidian existence was rife with political slogans of all stripes featuring "Recapture Mainland China." These slogans were printed on objects ranging from large murals and façades to bookmarks and tickets.

It was not until 1991 when President Lee Deng-Hui declared the termination of the Period of Communist Rebellion that the slogan of "recapturing the Mainland China" officially passed into history.

新聞照片：一群女學生站在「光復大陸山河」宣傳壁畫前
News picture: a group of girl students standing in front of a mural of "Recovery of Mainland China."

背後印著反共口號的喜帖
A wedding invitation printed with an anti-communist slogan: "Fortify Taiwan, recapture Mainland China, annihilate Zhu and Mao, expel Soviet bandits."

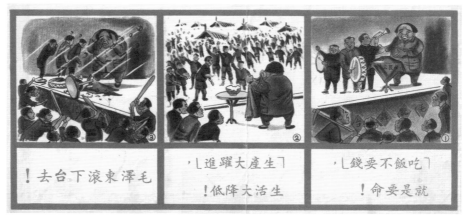

空投傳單
Airborne leaflet:
"Mao Zedong, get out!"

愛國獎券
A national lottery ticket:
"Annihilate communism
and resist Russia in a
single move; win instant
fortune by patriotism."

明信片
A postcard of Kaohsiung; the
slogan on the building's façade
said: "Recapture Mainland China;
pledge loyalty to our leader."

國小算數簿
An elementary school arithmetic
workbook: "Recapture Mainland China."

火車時刻表
A railway timetable printed with an anit-communist slogan: "Fortify
Taiwan as soon as possible, and prepare for recapturing Mainland China."

美國文化影響

美國在冷戰年代對台灣文化影響主要來自三方面。

一是來自美援，除了軍事、經濟、技術與物質的援助之外，華府亦鼓勵台灣的大學與美國境內的大學進行學術合作與人才交流。

二是來自美國新聞處的文化戰略，包括大量發行中文雜誌《今日世界》、推動台灣現代文學與現代藝術，並在其中注入美國價值觀。

三是美軍駐台以及越戰來台渡假期間，因應美軍娛樂需求而生的酒吧、夜總會等等場所與機構，它們為台灣帶來對美式的生活習慣、服裝風格、運動與飲食的想望。其中，美軍電台所播放的西洋音樂，更是對台灣流行歌曲影響深遠。

The Influence of American Culture

During the Cold War, the U.S. brought its cultural influence to bear on Taiwan through three channels.

The first channel was opened up by the U.S. aid. In addition to military, economic, technical and material assistances, Washington deliberately encouraged Taiwan's universities in academic and talent exchange with their American counterparts.

The second channel was established by the cultural strategy of the United States Information Agency. It widely published the Chinese magazine *World Today* which was imbued with American values and utilized as a promoter of Taiwanese modern literature and modern art.

The third channel was opened with the demands from the U.S. soldiers who were on leave from the Vietnam War or stationed in Taiwan. The concomitant explosion in the number of bars and nightclubs extensively introduced American lifestyle, fashion, sports and dietary habit into Taiwan. Besides, a seminal shift in Taiwanese pop songs were mapped around the Western music broadcasted by the American Forces Network Taiwan.

《今日世界》雜誌
World Today magazine

《青年英語》月刊
Chinese Youth Monthly

美國文庫（《今日世界》出版）
American Literature (published by *World Today*)

《中美社交會話》
Chinese American Conversation

唱片
Record: *House of Stars—
American Forces Network Hits Vol.1*

書式火柴
Matchbooks

法蘭西斯柯・卡馬丘
FRANCISCO CAMACHO

平行敘事
Parallel Narratives

單頻道錄像，47'11"，2018
Single-channel video, 47'11", 2018

這個世界所存在的多種歷史，已成為我們整個政治與社會生活的一部份，因為這些歷史可以解釋我們生命過程的前因後果，和我們群體的構造。我們從歷史學習理解和感知這個世界的方法，以及人生的哲學。

歷史並非複雜而有序的系統，而是液態的，隨著時間不斷改變，現今標註歷史變化的細節，和建構歷史的重大事件，在未來卻無關緊要，而某些過去隱而不見的事實卻會突然出現，改寫了我們的過去。

我們的歷史是活生生的，是伴隨我們一生的實體。它並非一成不變的陳年往事，而是當下指引我們未來方向的指南針，也是我們藉以解釋自己生命的方法。我們會記得當下受到衝擊的感受，這會改變我們對事實的觀點，扭轉我們覺知當下的方式，改變我們對未來的看法。

我們不能用科學家的規則，把歷史解讀為事實的線性排列，相反的，應該把過去看成是有多條叉路的途徑，每個交會點都導向多種不同的方向。

個人的歷史與認同是以多種不同的敘事所組成，但我們傾向於忽略甚至遺忘大部份的敘事。但是這些未知的敘事卻建構了我們的過去和我們現在所走的路，也難怪我們會錯誤地詮釋自己的歷史。

我們今天的世界，儘管經濟發展多元，科技先進，文化依然是各自為政，甚至彼此孤立，文化之間的觀念隔閡，令國與國互相誤解。分隔各個文化的鴻溝，仍然存在。

我們心中的世界圖像、我們的社會身份及知識，大多建基於一套理念。尼采在《不合時宜的沉思》中斷言人們對歷史進行科學探求，其成果將摧毀脆弱的心智，甚至妨礙未來世代從事自身的文化改革和復興事業。德勒茲對這理論的回應是：歷史的真實，不等同於人們切身體驗的真實。

順著這邏輯，我主張中國海員曾遠渡太平洋，到達彼岸考查事物。若把已被陳述的事情放一邊，再觀察美洲在西班牙統治前的考古文物，會發覺它們與另一個地方的器物很相似，而這些不同的文化使用了一些相同的技術。

要瞭解這兩個系統的古文物之間的關連，困難之處在於，必須先摒棄對科學和藝術的文化功能那些先入之見。要探索中國和南美洲「古代文物」的相似之處而不帶成見，就得尋找新方法，用那些似乎無理可循的實物證據，去平衡看似理性的學術研究語言。

Many histories of the world exist; they have become an integral part of our political and social life because they can explain to us causes and effects of the course of our life, as well as how the communities we live in are organized. Histories explain to us the understanding of the world and how we conceive it, they explain us the philosophy of our life.

Histories are not complex and orderly systems, they are liquid, they change throughout the time, the details that help us to remind them change, the important facts are irrelevant in multiple futures and the facts that were hidden suddenly come to surface and reinvent our past.

Our history is alive, it is an entity that accompanies us during all our life, it is not a fixed event in the past but it is a compass that guides our present and the way we rationalize our life. We can remember feelings that impact our present and this changes our point of view altering the way we perceive our present and changing our perspective of the future.

We can not read our history as a linear order of facts, with the discipline of a scientist, but instead we have to consider our past as a road of forking paths where every cross point is a connection to many different directions.

There are narrations that complete our personal history and identity, we ignore many of these narrations, we forget many of these narrations and we may misinterpret our own history. These unknown narrations however construct our past and therefore the path that we follow in our present.

Despite the economic diversification and technological progress in our world today, cultures remain separated, even isolated, the conceptual barriers that exist between them causing nations to misinterpret each other. The abyss separating cultures still remains.

Our images of the world we live in, our social identities, and our knowledge are largely based on a set of ideals. In *Untimely Meditations*, Nietzsche claimed that the products of a scientific pursuit of history might overwhelm weak minds and prevent future generations from undertaking their own projects of cultural reform and renewal. Gilles Deleuze responded to this theory by saying that the reality of history is not the same as reality experienced by people.

Following this logic, I submit that Chinese sailors crossed the Pacific Ocean in search of what could be found on the other side. Contrary to what has been said, when we observe archaeological artefacts from pre-Hispanic America, we notice that they are very similar to those of societies elsewhere in the world, and that these different cultures used some of the same technologies.

The challenge in understanding the links between these two bodies of archaeological pieces of art is in doing away with our preconceptions of the cultural functions of science and art. To investigate the similarities between Chinese and South American "antiquity" without prejudice, we must find new ways to reconcile the apparent irrationality of visual evidence with the apparent rationality of the language of scholarly research.

〈平行敘事〉，影像截圖，翻攝自魏聚賢著作《中國人發現美洲》（1982 年）
Parallel Narratives, video still, photographically reproduced from Wei Ju-Xian's book *The Chinese Discovery of America* (1982)

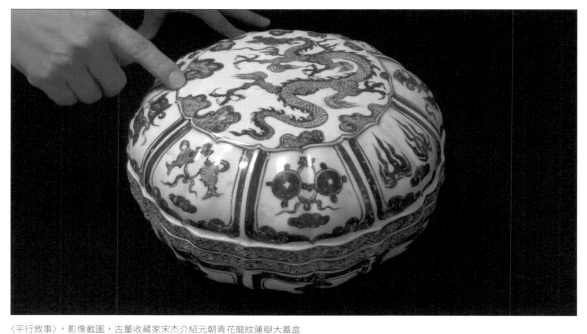

〈平行敘事〉，影像截圖，古董收藏家宋杰介紹元朝青花龍紋蓮瓣大蓋盒
Parallel Narratives, video still, antique collector Song Jieh introducing Blue-and-White "Dragon and Lotus Petal" large covered box of the Yuan Dynasty

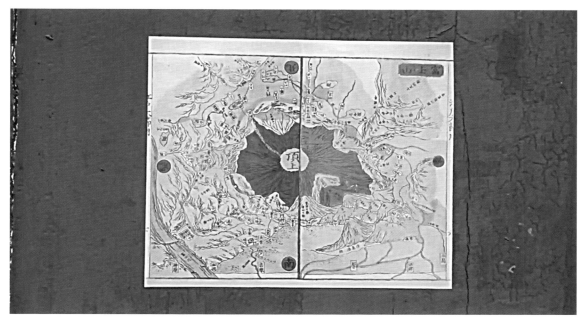

〈平行敘事〉，織布彩印，翻攝自「富士山地圖」（私人蒐藏，約 1850 年）
Parallel Narratives, cloth color print, photographically reproduced from "Mount Fuji Map" (private collection, circa 1850)

〈平行敘事〉，影像截圖，照片翻攝自宋兆霖著作《故宮院史留真》：文物裝箱前預備工作（2013 年）
Parallel Narratives, video still, preparation for crating, photographically reproduced from Song Zhao-Lin's book *The History of the National Palace Museum* (2013)

李 士 傑
SHIH-CHIEH ILYA LI

冷體計畫
Project Coldware

複合媒材裝置，2016
Multimedia installation, 2016

……求朱雀而自北門出。

—— 京極夏彥，《鐵鼠之檻》

冷戰是二次大戰結束後的一種跨國家層級的世界對話：全球國際均勢被拆解、劃分為自由與共產陣營，由兩大強權美國與前蘇聯收編戰後資源，各自集結組成對峙態勢。在冷戰中國家蛻變成為聯盟成員，為強權服務，各自的差異角色被功能化發展，結構性地支撐起巨大的陣營運作。

身在其中的台灣，更有個曲折複雜的歷史認同矛盾經歷：從戰前到戰後跨越了交戰國家陣營，經歷了戰敗與戰勝國的身份轉換，並在戰後成為被佔領的特殊區域，伴隨著中國內戰戰事失利、國民政府南遷而成為由蘇聯培育資助與訓練、日本軍事顧問秘密暗助、美援資源挹注，封存了中華文化的「自由中國」（free China）詭譎角色。

順利與全球冷戰體制無縫銜接的致冷引擎，我稱之為「冷體」（Coldware）。冷體無形，卻擁有實體、能造成影響，創造真實效應。中醫看待致病的寒氣，有著類似的建構性視角。中醫視寒為熱與動的反面，是一種相較於生命體活生生、溫暖循環體系的「阻斷物」。早期知識的創造者意識到外界溫度的變化，可以內在比喻、並且真實影響內在自身氣血運行順暢與否的關鍵要素，如一位中醫師所說：「……進到體內的寒氣是一種具體能量：以『氣』的形式在體內堆積、流竄，沈積日久，宛如休眠火山，壓縮緊實於氣血無法流通之處。一旦遭到正面摧擊，溫通引之、疏風散之，壓縮緊實的這一團積聚，開始慢慢分解、擴散，然後它必須找出口散逸。」

在幾十年之後，許多政治的建制已經灰飛煙滅，但人們仍然活在這些歷史與政治對立遺緒留下的無形「結界」之中。我們要如何才能從今日之資訊社會的「逆向工程」（reverse engineering），反向挖掘出那看不見的機制？本計畫企圖以法國歷史學家傅柯的「生活就是舞台」（tableau vivant）為思想工具，同時比較今日社會的右派政治組織「台灣民政府」表演現象，與素人科技與社會研究專家林炳炎先生的思想計畫，試圖捕捉看不見的「冷體」。希望藉由理解「冷體」致冷的運作動力，找到未來社會的解凍回暖契機。

製作團隊
藝術指導：劉吉雄
美術設計：廖旭方
特別感謝：林炳炎、YoHa（餘波）

...go through the northern gate in search of the Vermilion bird.

—Natsuhiko Kyogoku,
Barred Cage of Iron Murine

The Cold War is a type of international structure formed after the end of the Second World War. The previous global balance of power was replaced by the total confrontation between the democratic and communist blocs. The United States and the late Soviet Union, as the two superpowers during that period, pooled the post-war resources of their respective allies in order to gain strategic advantage over each other.

Other countries were closely allied with either the United States or the late Soviet Union, and served the interests of their respective alliance leaders. The originally diverse roles of these member countries were shoved aside by the functional requirements of this grand international system.

As an actor on the international stage, Taiwan has experienced a complicated sense of identity transformation. This island belonged to different camps before and after the war, underwent the identity shift from a vanquished nation to a victorious one, and became a special occupied territory in the post-war period. With the military setback and the Nationalist government's retreat to Taiwan, this island has become a bizarre mix of Soviet funding and training, undisclosed Japanese military officials participating, U.S. financial support, and traditional Chinese culture, which was given the intermediary and symbolic name "free China."

"Coldware", that's how I term the refrigeration system which helped and help Taiwan seamlessly blend into the international Cold War structure. Coldware is an intangible entity capable of wielding influences and exerting effects. Such a constructivist view bears a close resemblance to the way Chinese medicine treats the pathogenic cold. Chinese medicine regards the cold as the opposite of the heat and dynamics, as well as a "blocker" of the circulatory system of living organisms. Early polymaths compared the environmental temperature variation to the inner circulation of the human body, and identified the key factors that affect the smooth movement of air and blood therein, as a Chinese medical physician said:

The cold is a kind of energy which may intrude the human body and then accumulates, flows and deposits in the form of 'Qi' (air). It resembles a dormant volcano, blocking and impairing the circulation of air and blood. To remove these obstructions, we should warm and dredge these choke points and ameliorate the pathogenic influence. The physical cul-de-sacs of the cold will thus gradually disintegrate and dissipate from the exits of the body.

Decades later, many political regimes have been consigned to oblivion, yet we still live within the intangible "*sīmā*" (boundary) as an enduring legacy of the historical political confrontations. How can we employ "reverse engineering" to excavate the invisible mechanism from today's information society? Applying *tableau vivant*, the ideological device of French historian Michel Foucault hidden behind the surface of *Discipline and Punish*, this project seeks to compare the political scene of the right-wing organization "Taiwan Civil Government" with the ideological program undertaken by amateur STS (Science and Technology Studies) researcher Lin Pin-Yen, thereby visualizing the invisible "Coldware". On top of that, this project expects to indicate the turning point for the society to find the warm spring not far behind by reference to the underlying mechanism of Coldware.

Production team
Art director: Asio Liu
Graphic Designer: Prince Liaw
Special Thanks: Lin Pin-Yen, YoHa

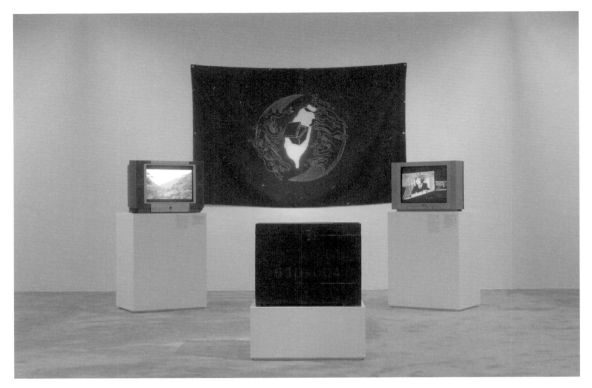

〈冷體計畫〉，展場局部
Project Coldware, installation view

冷體及其復返：內容物的遮蔽與揭露

李士傑

* 本文為「現實秘境」國際論壇「雙束現實 —— 歷史潛流中的感覺能指」(吉隆坡，2017.12.8–10) 講座的內容整理。

今天這場講座要與大家分享的是我在「現實秘境」展覽中的作品〈冷體計畫〉相關的思維跟裡面的曲折過程，由我來稍微地為大家解密，希望這些想法可以成為一些養分，並繼續在其他人的計畫、作品、創作裡面被挪用，這是我對自己一個小小的期許。

〈冷體計畫〉既是一個研究計畫，也是一個思考藝術可以怎麼有效中介與呈現這些衝突與撞擊的計畫。它的思考來源，可以溯及 2008 年我為台北雙年展的子計畫《戰爭辭典》所撰寫的〈冷，冷戰，冷的戰爭〉[1]。在該文中，我將台灣比喻為一個漂浮在太平洋黑潮之上的「冰箱」，雖有絕佳的「保鮮能力」，卻無處可去。

簡單介紹一下〈冷體計畫〉的展出方式。這件作品在展覽現場區分為中軸、左翼與右翼三個部份。在中軸，正中央的牆上是一面「黑潮旗」，裡面的圖案是一只漂浮的黑箱，地面上擺放的是我父親用來儲物的木箱，它原本的功能是金門九三砲戰防地裡的砲彈箱。展區的右翼懸吊著美國國旗、日本國旗、美軍佔領總部軍政府旗、台灣民政府旗與蓋亞那的國旗，左翼則陳列了我從素人科學與社會研究者林炳炎的「發現」之物中所挑選出的經典影像、文件與他的著作，並在說明中加上放入 QR Code，觀眾可以藉之連上網路得到更詳細的說明來理解他的研究。而在中軸與左右翼的交界處，各有一台傳統映像管電視機，在其陰極射線管的螢幕中，播放著經過自動剪輯程式處理過的影音：右翼的電視播放我所收集的「台灣民政府」社群媒體影音檔案，經過剪輯後以每十秒鐘一段的碎片化影像素材再重新連結而成；左翼則是我對林炳炎的訪談錄影，以及與美援相關的影片，同樣以每十秒鐘為單位，對稱串接而成。

至於什麼是「冷體」？為什麼要談台灣民政府？為什麼要關注林炳炎的研究？在回答這些問題之前，我想先從我為何／如何透過陳列這些物件與文件來作為一種思索「視覺的漏洞，可見的漏洞」的方法。

1　李士傑，〈冷，冷戰，冷的戰爭〉，《2008 台北雙年展國際論壇：戰爭辭典論文集》(台北：台北市立美術館，2009)。(參見 http://praxis.tw/archive/the-war-of-coldness.php)

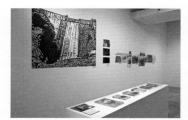

〈冷體計畫〉左翼與右翼

活物表

2013 至 2014 年在清華社會學研究所博士班階段，我在處理傅柯《規訓與懲罰》(Discipline and Punish) 當中的一個人文社科學轉變的「快閃」關鍵元素 ——tableaux vivants，英文直接翻譯是 living table，中文可以譯作「活物表」[2]，指活著的事物的「表格」，而意譯則為「生活就是舞台」。

傅柯認為這套奠基於視覺與想像的工具形成了一種新的力量，這種新力量與全控機構 (total institution) 同時誕生，藉由在圖表裡把身體實踐調整排列成陣，用以整頓軍隊、醫院、學校，就像下圖法國小學生的身體調教量表。這種力量對空間進行盤點、整頓，建構一套排他的體系，同時創造了「由一系列島嶼所組成的監獄系統」(carceral archipelago)，最終也構成了群體與自我的邊界，導致 (我們今天所謂的)「『人文學科』的誕生」。

「活物表」這個意義繁複多重的概念，跟今日的電腦一樣，有著媒介 / 計算的雙重意義：它既是一個「活物排成陣」的「活物表」，同時也是十九世紀末到二十世紀初上流社會的娛樂形式，就像今日社會的「角色扮演」(cosplay)，是一種「栩栩如生的畫作」。用今日的娛樂語言來說，「活物表」的第二義，可以說是實境秀 (reality television) 的原型與反轉，告訴著我們「生活就是舞台」。

也就是說，藉由從視覺出發的策略部署，就可以讓權力穿越邊界與滲透介面薄膜，傳遞力量。

透過這些工具的發現，與症狀的連結、解釋，傅柯其實在回答：我們的生活何以發展成今日的模樣？而我則是想從中解決一個謎團：「傅柯與 (今日我們所知道的) 資料庫」的關係為何？我認為我找到了一個思索的關鍵 ——「視覺的漏洞，可見的漏洞」(visual / visible bug)。我從這裡開啟了一趟旅程，沿著它去造訪力量、監禁技術與資料庫的關係。

2　傅柯，劉北成等譯，《規訓與懲罰：監獄的誕生》(桂冠出版社，1992)。

1818 年 H. Lecomet 的石版畫，描繪在馬紅港街合作教育學校內部，正在練習寫字的孩童。

右翼：台灣民政府，專業表演團體

〈冷體計畫〉正是從「活物表」的概念出發，尋找當代世界「力量」展現之「視覺漏洞」的範例，其中一個重要的例子就是我放在作品右翼的「台灣民政府」。

台灣民政府是在陳水扁政府時期從海外台灣獨立運動中分支出的一個由台灣民間發起的準政府組織，它宣稱自身的合法性來自於二戰結束後盟軍僅將台灣託管給中華民國（流亡政權），並未完成軍事佔領程序。它的成立時間是 2006 年，當時有二十多個台灣民間團體聯合集資到美國對美國政府提出行政訴訟，宣稱美國在二次戰後處理失當，讓台灣人民沒有獲得應有的待遇：從先前的被殖民狀態下獨立出來，成立自己的國家；而是讓中華民國政府接管，並且宣稱為其所屬領土。在訴訟被擱置後，這些民間團體宣布成立「台灣民政府」。雖然它是一套理論驅動的法律裝置，但是卻透過類似直銷的方式來擴大招募成員，辦理收費的「官員訓練講習」與出售「身分證」來賺取商業利益。

法律的行動是一個獨立的領域：國際法當中的規範，指涉了一種自給自足的現實。但是把這個「漏洞」翻譯到現實的台灣政治社會時空，就創造了一個平行時空。

我自己開始接觸台灣民政府的現象，是因為親戚繳費買身分證，成為了台灣民政府的成員。當時他們宣稱，已經有五萬人成為台灣民政府成員。在台灣最引起爭議的，是台灣民政府宣稱美國即將公開承認自己的錯誤，發給台灣人「美國軍政府台灣民政府」（USMGTCG）的身分證與護照，並且任何二十歲台灣公民都會配發房子，中國人則遞解出境。繳費且受過訓練的成員，可以擔任公職，出任台灣民政府的「州政府長官」。

台灣民政府的新聞，也隨著公民記者的影音報導、以及原民台的採訪紀錄，被正式當成新聞內容在媒體中傳播。他們三不五時就會上街舉辦的「州政府大遊行」，並將照片與影片上傳到 flickr / Youtube。在遊行隊伍中，前導旗手會手執美國國旗、日本國旗，以及想像的「美國駐台軍政府」旗，甚至會有他們的「警察部隊」── 身著鎮暴警察制服與裝備的「黑熊部隊」── 在街頭展

台灣民政府的「州政府大遊行」（本文作者翻攝自 YouTube）

演鎮暴操，更是不時以奇觀的形式進入主流媒體的鏡頭中被採訪報導。

人類學家蔡百銓認為，「台灣民政府」是大洋洲原住民的「船貨運動」(Cargo Cult) 的台灣版本 [3]。他們善用網路新媒體 Youtube 與 Facebook 流通內部訓練會議影片，其中的「州長官訓練課程」開始時都會唱電影〈出埃及記〉的歌曲〈This land is mine〉、美國國歌、日本國歌〈君之代〉。

這個現象非常的有趣，就像他們站在台中市的街頭的景象。我們不知道他們到底在遊行什麼？

> 台灣民政府發言人：「一般的遊行是人民對政府表達意見，台灣民政府的遊行是政府對民眾宣告。」[4]

我將這視為一個「視覺 (系統) 的漏洞」：我們注視著它，卻完全無法理解這些元素、動作組合在一起所代表的意義。它既讓我們完全不知道該怎麼看，怎麼理解，同時也用自己的影像視覺、影音敘事邏輯，來建構一套混淆但是「有效」的系統，得以吸收第二代成員，並透過資本運作站上國際舞台，繼續表演下去。

左翼：素人科學家，混雜現實挖掘者

第二個同樣讓我被深深吸引的「視覺的漏洞，可見的漏洞」現象，是素人科學家、退休台電資深工程師林炳炎，與他所帶頭挖掘的歷史檔案、出版的系列作品 —— 其中的一部分我放置在〈冷體計畫〉的左翼。所謂的「素人科學家」，其實是一種反諷的稱謂：主流科學社群由於其夾述夾議的敘事方式，抗拒接受林炳炎所撰寫的系列著作。

我們期待科學家是客觀的科學工具，但他們沒有辦法接受林炳炎把自己的家族故事、陰謀論通通帶進文本當中。林炳炎自費成立以台灣電力公司的日本名稱「台灣電力株式會社」為名的出版社，出版了一系列的令人驚訝的作品：從牽涉到台灣共產黨、俄羅斯記憶的家族故事、混凝土的科技史，和日本海軍戰爭結束前的研發機構，以及美國工程顧問公司 —— 懷特公司 (The J.G. White

3　蔡百銓，〈船貨崇拜研究：台灣民政府與約翰·弗洛姆運動〉，《台灣守護周刊》，第 107 期，2014 年 1 月 30 日。(參見 http://alliancesafeguard-ingtaiwan.blogspot.com/2014/01/blog-post_9999.html)

4　引述自台灣民政府發言人楊庭軒接受東森新聞台記者的訪問。(YouTube 影片網址 :https://www.youtube.com/watch?v=mO5VegmUM-8#t=38s)

Engineering Corporation) 的專案經理狄寶賽 (Valery Sergei de Beausset，或譯為狄卜賽) 的檔案故事。

在書籍的內文中，同樣令人深受吸引的是他的敘事形式。當你擁有無限多的線索時，線索的連結網絡指向了各種可能性，所想所思的「呈現」是一個很巨大的挑戰。我認為林炳炎選擇呈現的是一種 source book 的形式：最接近的譬喻是一份有五百道菜的食譜。

然而林炳炎卻已經從狄寶賽專案經理的地下室的塵封檔案中，挖掘出我們所不知道的美援故事。非常簡化地說，根據維基百科的說法：二十年間美國提供了大約四十億美元的金援。[5]

這些錢是怎麼發給台灣的？透過誰？有沒有哪些要求？這些要求與互動的細節，如何影響著台灣的國家建構？

這張照片是蔣經國贈送給狄寶賽的。在他們的中橫旅遊，相機紀錄著台灣人從來不知道的「狄寶賽」夫婦的目光。他們一家人 (包括女兒們) 跟我們在一樣的空間，卻不曾在記憶中相逢。從狄寶賽地下室的檔案中，林炳炎發現狄寶賽參與到非常多面向的台灣工業發展。

林炳炎曾經舉過一個經典的混雜範例：霧社大壩。當時他在二戰後的《台灣日日新報》數位典藏檔案追尋親戚林木順 —— 台灣共產黨

5 "Along with the $4 billion in financial aid and soft credit provided by the US (as well as the indirect economic stimulus of US food and military aid) over the 1945–1965 period,"(參見 https://en.wikipedia.org/wiki/Taiwan_Miracle)

蔣經國贈送給狄寶賽的照片，紀念在他們的中橫旅遊。(圖片提供：林炳炎)

創立者 —— 的足跡，卻看到與自己專業相關的「飛灰混凝土」的廣告，追索下去才知道原來霧社大壩 —— 在二戰終結時停工，然後在美國專家指導下繼續興建下去 —— 是一個 94% 美式、6% 日式作法的混雜大壩！

這一段的「視覺性／可視性的漏洞」發現過程，林炳炎自己記述如下：

> ……日本友人北波道子博士告訴我研究院檔案室有一件資料，她在近史所發現一筆資料：「台電公司飛灰利用問題」，迫不及待的前往檔案室，發現懷特的公文，編號如下：MSA-15.2，MSA-15.35，MSA-22.7，MSA-38.0。MSA 是當時美國共同安全署的簡稱，透露出懷特公司在執行美國的政策。這是美援時期，為了霧社壩復工的飛灰研究檔案。霧社壩混凝土由美國墾務局當顧問，此單位是美國政府機關，相關的研究報告要送給民營的懷特公司，這完全違反常理，吸引我的興趣，掉入戰後美援史。透過朋友，在哈佛大學的研究生 Adam Schneider 的協助，終於與狄卜賽取得連絡。找到懷特公司在台經理狄卜賽，並去密西根底特律拜訪他。[6]

連科技物都可以被重新發現，有著完全不同來源、跨越特定作法但是「有效」的混雜建構方式。為何我們的歷史、自我認識，仍然還是那麼單一而純粹？

為了要說明這種「視覺性／可視性的漏洞」，請讓我再引述一段林炳炎的文字，寫於 2017 年 4 月 22 日的〈懷念陳孟和前輩與葉雪淳前輩〉：

> 在他們家到處看到的是 1950 年代台灣的影像與物品，很多是當時被國民黨驅逐的藝術品，日本佛教廟宇的神像、石雕塑與石燈塔，就靜靜的在房屋與底特律河之間；林家花園被剝掉的磁磚就砌在圍牆上；日本人的繪畫精品掛滿牆壁；郭雪湖、藍蔭鼎等人的繪畫讓我神傷；到處是觀音山與大屯七星山與南湖大山的影像，在橫貫公路還沒有開通前台灣的景象。住在 de Beausset 家就如住在博物館，到處都是古物，de Beausset 夫人甚至於展現韓戰時，戰俘在戰俘營用金屬片所作粗糙的工藝品。[7]

6　引述自林炳炎個人網站文章，〈懷念陳孟和前輩與葉雪淳前輩〉，（http://pylin.kaishao.idv.tw/?p=6795）

7　同前註。

我最在意的是「就如」這個連接詞出現的脈絡。狄寶賽自己家中的收藏，就是一個被國民黨「驅逐」的文化藝術的集合。而在林炳炎的發現旅程中，因為他自己的家族故事生命記憶，所以他「搶救」下來這一批證據，見證那些被「驅逐」的事物曾經存在過。

在班乃迪克・安德森（Bennedict Anderson）的《想像的共同體》中，博物館等文化機構是一個新獨立國家內國族主義運作的重要「裝置」。如果這些博物館充滿著清洗與驅逐，而集體記憶另外掩埋於他處 ── 「就如」之處，唯有透過超越理性的情感才能帶領理性的挖掘保存團隊，穿越現實自我放逐與遺忘的困難險阻，到達搶救回自我認同與集體歷史的新現實彼岸。

〈冷體計畫〉的核心想法

作為一個行動主義者，我在〈冷體計畫〉整套研究背後的思想結構都指向一個行動：我們所承受的這些「詐騙」與（學術界、知識界社會）現實對某些現象的系統性地忽視，它背後的運作邏輯 ── 我稱之為「冷體」── 是什麼？如何回擊？倘若我們沒有清楚掌握整體，那所有的反應只是被捲入各種不由自主的騙局設計與時代浪潮罷了。

就像民族國家一樣，「冷體」是一種「想像機制」（imaginary institution）。如果用反對康德的「相關主義」（correlationism）的「思辨唯實論」（speculative realism）的說法，冷體既是理論、也是實際存在的一種機制。它就像是科技史上真空被發現之前的「以太」（ether），一種被科學論證創造出來的媒介。但同樣如同以太一般，科學家們鍥而不捨對其進行一個接一個的實驗，才有辦法驗證現象，推論出新的世界結構。

冷體作為一種機制自身，以及其創造的遮蔽與揭露，必須在思辨與實驗／實踐的同時被發現，才能被攤在陽光下。

為了要理解冷體如何在當下的現實中散佈，我把右翼「台灣民政府」與左翼「素人科學家」的命題都一一拆解並再推衍他們的反命題。

台灣民政府的反命題是「正牌政府」。正牌政府就奠基於合法的基礎上嗎？台灣民政府的存活就是依賴在現今政府的「不確定性」之上。這其實是一系列的「國家仿生學」（The Biomimicry of Nation/Quasi-Nation）的相互模仿共生關係：就如一個國家般地動起來。

相較於準政府組織的荒謬行為演出，深掘下去造成的是對眼前現實的認知失調：集體歷史如何同樣地被「部分真相」掩蓋冰封。我們需要打開那在黑潮之上漂浮的冷凍裝置，把沉積物解凍、切割，才能有機會開始接近（全新、多重版本的，與陌生的）真相。

林炳炎的反命題則是正規的知識領域：學術研究。他引述了新的歷史材料，例如挖掘狄寶賽的私人檔案，重新理解美援與台灣社會發展關係，並引用了原本未曾被台灣社會意識到的俄羅斯（舊蘇聯）文獻，加入了歷史的重新詮釋角度，與完全改變了我們注視當下事物的方式。

我們的學術領域如何理解多樣性的 source book？實踐與反身知識如何進入知識系統？如果是正規學院又是如何？

我以藝術作為一個「邂逅的介面」，在介面上創造了擁抱這些中介不確定性的可能性。最終藝術工作者得面對與觀眾相逢的現場：如何情感性地、系統化地帶回這些遺物，重新組合成一個多重真相聚攏，自我發現的當下。

Coldware and Its Return: The Cover and Disclosure of Content-Object

Shih-Chieh Ilya Li

* This article is an edited transcript of the symposium *Reality in its Double Bind: Emotional Signifiers in the Undercurrents of History* (Kuala Lumpur, Dec 8-10, 2017), which was part of the curatorial project *Towards Mysterious Realities.*

In this lecture, I would like to expound *Project Coldware*, my contribution to the meticulously choreographed exhibition *Towards Mysterious Realities*, and also decrypt the philosophy and intricacies behind it, in the modest expectation that these embedded ideas could be continuously re-appropriated as nutrients in others' creative projects.

Project Coldware was a thread of research and a project aiming to answer the question as to how art can effectively mediate and present multifarious conflicts and clashes. The idea of this project can be traced back to "Cold, Cold War, the War of Coldness," [1] an article I authored for *Dictionary of War,* a collaborative platform at the 2008 Taipei Biennial. In that article, I invoked the metaphor of a "refrigerator" carried along in the Kuroshio Current to represent Taiwan, an island exceptionally good at "maintaining freshness" yet leads nowhere.

1 Shih-Chieh Ilya Li, "Cold, Cold War, the War of Coldness," in *Proceedings on Dictionary of War: The International Forum of the 2008 Taipei Biennial* (Taipei: TMFA, 2009). (See http://praxis.tw/archive/the-war-of-coldness.php)

Let me briefly introduce the installation view of *Project Coldware*. It was comprised mainly of three parts: axis, left wing, and right wing. On the axis there was a wall with a "Taiwan upon Kuroshio Current flag" featuring the pattern of a drifting black box. On the floor in front of the wall lay a wooden case that my father used for storage. It was repurposed from an artillery shell crate in the Kinmen September 3rd Battle front. The right wing juxtaposed the flags of the United States, Japan, and Cooperative Republic of Guyana, as well as the flags of the Taiwan Civil Government and the U.S. Military Government, Taiwan. Apart

Taiwan upon Kuroshio Current flag

The right wing and the left wing of *Project Coldware*

from amateur researcher Lin Pin-Yen's writings, I carefully selected memorable images and documents for the left wing display from the objects he found, and provided a QR code for each item caption, affording the viewers a better, entangled grasp of his research by reference to detailed description online. On each side of the axis was a CRT television broadcasting an auto-edited video: the one on the right-hand side screened the video files I collected from the Taiwan Civil Government's social media. These files were divided into 10-sec. clips and then randomly connected with one another. The one on the left-hand side screened the video recording of my interview with Lin, the de Beausset home video footage archive, and some video files regarding the U.S. aid, both were also divided into 10-sec. clips and presented in an alternate fashion.

Now, you may wonder what the "coldware" is on earth, why I mentioned the Taiwan Civil Government, and why I followed Lin's research closely. Before answering these questions, I would like to explain why/how I displayed these objects and documents as a means to contemplate the "visual/visible bug."

Tableaux vivants

Between 2013 and 2014, when I was enrolled in the Institute of Sociology, National Tsing-Hua University as a doctoral student, I focused my research on a "flash" element of the turn of humanities and social sciences in Michel Foucault's *Discipline and Punish*; to wit, tableaux vivants,[2] literally translated as living tables, denoting "tables" of living beings.

2 Michel Foucault, *Surveiller et punir: Naissance de la prison*(Paris: Éditions Gallimard, 1975).

Foucault believed that this set of vision—and imagination—based tool generates a brand new power. Its emergence was synchronized with the birth of the total

institution. Arranging physical practices into arrays and matrix, the *tableaux vivants* have been used in disposition of troops, hospital staff and school students, as shown in the monitorial system for French elementary school students. Taking stock of spaces and then reorganizing them, this force constructed not only an exclusive system but also a "carceral archipelago, a prison consisting of a series of islands," which eventually formed the boundary between itself and the social body. The "humanities" (in the contemporary sense) were established as a result.

Interior of the School of mutual education, located rue du Port-Mahon, at the time of the exercise of writing. Lithograph by H. Lecomte, 1818.

Similar to modern computers, the meaning of *tableaux vivant*, as a sophisticated concept, is twofold: mediation/computation. It's a table compiled with arrays of living beings, as well as a form of patrician recreation in the late 19th- and early 20th-century. It can be counted as a "vivid and lifelike painting," and bears more than a passing resemblance to "cosplay" in the contemporary society. To phrase it in the entertainment jargon nowadays, the second meaning of *tableaux vivant* is tantamount to the prototype and inversion of "reality television," which reminds us that "life is exactly a stage."

Accordingly, the vision-based *dispositif* allows power to cross borders and penetrate the membranes of interfaces, so as to exert its force.

By means of the discovery of these tools as well as the correlations and explanations of these symptoms, Foucault was actually answering the question as to how we made our lives what they are today, and I'm trying to solve the following riddle: what is the relation between Foucault and databases (as we know them)? I believe that I've found a key entry point—the "visual/visible bug"—for cracking the riddle, from which I set out on an intellectual journey across the relations among powers, carceral techniques and databases.

The Taiwan Civil Government's "State Government Parade" (image from youtube).

Right Wing: The Taiwan Civil Government, a Professional Performance Company

Treating the concept of *tableaux vivants* as its point of departure, *Project Coldware* was an attempt to find the examples of the "visual/visible bug" that exerts "power" in the contemporary world. The "Taiwan Civil Government" I installed in the right wing of this work was a stellar example.

The Taiwan Civil Government (TCG) is a grass-roots pseudo-government organization, a ramification of overseas Taiwan independence movements during the presidency of Chen Shui-Bian. The TCG claimed its legitimacy from Taiwan's uncertain sovereign status after the ratification of the Peace Treaty of San Francisco, arguing that the U.S. military government in Japan still has the power to control Taiwan, and the Republic of China (R.O.C.) is an exiled regime which lacks the legitimacy to rule this island. In 2006, a total of more than 20 civil groups collectively filed administrative litigation against the U.S. Government, arguing that it failed to grant Taiwan due recognition in the post-war era—building an independent country from the former colonial regime—but instead allowed the R.O.C. to assume control and stake territorial claim to this island. No sooner was the litigation suspended, than these groups established the TCG. A theory-driven legal apparatus notwithstanding, the TCG has expanded by recruiting new members with disinformation and reaped profits from fake services with charges at the state level such as training courses for officials and issuing car plates and ID cards.

This litigation implied that Taiwan ought to be *de facto* an independent country as the international law stands, yet a parallel universe unfolds when we place the "visual/visible bug" in the socio-political context of Taiwan.

My initial understanding about the TCG phenomena was given by my relative who paid for their ID card and became its member. TCG openly claimed that it had recruited around 50,000 members. Of all the TCG's conducts, none are so controversial than its assertion that the U.S. is about to openly admit her fault and issue Taiwanese people with ID cards and passports of USMGTCG (U.S. Military Government Taiwan Civil Government). Besides, the USMGTCG will allocate a house to each Taiwanese citizen aged 20 years and above, and deport all Mainlanders. Those who completed the paid training courses are eligible candidates for public offices such as "Governor of the State."

The TCG has been mentioned in the news broadcasted nationwide due to the reports from citizen journalism and the interviews by Taiwan Indigenous Television. In addition, the TCG members stage the "State Government Rally" from time to time, and upload associated pictures and videos onto Flickr and Youtube. The standard-bearers in front of the procession tend to carry the flags of the U.S., Japan, and the imaginary USMGTCG. The TCG's police force— the uniformed, armed "Formosan Black Bear Unit"— may even execute a riot-control exercise on the street, a spectacle that occasionally attracts the coverage of mainstream media.

Anthropologist Alexander Bai-Chuan Tsai suggested that the TCG can be construed as the Taiwanese version of the cargo cult endemic among the aboriginal people in Oceania.[3] Its members are good at using new social media such as Youtube and Facebook for internal circulation of videos of training and meeting, among which "This Land Is Mine" (the Exodus Song), "The Star-Spangled Banner" (the national anthem of the U.S.) and "Kimigayo" (the national anthem of Japan) always prelude the "Training Course for the Governor of the State."

3 Alexander Pai-chuan Tsai, "A Study on the Cargo Cult: The Taiwan Civil Government and the John Frum Movement," *AST Weekly*, No. 107, 30 January 2014. (See http://alliancesafeguarding-taiwan.blogspot.tw/2014/01/blog-post_9999.html)

These phenomena (e.g. the scene that they stand on the street of Taichung City) are as intriguing as confusing. We have no idea about the appeal of their rally.

> *The TCG's spokesperson once explained: "people express their opinions to the government at general demonstrations; by contrast, the TCG announces to its people(to-be) at this public rally." [4]*

4 Quoted from the interview with the TCG's spokesperson Yang Ting-Xuan by an EBC journalist. (For the interview video on Youtube, see https://www.youtube.com/watch?v=mO5Veg-mUM-8#t=38s)

I regard these TCG moments as "visual/visible bugs": we watch with complete bewilderment what these elements and actions mean collectively. It baffles us on the one hand, and weaves its own images and videos into logical narratives on the other, based on which a confusing yet "efficient" recruitment system was constructed. The TCG's capital manipulation enables itself to take the international stage and continue its performance.

Left Wing: Amateur Scientist and Excavator of Hybrid Realities

As far as I am inspired and concerned, the second "visual/visible bug" which is every bit as fascinating as the TCG is Lin Pin-Yen, an amateur scientist, a researcher, and a retired engineer from the Taiwan Power Company, along with his publications and the historical material he found, part of which was displayed in the left wing of *Project Coldware*. The term "amateur scientist" is matter-of-factly an appellation savoring of satiricalness: Lin's publications have been rejected by the mainstream scientific communities as lacking academic rigor and mingling comments with narration.

We expect scientists to be objective scientific apparatuses, only to find that they cannot accept Lin's approach of including conspiracy theories and his family stories in his

texts. Lin set up the Taiwan Power Kabushiki Gaisha, a self-financed publishing house having produced a series of astonishing publications: family stories involving the Taiwanese Communist Party and Russia, development of concrete technology, war-time R&D institutions of Japanese Navy, and the "junk files" of Valery Sergei de Beausset, a project manager of J. G. White Engineering Corporation, a U.S. aid executive body.

What is equally enthralling is his narrative style in the content. The dense network of threads indicated infinite possibilities, which was why clarifying his thinking in his publications was like herding cats. In my opinion, Lin ultimately adopted the form of source book; a cookbook of 500 recipes may be the closest analogy.

Nevertheless, Lin managed to excavate the untold stories about the U.S. aid from de Beausset's files gathering dust in the basement. To summarize these files succinctly, "along with the $4 billion in financial aid and soft credit provided by the U.S. (as well as the indirect economic stimulus of U.S. food and military aid) over the 1945–1965 period, Taiwan had the necessary capital to restart its economy." [5]

5 See https://en.wikipedia.org/wiki/Taiwan_Miracle.

How did the U.S. transfer the large sums of money to Taiwan? Who played the intermediary role? Was the transfer accompanied by additional requirements? How did the details of these requirements and interaction influence the cause of nation-building in Taiwan?

This picture was a gift from Chiang Ching-Kuo to de Beausset. On the latter's family holiday along the Central Cross-Island Highway, the camera captured the gazes of Mr. and Mrs. de Beausset that we had never seen. Standing in the same space though, we haven't ever encountered the de Beausset's family (including his daughters) in our respective memories. From de Beausset's basement files,

The picture as a gift from Chiang Ching-Kuo to Valery Sergei de Beausset memorizing the family holiday along the Central Cross-Island Highway. (Courtesy Lin Pin-Yen)

Lin discovered that the project manager had been present in multiple dimensions of Taiwan's industrial development.

Lin also drew the Wushe Dam as a classic example of hybridization. Previously, Lin was tracing Lin Mu-Shun, one of his relatives and a co-founder of the Taiwanese Communist Party, by poring over the digital archive of *Taiwan Daily News* published in the post-war era, and surprisingly saw an advertisement for fly-ash concrete relating to his expertise. On closer investigation, the advertisement turned out to highlight the fact that the Wushe Dam—whose construction was suspended after the end of the Second World War and resumed in accordance with the U.S. experts' instructions—is a hybridized dam following 94% American engineering methods and 6% Japanese ones.

Lin wrote an account of this "visual/visible bug" as follows:

> No sooner did my Japanese friend Dr. Michiko Kitaba tell me that she found a file titled "Taiwan Power Company's Fly Ash Utilization" in the archives of the Institute of Modern History, Academia Sinica, than I was chafing at the bit to visit the archives, where I found a batch of documents numbered as MSA-15.2, MSA-15.35,

MSA-22.7, and MSA-38.0 from the J. G. White Engineering Corporation. "MSA" is an acronym for the U.S. Mutual Security Agency, indicating that the J. G. White Engineering Corporation was actually an executive body of American policies. These files contained fly-ash research dedicated to the resumption of the Wushe Dam construction in the U.S. aid period. The U.S. Bureau of Reclamation, a federal agency under the U.S. Department of the Interior, acted as an advisor on this project, yet, to my surprise, the Bureau was demanded to submit its research reports to a private-owned corporate (i.e. the J. G. White Engineering Corporation), which made no sense to me at all and ergo aroused my curiosity about the history of the post-war U.S. aid period. My friend Adam Schneider, a graduate at Harvard University, finally put me in contact with Mr. de Beausset, the former project manager of the J. G. White Engineering Corporation in Taiwan, who gave me an appointment to visit him in Detroit, Michigan. [6]

Even technological objects can be rediscovered and "effectively" constructed through the hybridization of techniques from different sources beyond specific rules. Then, why are our history and self-understanding still so monotone and unadulterated?

For the sake of expounding on this "visual/visible bug," I would like to quote another paragraph from Lin's article written on 22nd April 2017:

> *His home bristles with images and objects that reflect Taiwan's milieus in the 1950s. Many of them are artworks banished by the Chinese Nationalist Party, for example, deity statues, stone sculptures, and stone lanterns from Japanese temples. Now these artworks just stand quietly between the house and the Detroit River. The tiles peeling away from the Lin's Family Mansion and Garden are embedded on the perimeter walls. The interior features wall-covering exquisite Japanese paintings as well as those by Guo Xue-Hu and Lan Yin-Ding that make my thoughts wander far away. The images of several mountains in Taiwan*

6 Quoted from "In commemoration of precursors Chen Meng-He and Yhe Xue-Chun," an article published on Lin Pin-Yen's personal website. (See http://pylin.kaishao.idv.tw/?p=6795)

such as Guanyin, Qixing and Nanhu occupy every corner of his house. These images evoke a sense of nostalgia for the scenes prior to the completion of the Central Cross-Island Highway. When I stay at his home, it's almost as though I live in a museum, in which the antiques are so numerous that I can just bend down and pick them up. Mrs. de Beausset even showed me the coarse handicrafts made with sheet metal by the prisoners in the POW camps during the Korean War. [7]

7 *Ibid.*

What concerns me most is the context in which the conjunction "as though" was used. The collection in de Beausset's home is little more than an aggregate of the artworks "banished" by the Chinese Nationalist Party. Driven by his family stories and lingering memories, Lin took urgent steps to save this batch of evidence on his journey of discovery, which bore witness to the real existence of those "banished" things.

In his book *Imagined Communities*, Benedict Anderson argued that cultural institutions (e.g. museums) are crucial "devices" for the nationalist operation of a newly independent country. Provided that these museums are rife with cleansing and banishment, and collective memories lie buried elsewhere (i.e. in the site of "as though"), nothing can be more effective than the emotions beyond rationality in guiding the rational team of excavation and preservation to navigate through the untold dangers and difficulties of self-exile and oblivion in the real world, and arrive at the other shore, a new reality in which our self-identities and collective history are salvaged.

The Philosophy Underlying *Project Coldware*

As an activist, I intentionally directed the philosophy behind the entire research of *Project Coldware* towards an action of addressing the following questions. What is the underlying logic—which I term "coldware"—of all the deceptions we are suffering and the systematic ignorance of specific phenomena by academia and epistemic communities? How can we fight back? If we fail to grasp the full picture, we would lead nowhere and end up being enmeshed in devious schemes of all stripes and prevailing trends of times.

Coldware is as much an imaginary institution as a nation-state. From the perspective of speculative realism that refutes Kantian correlationism, coldware is not only a theory, but also an institution that really exists. It can be compared to "ether," a scientifically proven medium before the discovery of vacuum. Just like ether, however, we cannot prove anything and infer any new world structure from coldware until scientists have put in a great deal of effort to experiment on it.

As an institution, coldware *per se*, along with what it concealed and disclosed, can be brought to light only through synchronized processes of discovery in critical thinking and experiment/practice.

In order to grasp how coldware spreads in the contemporary world, I disassembled the propositions of the "TCG" in the right wing and the "amateur scientist" in the left wing respectively, and then infer their contrary propositions.

The contrary proposition of the TCG is "the genuine government." Can we regard a government as legitimate simply because we thought it's genuine? The TCG's existence rests exactly upon the "indeterminacy" of the current government in Taiwan. This is in fact a product of the "Biomimicry of Nation/Quasi-nation," a concatenation of symbiotic relations of mutual mimicry: as though it acts as a real country.

We would risk suffering from cognitive disorder toward the present realities if we delve deeper into the absurdity of this pseudo-government organization: How does collective history lie in the same way beneath a thick layer

of patient and biding ice formed with the "partial truth"? We need to crack the "refrigerator" carried along in the Kuroshio Current, so as to defrost and cut the sediments therein, as an effective way to get at the (brand new, multi-versioned and unfamiliar) truth.

Rigorous academic research is the contrary proposition of Lin Pin-Yen, who not only rediscovered how U.S. aid substantially shaped Taiwan's social development by reference to new historical material (e.g. de Beausset's private files), but also radically altered our way to gaze at the present world by introducing his re-interpretation of history and citing Russian (former Soviet Union) literature that the Taiwanese society has been unaware of.

What's the academia's understanding of a pluralistic source book? How do practice and reflexive knowledge enter into the epistemic system? What's the situation in formal education/academic training?

To sum up, I treat art as an "interface of encounter" on which I've opened up endless possibilities for embracing these mediatory indeterminacies. Art practitioners must inevitably face up to the sites where they encounter spectators, and the key question is how they retrieve these relics in an emotional yet systematic fashion, and reassemble them into a self-revealing, concurrent present at which multiple truths converge.

黄大旺
HUANG DA-WANG

溫室七十二變
Countless Changes of a Greenhouse

複合媒材裝置，2016
Multimedia installation, 2016

這是一個發生在「七十二年」的故事，對台灣人而言，由於普遍習慣使用民國紀元 (以 1912 年為民國元年)，七十二年象徵著歲次癸亥、豬年、甲子年的前一年，以及各式各樣的消費文化。在這間沒有玻璃、沒有嚴格溫溼度控制的「溫室」之中，不僅看不到許多人心目中共同的往日時光美好回憶，也聽不到當時的線索，只有一個幽閉者幽微的自言自語，以及空間外隱約傳來的壓力。當世界正在步向核戰，台灣停滯在欣欣向榮、莊敬自強的時代氣氛下，溫室裡更因為採光的關係，形成一個近乎與外界隔絕的世界。或許正因為如此，這個空間更變成某些人心目中的綠洲，他們紛紛在只有自己知道的角落，以及最值得向後代誇耀的位置，留下各式各樣的落款；而在他們離開之後，甚至還有一些人一而再、再而三地造訪，熟悉到就像自己的家一樣。他們唱著當時台灣最具爭議性的流行歌手羅大佑的〈現象七十二變〉，並且不斷重複當年的回憶⋯⋯。

這篇故事，也依照敘述者的觀點、社會經濟地位、年資、歷練、怨念等因素，有了各種不同的變奏。原先的喃喃自語，也因此有了各式各樣的想像，去映照出各個世代苦悶沒有出口的人生。不管過了多久，始終沒人過問，已經消失，並在原地留下一道影子的幽閉者，是被過去的亡魂帶走？還是原地腐化成為一道灰土？

This is a story about the happenings in the 72nd Year of the Republic. The Taiwanese are accustomed to using the Republic of China calendar (with 1912 as the first year).

The 72nd year was the year of the pig, and also the year of *guǐhài* in the Chinese sexagenary cycle, after which the cycle begins again at *jiǎzǐ*. On top of that, this year also marked a rampant consumer culture. In this greenhouse of no glasses and temperature-humidity controls, we neither see the halcyon days in our collective memories, nor find any clues about that time. What we hear and feel are nothing but the faint voice of an unknown figure's soliloquy and the indistinct pressure from the environment. When the world was at the brink of nuclear war, Taiwan was immersed in "a thriving and robust zeitgeist". The greenhouse has become an almost isolated world due to the natural and ambient light, and has come to be an oasis for some people as a result. They respectively left various autographs in their secret corners with their most proud heritage. After those people left, some of them even revisited the greenhouse time and again, insofar as to make it as familiar as their loving homes to them. They on the one hand sang the song "Countless Changes of Phenomena" composed and written by the most controversial Taiwanese pop singer Lou Da-You during that time, and on the other hand repeatedly took a stroll down memory lane...

The storyline is set in fluctuation with the variation in the perspective, socioeconomic status, seniority, experience and the cause of resentment of different narrators. The original soliloquy thus triggers all kinds of associations, throwing a spotlight on different generations in the throes of finding no exit in life. Suffering from long-term neglect, the soliloquist disappeared, leaving only a pale shadow of its former self. Was he caught by the ghosts of the deceased or reduced to nothing but a speck of dust on site?

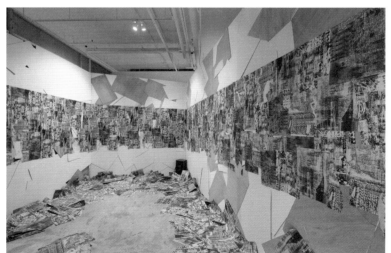

〈溫室七十二變〉，展場局部
Countless Changes of a Greenhouse, installation view

玉仁集體
OKIN COLLECTIVE

［練習02─幕間劇］
[Practice02—Interlude]

單頻道錄像，10'40"，2017
Single-channel video, 10'40", 2017

汝矣島公園作為一個舞台，它像是由時間與事件層層堆疊而成的薄餅，玉仁集體在此構思著一場由無法被定義的裝置與表演所組成的幕間劇。〈［練習02─幕間劇］〉拍攝的場景 ── 汝矣島公園 ── 過去曾是機場跑道所在，接著被改為五一六軍事政變的紀念廣場，如今則是一座公園。在公園的另一側，有一架民用 C-47 運輸機被擺放在大韓民國臨時政府建立時的歷史事件發生地。C-47 運輸機以歷史時間、空間和環境位置介入於此空間之中，喚起社會政治脈絡與歷史的關係。玉仁集體的表演轉化自對場所與身體、身體與語言、行動與行動的不同提問，其中參照了文字簡訊 ── 當今普遍的溝通形式 ── 使用擬聲字取代情感表達，以及具象詩的文學形式，而這樣的文學形式可見於韓國詩人李箱在日本殖民統治時期所寫的詩詞。

Regarding Yeouido Park as a stage in which thin layers of time and incidents are overlapped like crepes, Okin Collective conceived an interlude comprised of unidentifiable installations and performances. Yeouido Park, the space for [Practice02—Interlude], was once a runway for an airport, then a square to commemorate the May 16 military coup, and now it has become a park. On the other side of the park, there is a civilian transport C-47, placed at the coordinates of a historical event, where the Provisional Government for the Republic of Korea was established. The ways in which the C-47 aircraft intervenes in this space, with its coordinates set by its own place in time, space, and circumstance, invoke the ways in which sociopolitical context deals with history. Okin Collective's performance transcends the different questions that arise from place and body, body and language, and action and action, making reference to text messages, which have become a universal medium for communication, the use of onomatopoeia that substitutes for emotional expression, and the literary form of concrete poetry, which can be seen in Yi Sang's poems written during the Japanese colonial rule.

〈〔練習 02—幕間劇〕〉，影片擷圖
[Practice02—Interlude], video still

冷戰與場所：公園屬於誰？

玉仁集體

第一幕 飛行跑道

1916 年由日本人所建設的「汝矣島飛行場」（汝矣島位於橫貫首爾的漢江上）是韓國最早的機場。當年日本雖然稱其為民用航站，但實際上是要作為侵略亞洲大陸的跳板。

汝矣島飛行場剛啟用時，因為只用於飛機起降的最基本用途，所以僅建設了跑道與停機庫，但為因應日後滿州－朝鮮－日本的航空需求而慢慢增建，1929 年才擴建為機場，並命名為「汝矣島機場」。

1917 年，來自美國的世界級特技飛行員亞特·史密斯（Art Smith）在汝矣島飛行場駕駛著柯蒂斯飛機進行飛行表演。為一睹他絢麗的頂尖飛行技術，當時現場聚集的人潮有京城（首爾舊稱）人口的四分之一，其盛況不言而喻。

1922 年，第一位韓國飛行員安昌男（1901–1930），也在此處駕駛「金剛號」展示示範飛行。他在十六歲時看了亞特·史密斯的特技飛行後，便立志成為飛行員。安昌男以毫不遜於日本人的優秀飛行實力，讓殖民統治下的朝鮮人歡欣鼓舞，重拾民族自尊心。其後安昌男逃亡中國，為籌措韓國獨立運動的資金奔走，後來不幸因飛行事故結束了二十九年的短暫人生。

汝矣島機場在韓國光復後，經歷過韓戰的劫難，在 1953 年升格為國際機場。但因洪水導致漢江氾濫與頻繁的水災，汝矣島機場遂改為僅作空軍基地使用，最後於 1971 年關閉。

1959 年汝矣島機場（圖片出處：韓國國家記錄院）

第二幕 廣場

汝矣島機場成了廣場。自 1961 年 5 月 16 日的軍事政變後，獨裁的朴正熙把持政權達十八年之久，這座舖上瀝青的「五一六廣場」被設計作為緊急時使用的臨時飛行場。但自從成為廣場之後，這個地方事實上從未再被作為飛行場使用，而是舉辦了多場國軍日紀念儀式、閱兵儀式等大規模國家活動，例如「國風」。為了鞏固自身權力，與北韓的體制競爭成為軍事政權的藉口，朴正熙政權不斷召喚冷戰的恐懼。五一六廣場在文人主政後改名為「汝矣島廣場」，此後便更常被用作於選舉造勢、民主化集會與示威的場所。平時，則是市民溜直排輪、騎腳踏車的休閒空間。

1975 年 9 月 2 日在首爾汝矣島「五一六廣場」所舉辦的中央學徒護國團始業式（圖片出處：《韓國日報》http://www.hankookilbo.com/v/a3b35744760e4006b09e3f66da2f324e）

第三幕 公園

廣場成了公園。首爾市長吳世勳於 2007 年發佈了以漢江為中心的首爾改造藍圖「漢江文藝復興計畫」。計畫包括，在「汝矣島公園」兩萬九千平方公尺的白沙灘舖上草皮，將其設計為遼闊的草原。並且為了標顯這裡曾是韓國第一座飛行場，於是在其中設置了機場跑道上的象徵物件，如風錐、滑行道指標。還裝設了有多道水柱的水舞噴泉池、地面噴水的「水光廣場（小瀑布）」，以及「浮動舞台」——構築在水岸邊，能夠舉辦各種表演的開閉式水上舞台。最後再加上在出地鐵站的道路邊上建造的「鋼琴水道」，長達 415 公尺，為漢江流經首爾之長度（41.5 公里）的百分之一。

另一方面，漢江公園的造景事業，也被批評是吳世勳首爾市長為了競選連任而過度趕工，草率完成。工程相關人士說：「首爾市政府催促我們必須在九月底完工，讓我們時常必須進行夜間作業。」

吳世勳市長因為推行不合理的市政，而在 2011 年任期內主動請辭。

2011 年汝矣島鳥瞰圖（圖片出處：《中央日報》https://news.joins.com/article/4979854）

幕間劇

映入眼簾的，只有一片田野。一行人依序下來時，迎接我們的是幾位美軍士兵。完全非我們的預想，同胞的喜悅模樣完全消失在虛空之中。祖國十一月的風是如此刺骨，天空也不怎麼晴朗。……我的祖國原來是這麼荒涼的地方。我們所渴望的國土原來是如此冰冷。我就像牛一樣，使勁用穿著軍鞋的腳掘著土地。隨風飄揚的國旗、夢幻的歡迎人潮、向我們口乾舌燥地喊著的萬歲口號甚至推動著我們的身軀……黑漆漆的金浦的下午，並不怎麼歡迎我們。

上文擷取自光復軍張俊河先生的回憶錄《石枕 —— 張俊河的抗日大長征》（石枕出版，2015）。

2018 年的今日，汝矣島公園的角落安置著一架光復之後載送大韓民國臨時政府重要人士的 C-47 飛機。但事實上，1945 年八月降落在汝矣島機場跑道上的飛機是 C-46，而三個月後的十一月，載著張俊河先生等十五位臨時政府人士的 C-47 飛機所抵達的地方，其實是無人迎接、冷冷清清的金浦飛行場。這是因為當時日本雖然剛承認了《波茲坦宣言》，但朝鮮半島的軍事權和治安權仍然掌握在日本帝國手中。

2017 年的汝矣島公園 (攝影：玉仁集體)

2015 年是韓國光復的七十周年，首爾市長朴元淳購入了 C-47 飛機，並展示於汝矣島公園。由於保守勢力並不認同臨時政府的歷史，並挑起韓國建國時機的爭議，朴元淳市長以這項具政治意味的行動對保守派進行反駁。[1]

這架叫做 C-47 的飛行物體，以其自身的時間、場所以及事件所構成的座標來介入汝矣島公園，它提醒著我們以社會政治的脈絡來看待歷史。玉仁集體將此地視為一層層由時間與事件交疊而成的舞台 —— 猶如千層蛋糕 —— 構想出由無厘頭政治／行為所組成的幕間劇。

對我們來說，「廣場與公園」是什麼？汝矣島飛行場經由某種途徑成為廣場，後又成為公園，而這座公園又該是屬於誰的呢？玉仁集體的表演採用了現今已成為尋常溝通方法的文字簡訊、用來表現感情的擬聲字符，以及在李箱 (活躍於日本殖民時期的詩人) 作品中就出現過的具象詩，以此穿梭於場所與身體、身體與語言、動作與動作所引發的各種疑問之間。

161

Cold War and Place:
to Whom Does the Park Belong
Okin Collective

Yeouido Airport in 1959 (Photo from National Archives of Korea)

Act I: Runway

Korea's first runway was in "Yeouido Bihaengjang" (airfield) established in 1916 by the Japanese (Yeouido is an island in Hangang River which traverses Korea's capital, Seoul). The Japanese justified the establishment by arguing that it was for civilian use but in reality, it was intended to be employed as the bridgehead for invasion of the continent.

When the airfield opened, it only had the runway and a hangar since it was used to the minimum in take-offs and landings. However, it was expanded and given the name "Yeouido airport" in 1929 as the demand for flights that bridge Manchuria-Joseon-Japan increased.

In 1917, Art Smith, an internationally renowned aerobat from the U.S., performed on a Curtiss aircraft. The event attracted so much attention that one fourth of the population of Keijo (previous name for Seoul) gathered to witness the flashy cutting-edge technology.

In 1922, Korea's first pilot Ahn Chang-Nam (1901–1930) also demonstrated a flight from this airport on the aircraft "Geumgangho". He decided to become a pilot when he saw Art Smith's performance at the age of sixteen. Ahn Chang-Nam presented the people of Chosen under the colonial rule with joy and pride by boasting his highly skilled flight no less competitive than the Japanese. He then fled to China and raised funds for the independence movement before passing away so early at the age of twenty-nine from an unfortunate flight accident.

After independence, Yeouido Airport suffered the Korean War. It was upgraded to an international airport at 1953 but it was only used as an air force base as the frequent flood led to the overflow of Hangang River and flooding. In 1971, it was terminated at last.

Opening ceremony of The Korean National Defense Student Defense Corps in September 2nd, 1975, at 5.16 Square in Yeouido, Seoul. (Photo from *Hankook Ilbo*. http://www.hankookilbo.com/v/a3b 35744760e4006b09e3f66da2f324e)

Act II: The Square

Yeouido Airfield has become a square. The 5.16 Square was initially designed to be a vast asphalt square to serve as an emergency airfield for the military regime of Park Chung-Hee who maintained his dictatorship for eighteen years since the military coup he carried out. However, it has never been used as an airfield again since it became a square. Instead, it hosted Armed Forces Day celebrations or parades that aimed to be as imposing as can be as well as large scale government-led events such as "Gukpung (national wind)". The fear of cold war was constantly summoned along with the ideology competition with North Korea as an excuse to maintain the authority of the military regime. The 5.16 Square changed its name into Yeouido Square once the civilian government took charge. Since then, it was used more for electoral campaigns, rallies for democracy, and demonstrations. Usually, it is a space for leisure where citizens roller-skate and ride bikes.

Act III: The Park

The square has become a park. Mayor of Seoul, Oh Se-Hoon, announced "Hangang Renaissance Master Plan" that declared a remodeling of Seoul pivoting on Hangang

Bird's-eye view of Yeouido in 2011 (Image from *Joongang Ilbo*, https://news.joins.com/article/4979854)

River. The plan included a design to turn Yeouido Park into a vast lawn by laying turf on a 29,000 square meters of sandy beach, taking notice of the fact that it was Korea's first airfield. Wind cones, taxi way signs among other elements significant to an airfield's runway were to be installed to accord it a symbolic status of Korea's first airfield. There would also be a "waterjet" fountain made in several columns that move in choreography, "Mulbit Square (cascade)" with both a regular fountain and a ground fountain, as well as a "floating stage" which would serve as a retractable on-water stage to host various performances against the backdrop of the water's edge. Finally, by the road to the subway station, a "piano waterway" measuring one hundredth of the length of Hangang River—415 meters—was designed.

Meanwhile, there were criticisms that Hangang River Park construction was far too rushed for the benefit of Mayor Oh's reelection. The staffs in charge of the construction mentioned that "Seoul Metropolitan Government rushed us to finish the project by September which left us with frequent night shifts."

Mayor Oh pushed ahead with the unfeasible administration before voluntarily resigning from the post during his term in 2011.

Interlude

Yeouido Park in 2017
(Photo by Okin Collective)

All I saw was an empty plain. When we stepped off one by one, there were only a few American soldiers to welcome us. It was nothing like we had expected and the hopes of seeing our people whom we missed dearly vanished into the air. The November wind of my homeland was quite chilly, and even the sky wasn't so clear. ... How bleak is my homeland? Our much longed-for land has become this cold. I rubbed on the ground

in my military boots like a cow. Fluttering national flags, the welcoming party from a fantasy, and their shouts of hurray on top of their lungs have long retreated; a blue-black afternoon of Gimpo was turning its back on us.

The above text is an excerpt from Chang Chun-Ha's memoir *Dolbegae—Chang Chun-Ha's Great Journey Toward Independence* (Seoul: Dolbegae, 2015).

In 2018, a model of aircraft that transported the provisional government agents right after the independence—C-47—lies at a corner of Yeouido Park. Yet it was a C-46 that actually landed at the Yeouido Airport runway back in August 1945, and a C-47 that accommodated 15 agents of the provisional government including Chang Chun-Ha three months later in November at the deserted Gimpo airfield with no one to welcome them. At the time, the Japanese had already accepted the Potsdam Declaration but military authority and police power over the Korean Peninsula was still at their hands.

Celebrating the 70th anniversary of Independence in 2015, Mayor of Seoul Park Won-Soon bought a C-47 airplane and installed it at an exhibition site in Yeouido Park. This was also a political move against the conservatives who refused to accept the history of the provisional government and caused a controversy over the exact time of the Republic's national founding. [1]

The way a flying object—C-47—came to engage in Yeouido Park with a coordinate of its own time, place, and event as its axes reminds us of approaches of dealing with history from a socio-political context. Okin Collective has composed an interlude that consists of unknown apparatus and performance on a stage of this space where thin layers of time and events overlap over one another like a crepe cake.

1　[Editorial note] There are two disputing opinions on the formation date of South Korea. Conservative minorities do not acknowledge the legitimacy of the Provisional Government of the Republic of Korea and believe that the nation's founding date should be on August 15th, 1948, the day Japan surrendered. The progressive majority, on the other hand, argue that the founding day should be April 11th, 1919, the day the Provisional Government was established, and that the day Japan surrendered should be the National Liberation Day. As far as political stance is concerned, most of the conservatives are pro-Japanese and consider communists as their enemy. The progressives, on the other hand, distrust the Japanese and are more tolerant towards communists. When the conservative Park Geun-Hye came to power in 2013, the debate of the founding day of the nation resurfaced.

What are the "square and park" to us? Yeouido Airfield somehow became a square, and a park. Then whose park is it? Okin Collective's performance traverses various questions engendered by place and body, body and language, and gesture and gesture, taking text messages that became a universal means of communication, onomatopoeic marks that substitute expression of emotions, and a form of concrete poetry that can be seen in the works of Yi Sang who was a poet active during the Japanese colonial era as reference.

區秀詒
AU SOW-YEE

克里斯計畫 I：瑪利亞、錫礦、香料與虎

The Kris Project I:
The Never Ending Tale of Maria,
Tin Mine, Spices and the Harimau

單頻道錄像、物件與文件，15'，2016
Single-channel video, objects and document, 15', 2016

關於「克里斯計畫」

「克里斯計畫」從「棉佳蘭」出發，進而以解開線性時間軸想像歷史的方式，進一步重新檢視、想像馬來西亞和其鄰近區域（馬來群島）文化主體性的變異以及「他者」（Others）的異化過程。「東南亞」這個於1950、1960年代才出現的名詞，以及隨著二次世界大戰結束後冷戰時期所劃下的國家「界限」，這些看不見卻在意識中清楚烙下的國界實際上隱藏了掌權者虛構的能力，以及諸如民族、宗教信仰等的歷史幽魂們。「克里斯計畫」企圖啟動一部關於「他者化」的結構與演變史的書寫，以「電影」作為方法，嘗試牽連出1950、1960年代電影（明星）工業——電懋、國泰以及邵氏，和電影（明星）工業背後和冷戰相關的幽微關係與所因此建制的框架、看不見的界限，以及早於西方馬來群島殖民史甚至早於馬來王朝建立的文化（主體性）移動史間的多重對話與難題。1950、1960年代香港主要的兩家電影公司電懋和邵氏，實際上都來自當時候的馬來亞，其中電懋為國泰的子公司。1964年台灣轟動一時的神崗空難，來台出席當時亞洲電影節和擴展電影版圖的國泰老闆陸運濤為罹難者之一。陸運濤的罹難，宣告了電懋與國泰電影版圖的萎縮與消失。而二戰結束後，國泰與邵氏為了因應馬來群島（尤其是新馬）的電影市場，也各自建立了馬來電影的製片廠。

克里斯計畫 I：瑪利亞、錫礦、香料與虎

〈克里斯計畫 I：瑪利亞、錫礦、香料與虎〉以「棉佳蘭」一家隱秘的想像電影工作室為軸，以及導演 Ravi（「棉佳蘭計畫」裡〈棉佳蘭一日無光（第一章）〉中的其中一個角色，也是馬來西亞國小課本中最常出現的印度裔名字）一部嘗試借鏡於印度寶萊塢電影和電懋音樂性電影的處理手法，以拆解印度史詩《羅摩衍那》（Ramayana）和諸多民間傳說（人民和「外來者」版本）為敘事文本，卻音畫分離時空與素材錯置的「類電影」、和 Ravi 拍攝「電影」前所「蒐集」的各類照片、文件、物件等為座標，結合叩問文化主體性變異過程中「他者化」異質書寫的問題意識，共同組成觀者自行建構的意識影像。其中，Ravi 所「蒐集」的眾多資料當中除了《羅摩衍那》部分文本與其圖集以外，還包括日本將領德川義親於1921年在馬來亞森林成功捕獲一隻老虎的紀念照和當時他所寫的敘述文。老虎常和鼠鹿一同出現在民間故事中，也出現於馬來西亞的國徽，象徵著人民的勇敢與堅強。老虎也是殖民政府為建構馬來亞國族敘事而運用的隱喻之一。

About *The Kris Project*

The Kris Project departed from Meng-kerang, an imagined place, and gradually re-examine and re-imagine transformation of culture subjectivity of Malaysia and its' nearby region, as well as alienation of the "Others", through untying linear timeline and ways of re-imagining history. The term Southeast Asia emerged only during the 1950s and 1960s. Nation borders were drawn after the end of Second World War and during the Cold War. These borders were not visible but were printed into our consciousness. Abilities of people in power to fictionalize things and phantoms of nation, religion, and faith were hidden be-neath or behind these borders. Using "film" as a method, *The Kris Project* attempts to initiate a piece of writing on transformation as well as changing structure of "being the other" in history. While implicating the dark relations between film industry in the 1950s and 1960s and the Cold War, such as Motion Picture and General Investment Ltd., Cathay and the Shaw Brothers, this project also attempt to re-examine the restrictions that were built after, that is the invisible borders. *The Kris Project* also tries to construct multiple conversations and difficulties between the above mentioned film indus-try and history on the mobility of culture subjectivity earlier than the colonization era and even the establishment of Malay Sultanates. Motion Picture and General Investment Ltd. and the Shaw Brothers, two major film companies in Hong Kong during the 1950s and 1960s, were actually from the then Malaya. Cathay in fact, was the mother company of Motion Picture and General Investment Ltd. Loke Wan-Tho, the owner of Cathay, died in a plane crash in Taichung after attended the Asian Film Festival in the year 1964. Loke Wan-Tho's death signified the recession and disappearance of Cathay film. Both Cathay and the Shaw Brothers established their own production studio of Malay films after the Second World War.

The Kris Project I: The Never Ending Tale of Maria, Tin Mine, Spices and the Harimau

The Kris Project I: The Never Ending Tale of Maria, Tin Mine, Spices and the Harimau started from a hidden and imagined film studio in Mengkerang. Ravi, the film director, as well as one of the fictional char-acter appeared in *A Day Without Sun in Mengkerang (Chapter One)* (2013), also one of the regular Indian names to appear on Malaysian primary school textbooks, makes a dislocating "pseudo film" that tries to imitate Bollywood and Motion Picture and General Investment Ltd. musical filmmak-ing style, as well as deconstructing Indian epic *Ramayana* and all sorts of folklores, be it the people version or the "pendatang" version. Altogether with "collected" photos, documents, sketches, objects by Ravi for pre-production of his "film", and alienated writing of the "Others" during the trans-forming process of culture subjectivity, they form a self-construct images of the con-sciousness in the viewer's mind. Among the "collected" items of Ravi include a photo of Marquis Yoshichika Tokugawa in 1921, where he portrayed with the tiger he captured in Malayan forest. Tiger (harimau) and Sang Kancil were regulars in Malaysian folklores. Tiger also was presented on the national emblem of Malaysia, symbolizing courage and strength of the people, as well as a metaphor for national narrative of Malaya, implemented by the colonial government.

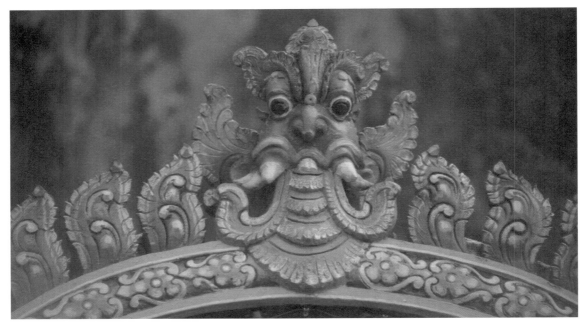

〈克里斯計劃 I：瑪利亞、錫礦、香料與虎〉，影片擷圖
The Kris Project I : The Never Ending Tale of Maria, Tin Mine, Spices and the Harimau, video still

〈克里斯計劃 I：瑪利亞、錫礦、香料與虎〉，影片擷圖
The Kris Project I : The Never Ending Tale of Maria, Tin Mine, Spices and the Harimau, video still

變體中的疆界：身體的試煉與想像

區秀詒

* 本文為「現實秘境」國際論壇「雙束現實 —— 歷史潛流中的感覺能指」（吉隆坡，2017.12.8–10）講座的內容整理。

Soma 與受傷的人

身體一詞，總予人某種生之想像，是活生生與呼吸鏈接的證明。然而，希臘文中的身體 ——soma—— 原來的意思為屍體。屍體指向死亡。如果身體與屍體，生與死之間存在兩個空間的邊界的話，則詭異地，希臘文中的身體，成為了生與死之間游離的字詞，一種帶點曖昧不明姿態的身體。這個字詞，牽動出當下社會強迫個體之身選擇站在其中一邊的絕對狀態的另一種面貌，像是某種警示性的預言。彷彿我們在自以為自由自在暢所欲言的浩瀚網路世界中，更需要絕對、明晰的選擇，如國家的邊界、道德的邊界、對與錯的邊界、正義與邪惡的邊界。這些在「自由」網路世界游弋的身體，正以絕對的姿態進行排除的行動。曖昧不明在現實的結界裡遭到排除，這是當代一齣必然上演的悲劇。然而邊界或疆界，真如一般人被形塑的意識中所以為的如此絕對，非一即二嗎？又邊界如果具有身體，是否能展開其變異的旅程？

十五世紀末，中世紀歐洲醫師約翰・基斯所持有的醫療檔案 (Johannes de Ketham's Fasciculus Medicinae) 中，〈受傷的人〉(wound man) 第一次在紙本出現。圖中，〈受傷的人〉的身體被多把利刃所挾持。這張圖像彷彿假定了這個人或許曾在戰爭或意外中受苦。圖像的旁邊是各式傷口的治療法。〈受傷的人〉在十六、十七世紀經常被用於外科文本中，來展示一名醫生會面對的可能傷勢 (wounds)。然而，〈受傷的人〉最重要的精神面向並不是要讓觀者感受其痛苦，而在於作為一種可以被治癒的展示或顯影，一

十五世紀末，中世紀歐洲醫師約翰・基斯所持有的醫療檔案中，〈受傷的人〉第一次在紙本出現。（圖片來源 https://en.wikipedia.org/wiki/Wound_Man）

種彰顯帝國威望的隱性操作法。十五世紀末一直到十六、十七世紀，〈受傷的人〉圖像始終成為醫療檔案裡最有力的隱喻。十六、十七世紀，正是帝國殖民勢力擴張的頂峰，大航海時代與地理大發現的全盛期。

如果我們把〈受傷的人〉看作一幅佈滿節點的身體「地圖」，再來映照現今地圖上東南亞和其鄰近區域的邊界狀態，於圖像或影像中生死一瞬的懸置，正好對身體存在的絕對性提出了疑問。正如阿蘭·巴迪歐 (Alain Badiou, 1937-) 在〈當前時代的色情〉一文中，對於當代崇拜物 —— 民主（體制）—— 的思考類似，借用巴迪歐的修辭，「身體」也是「一個既不知道自己來自何處、也不知自己去向何方、更不知自己意味著甚麼的詞」。這種對於身體存在絕對性的提問，正是思考身體和其政治（性）的關鍵。圖像和影像中懸置的身體，凝滯在時間中的，「不知道自己來自何處、也不知自己去向何方、更不知自己意味著甚麼」的一刻[1]，正好成為了身體和政治（性）連結的最重要線索。懸置的佈滿創傷的身體，啟動了權力機制與結構的進一步擴張。創傷 (wounds)，因為懸置而開啟了觀者視創傷為可被修補或消除的殘餘物的希望。這類希望，正符合了殖民帝國駕馭殖民地的熱望，讓一切的創傷從絕對的腐壞，轉身成為完美的活體 (living body)。腐壞、潰爛等惡質的殘餘物在這裡異化成歷史的隱喻，可視傷口外表下擾動的權力與政治暗湧。

1　Alain Badiou 著，張璐譯，《當前時代的色情》(河南：河南大學出版社，2015)，頁 28。

棉佳蘭

「棉佳蘭」是一個自 2013 年開始不斷地以變異的形貌在我作品中出現的虛構的地方。這個虛構的地方不僅僅出現在「棉佳蘭計畫」當中，也在「克里斯計畫」裡接續變異。

「棉佳蘭」沒有清晰可視的面貌與身體。如果影像是身體存在的某種可視證言，則「棉佳蘭」的影像也在不斷自我擦拭、覆蓋、掏空、改變中。「棉佳蘭」的創造與變身，並不是基於類似建築學上的精確策略。「棉佳蘭」所同樣具備的轉折本身，是不斷變異的身體，這個身體是活生生的 (living)，同時也作為一種展開與改變各式可見與不可見邊界的驅力。也就是說，活生生的身體 (living body) 牽動出了活的邊界 (living border)。原本隱匿在歷史框架 —— 無論

是哪一方的版本 —— 之下的，因為地圖的客觀測量權威性而幾乎無法動彈的邊界，在「棉佳蘭」重新獲得一種活的可能。

〈克里斯計劃 I：瑪利亞、錫礦、香料與虎〉，影片擷圖

克里斯計畫

如果說「棉佳蘭計畫」所欲辯證和檢視的對象是「馬來西亞」，那麼「克里斯計畫」的對象則為「東南亞」 —— 這個自太平洋戰爭結束不久後開啟了冷戰序幕才普遍的地域名詞。

「克里斯計畫」從「棉佳蘭」出發，企圖啟動一部關於「他者化」的結構與演變史的書寫，以「電影」作為方法，嘗試牽連出 1950、1960 年代電影 (明星) 工業 —— 電懋、國泰以及邵氏，和電影 (明星) 工業背後和冷戰相關的幽微關係與所因此建制的框架、看不見的界限，以及早於西方馬來群島殖民史甚至早於馬來王朝建立的文化 (主體性) 移動史間的多重對話與難題。1950、1960 年代香港主要的兩家電影公司電懋和邵氏，實際上都來自當時候的馬來亞，其中電懋為國泰的子公司。1964 年台灣轟動一時的神崗空難，來台出席當時亞洲電影節和擴展電影版圖的國泰老闆陸運濤為罹難者之一。陸運濤的罹難，宣告了電懋與國泰電影版圖的萎縮與消失。而二戰結束後，國泰與邵氏為了因應馬來群島 (尤其是新馬) 的電影市場，也各自建立了馬來電影的製片廠。這張因為層層疊疊錯綜交織的線索而不斷異化的地圖，如董啟章在《地圖集》所說的一樣，「不能於一刻間完成，而必須橫跨一段充滿外在變化的時空」。[2]

以電影和敘事作為方法，在「克里斯計畫」中，我撿拾起了 Ravi 之分身這個角色。Ravi，於〈棉佳蘭一日無光 (第一章)〉中消失於叢林中的人，也是馬來西亞課本最常出

現的印度裔名字。在「克里斯計畫」中，Ravi 變身成一位在棉佳蘭的叢林失蹤的電影導演，藉此想像並建構的一個電影工作室 ——「克里斯電影工作室」(Kris Film Studio)。

2 董啟章著，《地圖集》，(台北：聯經，2011)，頁 48。

香港九龍　Mu-Cha-Cha
台北金門　Mu-Cha-Cha，
新加坡和馬來亞　Mu-Cha-Cha，
你和我　Mu-Cha-Cha，
大家都　Mu-Cha-Cha，
Mu-Cha-Cha，Mu-Cha-Cha，
Mu-Cha-Cha

所有年紀少的兄弟姊妹，
凡是年紀老的爸爸媽媽。
不管紅黃黑白天下一家，
Mu-Cha-Cha

所有年紀少的兄弟姊妹，
凡是年紀老的爸爸媽媽。
不管紅黃黑白天下一家，
Mu-Cha-Cha

大阪東京　Mu-Cha-Cha，
巴黎倫敦　Mu-Cha-Cha，
南北的亞美利亞　Mu-Cha-Cha，
你和我　Mu-Cha-Cha，
大家都 Mu-Cha-Cha，
Mu-Cha-Cha，Mu-Cha-Cha，
Mu-Cha-Cha。

不管眼睛鼻子各式各樣，
笑聲都是一樣嘻嘻哈哈。
因此親親愛愛天下一家，
Mu-Cha-Cha

〈克里斯計畫 I：瑪利亞、錫礦、香料與虎〉最原始的啟發，來自於以上的歌曲，〈天下一家〉。這首歌是我童年的靡靡之音，源自電懋

於 1963 年，也就是當時的馬來西亞版圖 ── 即含括今日的馬來半島、新加坡以及北婆羅洲 ── 成立的那一年，由電懋的首席女演員葛蘭領銜主演的婚後復出之作 ──〈教我如何不想她〉。這部電影敘述葛蘭飾演的女歌手和前男友以及歌舞團領班之間的愛恨糾纏。電影中也因應主角身分的關係而順理成章出現大量歌舞片段以及歌曲。〈天下一家〉的歌詞，充分表現出電懋作為中產美國式生活代言人，順應著冷戰美國陣營所欲傳達的訊息而創造的歌曲。

〈克里斯計畫 I：瑪利亞、錫礦、香料與虎〉揀選了跟馬來西亞和東南亞區域相互牽連的關鍵字和區域的精神代表，想像「棉佳蘭」顯身以前的面貌與故事。作品的影片本身，以印度史詩《羅摩衍那》(Ramayana) 為敘事的不可視藍本。透過對於《羅摩衍那》的拆解和角色與地方等的置換，加上民間故事和殖民者相關的故事間交錯融合，形成一則即熟悉又陌生的類神話敘事。這個類神話敘事，以我循著冷戰期間英美陣營的共同對象之一，「馬來亞共產黨」的棲身之處用攝影機撿拾而來的影像作為影片的視覺要素。其中混合了葛蘭於〈教我如何不想她〉這部電影中演唱〈天下一家〉時在世界地圖上載歌載舞的片段，以及英國百代新聞社所拍攝，尤其是和當時把「馬來亞共產黨」逼退到泰國邊境的功臣鄧普勒公爵 (Sir Herald Templer) 相關的新聞影片。〈克里斯計畫 I：瑪利亞、錫礦、香料與虎〉作品名稱中的每一個關鍵字都附著複雜的面向和同時扮演各種分身。

持續變體中的疆界

「克里斯計畫」所欲試圖展開的，是以各種身體之想像與其變異的意義和指涉，映照出疆界如果具有身體或形體的話，同樣具有變體 (transfiguration) 的特徵。這種變異和一開始提到的希臘文 soma 同樣曖昧不明。而或許正因為這樣的曖昧不明，才有可能去鬆動我們已然被逐漸框架，恒常需要面對選擇題的當代現實之意識。或者應該說，「克里斯計畫」是「在現實的結界裡遭到排除」的曖昧不明之姿態，一次可能的復活。

Transfiguring Borders:
Trials and Imagination of Body

Au Sow-Yee

* This article is an edited transcript of the symposium *Reality in its Double Bind: Emotional Signifiers in the Undercurrents of History* (Kuala Lumpur, Dec 8-10, 2017), which was part of the curatorial project *Towards Mysterious Realities*.

"Soma" and the *Wound Man*

The term "body" has always implement imagination of the living, an evidence of connection between the living and breathing. However, "soma", body in ancient Greek indicated originally to corpse. Corpse refers to death. If there is a border between body and corpse, living and the dead, then body in Greek becomes a term wandering between life and death, it is then a body with a vague and uncertain gesture. The term "soma "draws an alternative image as opposed to the definite situation where individuals in contemporary society were forced to make distinct decision on which side to support. As if it is a warned prophecy. It seems like we need to make absolute and clear choice in the seemingly free world of expression in cyber space, be it on issues such as border of a nation, moral, right or wrong, justice or evil. These bodies cruising in the "free" world of internet are executing an act of exclusion with an invisible forceful and absolute gesture. Vague and uncertain situations are excluded in reality. This is a tragedy in contemporary time. Yet, is borders that absolute as people imagined, always a binary decision? Moreover, if borders have a body, will it be able to open up a trip of transformation?

At the end of the 15th century, *Wound Man* appeared on printed books for the first time. It is included in *Fasciculus Medicinae* owned by Johannes de Ketham, a doctor in medieval time. In the illustration, the *Wound Man* was seized by various pointed knives, proposing that the man

At the end of the 15th century, *Wound Man* appeared on printed books for the first time. It is included in *Fasciculus Medicinae* owned by Johannes de Ketham, a doctor in medieval time. (Picture from https://en.wikipedia.org/wiki/Wound_Man)

might suffer in a war or an accident. On the side of the illustration were curing methods of various wounds. *Wound Man* was used in surgical text during 16th and 17th century. It was a demonstration of possible wounds that a doctor will confront. However, the most important indication of *Wound Man* is not whether viewers could feel his pain, but as a demonstration of curable evidence, an invisible act to present the glory of an empire. The *Wound Man* has been the most powerful metaphor in medical documents from end of 15th to 17th century. The expansion of power and colonialism reached it's peak in the 16th and 17th century, it was the heyday of the age of discovery.

If we see the *Wound Man* as a bodily map filled with intertwining nodes, and the image situated within the suspension of life and death, and furthermore reflects the border situation between Southeast Asia and its nearby region, also works as a question for the absolute presence of a body. This is similar to the argument proposed by Alain Badiou in *The Pornographic Age*, where democracy, a contemporary object of fetishism was criticized. Borrowing the rhetoric of Badiou, "body" is also "a term not knowing where it came from, where it goes and what it means". Questioning the absoluteness of bodily existence is the crucial key to think about body and its politics. Image and the suspended body in the image, the moment of "not knowing where it came from, where it goes and what it means" that is froze in time becomes the most important clue of the relations between body and politics.[1] The suspended and wounded body initiates further expansion of power system and structure. Due to its suspension, "wounds" open up viewers' expectation of seeing wounds as something curable and residues that could be eliminated. These expectations meet the desire of colonialism. That is transforming all wounds from absolute ulceration to a perfect living body. Evil residues such as things that are rot-

1 Alain Badiou, *The Pornographic Age*, Chinese translated version, translated by Zhang Lu (Henan: Henan University Press, 2015), p.28.

ten or ulcerated transfigure into the metaphor of history, the undercurrents of power and politics beneath the visible wounds.

Mengkerang

Mengkerang is an ever transfiguring place existed in my works since 2013. It not only make its appearance in *The Mengkerang Project* but also continue its transfiguration in *The Kris Project*.

Mengkerang neither has a clear visible face and body. If image is a visible evidence on the existence of body, then the image of Mengkerang is constantly self-erasing, self-covering, emptying and changing. The creation and transfiguration of Mengkerang is not based on the accurate strategies of architecture. The transition of Mengkerang is its transfiguring body. This body is a living one, which also acts as forces to expand and changes various visible or invisible borders. That is to say, living border is triggered by the living body. The almost stationary border due to the authoritative objectiveness of measurement, hidden under historical context, regardless which side of the history, has found a possibility to live in Mengkerang.

The Kris Project

If Malaysia is the target for dialectical discussion and rethinking in *The Mengkerang Project*, then the target for *The Kris Project* is Southeast Asia.

The Kris Project I: The Never Ending Tale of Maria, Tin Mine, Spices and the Harimau, video still

Southeast Asia is a regional term being popularized after the end of the Second World War and the beginning of Cold War.

The Kris Project departed from Mengkerang. Using "film" as a method, *The Kris Project* attempts to initiate a piece of writing on transformation as well as changing structure of "being the other" in history. While implicating the dark relations between film industry in the 1950s and 1960s and the Cold War, such as Motion Picture and General Investment Ltd. (MP&GI), Cathay and the Shaw Brothers, this project also attempt to re-examine the restrictions that were built after, that is the invisible borders. *The Kris Project* also tries to construct multiple conversations and difficulties between the above mentioned film industry and history on the mobility of culture subjectivity earlier than the colonization era and even the establishment of Malay Sultanates. MP&GI and the Shaw Brothers, two major film companies in Hong Kong during the 1950s and 1960s, were actually from the then Malaya. Cathay in fact, was the mother company of MP&GI. Loke Wan Tho, the owner of Cathay, died in a plane crash in Taichung after attended the Asian Film Festival in the year 1964. Loke Wan Tho's death signified the recession and disappearance of Cathay film. Both Cathay and the Shaw Brothers established their own production studio of Malay films after the Second World War. The transfiguring "map" constructed by layering and intermingling clues, to put into words by Hong Kong writer Dong Qi-Zang in *Collection of Maps*, "could not be achieved in a short amount of time, but need to cross over a constant changing time and space". [2]

2 Dung Kai-Cheung, *Collection of Maps* (Taipei: Linking Publishing), 2011, p.39.

In *The Kris Project*, I gleaned the character as Ravi's synonym. Ravi, a character disappeared in a forest in the earliest work in the Mengkerang Project, *A Day Without Sun in Mengkerang (Chapter One)*, is also a familiar Indian name in Malaysian primary school text books. In *The Kris Project*,

Ravi transform into a film director disappeared in the forest of Mengkerang. And hence an imaginary film studio, Kris Film Studio, was constructed.

Hong Kong Kowloon Mu-Cha-Cha
Taipei Kinmen Mu-Cha-Cha,
Singapore and Malaya Mu-Cha-Cha,
You and me Mu-Cha-Cha,
Everyone Mu-Cha-Cha,
Mu-Cha-Cha, Mu-Cha-Cha,
Mu-Cha-Cha

Every young brothers and sisters,
Every old fathers and mothers,
no matter red yellow black or white all is one family
Mu-Cha-Cha

Every young brothers and sisters,
Every old fathers and mothers,
no matter red yellow black or white the world is one family
Mu-Cha-Cha

Osaka Tokyo Mu-Cha-Cha,
Paris London Mu-Cha-Cha,
South and North America Mu-Cha-Cha,
You and me Mu-Cha-Cha,
Everyone Mu-Cha-Cha,
Mu-Cha-Cha,Mu-Cha-Cha,
Mu-Cha-Cha

No matter every kind of eyes and noses,
Laughing sound are all the same.
Hence we're a loving the world is one family
Mu-Cha-Cha

The earliest inspiration of *The Kris Project I: The Never Ending Tale of Maria, Tin Mine, Spices and the Harimau* was from the above song, entitled *The World as One Family.* I listened to the song many times when I was a child,

since my mother is a fan of the singer. The song was originated from a film entitled *Because of Her*. A film produced by MP&GI in 1963, the year when the then Malaysian map was drew, a map included Peninsula Malaysia, Singapore and North Borneo, featuring Grace Chang, the leading actress of MP&GI. It was the first film that Grace Chang starred in since she got married. The film tells the love struggle between a songstress played by Grace Chang, her ex-boyfriend and the cabaret troupe manager. There are many singing and dancing scenes in the film due to the character's setting. Lyrics of *The World as One Family* portrayed the MP&GI as the spokesperson of American style living, where the company created songs according the messages that the America and its allies would like to convey during the Cold War.

The Kris Project I: The Never Ending Tale of Maria, Tin Mine, Spices and the Harimau chose keywords and regional spiritual representation within Malaysia and the Southeast Asia region, and furthermore imagined faces and stories of Mengkerang before its distinct appearance. The narrative of the film in the work was based on the Indian epic *Ramayana*. Through integrating deconstructed and changed characters as well as places in *Ramayana*, together with collected folklores and related stories of the colonial regime, a familiar yet strange pseudo mythical narrative was constructed. This pseudo mythical narrative appears through footages I gleaned in Peninsula Malaysia, following footsteps of the Malayan Communist, which is the enemy of the American allies during the Cold War. In between, intercutting with footages of Grace Chang dancing on a world map while singing the song *The World as One Family*, as well as news reel filmed by the Pathe News that are related to Sir Gerald Templer (1898–1979), the then British High Commissioner in Malaya who forced the Malayan Communist out of the then Malaya into the Malaysia and Thailand border. Each keywords in the title *The Kris Project I: The Never Ending Tale of Maria, Tin Mine, Spices and the Harimau*, carries complex dimension and pluralistic character.

The Transfiguring Border

The Kris Project attempts to open up meanings and metaphors of various kind of imagination and transformation of a body. Hence reflecting on the question if borders have a body, they too carry the essence of transfigura-

tion. Similar to the Greek word "soma", this transfiguration is also ambiguous. And maybe only through this ambiguity, our bounded contemporary consciousness on reality when constantly confronting multiple choices could be loosened. Or maybe we can say, *The Kris Project* is a possible re-live of the ambiguous gesture excluded from reality.

巴尼・海卡爾
BANI HAYKAL

無眠者的公墓
Necropolis for Those without Sleep

複合媒材裝置，2015
Multimedia installation, 2015

我對音樂的愛讓音樂以某種方式成為敵人。這不代表我現在厭惡音樂，反之，我想要更徹底研究它，了解是否有什麼方式可以重新去關注它。我不太確定自己是否期待著解答，但有一點我想說的是：「倘若無知是福，那麼通曉便是地獄。」也許不遠的將來，對周遭一切，和人之所以為人的道理，我們都將遺忘，或同今日一樣地無知，無論這些事情於今日或未來可能意味著什麼。或許到那時，我們會看到某種形式的烏托邦的表象，冷酷、機械且貪婪。或許到那時，我會找一種方法讓自己消失或死去。就像現在，雖然我發現了生命的意義，但轉譯得如此地拙劣因而看不出意義，所以我只能繼續追問。

文化冷戰，如同字面意義，意味著「文化」作為冷戰時期以交戰之利益為目的的策略和方法。在這個重要的時期裡，文化被大量對外傳播，是美國推銷民主價值的宣傳工具之一。音樂學家斯圖爾特·尼科爾森（Stuart Nicholson）在他的著作《全球化時代的爵士樂和文化》(Jazz and Culture in the Global Age) 中指出了冷戰時期爵士樂在國際化之下的複雜性，他說道：「……影像成功地覆蓋了現實，美國爵士樂不再只是『它自身』，……而是夾帶著美國的文化力量，投射美國民主與自由的符號和神話，促使其他國家支持美國的意識型態……」但是，使用音樂當成傳佈權力與控制社會的作法，早在十四世紀就已流行，當時的國王買通遊方藝人，四處頌揚國王的統治。藉由公共與私人的機構來展示國家所許可/鼓勵的經濟實力與開放性的類似策略，在今日仍留有回響與殘餘，它已不只是透過文化傳播，而這個趨勢正領導著二十一世紀的新加坡。這個城市一國家的「智慧國家」計畫（Smart Nation）[1] 是一種倡議，尋求另一輪社會、政治與經濟的綜合調查，並且將私人與公共設施的角色與利益重疊在一起，進一步影響/控制公眾、人民和空間。在這裡，風險資本家、藝術家、企業家與決策者被更深地捲入、糾纏進強勢資本主義的敘事裡，於其中，一般公眾與其空間的在場、存在與角色，多半被忽略或被剝削（有誰能夠從臉書和谷歌的產品/服務中真正地得到利潤與收益？），為的是去推展和餵養經濟（以及操控它的人），這種當下的地景（可稱之為公墓）提供了一個約略的印象，關於充滿著控制、權力與矛盾的過去。作家兼研究者耶夫根尼·莫洛佐夫（Evgeny Morozov）進一步地闡述：「科技失憶症，和對歷史（特別是科技失憶症的歷史）的漠然，一直是當今網路辯論的重要主題。」「機器土耳其人」（Mechanical Turk）[2] 是沃爾夫岡·馮·肯佩倫（Wolfgang von Kempelen）於十八世紀的發明，本作品以其作為指涉，比擬它背後的概念/思維，也間接指涉了現今由電商公司亞馬遜（Amazon）所提供的服務及詞彙的用途與存在。〈無眠者的公墓〉思考的是權力系統，和投射（保護）它的欲望，檢視政治的、經濟的和社會的地景之間的複雜網絡與關係，並且在現今新自由主義氛圍下 —— 恐懼、娛樂和無聊等等治理機制，經過調校，共組為沒有需求的供給 —— 追問公眾的角色為何。

1 〔編註〕「智慧國家」是新加坡於2014年發佈的政策，計劃於住宅和特定區域大量裝設感測器，蒐集空氣品質、交通流量、河流水位、交通流量和保安監控等等資訊，以這些大數據為公共服務的依據。

2 〔編註〕十八世紀的「機器土耳其人」據說是一具會下西洋棋的機器人，但後來被證明是騙局，它其實是由躲藏在機器內部的真人所操作。而亞馬遜網站的「機器土耳其人」則是一種網路媒合服務，使用者可在網頁上提出任務需求和報酬，另一批使用者則可在線上接受任務並獲取報酬。

My love for music brought me here. A place where music has, in some way, become the enemy. That's not to say I despise it. No, I want to study it even more. I want to understand if there is in fact a way to undo this indifference. I'm not quite sure I look forward to the answer. But this much I'll say: "If ignorance is bliss, then knowing is hell." Someday, and maybe not too long from today, all of us will forget about or simply remain ignorant of everything around us and what makes us human, whatever that may mean today or in the future. Maybe then, a semblance of a form of utopia is visible. Cold, mechanical and insatiable. Maybe then, I'll find a way to get lost and die trying. And just like today, how I found the meaning of life but because the translation was so bad it made no sense, keep questioning to know.

The Cultural Cold War, where the prefix "Cultural" symbolizes the strategies and methods built around the interest of engagement during the Cold War, is a significant period where culture was widely exported as part of state propaganda by the US promoting the promise of democracy. Musicologist Stuart Nicholson, in his book *Jazz and Culture in the Global Age*, addresses the complexities of the internationalization of Jazz music during the Cold War, stating, "...the successful projection of image over reality, whereby American jazz ceased to be 'a thing in itself', ...instead came with the weight of American cultural power behind it, projecting the symbols and myths of American democracy and freedom to encourage other nations to be sympathetic to the ideology of the United States...". Yet methods of disseminating power and control over society, particularly through music, has been prevalent as far back as the 14th century, where minstrels are paid to serve kings, singing praises of their rule. Today, the resonances and residues of similar strategies by both public and private bodies in its efforts to demonstrate economic prowess and openness permitted/encouraged by the state, is not merely through cultural exports that is leading Singapore in the 21st century. The city-state's Smart Nation[1] programme is an initiative that invites another round of social, political and economic inquiry altogether; the overlapping roles and interest of private and public institutions and their influence/control over the public, people and spaces. Where venture capitalists, artists, entrepreneurs and policy makers are further embroiled and entangled in the dominant capitalist narrative where the presence, existence and roles of the general

public and its spaces are often ignored or exploited (who truly benefits or profits from products/services such as Facebook and Google?) in an attempt to run and feed the economy (and those who operate it), this present landscape (referred to as a necropolis) offers a brief impression of a past riddled with control, power and contradictions. Amplifying theories of writer and researcher Evgeny Morozov, where he wrote, "Technological amnesia and complete indifference to history (especially the history of technological amnesia) remain the defining features of contemporary Internet debate.", this work references and draws parallels from the concept/ideas behind the late 18th century invention by Wolfgang von Kempelen, the Mechanical Turk (also alluding to the present day usage/presence of the term and service by electronic commerce company Amazon. com)[2], *Necropolis for Those without Sleep* reflects on systems of power and the desire to project (protect) it, examining the complex network and relationships of the

political, economic and social landscapes and asks questions pertaining to the role of the public in the present neoliberal climate, where control mechanisms such as fear, entertainment and boredom are calibrated to orchestrate supply without demand.

1 [Editorial note] "Smart Nation" is a policy announced by the Singaporean government in 2014 that involves installing sensors in residential and other certain areas so as to collect information on air quality, traffic flow, river water level, traffic flow and security monitoring. The big data collected was to be used as basis for public services.

2 [Editorial note] The "Mechanical Turk" that dated back to the 18th century was introduced as a chess-playing automaton, but it turned out to be a hoax, as it was actually controlled by a real person hiding inside the machine. Amazon.com Inc.'s "Mechanical Turk," on the other hand, is a web service that allows users to submit task requests and offer payment, while another group of users can accept tasks online and earn money.

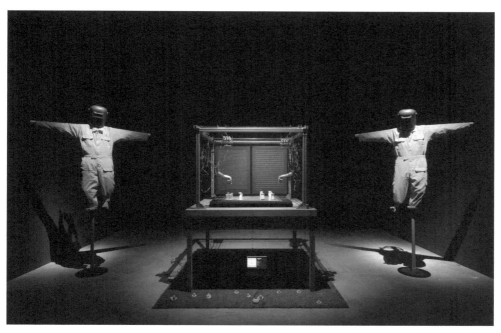

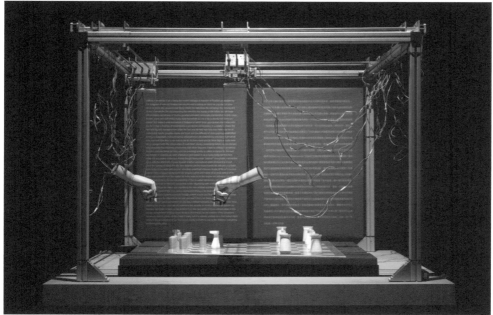

〈無眠者的公墓〉，展場局部
Necropolis for Those without Sleep, installation view

李燎
LI LIAO

春風
Spring Breeze

單頻道錄像，127'，2011
Single-channel video, 127', 2011

武漢某寫字樓下，找裡面上班的人在他上班時把
我鎖在樓下，直到他下班時給我解開。

I stood downstairs an office building in Wu-
han, asking someone who works there to
lock me up on site, and unlocked me after
he came off duty.

〈春風〉，影片擷圖
Spring Breeze, video still

消費
Consumption

複合媒材裝置，2012
Multimedia installation, 2012

2012 年 10 月 9 日李燎通過龍華的招聘市場應聘進入深圳富士康（龍華園區）當一名流水線工人，任職在 iDSBG 事業群 SMT 製造課的焊前自動光學檢測項目，工作 45 天，直到用自己生活之餘的工資足以購買一台該部門的產品 iPad mini (Wi-Fi 16GB)，11 月 23 日離職出廠。

On 9th October 2012, Li Liao completed the recruiting procedure and was employed as an assembly line worker at the Longhua Plant of Foxconn in Shenzhen. He took up the position of Pre-welding AOI in the SMT Manufacturing Division of the Innovation Digital System Business Group. He worked for the company for 45 days, and resigned from that position on 23rd November as the salary he earned and saved was able to afford an iPad mini (Wi-fi 16GB) produced by that factory.

〈消費〉，iPad 內的照片
Consumption, photo in iPad

〈消費—iPad 背面〉
Consumption—the back of iPad

〈消費—工卡正面掃描〉
Consumption—scan of employee's card

〈消費—合同掃描文件〉
Consumption—scan of contract

任興淳
IM HEUNG-SOON

工業園區
Factory Complex

單頻道錄像，95'，2014，2015
Single-channel video, 95', 2014

韓國經濟的急劇發展曾經讓世界其他國家感到驚訝，但隱藏在其後的卻是對被邊緣化的女工的壓迫。這部影片邀請觀眾進入女性工人階級的生活，從 1960 年代紡織工廠的勞動者，到現今的空服員、收銀員和非正規雇用工人的故事。勞動形式的外貌似乎已經改變，但是根本的核心問題依然如舊。在影片後段，我們看到柬埔寨的勞工狀況就如同當年的韓國，歷史再度重演。

The drastic economic development in South Korea once surprised the rest of the world. However, behind of it was an oppression the marginalized female laborers had to endure. The film invites us to the lives of the working-class women engaged in the textile industry of the 1960s, all the way through the stories of flight attendants, cashiers, and non-regular workers of today. The form of labor seems to change its appearance but the essence of a bread-and-butter question remains still. The film ends up in Cambodia, where we encounter the repetition of the history of labor that took place in Korea.

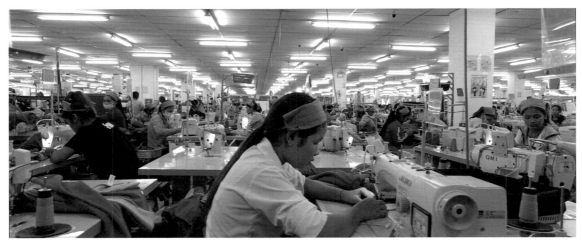

〈工業園區 — 工廠（柬埔寨）〉，影片擷圖
Factory Complex—A factory (Cambodia), video still

工業園區

金炫進

* 本文原發表於第五十六屆威尼斯雙年展的導覽手冊。

任興淳的作品關注和傾聽的對象是那些被國家以發展經濟為由，備受踐踏的弱勢族群和底層階級，他們大多來自亞洲的開發中國家，或為戰後時期的社會條件所困的國家，如南韓、越南和柬埔寨。任興淳的早期作品，例如城市研究計畫〈城南市計畫〉（1998–1999）、短片〈地下室我的愛〉（2000）、〈紀念物〉（2003），以及他在過去十年中長期涉入，以社群為主的多項公共計畫，皆在探討韓國社會在貪婪的新自由主義主導之下，其社會階級的運作場域，以及工業區內，包括弱勢族群在內的移工議題。他拍攝的紀錄片〈濟州祈禱〉（2011）探討濟州四三事件；在 1940 年代末到 1950 年代，當時的南韓政府為了根除共產主義者而屠殺了數千名民眾。拍攝過程中，任興淳也接觸了目睹這冷戰時代下的殘酷暴行的老婦，並對她們所承受的創傷有了更深層的認識，自此以後，他的攝影機便離不開這些人的強烈沈默，持續探索著民族神話是如何建構在人民的犧牲，以及對某些個體或社群的壓抑、忽視，與剝奪之上。平民實際上在近代歷史中所受的犧牲與創傷，是如何在當前的社會中被記憶，向來是他作品探究的重點。

在第五十六屆威尼斯雙年展（2015），任興淳首度放映錄像作品〈工業園區〉（2014）。這部片探索亞洲勞動者的現實處境，將婦女的位置詮釋為歷史的受害者。一開始的場景位在柬埔寨，一連串的槍擊瞄準的是一群正在韓國公司前抗議低薪的女性；影片之後便回溯到 1970 年代和 1980 年代，探討南韓的勞工剝削。這部作品描述韓國的跨國企業如何踐踏國家的基本勞動條件，也描述其黑暗的過去與現在，如何從母親一代延伸到女兒，更從過去的發展中國家延伸到當今的發展中國家。片中訪問多位從 1970 年代至今的韓國女工，冷靜爬梳當今的新自由主義所造成的可怕勞動環境；無止盡的工作量與焦慮成正比，佔據著勞工的生命，但不管再怎麼努力工作，也無法脫離貧困，這點對那些被一般勞動環境給徹底邊緣化的女性勞工而言尤甚。此作品的關注對象，有為了貧困的家庭，必須在惡劣不人道的環境裡日夜工作的縫紉工廠工人；有慘遭惡意解雇的大型企業臨時工；有漠視自家的半導體製造過程會引發白血病的企業；有超市的會計師；有分銷產業的外包工；有市政廳客服人員；有深受情緒勞動所苦，並時常遭受非人待遇的空姐。本作品不但與金鎮淑等參與過激烈抗爭的一線勞權鬥士進行嚴肅且深入的訪談，也將受訪者的故事與表現悲慘現實與情感創傷的影像結合，企圖傳達這些被新自由主義經濟輾過的女性勞工難以言喻的集體憂鬱。整部作品細膩描繪吃盡時代苦頭的女性觀點，並強烈質疑在一個不斷成長的經濟中，真正的社會「進步」到底是什麼。

Factory Complex

Kim Hyunjin

* This article was originally published in the guidebook of the 56th Venice Biennale.

Im Heung-soon's works attempt to listen to and sympathize with the never-ending struggles of social minorities and subalterns, who have been abandoned for the purpose of economic achievement in developing countries and in the post-warfare conditions of Asian countries like South Korea, Vietnam, and Cambodia. His earlier works—such as his urban research project, *Seongnam Project* (1998–1999), and his short videos *Basement My Love* (2000) and *Memento* (2003)—and his long-term engagement in several community-based public projects over the last ten years have often investigated scenes of classification and issues regarding industrial immigrant laborers, including social minorities, in Korea's rapacious neoliberal society. Since the film *Jeju Prayer* (2011)—which revisits the April 3 Jeju uprising, during which thousands of citizens were massacred in a process of communist eradication executed by South Korea's government in the late 1940s and 50s—the artist has been more aware of the trauma experienced by elderly women who witnessed the brutal violence of this Cold War situation, and his camera notably lingers on their strong silence. Closely observing the concomitance of national mythic rhetoric on the sacrifice of people and the individuals and communities who were suppressed, neglected and impoverished under authoritarian society, his works question how the wounds of civilians' actual sacrifices in recent history are remembered today.

At the 56th Venice Biennale (2015), Im Heung-soon introduced his new full-length documentary film, *Factory Complex* (2014), which portrays women as victims of history through the realities of labor in Asia. The film opens with a scene of gunfire directed at underpaid women protesting at a Korean company's factory in Cambodia and moves back to consider South Korean labor exploitation in the 1970s and 80s. In the film, the shady past and present of global Korean corporations that turn their backs on labor conditions in the country extends from the mothers' generation to the daughters', telling a story that spans from the developing countries of the past to those of the present. Through interviews with female workers in Korean society from the 70s to today, this work soberly investigates the

unhappy labor situation of endless work that encroaches on our lives under today's neoliberalism, contributing only to our anxiety, and shows destitute lives that cannot be overcome even through endless work—particularly those of women, who are marginalized in all working conditions. Its subjects span sewing factory laborers who have to work night and day for their families under poor, inhumane labor conditions; the reality and wrongful dismissal of temporary laborers in large-scale corporations; corporations' lack of responsibility for the leukemia caused in the process of manufacturing semiconductors; the accountants of supermarket stores; subcontracted employees in the distribution industry; city hall call center employees; and the emotional labor of female airline crews and the reality of their impersonal treatment. In addition to conducting solemn, revealing interviews with figures who have been behind some of the most fervent struggles and demonstrations, such as labor activist Kim Jin-Sook, the artist juxtaposes the interviewees' stories with images that imply a difficult, grim reality and emotional agony that cannot be expressed in words, confronting the collective melancholy of female laborers who have been cast aside under a neoliberal economy. It is a film attentive to the perspective of the women who have been suffering in this tough reality, bringing us to the strong question of what constitutes true social "growth" in an expanding economy.

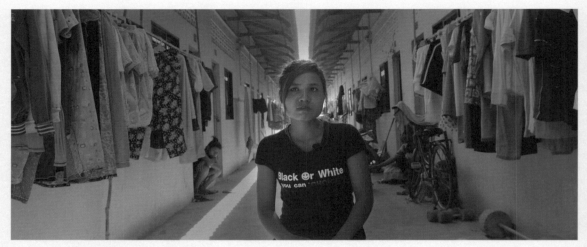

〈工業園區 — 訪談（柬埔寨）〉，影片擷圖
Factory Complex—Interview (Cambodia), video still

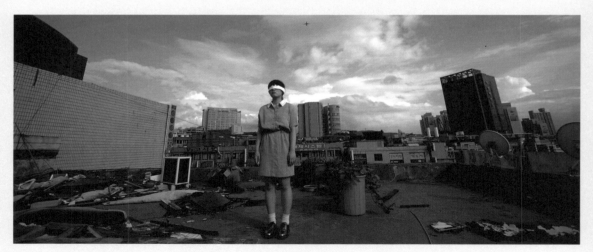

〈工業園區 — 遮蔽雙眼的女孩（韓國，首爾，九老工業區）〉，影片擷圖
Factory Complex—A girl who covered her eyes (Guro complex, Seoul, Korea), video still

〈工業園區 — 兩位面對面的女人（韓國，蔚山市）〉，影片擷圖
Factory Complex—Two women who face each other (Ulsan, Korea), video still

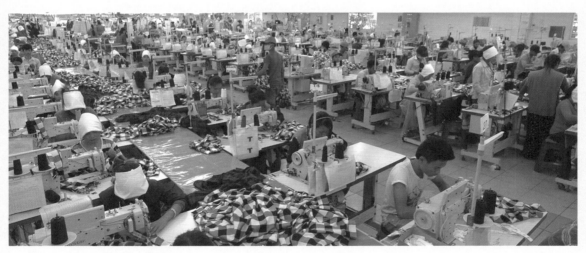

〈工業園區 — 工廠（柬埔寨）〉，影片擷圖
Factory Complex—A factory (Cambodia), video still

記憶與遺忘的腹語師：任興淳的藝術

李庸宇

* 本文原發表於展覽畫冊《Artist File—Next Doors: Contemporary Art in Japan and Korea》，2015–2016。

> 記憶（remembering）絕不是靜態的內省或回溯行為。它是一個痛苦的重組（re-membering）行為，是把被肢解的過去（dismembered past）重新組合起來，以便理解今天的創傷。
>
> ——霍米·巴巴 [1]

1　Homi K. Bhabha, *The Location of Culture* (London: Routledge, 1994), p.90.

沒有收件者的哀悼信、對無能動性的空間和時間獻上憂鬱的致詞、撫慰記憶的傷疤、安撫不安分的離去者、與死者交談：以上概念皆存於任興淳的作品之中。任興淳所創造的敘述框架，框出了底層階級的創傷與集體無意識，也框出了人民的記憶與遺忘，讓他得以潛進歷史所扭曲蒙蔽的殘骸之中。為了捕捉這些元素，他採取了短暫且破碎的拍攝手法，利用巧合反映出諷刺，並以重疊過去與現在來創造出衝突的聲音和影像。於是，他揭露出一種存屬於「之間性」的異常症狀（uncanny symptoms of in-betweenness）。在錯位的時空與現實中，這些症狀表現在其模糊邊界處所浮現出的物質性與頓悟之上，也表現在無法言說的地方意象（topoi）所促發的神奇臨界點之上。

一直以來，任興淳的藝術焦點便是要從現在之中找回過去。為此，必須重拾創傷的記憶，並找回被遺忘、埋藏在韓國現代歷史的潛意識中的人。在〈濟州祈禱〉（2012），任興淳用秀麗的風景來呈現濟州島，但也同時強調這個島是一個時間停格、與其母系起源脫節的空間。他循著心理地理學的蹤跡，觀察停滯的時間如何自行施展通靈術，在薩滿的地方意象中找尋自己的聲音。〈濟州祈禱〉召喚出仍烙印在生還者身上的濟州大屠殺殘像，他們不但必須正視死者的目光，還必須同時背負大屠殺的記憶。任興淳同時也試圖透過老祖母平靜的母愛角度，將那些支離破碎的韓國現代歷史片段縫合起來。他不但重現對於死者的記憶，也處理各種現代韓國的爭議，包括在濟州島南岸的江汀村興建美國海軍基地的爭議；「本地人」對於中國資本在該地區擴張的集體焦慮，以及受到離散觀點衝擊，將原住民與定居者視為二元對立；視外來者為不潔之人的排外主義。透過近乎靜心的方式，任興淳的作品撫慰了那些被迫活得宛如畜牲或蟻螻的無名人士。〈回家〉（2007）和〈來自越南的信〉（2009）處理南

韓的越戰退伍軍人的日常。曾以去殖民與現代化之名奉命到越南的他們，如今卻必須與非理性和瘋狂的記憶生活在一起。〈濟州祈禱〉向觀眾介紹曾被李承晚政權稱之為「對共產主義支持者的大規模征服行動」的濟州大屠殺的受害者。〈工業園區〉（2014／2015）則試圖撫慰韓國和柬埔寨女工的疲憊生活。〈轉世〉（2015）將戰爭期間慘遭韓國軍隊性虐待的越南祖母無言的日常生活，以及在兩伊戰爭中失去兒子的悲慘母親的生活並列，試圖安慰底層女性相仿的遭遇。

任興淳透過作品，在謙恭地聆聽他人的故事的同時，也將處於韓國和亞洲的邊界之外、被歷史蒙蔽的主體召喚到記憶的舞台之前。他將自身的懺悔和個人的敘述和諧地編進作品之中，藉此構建成涵蓋光譜兩端的全面性論述。他喚醒在韓國——這個時間與空間遭到扭曲的國度——不匀稱的時間性中不斷重複的歷史創傷，也喚醒了哀悼和憂鬱的政治，以及在民族主義、反共主義和殖民主義等多重經驗的帷幕後消失的無名他者。任興淳揭示了痛苦和責任所孕育的慾望拓樸圖，焦慮和集體創傷所帶來的影響，以及韓國社會中壓抑的回返。在這過程中，他將看不見的可視之物與聽不見的可聞之聲傳達了出去，在相衝突的不同論述背後，突顯出普世的修辭，進而創造團結的契機。

A Ventriloquist of Remembering and Oblivion: The Art of Im Heung-soon

Lee Yongwoo

* This article was originally published in the catalogue of *Artist File—Next Doors: Contemporary Art in Japan and Korea*, 2015–2016.

> *Remembering is never a quiet act of introspection or retrospection. It is a painful re-membering, a putting together of the dismembered past to make sense of the trauma of the present.*
> –Homi K. Bhabha, *The Location of Culture* (London: Routledge, 1994), p.90.

Letters of mourning without recipients, melancholic dedications toward agentless space and time, soothing the scars of memory, comforting the restless departed, and talking to the deceased: all key concepts that penetrate Im Heung-soon's work. Through a narrative framework that encompasses the trauma and collective unconscious of subalterns, as well as remembering and oblivion, Im delves into the debris concealed and distorted by history. His work captures these elements by shooting subjects in a momentary and fragmentary manner, through irony reflected by coincidental moments, and in the discordant voices and images generated by overlapping past and present. Im thus reveals uncanny symptoms of in-betweenness as manifested through the materialities and epiphanies that emerge from the blurry boundaries between dislocated times and realities, and the magical threshold provoked by unutterable topoi.

Im's consistent artistic focus lies in his attempt to recuperate the past within the present by reinstating traumatic memories and revitalizing the forgotten that has been buried in the subconscious of Korea's modern history. In *Jeju Prayer* (2012), Im represents Jeju Island through its scenic beauty while emphasizing it also as a temporarily suspended space, disconnected from its maternal origins. He examines the traces of psycho-geography, by which the suspension of time performs its own necromancy to find a voice within the topos of Shamanism. *Jeju Prayer* summons afterimages of the Jeju Massacre, imprinted on the lives of people who must live on while embracing gazes of the dead and bearing the memory of that massacre. Im's work further sutures the broken and ruptured moments of Korea's modern history through the maternal lens of a calm grandmother. It regen-

erates such moments as the current memory of the deceased. Through the space-time of modern Korea, it deals with various issues ranging from the recent dispute over the construction of a new US naval base on Gangjeong, the southern coast of Jeju Island, collective anxiety of the "local" against the expansion of Chinese capital in the area, and xenophobia against aliens stigmatized as impurities to the binary division of natives and settlers overwhelmed by diasporic perspectives. In almost a contemplative manner, Im's work soothes the lives of nameless others forced to live the lives of beasts and insects. *Come Back Home* (2007) and *Letters from Vietnam* (2009) deal with the everyday life of Vietnam War veterans in South Korea. Once deployed to Vietnam for the sake of decolonialization and modernization of their country, they now must live with the memories of irrationality and madness. *Jeju Prayer* introduces the victims of the Jeju Massacre, which was once called "a largescale subjugation operation against the communist sympathizers" by the Syngman Rhee regime. *Factory Complex* (2014/15) comforts the exhausted lives of female workers in both Korea and Cambodia. *Reincarnation* (2015) soothes the parallel lives of subaltern women by juxtaposing the wordless everyday lives of a Vietnamese grandmother who was sexually abused by the Korean military during the war and the life of a grievous mother who lost her son in the Iran-Iraq War.

Through his work, Im Heung-soon summons concealed subjects of history, who exist beyond the boundaries of Korea and Asia, to the stage of memory while listening courteously to the stories of the other. Im constructs a broad spectrum of discourse by harmoniously weaving in his own internal confessions and personal narratives. He resuscitates the historical trauma that has been repeated in the asymmetric temporality of Korea where space and time are distorted, the politics of mourning and melancholia, and the lives of the other who have vanished namelessly behind the curtain of multi-layered experiences of nationalism, anticommunism, and colonialism. Im reveals the topography of desires cultivated by pains and responsibilities, the affect of anxiety and collective trauma, and the return of the repressed in Korean society. In doing so, he communicates the invisibly visible and inaudibly audible, drawing attention to universal rhetoric behind the tension among different discourses and generating common solidarity.

專論
ESSAYS

當我們還是馬來亞人

覃炳鑫

* 本文為「現實秘境」國際論壇「雙束現實——歷史潛流中的感覺能指」（吉隆坡，2017.12.8–10）講座的內容整理。

了解英屬馬來亞的解殖運動的核心爭議，就必須先談到幾個廣泛的歷史力量，才能理解爭議背後的脈絡。因此，我想談的是爭議的歷史背景，而非具體內容；這往往比爭議本身更容易遭到誤解。

更具體而言，我想從下列三大股歷史動力的背景，去談論解殖問題：

1. 人權的論述
2. 國族主義
3. 社會主義

以及上述三者的關係：不單單視它們為意識型態，也要看成權力爭奪的機制。並且為了檢視創新如何從背後的歷史脈絡而出現，因此也要把它們視為技術（technology）。

我將會在接下來的四十分鐘內談論這些問題，然後大家可以提問。

1. 解殖浪潮
2. 二十世紀霸權簡史
3. 國族主義
4. 變革的力量
5. 技術與社會主義：自決與聯合國憲章
6. 冷戰

我們從解殖運動開始講起。第二次世界大戰後的解殖浪潮，也就是我們最熟悉的馬來亞所參與的那一波並不是最特別的。這在歷史上其實已經是第三波解殖浪潮，而且也不是最後一波，只要看 1990 年後的蘇聯發生的事就知道了。

第一波解殖浪潮從所謂的「新世界」（New World）開始。這個去殖民過程是從 1776 年，由十三個反抗英國統治的北美殖民地開始的，這個過程一直持續到 1822 年左右。第二波解殖浪潮始自所謂的「舊世界」（Old World），約莫從 1917 年左右一直持續到 1922 年左右。最後，才是我們都熟悉的這個時代，「第三世界」（Third World）的解殖運動。該運動從 1947 年的印度開始，一直持續到 1970 年代。

《人權和公民權宣言》，勒巴比耶繪製。
（圖 片 來 源：https://en.wikipedia.org/
wiki/Declaration_of_the_Rights_of_the_
Man_and_of_the_Citizen_of_1789）

第一波解殖浪潮始於美洲。其動力來自英法之間的衝突，也就是 1754 至 1763 年所發生的七年戰爭。戰爭結束後，英國和法國雙方幾乎都瀕臨破產。英國人雖然打贏了，但過程中他們的國債也幾乎翻了一倍，到了 1764 年已從原本的 7200 萬英鎊漲到近 1.3 億英鎊。英國人告訴遠在美國的殖民地說：「你們自己的防守自己出錢，我們沒辦法一直幫你們出」，美國人就不高興了，說「我們在議會中連半個代表都沒有，你們沒理由漲稅 —— 不給代表權就別來收稅！」雖然兩方的立場無明確對錯，但最後還是導致美國的被殖民者揭竿起義。同樣，戰後的法國被極端的累退稅制癱瘓，最終導致人民起義，衝進了巴士底獄。我們都聽過瑪麗·安托瓦內特（Marie Antoinette）那則杜撰軼聞，她問：「沒有麵包？那給他們吃蛋糕吧」。這絕對不是真實故事，但確實有捕捉到當時人民有多飢餓，而貴族的生活離人民多麼遙遠的狀況。

於是在法國大革命的陰影之下，整個現代時期就此展開。後來幾乎每起革命運動都會回顧法國大革命的理想。《人權和公民權宣言》宣稱「在權利方面，人們生來而且始終是自由平等的」，而且「這些權利即自由、財產、安全和反抗壓迫」。法國大革命的信條支撐著所有的現代政治意識型態，包括自由主義、國族主義、社會主義、女性主義和世俗主義。美國革命也同樣宣告所有人生來平等，這類人權宣言激發了世界各地許多類似的宣言。的確，胡志明在越南的獨立宣言，也特意以美國的獨立宣言作為典範。

「人皆生而平等」……但這裡的「人」其實指的是「男人」。一群男人一旦掌權，便立即開始壓迫所有與他們意見相左的人。在美國，人皆生而平等的觀念並沒有擴及至女性，也不包括美國原住民或奴隸。1865 年，在宣布了「人生而平等」不到一百年內，他們便針對「人」是否包括非洲奴隸這點，展開殘酷的內戰。

在當時的法國和其他地方，也存在著公民和非公民的身分區別。一般來說，公民身分只授予擁有房地產或有繳稅的男性。

更廣泛來說，在 1815 年，拿破崙戰爭結束和歐洲協調組織（Concert of Europe）的創立，為歐洲帶來一段長久的和平，這是一段和平、繁榮、技術進步的時期，中間還涵蓋了工業革命。但是，這段和平卻使得歐洲各國得以更專注在鞏固自家領土，並擴大至海外，尤其是非洲和亞洲的領土，而技術的進步與繁榮使他們比以前更有效且迅速地做到這一點。因此，美國和歐洲各國不但一邊高喊自由，一邊壓迫自己人，他們甚至將帝國主義擴展到世界其他地區。第一波解殖浪潮的大贏家是美國，之後不但將自己的帝國擴及至整個美洲大陸，後來甚至還跨過太平洋，延伸到夏威夷和菲律賓；而英國雖失去了北美洲，卻在南美洲獲得了非正式的影響力，甚至持續建立了第二個帝國，範圍比他們原本失去的還要大。

因此，從第一次革命浪潮（以及後來的解殖浪潮）中可以看到解殖幾乎不可避免地將導致新的壓迫。

這在歷史上發生過一遍又一遍。反殖民運動推翻了殖民政府，但是成功之後又發生了什麼事？他們想要掌握權力、建立國家、擊敗敵人，不論敵人是真實的還是自我認定的。沒人會想讓自己的辛苦白費，被欺負了這麼久，一定會想方設法要確保自己的團體永遠不再受欺壓。通常，這意味著自己要成為欺凌者。在第一輪解殖過程中，我們看到自由戰士們圍繞著所有人皆生而平等的觀念搖旗吶喊。但簡單來說，他們確保自身平等的辦法，就是將某些人從「所有人」的定義中剔除。

因此，當我們來到第二波解殖浪潮時，反殖運動者不得不尋找新的方式來號召團結。需要別的理由來推翻前一個掌權集團，並將權力集中到自己手上。他們須要號召人心，讓他人因某種原因認定你，而且唯有你，才是正當的統治者。更重要的是，還需要讓他人心服口服地委身於你的理想之下。他們最後找到的方法，是將反帝與崇尚自由的意識型態在地化，使其符合特定的種族、地理和文化背景。此現象我們現在稱之為國族主義。

國族主義決定了整個二十世紀。不論是資本主義或共產主義，都沒有這股力量這般強烈地影響著我們。在一個世紀的時間裡，我們從帝國的世界蛻變成民族國家的世界。馬來亞也不例外。

問題是，國界是人造的，是畫在沙上、描在水上，倏忽即逝的線條。對於靠軍事力量建立的帝國來說，國界通常取決於國家的軍隊能控制的範圍。但是對一個民族國家來說，民族國家會宣稱國家的邊界並非人造，而是等同於國家。Bangsa（馬來文「民族」）等同 negeri（馬來文「國家」）；「民族」即是「國家」。這是一個非常誘人的想法，但馬上會發現這是根本不可能實現的。沒有任何一個國家是由同一種人所組成，也沒有任何一個國家能夠讓人人意見一致。

因為國家並非實質的存在，而是一個想像的、被創造出來的社群，在科學或自然中沒有任何根據，它純粹來自歷史巧合。誠然，國家之所以存在，只是因為人們相信它存在，而那種信念的強度，就是驅動國家的力量。一個國家的生死，純粹取決於人民是否相信它的存在。但是這種信念可以完全重塑我們身邊的現實。國家是有創造力的，可以啟發並團結人民。但是國家也具有毀滅性：土地被一分為二、百萬人喪生、永恆

的仇恨從父親傳給兒子，也純粹基於這種信念。因為在每個現存的民族國家之內，都有著大批不屬於該民族的人。他們會遭遇什麼事？

在接下來所發生的事，我們可以看到來自雙方的衝擊。第一次世界大戰結束，歐洲大陸的帝國紛紛開始瓦解，從俄羅斯開始，接著輪到奧匈帝國、鄂圖曼帝國和德國。於是，這些帝國的臣民從舊有的帝國殘骸中建立了新的國家。這是第二波解殖浪潮，屬於「舊世界」的解殖。

這些國族主義和民族自決的想法 —— 認為我們民族的人民應享有自治，即治理自己民族的權利 —— 推動了第二波解殖運動，在二十世紀初席捲了整個世界，為土耳其、愛爾蘭、墨西哥，和俄羅斯等地所上演的革命運動採納，離我們更近的還有菲律賓和越南。最重要的是，這些想法啟發了中國與印尼的兩波民族主義運動，對馬來亞的影響最深遠。這些思想鞏固著馬來亞不斷增長的民族主義運動 —— 我們是馬來亞人，我們有自治的權力。

但解放和壓迫的循環從未間斷。第一次世界大戰雖然為歐洲地區帶來了大幅的解殖，卻忽略了大半的非洲和亞洲地區，而此時的歐洲解殖運動又催生出新的帝國強權。英國和法國瓜分了鄂圖曼帝國非歐洲的部分，包括中東地區，而德國的海外領地慘遭戰勝者所瓜分。在東南亞，澳大利亞獲得了德屬新幾內亞，德屬新幾內亞後來又與澳屬巴布亞殖民地合併，成為巴布亞新幾內亞。日本也獲得了德國在中國的領地，以及位在滿洲和內蒙古的領地。日本之後也將持續收服位在中國和東南亞的大片領地，擴張自己的帝國版圖。在很短的時間內，日本從被壓迫者轉型成為了壓迫者。

在歐洲，新民族國家的建立也衍發出種族滅絕和種族清洗事件，因為許多人不符合獨立後的新政府對於民族身分的定義。中東也受國族認同與公民身分的不同定義拉扯所苦，持續被種族和宗教暴力折磨。在印度，宗教和種族的衝突使印巴分治，使巴基斯坦與孟加拉開戰，也使克什米爾持續動盪不安。中國政府則對公民身分的定義相當嚴格，並套用至整個國家，連西藏和新疆也不例外。

因此，每當一個人贏得了國家公民的權利，就有無數其他人被迫淪為沒有國家的人。當新的國家訂下了自身的政治、種族和道德邊界，其餘尋求不同界限的人不是淪為被壓迫的少數人民，就是成為難民、或遭屠殺。種族離散和強迫離散與新民族國家的建立一樣，都是民族自決不可或缺的一部分。

第三波解殖浪潮中，國族主義不只是解殖者的專利，殖民者欲維護自身利益時也會採用。遇上甫獨立的民族國家，世界各地的殖民者時常會尋求當地的合作者，並將他們的地位提升至民族國家的代表，賦予定義民族的權力，再與之獨家談判。英國人為了控制他們混亂的多民族帝國，嘗試了兩種策略。第一個是分割，將領地切開分配給兩個不同的種族族群，並讓其中一群佔絕對多數。於是有了巴勒斯坦的分割，印度的分割，而馬來亞也被分成馬來亞聯邦和新加坡殖民地，一邊以「馬來人」為主，另一邊以「中國人」為主。三個案例都造成了血腥暴動和戰爭。

大約十五年之後，當這些手段開始不起作用時，英國人嘗試了一種新的策略：聯邦制。他們把抗拒他們的領地與相對忠誠的領地合併。因此有了中非聯邦、西印度群島聯邦和馬來西亞。再次強調，這些方法都以失敗告終。

而解殖運動又拿什麼作為新的國家概念？對於馬來亞來說，最強大的力量是在地社會主義（indigenous socialism）。

欲理解在地社會主義，我們需要退一步看二十世紀初的英屬馬來亞，及其當時嚴明的種族階級劃分：歐洲人、歐亞混血、亞洲人。但從二十世紀初開始，一連串歷史事件開始逐漸侵蝕西方優勢，而馬來亞人則透過新興的大眾媒體得知這些消息。讀到世界大戰時上百萬個歐洲人在戰壕中互相廝殺，甚至用毒氣相互攻擊，很難不開始質疑：等等，這些瘋子是誰？讀到上百萬受壓迫的人推翻殖民者的時候，很難不問：等等，那我們呢？聽到日本在中日戰爭中擊敗俄羅斯，成為一流軍事大國時，很難不去質疑：等等，也許白人並非天生優越。

馬來亞人民環顧四周，開始意識到：等等，我是出生在這裡的人，但富裕的歐洲人卻壟斷了一切。我們努力工作，卻被雇主剝削虐待；歐洲人過著奢華的日子就算了，還不斷命令我們。歐洲人不但為自己人保留了最好的工作，還不允許當地人在公部門擔任要職。任何不是白人、不會說英語的人，都會受到系統性的歧視。

正是這種階級性的迫害，形成了變革的動力。這其中受到了很多外來的影響，例如辛亥革命和新文化運動就將復興和革命的理想輸出給馬來亞華人。

印尼二十世紀初所出現的新型態的組織，在思想和領導力上對英屬馬來亞產生了巨大的影響。這些組織包括印尼人所創辦的第一個工會；以及成立於 1908 年的至善社（Budi Utomo），一個為受過教育且向上流動的行政階層「普裡亞伊」（Priyayi）發聲的政黨；還有成立於 1912 年的「伊斯蘭聯盟」（Sarekat Islam），這是馬來世界的第一個群眾組織，本質上是支持印尼貿易商的商業聯盟。像至善社這類組織，為日後的新加坡馬來聯盟（Kesatuan Melayu Singapura; Singapore Malay Union）奠定基礎，這是馬來亞第一個馬來亞政治聯盟，也是馬來民族統一機構（UMNO）的前身。

這一時期出現的另一種意識型態是伊斯蘭復興運動（Islamic reform movement），又稱現代主義運動（modernist movement），起源於開羅，並透過新加坡進入印尼。伊斯蘭現代主義運動遭到蘇丹和保守派擋在馬來亞的其他地區之外，但在新加坡這開放的都會大受歡迎，並由此輸出至整個東印度群島。

在印尼則出現了第三種思想流派，激進社會主義（radical socialism），具十足的影響力。1914 年，馬林（HJFM Sneevliet，又名史內列）創立了激進左派的東印度社會民主聯盟（Indies Social-Democratic Association，簡稱 ISDV）。第一次世界大戰後，殖民當局將該黨的荷蘭籍領導人全數逮捕，使黨落在當地的印尼人手中，後者在 1924 年將該黨重新命名為印度尼西亞共產黨（Partai Komunis Indonesia），即 PKI，這是亞洲第一個共產黨。該黨成員全部是印尼人，但幾乎不曾提到馬克思和

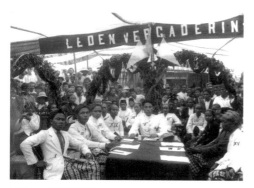

會議中的伊斯蘭聯盟，1921。
（圖片來源：https://en.wikipedia.org/wiki/Sarekat_Islam）

列寧，反而將他們的無階級社會想像成浪漫化的滿者伯夷王國（Majapahit），該王國不僅被視作先於荷蘭殖民時期的偉大平等時代，更重要的是，也先於伊斯蘭教的進駐。他們借用了印尼神話中的預言，說正義之王拉杜阿德（Ratu Adil）即將降臨，為整個印度尼西亞帶來全面的和平。一旦荷蘭人在 1926 年粉碎了 PKI，他們的許多領導人便逃往新加坡。

資本主義的失敗刺激了這些新思潮湧現。1930 年代，見證了全球大蕭條。在馬來亞，幾乎看不到照理來說給英國統治應出現的經濟利益。人民的日子很難過，即使努力工作，依然窮困。但從更根本上來說，這個時期見證了資本和勞動關係的轉變。從二十世紀初的現代工業經濟開始，傳統上以同業公會為基礎的勞動監管體系已不管用，急需不同的勞動組織體系。西式的工會組織被引入馬來亞。但打從一開始，這些組織就與中國民族主義和激進主義的崛起不可分割。國民黨左派組織為了宣傳資助在中國本地的活動，組織了許多現代勞工組織，包括 1926 年成立的南洋總工會（GLU）。

於是經濟力量、社會力量、意識型態力量、政治力量，一齊在馬來亞產生作用，尤其在馬來亞的憤怒上產生作用，催生出新的想法，並激盪出多場針對人、社會，和治理本質的精彩思辯與公眾討論。

但英國人並沒有解決這些問題。總的來說，他們用鎮壓手段，壓抑並終結了這段思想辯論和社會分化的日子。但是，自決、民主，和自由的語言已成為公眾的共同語言。

幾乎每一位參與馬來亞反殖民奮鬥過程的領導人都曾受到這段時期的啟發。他們共同對殖民歧視感到強烈不滿，也對殖民國家未能滿足馬來亞人民的需求，或針對全球經濟的轉型做出即時應變感到不滿；共同受到席捲世界的民族主義和自決的思潮影響，也同時都承受過國家暴力與迫害。借鑑獨立組織的悠久歷史，他們將領導馬來亞的獨立奮鬥，並相互對立。[1]

1　Karl Mannheim, "The Problem of Generations", in Paul Kecske-meti (ed.), *Essays on the Sociology of Knowledge: Collected Works of Karl Mannheim* (London: Routledge, 1952), pp.304-312.

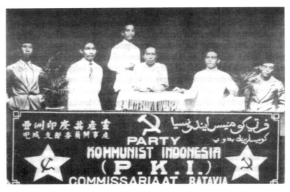

印度尼西亞共產黨於 1925 年在巴達維亞（現雅加達）召開會議。
（圖片來源：https://en.wikipedia.org/wiki/Communist_Party_of_Indonesia）

於是在一戰至二戰期間，馬來亞民族主義風起雲湧。這個時間點開啟了關於馬來亞身分認同，以及馬來亞民族的意義與共同價值觀的辯論。因為如果馬來亞要獨立，欲享有自決，馬來亞就必須自治。那，要怎麼做？身為馬來亞人意味著什麼？例如，是否要保留殖民者的資本主義制度，還是試圖建立一個基於正義平等的新社會？馬來亞是馬來人的土地嗎？還是穆斯林的土地？還是多元種族的土地？我們有什麼共同的價值觀？嘗試回答這些問題的主要群體此時興起：有組織的勞工、工會；受過西方教育的在地菁英；宗教團體；馬來貴族和菁英。影響辯論的主要張力則可分為：現代與傳統、地方與全球、宗教與文化之間的緊張關係，特別是在馬來習俗（Adat）與伊斯蘭現代主義派之間的拉扯。不過最重要的仍是資本和勞動之間的拉扯，這是殖民時期的經濟中最明顯的分歧，體現全球資本主義與在地社會主義之間的衝突。

一旦英國人被日本人趕走，日本人又隨後撤離，這些力量便在馬來亞中被釋放出來，圍繞著馬來亞身分認同，彼此爭鬥又彼此合作。這是馬來亞解殖運動的背景，也是馬來亞人民的冷戰背景。

你看，我們今天會將冷戰視為兩種意識型態之間的衝突，視為民主和共產主義之間的矛盾，已彰顯出勝利者如何徹底改變了我們對這些衝突的看法。對於馬來亞人民，尤其是那些代表馬來亞人民對抗資本主義菁英的人來說，冷戰其實是這些早期衝突和爭奪的延續。關乎殖民主義，關乎不公不義，關乎平等，關乎主權，關乎自決。這些是馬來亞社會主義所探討的問題。

馬來亞社會主義是一個複雜的問題，因為有非常多的面向。對很多不同的人來說，意味著很多不同的東西，也包含了很多不同的觀點，但還是在此提供幾點共識。

首先，他們相信理性思想可以改變社會。第二次世界大戰揭示了人類有能力發明可能會毀滅全人類的技術。但是社會主義者認為，如果這是真的，那麼也代表我們也有能力拯救人類。1950 年代，是一個人類擊敗其生存之最大威脅的時代：抗生素的發明，意味著被感染不再是等死；雷射光使我們能夠看到人體內部；核能意味著近乎無限的能量。在整個西方世界，福利國家的創立，承諾人們可以擺脫他們無法控制的力量，特別是貧窮和疾病。因此，若我們已經能夠創造這些足以重塑人類社會的機制，為何不能創造新的人類社會？

這就是馬來亞社會主義的基本前提。對他們來說，像種族主義和民族主義這類社群差異，可以透過本質上合理的規劃，透過建立制度，為人類這種受經濟驅動的生物塑造誘因而最終化解，創造一個新社會。對於馬來亞身分認同的未來和內容的辯論，全都建在這個基本假設之上。他們認為，種族和階級都是政治問題，可以透過合理的政治談判克服。有人甚至認為，這些政治單位的邊界是可以協商的，為什麼非得要馬來亞這個殖民主義的產物？為什麼不把整個馬來世界，從巴布亞到馬來亞，從菲律賓的呂宋到婆羅洲、到帝汶，全部統合到同一個政治單位之下？假使我們都是理性的，這些一切都可以商量。

但是，如果我們要超越種族和國籍等狹隘思想，那麼支撐這個政治單位的理由是什麼？答案是自決。

這是另一個重點。這關乎 1945 年《聯合國憲章》所表達的理想，而對馬來亞，也關乎 1955 年萬隆會議上所表達的理想。二者都肯定了「人民和民族自決原則」，各民族國家有權「自由選擇自己的政治與經濟制度，和自己的生活方式」。問題的關鍵就是自決。一個政治單位必須對其人民負責；其人民必須可依照自己的自由意志，選擇參加該政治單位。

同樣的情況下，資本主義則呈現出不同的色彩。帝國主義是資本主義的自然延伸，這個現象已被廣泛理解與承認。資本會移轉到投資回報率最高的地方，而投資回報率最高的情況，就是當你可以剝削人，而且沒有法律保護他們免於遭剝削的時候。這個原理支撐著帝國主義和殖民主義 。支撐 Uber 的也是相同的原則。

前殖民地國家的左派，特別是馬來亞的左派，知道如果我們繼續依照先前殖民者所留下的經濟、社會，和文化過日子，這些前殖民者們將持續深深地介入他們的前殖民地。夸梅‧恩克魯瑪（Kwame Nkrumah）稱這為新殖民主義（neo-colonialism）。如果我們繼續用英語作為通用語，英語人士將會持續深入影響我們的社會。如果繼續讓英國人持有我們一半的經濟，那麼他們會用這些來控制我們的政治生活，也勢必會破壞我們的民主。對資本主義提出質疑，是因為資本主義會將解殖中的國家綁在一個賦予過去帝國強權者特權的權力結構之中，讓這些大國的權力得以透過新的方式延續下去，因為資本主義制度賦予西方菁英特權。所以他們對資本主義的質疑，是根植於反殖民主義，而非資本主義本身。

因此，如果我們要建立一個基於民主、平等與正義的新社會，就必須對過去生活中的每一項習以為常的假設提出質疑，從而獲得如何重塑的理性共識。所以，真正的主權和自決，需要權力本身的解殖：這是一種治理的過程，而非結果。

此外，如果繼續與西方結盟，將會被捲入西方針對其他前殖民地所發起的殖民戰爭。因此就有了不結盟運動（non-aligned movement），希望遠離冷戰。對馬來亞的左派來說，冷戰是前殖民者的事，他們口中的敵人從來沒拿我們怎麼樣。因此，的確，史達林有勞改營，中國有大躍進，但他們從來沒有殖民過我們。美國殖民了菲律賓；英國殖民了馬來亞和緬甸；法國殖民了中南半島；荷蘭殖民了印尼。這些人剝削、折磨、屠殺我們長達數百年，為什麼我們還要站在他們這一邊？這愚蠢的冷戰我們還是不要參與吧。

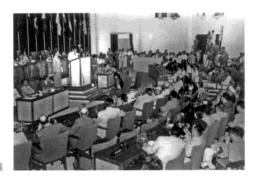

1955 年的萬隆會議

這當然不是前殖民國家想聽到的，但是，這也絕非那些欲保存舊社會秩序的馬來人 —— 貴族、地主菁英、資本家菁英 —— 想聽到的。君主制沒有任何理性可言。少數齷齪的有錢人之所以掌握大量的土地或資本，原因無他，只因繼承，這沒有任何理性可言。

正是這些貴族、資本家和地主菁英，組成了與英國結盟的新加坡馬來聯盟，並利用民族主義作為權力的技術，透過這個保守的機構，反對那些想透過理性主義路線重塑馬來亞，那些希望掃除社群主義（communalism）、掃除種族和階級，建立一個民主和自決的社會的人。

這是冷戰在馬來亞開打的背景。保守派菁英拿民族主義當成打擊馬來亞社會主義的棍棒。他們斥責社會主義者的反民族主義傾向，說他們是叛徒。這就是為什麼共產主義對於這個說法這麼重要。只要強調共產主義，就可以將馬來西亞左派描繪成一群屈服於外國意識型態之下的國民叛徒，還可以把他們抹黑成邪惡的禽獸。這是一種古老的戰術，將敵人詆毀成「他者」（Other）。一旦把你變成十惡不赦的壞蛋，就怎麼搞你都行，可以透過馬來西亞內安法令（ISA）把這些人關起來、拷問、處決。後來事情也就這麼發生了。

總結一下。在展開的歷史背景下，我們可以看到某些主題被突顯出來：

1. 當解殖導向解放，卻也帶來新的壓迫。
2. 二戰後的馬來亞解殖背景，必須從二戰前的霸權脈絡去理解。
3. 殖民者和解殖者都懂得運用意識型態，即政治單位的構思。
4. 欲理解馬來亞解殖運動，需明白本質上這是狹隘的排外民族主義與廣泛包容的社會主義之間的競爭。
5. 但是，民族主義站在冷戰的勝利方，與國際資本結盟而獲勝。
6. 從馬來左翼的角度來看，冷戰是殖民主義的延續。關乎維護主權和自決的原則。

When We Were Malayan

Thum Ping-Tjin

*This article is an edited transcript of the symposium *Reality in its Double Bind: Emotional Signifiers in the Undercurrents of History* (Kuala Lumpur, Dec 8-10, 2017), which was part of the curatorial project *Towards Mysterious Realities*.

To understand the central conflicts of Malaya's decolonisation, we need to talk about several broad historical forces which set the stage for this debate. So rather than talk about the specifics of the debate, I wanted to talk about the context of the debate, which is often far more misunderstood than the debate itself.

In particular I want to talk about decolonisation in the context of three great historical forces:

1. The discourse of human rights
2. Nationalism
3. Socialism

And their relationship, not just as ideologies, but as mechanisms through which power was contested. As technology in the sense of how these were innovations in response to historical contexts.

So I'll talk about those for 40 minutes, and then we can take questions.

1. Waves of decolonisation
2. Brief history of forces of 20th century
3. Nationalism
4. Forces of change
5. Technology and socialism – self-determination, UN charter
6. The Cold War

So let's start with decolonisation. Now, the great post World War II wave of decolonisation, the one we are the most familiar with, the one which Malaya was part of, was not unique. It was actually only the third wave of decolonisation, and given events in the Soviet Union since 1990, not the last.

The first great wave of decolonisation is what may be called "New World" decolonisation, beginning in 1776 with the rebellion of the thirteen North American colonies against British rule. It lasted until around 1822. The second, which we can call the "Old World" decolonisation, began around 1917 and lasted until around 1922. And finally, the era we are all familiar with, "Third World" decolonisation, beginning in 1947 with India and lasting until the 1970s.

The first great wave of decolonisation began in the Americas. The impetus for the first great wave of decolonisation was the conflict between Britain and France, known as the Seven Years' War, 1754 to 1763. Britain and France both ended the war virtually broke. The British won but in the process their national debt nearly doubled, rising from £72 million to almost £130 million by 1764. The British told their colonies in America, look, you have to pay for your own defence. We can't keep paying for you. The Americans were unhappy, saying you can't raise taxes on us when we have no representatives in Parliament—no taxation without representation! Both sides had a point, but this lead the American colonists to rebel.

Likewise, the French people, crippled with an extremely regressive tax system, eventually revolted and stormed the Bastille. We are all familiar with the apocryphal story of Marie Antoinette saying, "They have no bread? Then let them eat cake." It's certainly not a true story, but it does capture exactly how hungry the people were and how removed from their lives the aristocracy were.

The entire modern era has unfolded in the shadow of the French Revolution. Almost all future revolutionary movements looked back to the Revolution's ideals. *The Declaration of the Rights of Man and of the Citizen* declared that "Men are born and remain free and equal in rights", and that "These rights are liberty, property, safety and resistance against oppression.". The principles of the French Revolution underpinned all modern political ideologies, including liberalism, nationalism, socialism, feminism, and secularism. Likewise, the American Revolution, with its declaration that all men are created equal, this declaration of human rights inspired many similar declarations around

Declaration of the Rights of Man and of the Citizen in 1789, painted by Jean-Jacques-François Le Barbier. (From: https://en.wikipedia.org/wiki/Declaration_of_the_Rights_of_the_Man_and_of_the_Citizen_of_1789)

the world. Indeed, Ho Chi-Minh explicitly modelled the Vietnamese decla-
ration of independence on the American one.

All men are created equal...but only MEN. No sooner did one group of
men assume power than they promptly began oppressing everyone who
disagreed with them. In America, the notion that all men are created equal
was not extended to women, to native Americans, or to the enslaved. In
1865, less than one hundred years after they declared all men are created
equal, they turned on each other in a brutal civil war over whether "all men"
included African slaves.

In France, and elsewhere, there was a distinction between citizens and
non-citizens. In general, citizenship was granted to men who were property
owners or taxpayers.

More broadly, in 1815, the end of the Napoleonic Wars and the Concert of
Europe ushered in a period of long peace in Europe, a period of peace,
prosperity and technological progress, including the industrial revolution.
But this peace enabled the European states to focus on consolidating their
territory at home, and expanding territory abroad especially in Africa and
Asia, while the advances in technology and prosperity enabled them to do
so more effectively and swiftly than before. And so the United States and
the European states did not just cry freedom while oppressing people with-
in their own countries; they expanded their imperialism to the rest of the
world. The big winners from the first wave of decolonisation was America,
which went on to build its own empire that stretched all the way across the
continent and later across the Pacific Ocean to Hawaii and the Philippines;
and Britain, which lost North American but gained informal influence over
South America, and went on to build a second Empire even bigger than the
one they just lost.

So, the first wave of revolution—and what the subsequent waves of
decolonisation will show—is that decolonisation leads almost inevitably
to new oppression.

This is what happens over and over again. The anticolonial movement over-
throws the colonial government. But what happens after they win? They
want to hold on to power and build up the country and get rid of their ene-
mies, real or perceived. You don't want all your hard work to go to waste. At
the end of the day, you've spent so much time being bullied that you want
to ensure that your group will never be bullied again. And often, that means
you to becoming the bully. In the first round of decolonisation, freedom
fighters rallied around the idea that all men are created equal. And to put it

simply, they ensured their equality by excluding others from the definition of "all men".

So when we reach the second wave of decolonisation, anticolonial movements had to find new ways of sustaining group solidarity. So you need something else to justify your overthrowing the previous group and consolidating your hold on power. You need group solidarity. You need to convince people that you, and you alone, somehow have the right to rule. More than that, you need to convince people to subjugate themselves to this ideal. The answer was to localise anti-imperial, pro-freedom ideology into racial, geographical, and cultural contexts. That phenomenon which we today call nationalism.

Nationalism has defined the 20th century. No other force, not capitalism, not communism, has defined us so strongly. In the course of the century, we transformed from a world of empires into a world of nation-states. Malaya was no different.

The problem is that borders are artificial things, lines drawn on sand and writ on water. For an empire built on military power, a boundary is usually determined by what your army can hold on to. But a nation-state, a nation-state declares that the border of the country is not artificial but is identical to the nation. The *bangsa* is the *negeri*. The 民族 is the 國家 . This is a very seductive idea, but we call see right away that it simply is not possible. No country can ever have a uniform group of people in it. No country can ever have every single person in it agree on everything.

Because a nation does not exist in and of itself. It is an imagined, a created community. There is no basis for it in science or nature. It is purely from historical coincidence. Really, nations exist only because people believe that they exist. And that strength of that belief, that is what drives the nation. Nations live and die purely from the belief of their existence. But that belief can literally reshape reality around us. Nations create. They inspire. They draw together. But nations also destroy. Lands torn into two, millions of lives lost, eternal hatreds passed down from father to son, purely because of this belief. Because for every nation-state that exists, there are plenty of people in the state who do not belong to the nation. And what happens to them?

And we can see both impacts in what happens next. The First World War ended with the collapse of all the European continental empires, starting with Russia, then on to Austria-Hungary, the Ottoman Empire, and the German. The subject peoples of these Empires established new states out of

the wreckage of these empires. This is the second wave of decolonisation, that of the "Old World".

The ideas of nationalism and self-determination—that we the people of a nation, should get to govern ourselves, a nation—these ideas drove the second wave of decolonisation. These two ideas swept the world at the beginning of the 20th century. They were employed by revolutions in Turkey, Ireland, Mexico, and Russia, among others. Closer to home, Philippines and Vietnam. Most of all, they helped inspire the two nationalist movements which would have the greatest influence on Malaya, in China and Indonesia. These ideas underpinned the growing nationalist movement in Malaya. We are Malayans, we have the right to rule ourselves.

But the cycle of liberation and oppression always continues. The First World War brought decolonisation to large parts of Europe but not to most of Africa and Asia. And again the new decolonisation in Europe gave birth to new imperial powers. The non-European bits of the Ottoman Empire were divided up between the British and French, including the Middle East. The Germany overseas empire was divided among the victors of the war. In Southeast Asia, German New Guinea was given to Australia, and later merged with the Australian colony of Papua to form Papua New Guinea. Japan was also given a number of colonies, including Germany's possessions in China, as well as Manchuria and inner Mongolia. Japan would later go on to conquer large swatches of China and Southeast Asia for their own empire. In a short period of time, Japan transformed from oppressed to oppressor.

In Europe, the creation of the new nation-states also led to genocide and ethnic cleansing, because many people did not fit in with what the new, post-independence governments saw as part of the nation. The Middle East remains wracked in ethnic and religious violence over the different definitions of the national identity and citizenship. In India, religious and ethnic conflict led to the Partition, and war between Pakistan and Bangladesh, and the continued conflict in Kashmir. China's government imposes a strict definition of citizenship over the entire state, including Tibet and Xinjiang.

So for every person who won the rights and privileges of statehood, countless others were made stateless. As new nations fixed their political and ethnic and moral boundaries, those who had sought different boundaries either became oppressed minorities, or became refugees, or were killed. Ethnic and forced diasporas are as integral a feature of national self-determination as the creation of new nation-states themselves.

In the third wave of decolonisation, nationalism was deployed, not so much by the anticolonial forces, but also by the colonial forces in defence of their privilege. What colonial forces around the world tried to do was to find local collaborators, raise these local collaborators up as representative of the new independent nation-states, give them the right to define the nation, and then negotiate exclusively with them. For the British, in order to affect this out of their messy multinational empires, they tried two tactics. The first was partition, to separate ethnic groups into separate territories in which one group was a clear majority. The partition of Palestine. The partition of India. The partition of Malaya, into the Federation of Malaya and the colony of Singapore. One dominated by "Malays" and the other dominated by "Chinese". And with all three, they ended up with blood and riots and war.

From about 15 years later, when this wasn't working, the British tried a new tactic. Federation. They merged territories which were more resistant to them with territories which were more loyal. Hence, the Central African Federation, the West Indies Federation, and Malaysia. And again, none of them worked out.

What did the anticolonial movement rally around as the new conceptu-alisation of the state? For Malaya, the most powerful force was indige-nous socialism.

To understand indigenous socialism, we need to take a step back to Malaya in the early 1900s, when Malaya existed in a state of a clear racial hierarchy. Europeans; Eurasians; Asians. But from the 1900s, events began stripping away western superiority, carried to Malaya by the new mass media. You could not read about millions of Europeans killing and gassing each other in the trenches of World War I, without starting to wonder, wait, who are these maniacs? You could not read about millions of oppressed people getting rid of their colonial masters and ask, wait, what about us? You could not hear about Japan defeating Russia in the Sino-Japanese war and be-come a top tier military power and start to wonder, wait, maybe the white man is not inherently superior after all.

Malaya's people looked around, and they started to realise that, wait, I was born here but the rich Europeans monopolise everything. We work hard but are exploited and abused by our employers; they lead lives of leisure and order us around. The Europeans keep all the best jobs for themselves, and don't allow us locals to rise up the civil service. There is systemic dis-crimination against anyone who is not white, who cannot speak English.

It is this class based, hierarchical society that formed the impetus for change. There were many influences. The Chinese revolution and the New Culture Movement exported the ideals of reform and revolution to Malaya's Chinese.

In Indonesia, New forms of organisation, thought, and leadership that emerged in the early 20th century had a huge influence on Malaya. Such as the first trade unions founded by Indonesians; or Budi Utomo, founded in 1908, which was a party which represented the interests of the upwardly mobile educated administrative class, the priyayi; or Sarekat Islam, founded in 1912, the first mass organisation in the Malay world, which was essentially a commercial union to support Indonesian traders. Organisations like the Budi Utomo are an antecedent for the later formation of the Kesatuan Melayu Singapura (Singapore Malay Union), the first Malay political association in Malaya, and a direct forerunner of UMNO.

Another form of ideology that emerged in this period was the Islamic reform movement, or modernist movement. It was originated in Cairo, and entered Indonesia through Singapore. The Modernist Islamic movement was kept out of the rest of Malaya by the Sultans and the conservative establishment, but it was welcomed in open cosmopolitan Singapore, and was exported throughout the East Indies.

And a third stream of thought arose in Indonesia which would have a major influence was radical socialism. In 1914, the radical left-Indies Social-Democratic Association, ISDV was founded by HJFM Sneevliet. After World War I, the colonial authorities would arrest all the Dutch leaders of the party, leaving it in the hands of local Indonesians, who in 1924 would rename the party the Partai Komunis Indonesia, or PKI, the first communist party in Asia. The party was thoroughly Indonesian. It barely spoke about Marx and Lenin. Instead, they presented their classless society as a reincarnation of romanticised Majapahit, seen as a great egalitarian age before the Dutch had come, and significantly, before Islam; and drew on the messianic prophecy of the Ratu Adil, the just king who would establish universal peace in Indonesia. Once the Dutch crushed the PKI in 1926, many of their leaders would flee to Singapore.

Now these new strands of thoughts were catalysed by the failure of capitalism. The 1930s saw the global depression known as the Great Depression. In Malaya, there was little evidence of the supposed economic benefits of British rule. People struggled. Even if you worked hard, you were still poor. But more fundamentally, this period saw a transformation of the relationship between capital and labour. The beginnings of a modern industrial

economy in the early 1900s required a different system of labour organisation from the traditional guild-based system of labour regulation. Western-type trade union organisations were introduced into Malaya. But from the outset, they were linked with the rise of Chinese nationalism and radicalism. The Kuomintang's left-wing organised modern labour organisations to obtain support and funding for its activities in China, including the Nanyang General Labour Union (GLU) in 1926.

So you have economic forces, social forces, ideological forces, political forces, acting upon Malaya, upon the anger of Malayans, and producing new ideas. It stirred up great intellectual debate and public discussion about the nature of man, society, governance.

But the British didn't address these concerns. In general, they used repression to shut down and end this period of continuous intellectual debate and public dissension. But the language of self-determination, democracy, and liberty were now common currency among the public.

Into this world was born nearly every future leader of Malaya's anti-colonial struggle. They would be defined by a shared sense of grievance at colonial discrimination; by the failure of the colonial state to meet the needs of Malaya's people and the transformation of the global economy; by the swirling currents of nationalism and self-determination sweeping the world; and by a shared experience of state-sanctioned violence and oppression. Draw upon a long history of independent organisation, they would lead the struggle for independence and opposition to each other. [1]

And so it is here, in the inter-war years, we see Malayan nationalism arise. It is here we see the beginnings of the debate over Malayan identity over the meaning, the shared values of the Malayan nation. For if Malaya is going to have independence, if it is going to have self-determination, if Malaya is going to govern itself. Then, how? What does it mean to be Malayan? For example, do we preserve the colonial capitalist system, or do we try to build a new society based on justice and equality? Is Malaya a Malay land? A Muslim land? Or a multiracial land? What shared values

A meeting of the Sarekat Islam, 1921. (From: https://en.wikipedia.org/wiki/Sarekat_Islam)

The Communist Party of Indonesia (Indonesian: Partai Komunis Indonesia, PKI) meeting in Batavia (now Jakarta). (From: https://en.wikipedia.org/wiki/Communist_Party_of_Indonesia)

1 Karl Mannheim, "The Problem of Generations", in Paul Kecskemeti (ed.), *Essays on the Sociology of Knowledge: Collected Works of Karl Mannheim* (London: Routledge, 1952), pp.304-312.

do we have? And we can see the rise of the main groups who would try to answer these questions: organised labour, the trade unions; the Western educated local elite; religious groups; the Malay aristocracy and elite. And the main forces which would shape their debates: tensions between modernity and tradition, between local and global, between religion and culture, especially as expressed in the tension between Malay adat and Islamic modernism. But most of all, between capital and labour, the most stark divisions of a colonial economy. This was expressed as conflict between global capitalism and indigenous socialism.

Once the British were swept away by the Japanese, and then the Japanese were swept away themselves, these forces which were unleashed in Malaya, which clashed and collaborated over Malayan identity. This is the context for Malayan decolonisation and the context of the Cold War from the perspective of the Malayan people.

You see, the fact that we think about the Cold War today as a conflict between ideology, between Democracy and Communism, shows how thoroughly the victors have been able to shape the perceptions of the conflict. For the people of Malaya, and in particular for those who fought on behalf of the people of Malaya against the capitalist elite, the Cold War was a continuation of these earlier conflicts and contestations. It was about colonialism. It was about injustice. It was about equality. It about sovereignty. It was about self-determination. These were the issues that Malayan socialism was wrapped up around.

Malayan socialism is a complicated issue, because it is very multifarious. It meant a lot of things to a lot of different people. It encompassed a huge range of different perspectives. But here's a broad outline of the common points of agreement.

First, was a belief in rationalist thought to transform society. World War II had demonstrated the ability of mankind to invent technology which could literally destroy all of mankind. But what socialists believed was that if this is true, then we also had the capacity to save mankind. The 1950s was a time where when some of the greatest threats to our existence were being defeated. Antibiotics meant that getting infections was no longer a death sentence. X-rays allowed us to look inside the human body. Nuclear power meant virtually limitless amounts of energy. Across the West, the creation of Welfare states promised that people could truly be free from forces beyond their control, particularly the forces of poverty and disease. So if we can create these institutions which can literally radically reshape human society, why can we not create new human societies?

And that is the central premise of Malayan socialism. To them, communal divisions, like racism and nationalism could be overcome through essentially rational planning, by creating institutions and shaping incentives for man, as an economic animal, to ultimately create a new society. That was the fundamental assumption that underpinned their debates about the future and content of Malayan identity. From their view, race and class are political issues which can be overcome through rational political negotiation. Some even suggested that the borders of the political unit can be negotiated.

Why should we stick with a Malaya that is the product of colonialism? Why not reunite the entire Malay world, from Papua to Malaya, from Luzon in the Philippines to Borneo to Timor, all under one political unit? Because if we are rational, all this can be negotiated.

But if we are moving beyond such narrow ideas as race and nationality, then what underpins the rationale for this political unit? And the answer is self-determination.

This is the other important point. It was about the ideals as expressed in the United Nations charter of 1945, and equally, for us in Malaya, it was about the ideals expressed in the Bandung conference of 1955. Both affirmed the "principle of self-determination of peoples and nations," and the right of nations to "freely choose their own political and economic systems and their own way of life". This is the crux of the issue. Self-determination. A political unit must be responsible to its people; its people must freely choose to be in that political unit.

And in this context, capitalism takes on a different hue. Imperialism was a natural extension of capitalism. This is a phenomenon that is widely

The Bandung Conference in 1955

understood and accepted. Capital moves where it has the greatest return on investment. The greatest return on investment comes when you can exploit people and there is no legal protection against the exploitation. That was the principle that underpinned imperialism and colonialism. That's the same principle that underpins Uber.

The left in former colonial countries, and especially Malaya, recognised that former colonial countries would continue to exert great influence over their former colonies if we continue to lead economic, social, cultural lives that followed along our former colonisers. Kwame Nkrumah gave this the name neo-colonialism. If we continue to use English as our lingua franca, then we allow English speakers to have an outsize influence on our society. If we continue to allow the British to own half of our economy, then they will use that to control our political lives. It will undermine our democracy. So their suspicion of capitalism was because it tied the decolonising states into a power structure that privileged, that perpetuated the power of the former imperialist powers in new ways. Because the capitalist system privileged the Western elite. So their scepticism of capitalism was rooted in anticolonialism, not capitalism per se.

So if we are to build a new society based on democracy, based on equality, based on justice, then we must question every assumption about our lives and come to rational conclusions about how it should be reshaped. So, genuine sovereignty and self-determination required the decolonisation of power itself—as a process of governance, rather than an outcome.

Furthermore, if we continue to ally ourselves with the West, then we would be drawn into their colonial wars against other former colonies. Hence, the non-aligned movement. The desire to stay out of the Cold War. The Cold War, to the Malayan left, was about our former colonial masters, against people who had never done anything to us. So yes, Stalin has his gulags and China has the Great Leap Forward, but they have never colonised us. The US colonised the Philippines; Britain colonised Malaya and Burma; the French colonised Indochina; the Dutch colonised Indonesia. Why should we be on their side when for hundreds of years they exploited and tortured and murdered us? Let's just stay out of this stupid Cold War entirely.

This, of course, was not what the former colonial powers wanted to hear. But it was also not what the people with a vested interested in the established social order here in Malay wanted to hear. The monarchy. The landed elite. The capitalist elite. There is nothing rational about monarchy. There is nothing rational about large amounts of land or capital being held by a few people who are filthy rich for no reason other than they inherited it.

It is these people, the monarchy, and the capitalist and landed elite, who formed the Alliance, who allied themselves with the British, and who used nationalism, as a the technology of power, this conservative establishment, against those who wanted to reshape Malayan society against rationalist lines, who wanted to sweep away communalism, sweep away race and class, to create a society of democracy and self-determination.

This is the context under which the Cold War was fought in Malaya. The conservative elite wielded nationalism as a cudgel to bash Malayan socialism. They attacked socialists as being anti-national and therefore traitors. That's why communism is so important to this narrative. By emphasising communism, they could portray the Malayan left-wing as not just subservient to a foreign ideology, and hence traitors to the people, but turn them into this evil subhuman enemy. It's an age old tactic and reducing your enemy to the "Other". And once you turn them into subhuman evil, you can do whatever you want. You can lock them up under ISA, torture them, kill them. And that's what happened.

So to summarise.

In the context of a broad sweep of history, we can see certain themes stand out.

1. Decolonisation leads to liberation but also to new oppression.
2. Context for Malaya's decolonisation in post WWII must be understood in the forces which came before WWII.
3. Ideology, the conceptualisation of the political unit, is deployed in service both of the coloniser and the decolonised.
4. To understand Malayan decolonisation, we need to understand that it was, fundamentally, a contest between a narrow exclusive nationalism and a broad inclusive socialism.
5. But the nationalism won through an alliance with international capital, by picking the winning side during the Cold War.
6. From the perspective of the Malayan left, the Cold War was about the perpetuation of colonialism. It was about upholding the principles of sovereignty and self-determination.

馬來馬共的歷史論述

魏月萍

* 本文擷取自〈馬來馬共的歷史論述與制約〉，原刊載於《馬來西亞華人研究學刊》第14期，馬來西亞華社研究中心出版，2011。

二十世紀殖民地國家人民的覺醒意識顯著提高，包括東南亞在內，許多國家的獨立運動風起雲湧，各國爆發了反對殖民統治的革命。馬來民族也有新的覺醒 —— 印度尼西亞革命、俄國革命、中國革命和其它國家的革命影響著這一區域的獨立運動 [1]。在 1930 年代，在馬來人當中有三種政治路線，分別是民族主義、宗教主義與社會主義思想，雖然政治理想不盡相同，但當時大家擁有共同的目標，即以反殖、爭取馬來亞的獨立為終極目標 [2]。1930 年 4 月 30 日 [3]，代表工人階級和被壓迫階級的政黨 —— 馬來亞共產黨（Parti Komunis Malaya）成立了，但初期馬共成員大多數是華人。當時馬來族群也組織起來，堅持民主社會主義及獨立原則，在 1938 年成立了馬來青年協會（Kesatuan Melayu Muda，簡稱 KMM）。馬來青年協會被學界認為是第一個馬來民族主義運動組織，有趣的是，創立者依布拉欣・雅谷（Ibrahim Yacoob）把自己定位為左翼民族主義者 [4]。後來許多青年協會成員參加馬共領導的抗日鬥爭，成為最早加入馬共的馬來人，馬來馬共主要領導人阿都拉・西迪（Abdullah C.D.）即是其中一位。他是在一次接觸了馬共民運組織的代表葉碧紅，被她動人的演說觸動了情感與理想，毅然決定要擁護馬共，並認為馬來族與華族須並肩作戰。這樣一種轉折值得思索，如馬來西亞理科大學教授謝文慶的研究顯示：馬來青年協會和馬共各有爭取獨立的方案，馬來青年協會追求的是獨立的馬來亞與印度尼西亞的統一，而馬共則要建立多元族群的共產主義共和國 [5]。由此可見，加入馬共的馬來人在不同的「未來的國家」想像與認同的價值世界，如何確認自己的身份與位置，乃是一個複雜、矛盾、充滿權衡與揀選的過程。

追溯馬來人的反殖革命思想的源頭或知識來源，可窺見 1920、1930 年代馬來亞人民對共產思潮與革命進步思想的接受，是有兩個主要不同思想文化的管道，一為中國國共分裂之影響，不少中國共產黨人南下尋求支持，在南洋以反帝反殖為號召，進行抗爭運動，他們拉攏的主要對象是華人。二為印度尼西亞共產黨思潮與革命，為馬來馬共提供了理論知識資源與軍事訓練。而在太平洋戰爭之後，馬來馬共有感相對於華人，對抗日與反殖反帝抗爭覺悟落後，

1　Abdullah C.D., *Memoir Abdullah C.D.(Bahagian Ketiga)—Perjuangan di Sempadan dan Penamatan Terhormat* (Kuala Lumpur: SIRD, 2009), p.293.

2　同前註。

3　有關馬來亞共產黨的成立日期，學界仍存有爭議，此暫存不論。此乃依陳平於其回憶錄《我方的歷史》所誌的日期。

4　Rustam A. Sani, *Social Roots of the Malay Left: An Analysis of the Kesatuan Melayu Muda* (Kuala Lumpur: SIRD, 2008), p.9.

5　Cheah Boon Kheng, *Red Star over Malaya: Resistance and Social Conflict During and After The Japanese Occupation, 1941–1946* (Singapore: Singapore University Press, 1983), pp.101-102.

於是積極加入馬克思主義學校 (Sekolah Marxist Malaya) [6]、設立圖書館等，吸收有關反帝革命與祖國獨立的進步意識。馬來西亞政治社會學者魯斯旦・沙尼 (Rustam A. Sani) 曾指出，二戰前馬來亞馬來人對政治態度是遲緩與不成熟，但這並非說馬來人缺乏政治意識。從 1876 年至 1941 年，大概有 147 份馬來報在馬來半島及海峽地出版，尤其是一份名為 Al-Imam 的報紙，凝聚了伊斯蘭知識青年。Al-Imam 深受埃及伊斯蘭教改革運動影響，廣泛影響了馬來亞的「馬來—阿拉伯」社群 [7]，這一點說明了宗教改革運動是馬來政治文化重要組成之一。馬來馬共主要領導人阿都拉・西迪曾經透露自己的政治思想啟蒙，與印度尼西亞革命人士有緊密關係：

> 實際上對我的早期政治思想成長，產生的影響有幾個因素，其中一個是我的歷史知識，另一個是我同那些和我有著相同志趣的親屬及朋友的密切關係。此外，是我和到馬來亞避難的印度尼西亞鬥士的密切的關係，這是我的幸運。這些早期的養分激發了我的抗英精神，使我投身到抗英鬥爭中，1939 年我參加了馬來青年協會。[8]

> 對我在政治上的成長，伊努伯確實起著重要作用。他收藏了很多從印度尼西亞帶來的書，其中也有陳馬六甲 (Tan Malaka) 的著作，他把那些書借給我看，我如飢似渴地把書讀完，然後趕快歸還給他。他不僅借書，而且還對有關的書做分析，他除了解釋什麼叫做獨立、什麼是殖民統治、什麼是革命等等。此外，還向我分析，馬來亞的地位就是作為英國的殖民地，並且說明馬來青年聯盟的作用，就是馬來人向英國殖民者爭取獨立的一個組織。[9]

早期阿都拉・西迪在念江沙克列福英文源流學校 (Clifford School) 時，就已著手研讀有關馬來半島歷史書籍，而該學院校長也有不少有關馬克思思想的藏書，後來認識了因印度尼西亞獨立革命失敗而逃到馬來半島當膠工的伊努伯 (Pak Inu)，把他視為政

6　馬克思主義學校於 1946 年成立，主要舉辦了有關馬克思主義理論的短期課程，內容包含蘇聯的布爾什維克運動；共產黨擴張勢力的成功案例以及共產黨在東南亞的未來計畫等，藉此提高馬來同志的理論水平與策略意識的醒覺。講師多為印度尼西亞共產黨員如阿里明 (Alimin)，許多參加課程訓練的馬來馬共，往後都成為馬共的重要幹部。

7　同註 4，p.5。

8　Abdullah C.D., *Memoir Abdullah C.D.(Bahagian Pertama)—Zaman Pergerakan Sehingga 1948* (Kuala Lumpur: SIRD, 2005), p.16.

9　同前註，p.18。

《阿都拉・西迪回憶錄（一）——至 1948 年的運動》(吉隆坡：SIRD，2005)

10 同前註。

11 同前註，p.160。

12 賽‧胡先‧阿里（Syed Husin Ali）著，賴順吉譯，《馬來人的問題與未來》（吉隆坡：策略資訊研究中心，2010），頁1。

13 同前註，頁16

14 Abdullah C.D., *Memoir Abdullah C.D.(Bahagian Kedua)— Penaja dan Pemimpin Rejimen Ke-10* (Kuala Lumpur: SIRD, 2007), p.6.

15 劉鑑詮主編，《青山不老——馬共的歷程》（香港：明報出版，2004），頁85。

治導師，這之後他開始關心馬來亞獨立和馬來人鬥爭問題[10]。印度尼西亞獨立運動之所以成為馬來馬共反殖與爭取獨立的精神與思想重要資源之一，在於馬來民族具有接近的價值認同世界。阿都拉‧西迪曾說：「馬來亞人民和印度尼西亞人民是兄弟，來自同一個馬來族，同在一個馬來世界。」[11]「馬來世界」（Alam Melayu）指的是涵括「馬來群島」（Nusantara）的廣大地區。當時馬來半島、印度尼西亞與菲律賓的馬來人，鑑於共同的語言與文化傳統，一般被稱為「馬來」（Malays）或「馬來─印度尼西亞人」（Malayu-Indonesians），他們是組成馬來群島主要的種族[12]。這樣一種「同族」與「同語」的文化身份與語言認同，形成具社會文化或語言紐帶的共同體。後來殖民者重新劃定邊界，把以上所述不同島嶼的馬來人種納入不同的疆界，才被誤解以為馬來人僅是指稱馬來半島的馬來人。二戰前夕另一個值得注意的現像是，馬來半島不少宗教師（Ulama）與馬來民族主義者在反殖與民族鬥爭中扮演重要的領導角色，他們提出「大馬來由」（Melayu Raya）概念，以涵蓋印度尼西亞範疇來爭取獨立，政治態度偏向印度尼西亞[13]。因此二戰之後，「全面獨立」與「印度尼西亞統一」是馬來民族主義運動者積極欲達致的目標。可是1957年馬來亞取得獨立以後，馬印兩地政治想像開始出現分歧，蘇卡諾（Soekarno）在1960年代激烈反對「馬來西亞」（Malaysia）的成立，繼而提倡具明顯政治野心的「大印度尼西亞」（Indonesia Raya）區域構想[14]，希望建立一個涵括馬來半島、新加坡、泰國南部、砂拉越、沙巴、汶萊和菲律賓等的政治版圖[15]。其實「大印度尼西亞」一直是1930年代馬來青年協會，或後來青年協會重整後命名為印度尼西亞半島人民協會（Kesatuan Rakyat Indonesia Semenanjung，簡稱KERIS）的「國家想像」，只不過因為出現了到底是「誰包含誰」的主導權競爭，導致後來這個計畫沒有實現，從此以後，馬印進入對抗時期。

《我方的歷史》（新加坡：Media Masters，2004）

這樣的歷史知識背景，有助於了解自 1930 年代始，馬來亞人民的各種共同體想像與競爭，尤其是不同的馬來政治力量雖然共有追求獨立的大目標，但彼此間考慮的目標與利益並不一致，追求「全面獨立」和與「印度尼西亞統一」是大多數馬來民族的終極目標。若參照華人社會的歷史知識脈絡，1930 年代的華人社會是處於「南洋」[16] 想像與認同脈絡，政治與文化認同也多傾向於中國，例如馬共總書記陳平在《我方的歷史》中記述：

> 在整個 1930 年代，你可以從懸掛在住家和店屋牆上的照片看出實兆遠 —— 事實上整個馬來亞 —— 華人的政治傾向。1931 年 9 月的「九一八」事變之後不久，牆上所懸掛的照片是針對中國所發生的事件作出反應。

> 在 1930 年代初，一些家庭把國民黨的蔣介石大元帥視為中國真正的領袖。他的照片懸掛在這些屋子的牆上和走廊。但幾乎每一間店屋都有懸掛孫中山的照片。每一個人都把孫中山當成中華民國國父。[17]

1930 年代的馬來亞實已是「多元社會」（Plural Society）。魯斯旦·沙尼從 1930 年代的族群人口分佈證明多元社會的建立，指說當時馬來人佔 49.2%、華人 33.9%、印度人 15.1%、其它族群為 1.8%。[18] 不同社會空間的想像與多元意識型態競爭、牽扯、共存。如上所述，1930 年代的中國南來華僑雖仍未有落地歸根的想法，縱然如此，僑居在南洋的華僑一直都有鮮明的反殖意識。進入 1950 年代後，他們對馬來亞的地方認同更是逐漸增強[19]。至於印度社群，情況更為複雜。在 1920 至 1930 年代，大部份印度人對於馬來亞的政治態度是沉默的；一直到 1940 至 1945 年以後，印度社群對馬來亞才有較明顯的存在感，開始通過組織或報紙來發出聲音，爭取自身的權利。馬來亞時期的印度社群內部階級差異甚大，劃分意識甚強，不只有意劃分興都和穆斯林，受英文教育及非英文教育的區別，更把社群分成四個不同的階層：菁英、上層、下層與勞工。[20] 因此有了以上這些層面的基本了解，接下來將進一步探索目前馬來馬共歷史論述所關注的幾個層面，姑且歸納為以下三點：（一）冷戰局勢中的馬來馬共；（二）馬共與馬來左翼的關係；（三）馬來族群對馬共的支持。以下將扼要論之。

第一點：冷戰局勢中的馬來馬共

馬來西亞理科大學人文與社會科學院學者阿都拉曼·哈芝·依斯邁（Abdul Rahman Haji Ismail）認為馬來亞時期的大多數馬來族群，對冷戰局勢以及東西方意識型態的矛盾衝突缺乏警覺與關注，馬來族群更關心的是「土地」問題 —— 在馬來亞這塊土地的主權（sovereignty）、擁有權（ownership）以及土生原住民

16 對「南洋」的指涉，學界曾歸納成三種說法：（一）以許雲樵在《南洋史》所云為準，其曰：「南洋者，中國南方之海洋也，在地理學上，本為一曖昧名詞，範圍無嚴格之規定，現以華僑集中之東南亞各地為南洋。」（二）以馮承鈞《中國南洋交通史》的看法為主，其認為南洋包括了明代史籍所謂的東西洋。（三）依據李長傅《南洋史入門》的分類，廣義的包括印度支那半島、馬來半島與群島：始自澳大利亞，止於紐西蘭，東太平洋諸島與西面印度。而狹義則指馬來半島及馬來群島而已。

17 陳平，《我方的歷史》（新加坡：Media Masters，2004），頁 37。

18 同註 4，p.13。

19 魏月萍，〈中國與在地：新馬兩地對南洋研究傳統的知識認同〉，載李志賢編《東南亞與中國：連接、疏遠、定位論文集》（新加坡：亞洲研究學會，2009），頁 170-171。

20 Muzafar Desmond Tate, *The Malaysian Indians: History, Problems and Future* (Kuala Lumpur: SIRD, 2008), p.21, p.25.

《馬來西亞 —— 馬來左翼運動史》(吉隆坡:策略資訊研究中心,2007)

21 Abdul Rahman Haji Ismail, "1948 and The Cold War in Malaya: Samplings of Malay Reactions" (in *Kajian Malaysia* vol.27, 2009), p.155, p.196.

22 許德發,〈「承認」的鬥爭與華人的政治困擾〉,載文平強、許德發合編《勤儉興邦 —— 馬來西亞華人的貢獻》(吉隆坡:華社研究中心,2009),頁238。

23 Cheah Boon Kheng(edited), *The Challenge of Ethnicity: Building a Nation in Malaysia* (Singapore: Marshall Cavendish Academic, 2004), p.45.

24 同註1,p.305.

(natives) 身分維護的問題。與此同時,他們也關心在馬來亞獨立後,馬來政府是否仍然可以保有政治優勢與管理權,以致對外國事務不表熱衷[21]。「土地」是馬來民族宣稱主權的歷史根源,也是取得原居民合法性的依據,這樣一種「原地主義」[22] 的歷史建構,在憲法保障之下成為一種難以打破的族群政治結構。在 1948 年的馬來亞聯邦聯盟協議,英殖民地政府不但「承認」了馬來主權的合法性,同時也承認馬來人可享有特別的地位,包括以馬來文作為國家語言、回教為國教、馬來統治者為建制化的君主等。至於非馬來人亦可取得公民權、自由信仰以及保留本身的母語的權利。這說明後殖民的馬來西亞,其實仍沿用殖民時期建構的族群結構觀念,來鞏固馬來人的特權。而非馬來人在對抗馬來民族主導的特權意識時,無法打破「歷史的協商」所造成的不平等結構[23]。因此當我們回看殖民歷史,便可了解馬來政府與馬來族群面對後殖民情景的去殖民工程,持有曖昧的態度,皆因在殖民統治當中,雖不能說是分享了殖民成果,但自身族群的利益卻是受到保障。然而投入反殖反帝運動的馬來馬共,對階級與資本家的剝削具深刻的體悟,尤其是獨立以後,馬來亞從封建社會轉向半殖民半封建社會,英國人還是掌握了大量的土地與橡膠園[24];甚至在 1970 年代重要的新經濟政策(NEP)底下,英國人仍然擁有馬來西亞重要企業資本。

第二點:馬來馬共與馬來左翼的關係

研究馬來左翼運動史的社會科學與人文系學者莫哈默・沙勒・藍利(Mohamed Salleh Lamry)曾指出,馬來政治文化中存在左/右

不同的政治思潮與路線，也警惕不可以西方語境下的解釋來理解馬來左/右政治思潮，所以必要先行了解「左翼」(Left Wing) 在馬來政治文化脈絡的含意。馬來亞大學歷史學者邱家金 (Khoo Kay-Kim) 把 1950 年代馬來左翼分為五組不同的立場：第一組是指參與馬共的馬來人，他們是「極左」分子。第二組是在廣義上支持社會主義，但這組人在緊急狀態時期加入了極左陣營。第三組是回教左翼分子，後來許多人加入了回教黨。第四組則為「左翼過客」，但其中不少人也在政府執行緊急法令時期選擇加入右翼陣營的「巫統」(Umno)。最後一組是具強烈民族主義者，他們反英也反巫統 [25]。魯斯旦・沙尼也認同馬來政治有兩種政治路線，一是以馬來傳統政治為基礎，被英殖民政府政治權威所認可的「巫統」，二即是左翼流派，不過魯斯旦・沙尼試圖從「社會根源」而非以「意識型態」為視角，說明馬來左翼的土壤是根植於馬來亞，並主要反駁威廉・羅夫 (William R. Roff) 所提出的印度尼西亞左翼分子「影響論」[26]。這樣的一種觀察提供從社會變遷角度來審視所謂「左翼」的力量，試圖從族群人口結構的變化、馬來領導危機與馬來人的文化身分危機等因素去了解左翼政治力量的形成。

馬來左翼份子與馬共雖然建國大藍圖不一樣，但在反殖上有許多合作，或結為運動盟友，1948 年 6 月宣布緊急狀態則是個轉折點。英殖民政府宣布實施緊急法令，取締進步民主政黨和組織，不少馬來左翼組織被禁以及左翼分子被英政府逮捕，促使許多馬來左翼分子成為馬來馬共並加入馬共武裝鬥爭，例如被喻為「馬共的馬來人陣線的祖國保衛團 (Pembela Tanah Air，簡稱 PETA) 左翼組織主

25　Mohamed Salleh Lamry 著，謝麗玲譯，《馬來西亞 —— 馬來左翼運動史》(吉隆坡：策略資訊研究中心，2007)，頁 18-20。

26 同註 4，pp.7-9.

蘇基林和平村的第十支隊 (馬來馬共) 博物館 (圖片提供：魏月萍)

27 同註 25，頁 189。

28 同註 15，頁 102。

29 Muzafar Desmond Tate, *The Malaysian Indians: History, Problems and Future* (Kuala Lumpur: SIRD, 2008), p.82.

30 有關印度尼西亞共產主義的歷史起源，請參閱 Ruth T. Mcvey, *Kemunculan Komunisme Indonesia.* (Jarkata: Komunitas Bambu, 2010)。

31 同註 12，頁 59。

席瓦希安努亞（Wahi Anuar），因為這樣，有學者認為難以辨別這些馬來馬共黨員究竟是民族主義抑或共產主義者[27]。

第三點：馬來族群對馬共的支持

馬共總書記陳平在檢討馬共的失敗原因時，曾歸咎於無法爭取馬來人和印度人的支持。再加上在 1930 年代作為馬來人共產與革命思想來源的印度尼西亞，由於在爪哇和蘇門答臘革命失敗後已逐漸沈寂。馬共無法突破種族的界限，對馬來農民與印度工人無法產生巨大的召喚力是馬共發展的內在困境，拉欣諾在訪談時也特別強調了以下幾點：

> 從社會發展背景來看，廣大的馬來族群世代生活在傳統的農村社會，沒有受到重大的外來思潮影響。英國實行殖民地統治以來，以保護者的姿態出現，維持馬來族的傳統習俗，蘇丹制度和回教信仰，使得馬來社會相對的呈現平穩狀態。馬來人和印度人並沒有因社會的發展和變遷遭到重大的打擊。與此同時，殖民地時代的馬來中產階級，多數是英政府委任的公務員，它們的利益與英政府相契合，因而沒有受到激烈的革命思潮所影響。

> 在思想方面，早期馬來民族的領導者很多留學埃及，學習宗教教義，他們回國後，從事宗教指導和傳播工作，而非社會興革活動。他們擁護傳統的封建制度和回教倫理，以及願意接受英國人的保護。

> 儘管有部份馬來知識分子不滿意殖民地政府的統治，而欲從事社會改革，建立新社會，但是，從馬來亞的歷史發展證明，傳統派的領導份子較能得到群眾的支持，這使到共產主義不能在馬來人社會中發生強大的影響[28]。

馬來人是基於什麼原因支持或不支持馬共，宗教常被認為是最關鍵的因素。加入馬共，信仰共產思想，與自身的宗教信仰是否產生抵觸？有研究者指出，馬來亞時期的共產主義思想對印度人而言，較缺乏吸引力，主要也在於它反對宗教的立場。[29] 共產思想與伊斯蘭教信仰的關係，是一個需要被梳理的領域，要不如何解釋擁有近乎 85% 伊斯蘭教徒的印度尼西亞，卻是世界第三大的共產國家？[30] 另外，英政府於殖民地時期，也曾利用宗教為身份認同基礎，煽動共產思想與宗教是有所抵觸的言論。獨立後的馬政府也試圖以伊斯蘭教義來對抗共產思想，1970 年代大馬第三發展計畫書中出現一段文字：「額外的力量是伊斯蘭及國內其它宗教，他們是反擊陰險共產黨宣傳的強大保壘。」[31] 馬來馬共領袖阿都拉・西迪曾經在清真寺祈禱完畢後被陌生人抓住，被告誡「你要重新入馬來教」，有感而發道：

他們禁止我參加共產主義運動，是什麼意思。在抗日戰爭中，我見證了各種各樣和各種立場的人，那些真正能啟發我的，都是英勇無畏地把一切甚至生命奉獻給祖國的人。我看到，馬來民族中只有具有愛國民主精神的真正共產黨人和民族主義者才能做到這一點。而另一部份自我吹噓具有高深的宗教學問的人，卻忠實地跟著日本法西斯的指揮棒轉。這又意味著什麼？而且維護民族、宗教和祖國是信仰的一部份，難道不是這樣嗎？[32]

如前所述，馬來馬共黨員當中，有不少有名的宗教師，例如阿布‧沙瑪 (Abu Samah) 提到淡馬魯市回教堂的阿訇 (Iman)，也加入馬共成為黨員和地下幹部 [33]。1960 年由阿都拉‧西迪所領導的第十支隊的馬來戰鬥部隊逐漸擴張影響，當時他就倡議組織一支由馬來伊斯蘭青年組成的進步政黨，串連所有愛國的伊斯蘭青年與宗教師，此舉引發政府的鞭撻，指責馬共利用伊斯蘭教 [34]。甚至在馬共走出森林後，「恐共症」仍不斷蔓延以達到某種政治目的，馬共成為渲染的大帽子，用以取得馬來人的團結。馬來領袖不時強調要用伊斯蘭教的強烈信仰來對抗共產主義，渲染「共產黨是華人及華人是共產黨」的言論。針對這點，莫哈默‧沙勒‧藍利曾表達了精闢的看法：

　　……雖然他們依循共產主義的道路鬥爭，並與共產主義者並肩作戰，事實是他們利用馬共以達到他們身為民族主義者的目標，換言之，他們是始終堅信伊斯蘭的民族主義份子，可是卻以馬克思列寧和毛澤東思想作為政治鬥爭的理論和策略。所以，他們同時擁有共產主義者、伊斯蘭和民族主義的特質。[35]

32 Abdullah C.D., *Memoir Abdullah C.D.(Bahagian Pertama)— Zaman Pergerakan Sehingga 1948* (Kuala Lumpur: SIRD, 2005), p.111.

33 遊礫譯，《伊斯蘭‧馬來人‧共產黨——阿卜杜拉‧西迪‧拉昔‧邁丁‧阿布‧沙瑪訪談錄》(吉隆坡：策略資訊研究中心，2007)，頁 78。

34 同註 1，pp.114-118。

35 同註 25，頁 191。

立在蘇基林和平山上的緊急狀態五十週年紀念碑 (圖片提供：魏月萍)

簡言之，在冷戰局勢下的馬來馬共，對共產主義的吸收是出自戰略的心理，而並非把它看作是信仰或意識型態。這才能說明為何他們得以妥善安頓共產主義、伊斯蘭主義以及民族主義三者之間的關係。而愛國、民族與民主的因素，也成為他們和其它左翼力量之間可以合流或合作的最關鍵原因。馬來馬共作為馬來政治文化左翼力量的一環，所參與的馬共鬥爭後來亦形成馬來本土政治系譜的其中一個流派。

Discourses About Malay CPM's History

Ngoi Guat-Peng

* This article is excerpt from "The Historical Discourse of Malay Communists and It's Limitation", *Journal of Malaysian Chinese Studies Malaysia*, vol.14, 2011.

The significant rise of consciousness among colonial subjects in the twentieth century, including people in Southeast Asia, created waves of independence movements and gave rise to anti-colonial revolutions around the globe. The new consciousness was seen in the Malay people too, as revolutions in Indonesia, Russia, China and other countries impacted on independence movements in this region.[1] In the 1930s, there were three political choices among the Malays: nationalism, religion and socialism. Although people's political ideals might be dissimilar, their ultimate goal was, however, the same; that is, the pursuit of Malayan independence through anti-colonial struggles.[2] On 30th April 1930,[3] the CPM (Parti Komunis Malaya) was founded as a party representing the working and the oppressed classes. In its early days, the CPM was comprised of mostly Chinese. Meanwhile, the Malays too began to organize themselves politically by forming Kesatuan Melayu Muda (the Malay Youth League, or KMM) in 1938, asserting the principles of democratic socialism and independence. The KMM is considered by the academic community as the first Malay nationalist activist organization. Interestingly, its founder, Ibrahim Yacoob identified himself as a left-wing nationalist.[4] Later on, many of the KMM members joined the CPM in their resistance against Japan, becoming the first among the Malays to join the CPM, Abdullah C.D—a leading Malay figure in the CPM—being one of them. His sentiments were aroused and ideals stirred when he first listened to a moving speech by Ye Bi-Hong, a representative from the CPM's mass movement organization, and he

1 Abdullah C.D., *Memoir Abdullah C.D.(Bahagian Ketiga)— Perjuangan di Sempadan dan Penamatan Terhormat.* (Kuala Lumpur: SIRD, 2009), p.293.

2 *Ibid.*

3 There is still a dispute over the founding date of CPM, which is not discussed here. The date used in this article is based on that provided by Chin Peng in his memoirs *My Side of History*.

4 Rustam A. Sani, *Social Roots of the Malay Left: An Analysis of the Kesatuan Melayu Muda* (Kuala Lumpur: SIRD), 2008, p.9.

decided resolutely to support the CPM, firm in the belief that the Malays and the Chinese must fight shoulder to shoulder. A turnaround such as this is worth pondering. Research by Professor Cheah Boon Keng of University Science Malaysia, for instance, indicates that both the KMM and the CPM had their respective projects for the independence, with the former pursuing a unification between an independent Malaya and Indonesia, while the latter sought to establish a multi-ethnic communist republic.[5] Seen in this light, it was a complex and conflicting process for CPM Malays to ascertain their identity and position, as they were caught in a world of different imaginations and identifications in search of a "future state." It was also a process of various selections and negotiations they made.

By retracing the sources of anti-colonial revolutionary ideas or knowledge of the Malays, one can see that the Malayan people's acceptance of the Communist ideology and progressive revolutionary ideas was made possible mainly by two different cultural and intellectual channels: one was the Chinese communists who, impacted by the split between the Nationalists (Kuomintang) and the CCP in China, went south to seek support and, as a result, called for resistance in Southeast Asia in the name of anti-imperialism and anti-colonialism, targeting the Chinese as their main base of support. The other was Indonesia's communist revolution and thoughts, which provided Malay CPM with the knowledge and military training they need. After the end of the Pacific War, the Malay CPM felt itself lagging behind the Chinese in terms of their anti-Japanese invasion, anti-colonial and anti-imperialist consciousness, and thus they began to proactively attend the Malayan Marxist School (Sekolah Marxist Malaya), set up libraries and so on,[6] so as to obtain progressive knowledges related to the anti-imperialist revolution and the independence of their motherland. Malaysia's socio-political scholar Rustam A. Sani once pointed out that, the lethargy and immaturity of the pre-Second World War Malayan Malays towards politics did not mean that political consciousness was wanting. From 1876 to 1941, roughly 147 Malay newspapers had been published in the Malay Peninsula and the Straits Settlements. A newspaper entitled *Al-Imam*, in particular, had rallied

5 Cheah Boon Kheng, *Red Star over Malaya: Resistance and Social Conflict During and After The Japanese Occupation, 1941–1946* (Singapore: Singapore University Press. 1983), pp.101-102.

6 The Marxist School was founded in 1946, providing mainly short-term courses related to Marxist theory, while also including Bolshevik Movement in the Soviet Union, the successful cases of the expansion of communist forces as well as the future project of the communists in Southeast Asia, so as to raise the theoretical understanding and strategic awareness of the Malay cadres. Many of the lecturers were members of the Communist Party of Indonesia, such as Alimin, and many CPM members who participated in the courses later become key cadres of the CPM.

the Muslim intellectual youths. *Al-Imam* was profoundly influenced by the Islamic reform movement in Egypt, and had a widespread impact on the Malay-Arab communities in Malaya.[7] This illustrates that the religious reform movement is an important component of Malay's political culture. Abdullah C.D., a key leader of the Malay CPM, once disclosed that his political and intellectual enlightenment was closely related to Indonesian revolutionaries:

> *In fact, several factors have impacted on the development of my political thoughts in my early years; one of them was my knowledge about history, and another being my close relationship with friends and relatives who shared with me common ideals and aspirations. There was also the close relationship between me and the freedom fighters who had fled Indonesia for Malaya, and I count myself rather fortunate. These early experiences generated the anti-British spirit in me, propelling me into the anti-British struggle. In 1939, I joined the KMM.*[8]

> *Pak Inu had been significantly instrumental in the growth of my political consciousness. He had a big collection of books from Indonesia, and among them were Tan Malaka's works. I borrowed the books from him, read them hungrily, and return them to him the soonest. More than just lending me the books, he even analyzed them for me, explaining to me what does independence mean, what is colonial rule and revolution. Moreover, he explained to me the status of Malaya as a British colony, as well as the role of the KMM as a Malay organization fighting for independence from the British colonial rule.*[9]

When he was still a student at Clifford School in Kuala Kangsar, Abdullah C.D. had begun to read books on the history of the Malay Peninsula. The school principal at Clifford also had a good selection of books on Marxist thought. Abdullah C.D. later came to know Pak Inu, a revolutionary and independence fighter who had fled Indonesia to be a rubber-tapper in the Malay Peninsula following a failed uprising, and whom Abdullah C.D. would regard as his political mentor. Since then, he began to be concerned about Malayan independence as well as the issue of the Malay struggle.[10] That the Indonesian independence movement would become an important spiritual and intellectual resource in the Malay CPM's anti-colonialist

7 Rustam A. Sani, *op. cit.*, p.5.

8 Abdullah C.D., *Memoir Abdullah C.D.(Bahagian Pertama)— Zaman Pergerakan Sehingga 1948* (Kuala Lumpur: SIRD, 2005), p.16.

9 *Ibid.*, p.18.

10 *Ibid.*

The Memoirs of Abdullah C.D (Part One)—The Movement until 1948 (Kuala Lumpur: SIRD, 2005)

11 *Ibid.*, p.160.

12 Syed Husin Ali, *The Malays: Their Problems and Future*, translated by Lai Soon-Ket (Kuala Lumpur: Strategic Information Research and Development, 2010), p.1.

13 *Ibid.*, p.16.

14 Abdullah C.D., *Memoir Abdullah C.D.(Bahagian Kedua)— Penaja dan Pemimpin Rejimen Ke-10* (Kuala Lumpur: SIRD, 2007), p.6.

15 Liew Chen-Chuan, ed., *Still the Evergreen Mountain: CPM's Journey* (Hong Kong: Ming Pao, 2004), p.85.

My Side of History (Singapore: Media Masters, 2004)

and independence movement was due to the similar worldviews and values shared among people of Malay. Abdullah C.D. once said, "Malayan and Indonesian peoples are brothers, originating from the same people of Malay and living in the same Malay world".[11] The "Malay world" (Alam Melayu) refers to a vast region encompassing the "Malay Archipelago" (Nusantara). In those days, the Malays living in the Malay Peninsula, Indonesia and the Philippines were known as "Malays" or "Malayu-Indonesians" due to their shared languages and cultural traditions, and they were the major ethnic group living in the Malay Archipelago.[12] Such a "same-race" and "same-language" identity in terms of culture and language engendered a community with societal culture or linguistic ties. Later, the colonizers redrew the boundaries and placed the above-mentioned Malays from different islands into different territories, resulting in the misunderstanding that "Malays" only meant those living in the Malay Peninsula.

What's also noteworthy was the phenomenon right before the Second World War that some religious teachers (ulama) in the Peninsula and Malay nationalists had become important leaders in the anti-colonial and nationalist struggle. They promulgated the concept of "Greater Malay" (*Melayu Raya*), so as to include Indonesia in their fight for independence, with a politically pro-Indonesia attitude.[13] Thus, after the end of the Second World War, "full independence" and "Indonesian unification" were the two goals that the Malay nationalists were enthusiastically working towards. However, since Malaya achieved independence in 1957, differences in the political imaginations in Malaya and Indonesia started to surface. In the 1960s, Soekarno vehemently opposed the formation of "Malaysia," and proposed in its place a politically ambitious regional framework in the form of a "Greater Indonesia" (Indonesia Raya),[14] in the hope of creating a political territory covering the Malay Peninsula, Singapore, southern Thailand, Sarawak, Sabah, Brunei and the Philippines.[15] In fact, "Greater Indonesia" had long been an "envision of nation" on the part of the KMM (regrouped and renamed later as Kesatuan Rakyat Indonesia Semenanjung, the Indonesia-Peninsular Youth League). But the project wasn't carried out in the end due to the competition over who should have a dominant posi-

tion as well as "who should include whom." Since then, Malaya and Indonesia entered into a period of confrontation.

A historical background as such is conducive to understanding the various envisions of and competitions over a community on the part of the Malayan people since the 1930s. The different Malay political forces might share a grand objective of independence, but they differed in terms of the goals and interests that really mattered to them. For the majority of the Malays, the pursuit of "full independence" and "Indonesian unification" was an ultimate goal. If we take the prevailing knowledge about history in the Chinese community into consideration, the Chinese community in the 1930s was caught in an imagination of and identification with *Nanyang* (South Sea),[16] while their political and cultural identifications were inclined towards China. As stated by Chin Peng, CPM's General-Secretary, in his *My Side of History*:

> *Throughout the 1930s, you could tell the political leanings of the Chinese in Sitiawan—or indeed throughout Malaya—by the photographs displayed in their homes and shophouses. Soon after the Mukden Incident in September 1931, photos displayed on the wall were people's responses to events happened in China....In the early 1930s, some households regarded Kuomintang's Generalissimo Chiang Kai Shek as the true leader of China. His photograph dominated walls and hallways of these homes. But nearly every shophouse carried a picture of Sun Yat Sen, whom everyone considered the founding father of the Republic of China.* [17]

If anything, Malaya in the 1930s was already a "plural society." Analyzing Malaya's demographic composition from the 1930s onwards, Rustam Sani pointed out that the Malay population stood at 49.2%, the Chinese at 33.9%, Indians at 15.1% and other ethnicities at 1.8%, and therefore there existed a plural society,[18] with different social envisions and diverse ideologies competing and coexisting with one another. As described above, although the Chinese who came to Southeast Asia in the 1930s might not have had the idea of putting down roots there yet, there has always been a strong anti-colonial consciousness among them. Entering the 1950s, their identification with Malaya only became

16 As far as the concept of *Nanyang* (Southern Ocean) is concerned, it can be summarized in three academic views: (1) based on Hsu Yun Tsiao's *History of Nanyang (Nanyang Shi)*, in which "Nanyang means the ocean to the south of China and was an ambiguous term in geography, for there was no strictly fixed boundary to begin with. It now refers to the various places in Southeast Asia in which overseas Chinese concentrate"; (2) largely based on Feng Cheng Jun's *A History of Communication between China and Southeast Asia (Zhong Guo Nanyang Jiao Tong Shi)*, which is of the view that Nanyang covered the so-called Eastern and Western Ocean (*Dong Xi Yang*) as in the historical sources of the Ming Dynasty; (3) based on the classification in Li Chang-Fu's *An Introduction to Nanyang History (Nanyang Shi Ru Men)*, which in a broad sense included Indo-China, the Malay Peninsula and the archipelago: beginning in Australia and ending in New Zealand, the islands in the eastern Pacific Ocean, facing India to the west. In a narrow sense, it refers only to the Malay Peninsula and the Malay Archipelago.

17 Chin Peng, *My Side of History* (Singapore: Media Masters, 2004), p.37.

18 Rustam A. Sani, *op. cit.*, p.13.

19 Ngoi Guat-Peng, "China and the Local: the Epistemological Identification of Singapore and Malaysia towards the Tradition of Southeast Asian Studies." In *Southeast Asia and China: Essays on Linking, Distancing and Positioning*, edited by Lee Chee-Hiang (Singapore: The Association for Asian Studies, 2009), pp.170–171.

20 Muzafar Desmond Tate, *The Malaysian Indians: History, Problems and Future* (Kuala Lumpur: SIRD, 2008), p.21, p.25.

21 Abdul Rahman Haji Ismail, *1948 and The Cold War in Malaya: Samplings of Malay Reactions* (in *Kajian Malaysia* vol.27, 2009), p.155, p.196.

22 Khor Teik-Huat, "A Struggle for 'Recognition' and the Political Predicament of the Chinese." In *Reviving the State through Industriousness and Thriftiness: The Contribution of the Malaysian Chinese*, edited by Voon Ping-Keong and Khor Teik-Huat (Kuala Lumpur: The Centre for Chinese Studies, 2009), p.238.

stronger as time went by.[19] As for the Indian community, the situation was even more complex. From the 1920s to the 1930s, the majority of the Indians were silent in terms of their political attitudes towards Malaya; it was not until after 1940–1945 that the Indian community became more visible in Malaya, as it began to speak out through organizations or news-papers and to fight for its own rights. The class differences within the Indian community during the Malayan era were rather huge and the awareness of divisions strong. Not only did they divide themselves along the lines of Hindu-Muslim, English-educated and non-English educated, there were even four classes within the community: the elite, the upper class, the lower class and the laborers.[20]

This article will further analyze several dimensions that concern the current discourses about Malay CPM's history: (1) the Malay CPM in the Cold War framework; (2) the relations between the Malay CPM and the Malay left; (3) Malay people's support for the Malay CPM.

CPM in the Cold War Framework

Abdul Rahman Haji Ismail, a scholar at the College of Humanities and Social Science in University Sains Malaysia, is of the view that the majority of the Malays during the Malayan period were not alert and attentive enough to the Cold War framework and the ideological conflict between the East and the West; they were more concerned about the "land" issue-the sovereignty, owner-ship of the land called Malaya, as well as protecting the identity of the natives. Meanwhile, they too were concerned about whether, after the independence, the Malay government would still be able to maintain political advantage and the right to rule, as a result of which they did not appear too enthusiastic about foreign affairs.[21] "Land" is a historical source with which the Malay people declare their sovereignty, and also a basis from which the indigenous populations obtain their legitimacy. A historical construction of a "theory of indigenousness" as such,[22] constitutionally buttressed, became an ethno-political structure that was hard to break. Under the 1948 Malayan Union Agreement, the British colonial administration not only "acknowl-

edged" the legitimacy of Malay sovereignty, but also the special position of the Malays, including making Malay the national language, Islam the state religion, as well as the establishment of a monarchy made up of the Malay rulers, to name a few. As for the non-Malays, they too could claim citizenship, freedom of religion as well as the right to preserve their mother-tongue. All this illustrates that the post-independence Malaysia has continued to make use of the ethnic structure constructed during the colonial period to strengthen the privileges of the Malays. The non-Malays have been unable to dismantle the unequal structure caused by such "historical negotiations" when it comes to resisting the predominately Malay privileges.[23]

Looking back on colonial history, one will understand the ambivalence on the part of the Malay government and the Malay community towards decolonization, for while the Malays may not be said to have enjoyed the fruits of colonialism, there is no denying that their ethnic interests were nonetheless assured during colonial rule. However, the Malay CPM devoted itself to the anti-colonial and anti-imperialist movement and was deeply cognizant of the exploitation of the capitalists. They were keenly aware that, especially after independence, the British still owned a huge amount of land property and rubber plantations at a time when Malaya was transitioning from a feudal to a semi-colonial, semi-feudal society.[24] Even under the New Economic Policy in the 1970s, the British remained in control of the capital of Malaysia's major enterprises.

The Relations between CPM and the Malay Left

Mohamed Salleh Lamry, a social science and humanities scholar whose research focused on the history of the Malay left-wing movement, once pointed out that there existed in Malay political culture a political difference between the left and the right, and also warned that one must not seek to explain the leftist and rightist political thoughts of the Malays in a western sense. As such, it is necessary to first understand the meaning of "Left Wing" in the Malay politico-cultural context. Khoo Kay Kim, professor of

23 Cheah Boon Kheng(edited), *The Challenge of Ethnicity: Building a Nation in Malaysia* (Singapore: Marshall Cavendish Academic, 2004), p.45.

24 Abdullah C.D., *Memoir Abdullah C.D.(Bahagian Ketiga)— Perjuangan di Sempadan dan Penamatan Terhormat, op. cit.,* p.305.

history at University Malaya, divides the Malay Left of the 1950s into five categories: the first includes the Malays who joined CPM and were hence the "extreme left"; the second includes those who had supported socialism in a broad sense, but joined the extreme-left during the Malayan Emergency; the third includes the "Islamic left," many of whom later joined the Islamic Party; the fourth includes the "transient left," quite a few of whom joined the right-wing UMNO (United Malays National Organization) when the government carried out Acts of the Emergency; the last category includes the staunchly nationalistic people, who were opposed to both the British and the UMNO.[25]

Rustam A. Sani agrees that there were two political lines in Malay politics. One was that of UMNO, which was based on traditional Malay politics and was acknowledged by the British colonial authorities. The other was that of the left-wing school, and Rustam A. Sani[26] attempted to elaborate from the perspective of its "social origin," rather than "ideology," that the Malay left was rooted in Malaya, so as to rebut what William R. Roff (1967) had argued, that it was "influenced" by the leftists in Indonesia. Such a perspective allows us to examine the power of the so-called "left-wing" by way of social change, to join the CPM and carry out the armed struggle. One of these was Wahi Anuar, leader of the left-wing organization Pembela Tanah Air (the Protector of the Motherland, popularly known as "the Malay Front of CPM"). Because of such development, some scholars consider it hard to tell if these Malay members of the CPM were nationalists or communists.[27]

Malay People's Support for the Malay CPM

In re-examining the CPM's defeat, General Secretary Chin Peng attributed it to the failure to garner support from the Malays and the Indians. Furthermore, Indonesia, its communist and revolutionary thoughts being the inspiration for Malays in the 1930s, became a lot less active since the revolutions in Java and Sumatra failed. As a result, the CPM was unable to tear down the barrier between ethnic groups, and its inability to rally Malay

25 Mohamed Salleh Lamry, *Malaysia: History of the Malay Left-wing Movement*, translated by Seah Li-Ling(Kuala Lumpur: Strategic Information Research and Development, 2007), pp.18-20.

26 Rustam A. Sani, *op. cit.*, pp.7-9.

27 Mohamed Salleh Lamry, *op. cit.*, p.189.

Malaysia: History of the Malay Left-wing Movement (Kuala Lumpur: Strategic Information Research and Development, 2007)

farmers and Indian workers was the dilemma obstruct-
ing its development. Rahim Noor in an interview, too, has
emphasized the following:

Museum of Tenth Regiment (of the
Malayan People's Liberation Army) in
Peace Village in Sukhirin (Photo from Ngoi
Guat-Peng)

> *Considering the transformation of society, the Malay people at*
> *large have lived for generations in a traditional peasant society,*
> *extricated from the influences of major external thoughts. During*
> *colonial rule, the British portrayed themselves as a guardian who*
> *maintained Malay traditions, customs, sultanates and the Islam-*
> *ic faith, bringing about relative stability to Malay society. The*
> *Malays and the Indians were spared the severe impact caused by*
> *social development and changes. At the same time, the middle*
> *class during the colonial era were mostly civil servants appointed*
> *by the British, and their interests were in line with those of the*
> *British authorities. As such, they were immune to the influence of*
> *radical revolutionary thoughts.*
>
> *In terms of people's thoughts, many of the Malay leaders in*
> *the early days had studied in Egypt, where they learnt about*
> *religious doctrines. Upon return, they involved themselves in re-*
> *ligious teaching and proselytization rather than in social reform.*
> *They supported tradition, feudalism and Islamic ethics, and were*
> *willing to receive protection offered by the British.*
>
> *Even though a certain number of Malay intellectuals were*
> *dissatisfied with British rule and intended to devote themselves*
> *to social reform and establishing a new society, Malaya's*
> *historical development proves however that it is the traditional*
> *leaders who have been able to garner greater public support,*
> *rendering communism unable to create a powerful impact*
> *within Malay society.*[28]

Religion is often considered the most crucial factor behind
Malays' support, or the lack thereof, for the CPM. Would
joining the CPM or embracing communist thought run
counter to one's own religious beliefs? Researchers pointed
out that communism was less attractive to the Indians
during the Malayan period mainly due to its alleged an-
ti-religious stance.[29] It is necessary to clarify the relations
between communist thoughts and Islamic beliefs, other-
wise it would be difficult to explain how Indonesia, with
Muslims making up 85% of its population, came to be the
third largest communist country in the world.[30]

28 Liew Chen-Chuan, *op. cit.*,
p.102.

29 Muzafar Desmond Tate, *The
Malaysian Indians: History, Prob-
lems and Future* (Kuala Lumpur:
SIRD, 2008), p.82.

30 For the historical origin of
communism in Indonesia, see
Ruth T. Mcvey, *Kemunculan
Komunisme Indonesia* (Jarkata:
Komunitas Bambu, 2010).

31 Syed Husin Ali, *op. cit.*, p59.

32 Abdullah C.D., *Memoir Abdul-lah C.D.(Bahagian Pertama)— Zaman Pergerakan Sehingga 1948* (Kuala Lumpur: SIRD, 2005), p.111.

33 You Li, trans., *Islam, the Malays and the Communist Party: an Interview with Abdullah C. D, Rashid Maidin and Abu Samah* (Kuala Lumpur: Strategic Information Research and Development, 2007), p.78.

On the other hand, the British colonial government had also emphasized an identity based on religion and fermented narratives about how the communist thought was incompatible with religion. The post-independence Malay government, too, sought to fight against communist thoughts with Islamic doctrines. The Third Malaysia Plan of the 1970s stated that "An additional source of strength is that Islam and other religions practiced in this country continue to provide a strong bulwark against insidious communist propaganda"[31]. Abdullah C.D. the Malay CPM leader was once stopped by a stranger after he prayed at the mosque and was warned that "you need to re-embrace the Malay religion." Full of emotion, he said after this event that:

> *Why on earth did they ban me from the communist movement? In the anti-Japanese war, I met people from all walks of life and with various positions, but only those who would sacrifice everything bravely and fearlessly for their motherland could truly inspire me. I saw that, among the Malays, only the true communists and nationalists who were full of democratic and patriotic spirit could do that. On the other hand, those who blew their own horn with their deep religious knowledge chose to be dictated faithfully by the Japanese fascists. What did all this mean? Wasn't safeguarding our nation, religion and motherland part of the faith?*[32]

The monument erected in Peace Village in Sukhirin to commemorate the 50th anniversary of the Emergency of Malaya in 1948 (Photo from Ngoi Guat-Peng)

As described above, there were a good number of well-known religious leaders among the Malay CPM members. Abu Samah, for instance, mentioned that the Imam at the Temerloh mosque also joined the CPM and became an underground cadre.[33] As the Malay fighting group Tenth Regiment he led expanded its influence in 1960, Abdullah C.D. proposed the formation of a progressive party made up of Malay Muslim youths so as to connect all the patriotic young Muslims and religious leaders. Such a move triggered strong criticism from the government, which accused the CPM of exploiting Islam.[34] Even after the CPM came out of the jungle, this "communist phobia" continued to be stirred up by some for certain political purposes, and CPM became a bogeyman to stimulate a sense of unification among Malays. Malay leaders often stressed the need to fight against communism with a strong Islamic faith,

and played up the argument that "the communists are Chinese and the Chinese are communists." Regarding this, Mohamed Salleh Lamry once expressed a succinct view:

> ...while they followed the communist path of struggle and fought shoulder to shoulder with the communists, the fact is they were using CPM to achieve their objectives as nationalists. In other words, they remained nationalists staunch in their Islamic faith while adopting the Marxist-Leninist-Maoist thought as their theory and strategy in political struggle. Hence, they retained simultaneously the characteristics of the communists, Islamists and nationalists.[35]

To put it simply, the CPM under the framework of the Cold War took in communism as a strategic move, rather than taking it on as a belief or ideology. Only an understanding such as this can explain how the CPM could have properly managed the relations between communism, Islamism and nationalism. Meanwhile, patriotism, nation and democracy became the key factors that enabled the CPM to ally or cooperate with other left-wing forces. As part of the left-wing forces in Malay's political and cultural scenes, Malay CPM's involvement in the CPM's struggle evolved subsequently into one of the schools in Malay's local political spectrum.

34 Abdullah C.D., *Memoir Abdullah C.D.(Bahagian Ketiga)—Perjuangan di Sempadan dan Penamatan Terhormat*, opt. cit., pp.114-118.

35 Mohamed Salleh Lamry, *opt. cit.*, p.191.

死者的現下史學
試論冷戰島鏈的記憶政治與遺忘美學

許芳慈

將死者視為如同生前一般的個體，很容易模糊死者的本質。試著用我們認為死者可能採取的方式來想像死者：以集體的方式想像他們。這個集體不只會跨越空間孳長，也會跟隨時間繁增。它將包含所有活過的人。也就是說，我們也將被想像成死者。生者將死者簡化為曾經活過的人；然而，死者早已把生者涵括在自身的大集體之中。

—— 約翰・伯格〈死者經濟學十二論〉[1]，2007

1　約翰・伯格。〈死者經濟學十二論〉，吳莉君（譯），《留住一切親愛的：生存・反抗・慾望與愛的限時信》（台北市：麥田出版社，2016），頁16。原文請見：John Berger, *Hold everything dear: Dispatches on survival and resistance* (Vintage Books, 2008).

2　阿席斯・南地，〈記憶之工〉，「亞洲現代思想年度講座（Modern Asian Thought Annual）」（新竹：交通大學，2014. 07）。（參照現場發送，由張馨文譯，邱延亮校訂之譯文，該演講隨後發表於《人間思想》第九期，2015 年春季號。）

3　Matt Bluemink, "Stiegler and Derrida: The Technical History of Memory", March 24, 2015, *Blue Labyrinths*. 18 March, 2016 (https://bluelabyrinths.com/2015/03/24/grammatisation-the-technical-history-of-memory/).

I.

之於死者，檔案是動詞還是名詞？抑或，檔案以言說中的矢量信息存在，闡釋著死者在當下某種單向存在現況，延續著這個脈絡，以驅動檔案為目的而遭再現的死者，除了其「外部」作為憶訣的功能 [2]，使格式化的條目式短記憶得以不斷地被調閱之外，其相對應的長記憶，或是柏拉圖提出的「靈魂記憶」，是否還存在於死者「內在」的集體精神光景中 [3]？如何理解死者存在於當下的意義？倘若將約翰・伯格於 2007 年以巴勒斯坦等在地流放的政治對抗運動為對象發表的〈死者經濟學十二論〉，與柄谷行人面對日本戰終諸多精神癥結進行反省的〈「已死的他者」和我們的關係〉並置閱讀，兩個從表面上看來毫不相關的事件，事實上體現著某種「內在緊密相連的歷史結構」所造就的情感動力，督促兩人不約而同地透過書寫表現與死者對話的迫切性。

承襲著上述的認知座標，本文將嘗試透過死者與檔案的辯證，返身諦視�於太平洋海域、亞洲大陸之間的帶狀島群，特別是在二戰時期結束後，其指稱意符隨即從「太平洋劇場」轉為「第一島鏈」，那朵悠然從廣島的哀鴻遍野中悠然竄起的蘑菇雲，促成了這個地域詞彙的更迭，也在視覺上衝擊了英籍作家喬治・歐威爾（George Orwell），觸動他在 1945 年於倫敦《論壇週報》發表名為〈你與原子彈〉的評論，文中他不單預示未來的區域重整將以全球規模，深受某種「意識型態意蘊」的牽制，就歐威爾的解釋那是「一種世界觀、一種信仰更是一種社會結構」，更重要的是「冷戰」一詞也同

時在歐威爾的筆墨滲潤紙張中化育而成 [4]，使得往後諸多歷史化探究「冷戰」的嘗試，也不得不返還這個銘刻於戰後心靈的震懾景貌——瞬息的飛灰煙滅之上緩緩騰升的蘑菇雲 [5]。

至此後「冷戰」在國際關係、軍事政策研究乃至大眾輿論中，都不約而同地指向一個二元對立的世界觀，雙方陣營分別護擁摧毀性核武，並持續發展破壞性武器的恐怖平衡來深化分一為二的鴻溝，所謂「第一島鏈」便是在這個前提下，由美國國務卿杜勒斯於 1951 年韓戰時期提出，以防堵中華人民共和國與前蘇聯等共產勢力為目標，在太平洋的前沿所進行的軍事部署，1951 年美日雙方簽署的《美日相互合作與安全保障條約》便體現著以美國為首的民主陣營，將「第一島鏈」化作冷戰最前線的謀畫 [6]。因此，回歸生命經驗中的歷史現實，當伯格與柄谷的論述皆可溯源到第二次世界大戰後，國際政治無縫接軌地挾冷戰話術所進行權力的重新分配，這不單單是區域政治疆界劃定的議題，在弗朗西斯·福山（Francis Fukuyama）於 1989 年回應蘇聯瓦解後提出「歷史的終結」命題之際，因為共產主義式政治運作的想像失效，社會內部垂直階級的區異與矛盾發生了跨國式地劇加強化，霸佔文化表現形式並收編學術體系回應存在困境的機制，同時癱瘓死者與現下的對話可能 。

4　George Orwell, "You and the Atomic Bomb." George Orwell's Library. 3 Aug. 2013. Web. 23 Apr. 2015. (http://orwell.ru/library/articles/ABomb/english/e_abomb)

5　R. Chow, *The age of the world target: Self-referentiality in war, theory, and comparative work* (Duke University Press, 2006).

6　Richard H. Immerman. *John Foster Dulles and the Diplomacy of the Cold War* (Princeton University Press, 1992), p.203.

II.

以無敘事後劇場取徑為人所知的日本籍劇場工作者高山明與其 Port B 團隊於 2008 年以豐島區東池袋太陽城大廈為主題創作的「陽光 62」便是在這個脈絡下，重新檢視「終戰」之於日本當下集體性失憶的問題。建設工事於 1973 年開始，由季節集團創辦人堤清二主導，太陽城大廈完工於 1978 年，座落在池袋區，高六十層樓，不論從哪個角度都必須帶著仰望的視角，引領這座當時全東京最高的建築。讚嘆聲中又有多少人記得，這座日本戰後建築工藝的驕傲，可是座落在當年專門關押受戰後遠東國際軍事法庭定讞為戰犯，並且是處決如同東條英機等甲級戰犯之所在的巢鴨監獄，連當今日本首相安倍晉三的外公，同時也曾在美國扶持下於 1970 年代出任日本首相的岸信介，也曾因其甲級戰犯嫌疑的身份收押於巢鴨監獄。倘若再將時間軸往回推，日本政府於二戰期間也在巢鴨監獄處死大量左翼運動者，其中最為人知的當是 1944 年因佐爾格間諜事件蒙難的尾崎秀實。西武集團成功將巢鴨監獄連同日本的戰爭記憶連根剷除，並將這一區轉化為東京最繁華的商業區之一，對高山明來說，這種地景的改變直接導致了「都市言說的解體」，所謂「終戰」自然也無法進入社會脈絡中獲得倫理與精神上的認知。

經歷過第二次世界大戰，在世時曾以筆名辻井喬發表，兼具詩人、作家、兼實業家身份的堤清二，為何決定將太陽城商廈如紀念

《陽光 62》的參與者們，背景為
陽光 60 大廈（2008 年三月東京
池袋區）。（圖片版權：Takayama
Arkira PortB）

碑一般地豎立？摒除商業利益，其私密的個人考量早已無從考察。
然而，面對眼前太陽城商廈在日本戰後記憶地景上造成的龐大窟
窿，高山明的「陽光 62」試圖透過一趟以太陽城大廈為路徑重心的
都市漫步，隨機地安排觀眾五人為一組，參與者有的接收廣播收音
機傳來的訊息與指引，有的負責拍照記錄旅途過程，有的擔任方向
定位指導，也有人負責計時，各司其職藉著彼此的聆聽與溝通，以
身體的移動與感知映照出不容見於日本當今公共歷史意識中的「異
質空間」，在其中身體感官經驗透過相互傾聽的詩意，面對集體失
憶的事實，在這趟旅程中戰爭經歷、戰敗壓抑與戰後冷戰推動泡沫
經濟的空間重疊貫通了時間。在高山明「陽光 62」的都市劇場脈絡
中，面對遺忘儼然成了記憶不求痊癒的精神療癒，如同高山明反思
這齣創作而做出的回應：「戲劇是沒有結論的法庭，而以審判為方向
前進的過程中，所發生的對話即是教育。」[7]

7　高山明，〈Babel（巴比倫／雜
音）——語言／都市的統合與解體〉，
「日曜日式散步者：高山明 X 超現實
主義與都市記憶工作坊」（台南：志開
國小，2016.03）。

III.

從伯格與柄谷兩位批判知識份子的陳述到高山明的都市劇場實踐，
都投射出與冷戰話術不同的當代生命政治型態，而這股敘事似乎都
不約而同地暗示著，以國族文法書寫的歷史，取消了當代贖回死
者聲音的權力，並招致倖存者的瘖啞。以台灣電影新浪潮導演萬仁
於 1995 年發表的劇情片《超級大國民》為例，由資深演員林揚飾演

的許毅生彷彿是白色恐怖倖存者的標準謄本。由於參與讀書會遭逮捕後未經審訊直接入監。許毅生除了必須面對妻喪的缺席，也錯失了參與獨生女成長，數十年的牢獄生命，始終不得至親的體諒與理解。擔負著當年因嚴刑拷打出賣同伴的罪惡感，他陰鬱壓抑的情緒貫串了全片的色調氛圍，直到接近片尾，許毅生拖著他孱弱微顫的軀體來到早遭世人忘卻的六張犁極樂公墓（又名戒嚴時期政治受難者墓園），幽暗的竹林內，撥開掩蓋在枯黃竹葉中，佇立著難以計數磚塊大小沒有名字的墳碑，老先生蜷蹲在碑林中給三十年前蒙難的夥伴點上一隻隻蠟燭，鳥瞰的鏡頭遠眺黃昏的台北都會地景，平行畫面下方黯黑，燃著點點火光搖曳在這片日頭月光都照不透的遍山野塚。

許毅生近五分鐘泣不成聲的台語獨白，揭開籠罩著許毅生的「罪惡、苛責、思念、悲憤」[8]，也遙應由吳念真撰寫的片頭：「霧散了景物終於清晰但是為什麼都含著眼淚」，姑且不論這份因為冷戰結構下，假託掃除共產黨人之名執行的國家暴力所撫育的悲情，如何由與戒嚴時期國民政府同樣親美的民進黨接收，並成功化歷史的悲屈為動力，把 1996 年將新公園更名為二二八紀念公園的台北市市長陳水扁送入總統府，推動台灣首次政黨輪替。在片中，伴著從摯友遭槍決的畫面中驚醒的許毅生，觀眾隨他的重訪而造訪了另一座台北市 —— 新店溪畔的馬場町、警備總部保安處（今日的獅子林大廈）、青島東路的警備總部軍法處（今日的喜來登飯店）—— 現在，死者的「集合住宅」是全島各地的二二八紀念館與紀念碑，上頭的肖像照片除了各自的姓名與編號外，他們臉龐上的情感喜憂，彷彿蒙上一層台灣國族意識濾鏡，僅有那些與太陽花運動的反中情緒光譜一致的政治正確，才得以在「哀悼的視閾」之內獲得弔念與追懷，其他逾越這道光譜的死亡、族裔、生命歷程等等，都將棄置在歷史所遺忘的幽谷中。早逝的台灣美術史學家陳香君，在遺作《紀念之外：二二八事件‧創傷與性別差異的美學》便以她實地造訪嘉義二二八紀念公園和台北二二八紀念館的心得開啟整本書的討論，細膩地彙整了詹姆斯‧揚與皮耶‧諾哈記憶與場域的相關論述提問：「人們將記憶的社會責任留在記憶場域（lieux de mémoire，或譯為「記憶所繫之所」）上，如紀念館、紀念碑或是其他物件，於是他們就可以遺忘，繼續過著輕鬆好過的生活？」[9]換言之，從東京巢鴨監獄到台北戒嚴地景所經歷的資本建築置換與抹除，也就是諾哈所指的那些消逝的「記憶棲居之所」[10]，取而代之的是將死者名詞化的紀念碑，即使每一位列名在紀念碑上的亡魂來到馬場町的路途遠近方向不一，他們存在的當下意義，卻或多或少侷限於為合理化新國族的誕生化育，召喚特定歷史所存在的憶訣。

8　摘自《超級大國民》片中許毅生自白中的陳述（約略於 1:47:36 處）。

9　陳香君。〈引言〉，周靈芝、項幼榕（譯），《紀念之外：二二八事件‧創傷與性別差異的美學》（台北市：典藏出版社，2014），頁 26。

10 See Pierre Nora, "Between Memory and History: Les Lieux De Mémoire", *Representations* 26 (1989): pp.7-24. *Jstor*. Web. Jan. 2016, 7.

IV.

11 鶴見俊輔，〈向一九三一年至一九四五年的日本趨近〉，邱振瑞（譯），《戰爭時期日本精神史1931–1945》（台北市：行人出版社，2011），頁11。

12 即使鶴見在這個論調上仍以沖繩作為日本國族的一部份來理解，但他同時有意識地反轉本島中心論，援引民俗學家柳田國男的研究，投出「日本文化的祖先是從南方經沖繩到日本」一說，強調相較於受政府機制全面控管的日本本島人，沖繩人因為保有較完整的民間儀式自我組織，因此日本本島經驗必須重視。

13 參見鶴見俊輔。〈關於轉向〉，邱振瑞（譯），《戰爭時期日本精神史1931–1945》（台北市：行人出版社，2011），頁26-31。特別是書檢討共產主義者思考方向轉變一事，鶴見視其為「大致意為在國家的強制下所產生的思想變化。這時期所展現的強制力，就是國家的強制力。」當然其中鶴見也沒有忽視自發性的決定因素。

14 新崎盛輝，〈上部：美軍統治時代：1945年–1972年〉，胡冬竹（譯），《沖繩現代史》（北京：三聯書店，2010），頁25。

鶴見俊輔在《戰爭時期日本精神史1931–1945》這本將特定年代的日本精神結構，視為東亞現代史的「共同畫卷」[11] 著手考掘的知識工程，提供了關於遺忘的區域性意義關鍵的分析平台。在其結語的前一章，鶴見以日本本島人的歷史經驗，檢討了沖繩問題並以「戰爭的終結」為其篇名，這樣的命名與篇文安排，彰顯了兩個關鍵的議題。首先，文章從1945年入手，往前後展開闡述沖繩問題，加上文內檢討的美軍基地議題乃至沖繩復歸（1972年），遠遠超過書名的斷代框架，這樣時代錯置的巧妙著墨，為的是撥開籠罩在以日本本島戰爭記憶之上的蘑菇雲，提醒普世眾人看見經歷燒夷彈洗禮的沖繩列島作為太平洋戰爭的最後篇章，更重要的是，鶴見以他自身參與1960年代反岸信介政府強行通過日美新安保條約，親身組織公民運動團體「沈默的多數協會」的經歷，以沖繩為參照點[12] 貫徹書中討論的「十五年戰爭」的思想史意涵，提升「轉向」[13] 一詞所體現的尖銳地批判力道。換句話說，日本政府如何在1945年8月15日宣布投降的同時，默許美軍對沖繩列島的持續佔領，即刻「轉變」與美國的敵對狀態（包含國民的情感結構無法回應，美國主導日本國政的內化），政策性地支持美國軍事政府對沖繩的統治，即使美方的佔領政策完全違背其守護民主與民族自決的國際外交準則，於中美備忘書中，美方文件曾提及：「只要是軍政府統治琉球列島，就不可能確立恆久的民主政府和完全的民主。」[14] 在其憲法第九條「日本不能有開戰權」的前提下，日本政府犧牲已在太平洋戰爭中失去四分之一島民的沖繩，並委身擔任美國發動韓戰與越戰最大的後勤支援。

丸木位里（1912-2000）與丸木俊（1901-1995），〈沖繩戰圖〉，1984，設色水墨，4×8.5公尺（攝影：許芳慈）

「玉碎」是 1945 年美軍鋪天蓋地轟炸沖繩的三個月「鐵風暴」中，最闇黑的側面，沖繩大島叢林中有著因珊瑚礁岩形成的天然地下洞穴，在洞穴中是沖繩人口中「戰爭中的戰爭」發生的所在，當時由牛島滿中將率領的日本士兵，謹守東機英條「政戰訓」立志與美軍戰到最後一兵一卒，不但動員青壯男女體現為保國體／天皇的完整，尋求自我犧牲的精神，他們也將槍口對準躲藏在地下洞穴中與森林裡的沖繩婦孺，要求他們集體自決（又稱為「強制集團死」）。來自日本本島，同樣活過太平洋戰爭時期的藝術家夫妻丸木位里與丸木俊，在到訪沖繩期間，傾耳聆聽戰時倖存者們的經歷後，深感戰時沖繩人們體驗的「地面戰」，與本島經歷之「空襲」經驗迥異的慘烈，於 1984 年以倖存者的証言為創作立基，協同完成了的巨幅水墨設色〈沖繩戰圖〉（4 x 8.5 公尺）。佇立在巨幅畫作之前，墨黑如濃淡不一如硝煙扭曲地暈散滿溢畫面，硃紅是戰火燒夷的天空，也是集體自決的血河流注到青靛的海水中，那片被美軍戰艦覆蓋的藍海。從戰爭的倖存者，對於死者的告白，不論自發與否，都不免帶著死者遺言執行人的精神狀態活著，死者則因為他們的死亡持續地活在倖存者的生命中。〈沖繩戰圖〉的証言性，也恰恰來自於這股嘗試體現倖存者感受的死亡所做的努力。相對於在國族論述中動彈不得的死者，作為死者之罔兩的倖存者卻總是在戰爭記憶中遭到遺忘的一群。

<div align="center">

V.

</div>

法籍人類學家馬克・歐傑（Marc Augé）曾這樣剖析記憶與遺忘的關係：「記憶由遺忘雕琢而成，如同海岸的輪廓是海洋的創作。」[15]人的存在不單是由其保有的記憶定義，同時也需要考量所遺忘的那些，不僅要去檢討遺忘的成因後果，同時也要試圖將遺忘視為記憶的一種形式，對歐傑來說：「遺忘是記憶的生之驅力。」[16] 將美國意志打造的冷戰島鏈 —— 日本、沖繩、台灣 —— 放到歐傑對於遺忘的討論中理解，死者與檔案的關係是否有可能朝向某種以生之驅力帶動為前提所重新建構的相對關係？倘若遺忘能夠被理解為檔案實踐的精神動能，進而構成具有釋放歷史意識潛力的檔案庫，是否冷戰的區域政治以及其體現的知識型態會有重構的可能？從高山明的「陽光 62」都市劇場，到萬仁在《超級大國民》安排許毅生走過消失的台北戒嚴街景，乃至丸木夫妻透過繪製〈沖繩戰圖〉進行傾聽倖存者的工作，由認識遺忘的感性層次驅動檔案實踐，釋放禁錮在碑上銘文的死者，帶領我們重新認識死者所體現的現下意義，如此，死者就不單單是非生命形式存在的意識，更是我們認識過去與現在動態關聯的重要歷史觀點。

15 See Marc Augé, *Oblivion* (University of Minnesota Press, 2004), p.20。此段譯文如下："Memories are crafted by oblivion as the outlines of the shore are created by the sea."

16 同前註 p.21. 此段譯文如下："... oblivion is the life force of memory and remembrance is its product."

Historiography of Death:
Preliminary Thoughts on Memory Politics and the Aesthetics of Oblivion along the First Island Chain[1]

Hsu Fang-Tze

To see the dead as the individuals they once were tends to obscure their nature. Try to consider the living as we might assume the dead to do: collectively. The collective would accrue not only across space but also throughout time. It would include all those who have ever lived. And so we would also be thinking of the dead. The living reduce the dead to those who have lived; yet the dead already include the living in their own great collective.

—John Berger,
Twelve Theses on the Economy of the Dead (1994)[2]

I.

In relationship with death, does the notion of archive resemble a noun or a verb? Discursively, the term "archive"more or less suggests the singularity of death in the contemporary. Apart from being represented by the archive and being externalized as a mnemonic device[3] for retrieving the short-term and/or cataloged memory related to the event of death, comparatively speaking, would there be memories of the world-soul (to use Plato's term[4]) existing and interiorizing within the collectiveness of death? How could one better comprehend the contemporaneity of death? How could one historio-politically situate the meaning of death within the present embodied by the living one? Two readings of the critical meaning of death go beyond the metaphysics and land right at the heart of the politics of historiography. First, there is John Berger's

1 Yoshihara Toshi indicates "The term first island chain refers to a transregional offshore archipelago that stretches across Eurasia's entire eastern seaboard. While Western sources differ over the exact geographic scope of this island chain, most concur that this long band of islands centres primarily on the Japanese home islands, the Ryukyus, Taiwan, and the Philippines." He also traces the inception of the geopolitical arrangement back to General Douglas MacArthur's famous address to the joint session of Congress on April 19, 1951, pointing out that "MacArthur argued that control of "a chain of islands extending in an arc from the Aleutians to the Marianas" would enable the United States "to dominate with sea and air power every Asiatic port from Vladivostok to Singapore and prevent any hostile movement into the Pacific." See, Yoshihara, Toshi. "China's vision of its seascape: the first island chain and Chinese seapower." *Asian Politics & Policy* 4.3 (2012): pp.293-314.

"Twelve Theses on the Economy of the Dead" that reflects upon his observations regarding the notion of exile and the politics of resistance with respect to Palestine's independence movement. Then, there is Kojin Karatani's "The Relationship between Us and 'the Others Who Already Died'"[5] that reflexively questions the conundrum of postwar Japanese people to recognize the historicity of the end of war. If one could analytically read John Berger's text alongside that of Kojin Karatani and contextually approach the seemingly irrelevant historical backgrounds of the two writings, one would encounter a sense of emotional motivation that not only reverberates between these two leading intellectuals but also coheres in an intimately connected structure of history. In which case, it is precisely such an emotional motivation that triggers these two scholars to express a sense of historical urgency to re-establish a conversation with death.

By referring to the experiential epistemology exemplified by Berger and Karatani, I attempt to historicize the geopolitical formation of the First Island Chain by foregrounding the dialectical tension between "the Others Who Already Died" and the archive. From the Pacific Theatre to the First Island, it is particularly crucial to situate such a paradigm shift of geopolitics within the transition from the termination of World War II to the arrival of the Cold War, as inaugurated by the glowing mushroom cloud above Hiroshima and Nagasaki and as foreseen by the renowned British author George Orwell, in his 1945 essay titled "You and the Atomic Bomb." This is also why much of the literature on the Cold War gives etymological credit to George Orwell's article, which was first published in *Tribune*, a London-based socialist weekly. Writing in the aftermath of the nuclear bombing in Hiroshima and Nagasaki, Orwell rightly forecast a geopolitical power reconfiguration characterized and reinforced by "ideological implications—that is, the kind of world-view, the kind of beliefs, and the social structure that would probably prevail in a state which was at once unconquerable and in a permanent state of 'cold war' with its neighbors."[6] If horror is the collective state of mind beyond the division between communist and democracy camps, whereby the antagonistic dichotomy between the two is what the general public commonly associates with

2 John Berger, "Twelve Theses on the Economy of the Dead." *Left Curve,* no.31 (2007), p.77.

3 Ashis Nandy, "Memory work", *Inter-Asia Cultural Studies* 16.4 (2015), pp.598–606.

4 Matt Bluemink,"Stiegler and Derrida: The Technical History of Memory." *Blue Labyrinths*, March 24, 2015. Web. 18 March, 2016. (https://bluelabyrinths.com/2015/03/24/grammatisation-the-technical-history-of-memory/)

5 "The relationship between us and 'the Others who already died'" can be found in Kojin Karatani's Japanese monograph titled *Ethics 21* published by Heibonsha Limited (平凡社ライブ ラリー) in 2003.

6 George Orwell, "You and the Atomic Bomb", George Orwell's Library, August 3, 2013. Web. April 23, 2015. (http://orwell.ru/library/articles/ABomb/english/e_abomb)

the period, the mushroom cloud as the key vision of the Cold War would probably be the only imaginable consensus between the two ends of this ideological spectrum.

Since Orwell's literalization of the Cold War, the term has come to unanimously imply an operational dichotomy both in the academic field of international relations and military history and in the daily conversation about politics. What the Cold War's binaries have symbolized is the balance of terror between the camps of liberal democracy and communism. However, the division between the two opposite ends of this spectrum has also been deepened into an abyss, which can be attributed to the cataclysmic nuclear weaponry held by both camps and their continuous expansions of those military forces for massive deconstruction. Under such circumstances, John Foster Dulles, the then U.S. Secretary of State, proposed the notion of the First Island Chain in 1951 during the heated Korean War as both a strategical alignment between pro-American governments along the archipelagoes and as guidelines for the American military deployment. As part of the policy of American Cold War containment, the signing of the Treaty of Mutual Cooperation and Security between the United States and Japan in 1951 has concretized the First Island as the Pacific frontline for the democratic camp dictated by the United States.[7] Therefore, according to the lived experiences of historical realities on the ground, both Berger's and Karatani's theses of reconsidering death can find their shared root in the redistribution of colonial power through the state-building processes in their respective contexts, wherein the reigns of terror were facilitated by the Cold War rhetoric. In other words, the attempt to recognize the historicity of the First Island Chain is not only about the geopolitical procurement of boundaries but also, more essentially, about the homogenization of the relationship between the past and the present into a unified narrative of national history. Francis Fukuyama's iconic thesis "The End of History"(1989) exemplifies this triumph of the capitalistic production of social relations in accordance with the failures of the communist mode and of other alternative modes of political imaginations. Fukuyama's thesis is also a remark on how American hegemony intensifies the class division at the transregional scale, while paralyzing the

7 Richard H. Immerman, *John Foster Dulles and the Diplomacy of the Cold War* (Princeton University Press, 1992).

Participants of the *Sunshine 62* with the Sunshine 60 in the backdrop. (March 2008 Ikebukuro Tokyo) (Photo credit: Takayama Arkira PortB)

political capability of cultural expressions and knowledge production in the realm of academia. Death can never find closure from the present, which loses contact with the past in the linearity of time consolidated by national history.

II.

Known for their post-dramatic methods, Japanese director Akira Takayama and his theater collective Port B launched an urban theatre project titled *Sunshine 62* in 2008. By foregrounding the collective amnesia regarding the political meaning of the end of the war, *Sunshine 62* was a performance of a tour. The itinerary of the tour was centered around Sunshine 60. Adjoining the Sunshine City complex, Sunshine 60 is a 60-story, mixed-use skyscraper in Ikebukuro, Toshima, Tokyo. It was developed by Seiji Tsutsumi, the founder of Saison Group. Construction of Sunshine 60 commenced in 1973 and was completed in 1978. Being one of the tallest buildings in the 1970s, people could see it from all over Tokyo when they looked at the city skyline. Ironically, while the majority of residents are still impressed by such an accomplishment of civil engineering, very few realize that Sunshine 60 is actually built on the site of the former Sugamo Prison. From Tojo Hideki to Nobusuke Kishi, all the Class A war criminals were jailed in Sugamo

Prison after the International Military Tribunal for the Far East. Moreover, during World War II, the majority of leftist intellectuals and activists were executed in Sugamo Prison, including Hotsumi Ozaki. In other words, the construction of Sunshine 60 not only transformed the area into one of the busiest business districts in Tokyo but also eradicated the traces of the war in Japanese society, which is represented by the deconstruction of Sugamo Prison. For Takayama, such a drastic shift in the urban landscape led directly to the "deterioration of discoursing urban parable," and as a result, the historical meaning of "the end of the war" can never be a part of the postwar Japanese social context and be acknowledged by the ethics of society.

What does it mean when someone like Seiji Tsutsumi, a successful businessman and a poet who wrote under the pseudonym Tsujii Takashi and who lived through World War II, decides to build Sunshine 60? Apart from the business reason, there is no way to investigate Tsutsumi's motivation for constructing Sunshine 60—a monumental building erected upon the city landscape of Tokyo. For Takayama, Sunshine 60 is an abyss on the postwar Japan memoryscape, hollowed out of the Sunshine City complex. Therefore, *Sunshine 62* attempts to create a heterotopia by activating the historical consciousness of the Japanese public in the present-day. *Sunshine 62* is urban theatre, in which the paths of strolling navigators weave around the neighborhood of the Sunshine City complex. The participants are randomly in groups of five. During the tour, each of them has a designated task and the collaboration between the team members is the key to completing the journey. One person is responsible for timing the entire exploration while another guides them using a map. Someone else has a radio and receives directions from it, while a fourth takes pictures of the group to document the journey. Through this interdependency, in which these performative participants must coordinate and converse with one another, Takayama creates a situation that enables the participants to explore their own sensorial experience via the poetics of listening to each other. The journey encapsulates a time-space temporality, which traverses layered strata of modern Japanese history. These interdependent layers consist of the dramatic experiences of war, the oppression of the surrender, and the economic miracle propelled by the Cold War. As Takayama once said, "Theatre is a court seeking no decree but seeking a direction towards a trail. What happens along the way is what pedagogy and dialogue come to stand for." In the case of Takayama's *Sunshine 62*, the theatrical encounter with the collective amnesia, hence, offers participants no cure for their own forgetfulness but a collective therapy that memorizes the sociological mechanisms of oblivion.

III.

What has been revealed by the above-mentioned examples, from the theses of John Berger and Kojin Karatani to Akira Takayama's urban theater project, is a regime of biopolitics that differs drastically from the dominant narrative of Cold War binaries. These critiques of history, exemplified by Berger, Karatani, and Takayama, coincidently illustrate how the historiography of the nation state has muffled people's ears and subsequently silenced the voices of the dead. Another example of such politics of histography in terms of the silencing mechanism of historical writing can be found in *Super Citizen Ko* (1994). Directed by Jen Wen, one of the auteurs of Taiwan's New Wave cinema movement of the 1980s, the main protagonist I-Sheng Ko (portrayed by actor Lin Yang) represents a typical survivor of the White Terror. In *Super Citizen Ko*, Ko is detained without trial and thrown into jail with an accusation that he was a member of a Marxist reading group. Not only was he absent at his wife's funeral but he also failed in his parenting responsibilities. Burdened with the pain of betrayal for his survival during the heinous torture and his daughter's denial of him as her father, Ko's sorrow permeates the entire film and tints almost every scene with a unified dark monotone.

Towards the end of the film, Ko drags his aged body to the Memorial Cemetery for Victims of Political Persecution during the Martial Law Period on the outskirts of Taipei City. Walking like a candle flickering in the wind, Ko totteringly navigates through the bamboo forests and uncovers a cluster of tombstones with no names inscribed upon them. In this final scene, the camera first zooms onto Ko's wrinkled face, lit up by a candle. Ko is squatting among the tombstones and kindling candles for those who were executed without trial thirty years ago. The camera then shifts to a bird's-eye view and pans through Taipei from afar. Sparkling candles visually correspond to the urban landscape in the evening, with the lights from occupied houses in the city. By setting up this juxtaposition between the lively city and the bleak cemetery, between the solitude represented by Ko on the mountain and the togetherness suggested by those households at foot of the mountain, and between the fading memory of the deaths and the saturated material well-being of the living, Ko delivers an emotionally charged monologue in Taiwanese, which unveils the past that haunts him throughout the film. The words uttered by Ko in this five-minute monologue, such as "guilty, self-blame, longingness, and grief," resonate with what was written by the acclaimed Taiwanese scriptwriter Nien-Jen Wu on the caption right at the beginning of the film: "How come there are still tears in my eye even when the scene has finally cleaned after the fog dissipated." Regardless, of how such a tremendous anguish has mobilized the equally pro-American opposition party under the long shadow of the Cold

War, this collective grief has successfully been transformed into political momentum. It is this politicized mourning that sent Chen Shui-Bian into the Presidential Hall in 2000, marking the first change in the governing party in the history of Taiwan democracy.

In one of the scenes in *Super Citizen Ko*, the audience travels through Taipei with Ko, who is abruptly woken by the reoccurring nightmare about his best friend, who was executed in front of him. From Machangting Memorial Park on the banks of Xindian River, to the Security Wing of the Taiwan Garrison Command in the Ximending district (the Lion Forest Building today), and to the Judge Advocate's Department of the Taiwan Garrison Command on Qing-dao East Road (the Sheraton Hotels and Resorts today), following Ko's footsteps, the audience meanders through the heterotopia of Taipei. The audience sees the systematic cleansing of architecture once the scene of political mass killing. This justified erasure was done by overwriting the signs of remembrance with symbols of capitalist progression in the name of urban rejuvenation.

Nowadays, the amalgamated dwellings of the dead are the monuments found in every city on Taiwan Island. Portrait photographs of these victims of the White Terror are displayed in these memorial halls but the monuments have been reconfigured into an integrated part of Taiwan nationalistic ideology. As a result, the individual narratives and personal emotions of these political victims have inevitably been filtered out by the grand narrative of history and the ritualistic commemorations. The late Taiwanese art historian Elsa Hsiang-Chun Chen discussed such entangled memory politics in her posthumous work *Beyond Commemoration: The 2-28 Incident, the Aesthetics of Trauma and Sexual Difference*. She unfolds the thesis with her reflections of a series of site visits to the 228 Peace Memorial Park in Taipei and Chiayi.[8] By recounting her experiences in these two sites, Chen compares James E. Young and Pierre Nora's theoretical analysis on the subject of memory and site to raise a profound question, "When people can deposit their social responsibility of memory to the *milieux de mémoire* represented by memorial halls, monuments, or other objects, does that mean that they

8 Chen Hsiang-Chun, *Beyond commemoration: the 2-28 incident, the aesthetics of trauma and sexual difference*, Diss. (University of Leeds, 1995).

can forget and continue their life and business as usual?"[9] In other words, what has been erased by the symbols of capitalist progression, exemplified by Sugamo Prison in Tokyo and the fading martial law landscape in Taipei, is precisely what Nora refers to as the dissipation of *milieux de mémoire*. The replacement of the real environment of memories are the names of the dead listed up on the monuments. Although those who are commemorated in public ceremonies were from different backgrounds and were executed for various reasons, their meaning in the present has very much been streamlined into a mnemonic device for a specific past—a hegemonic past for legitimizing the birth of the nation state.

9 See Pierre Nora, "Between Memory and History: Les Lieux De Mémoire." *Representations* 26 (1989), pp.7-24. *Jstor*. Web. Jan. 2016, 7.

10 Moriteru Arasaki, *Okinawa Gendaishi* (A Contemporary History of Okinawa),(Tokyo: Iwanami-shoten. 1996), p.2.

IV.

"The postwar lived experience of Okinawans is the sharpest sword piercing through the self-contradictory of the post-war Japanese history,"the late Okinawa historian Arasaki Moriteru forthrightly addresses in the introduction of *Okinawa Gendaishi* (*Modern History of Okinawa*, 1996).[10] If the focal point—the end of the war—of the pandemic commemorative act can be re-examined from the historical

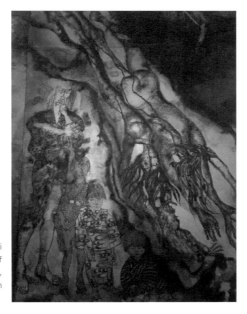

Iri Maruki (1901-1995) & Toshi Maruki (1912-2000), Picture of the *Battle of Okinawa*, 1984, Watercolor and Ink, 4m×8.5m (Photo by Hsu Fang-Tze)

trajectory of Okinawans' lived experiences, the discussion can't take off before we clarify, supposedly, which war should be ended. On 1st April 1945, the American troops disembarked on the northern part of Okinawa island; the Battle of Okinawa represents the epilogue of the Pacific War. For the Allied forces, the battle was codenamed Operation Iceberg, but it was *tetsu no bofu* (鉄の暴風) to Okinawans, which literally means typhoon of steel.[11] In 1984, an artist couple, Iri Maruki (1901–95) and Toshi Maruki (1912–2000), from the Japanese mainland accomplished their 8-meter-long and 4-meter-high watercolor painting titled *Battle of Okinawa*. The eight-part series on war atrocities critically reveals that the brutality of the Battle of Okinawa, which killed one out of four Okinawan residents (around one hundred and fifty thousand), was also contributed to by the command of *Gyokusai* (shattering like a jewel), which is a command from the central Japanese military government and literally means "to die gallantly as a jewel shatters" in order to protect the completeness of the Japanese Empire.[12] Apart from what is visually depicted in the watercolor, including scenes of people jumping off a cliff as a group and Japanese soldiers bombing children with grenades, there are a few lines of verse written in Kanji (Japanese written in Chinse characters). It was Hideki Tojo's famous *Senjinkun*, "The Code of Conduct on the Battle", that propagated such an agenda. It is also important to mention that Mr. and Mrs. Maruki are also the artists behind the monumental *Hiroshima Panels* (1950–1982). However, unlike the enduring status of Hiroshima and Nagasaki on our collective memoryscape, those who lost their lives during the three-month Battle of Okinawa—including local civilians, forced laborers from Korea and Taiwan who died serving the Imperial Japanese Army, and thousands of average Japanese and American soldiers who were killed—have slipped into oblivion in the global mediascape.

Hence, for Okinawans, the Battle of Okinawa can never be simplified as the battle between the Allied forces and the Imperial Japanese Army. In the underground caves and forests, there were battles within battles. It was even more unacceptable when *Gyokuon-hoso* (the Jewel Voice Broadcast) aired throughout Japan in which Japanese Emperor, Hirohito, read out the Imperial Rescript on the Termination

11 The phrase 'Typhoon of Steel' becomes the common synonym of the Battle of Okinawa among the Okinawan after *Tetsu no bofu: Genchijin ni yoru Okinawa-senki* (Typhoon of Steel: War Record of the Battle of Okinawa by Local People) published by *Okinawa Taimusu* Sha (Okinawa Time) in 1950. The book was also circulated in mainland Japan through the *Asahi Shinbun* Sha (The Asahi News Company).

12 Sato Hiroaki, "Gyokusai or 'Shattering Like a Jewel': Reflection on the Pacific War." *The Asia-Pacific Journal*, vol.6, no.2, 2008, https://apjjf.org/-Hiroaki-Sato/2662/article.html.

of the War. The unconditional surrender of the Japanese military then leads to the immediate American military occupation and the establishment of the United States Military Government of the Ryukyu Islands; it was the beginning of years and years of militarization. The American military occupation was later normalized by the Treaty of San Francisco, signed in 1951. Since a significant number of farmlands were claimed by the American military for building up military camps and army bases, the majority of Okinawans were forced to join the service section to support the logistical needs of military operations in Okinawa. By the 1950's, since the economic stabilities of Okinawa were heavily dependent on the American bases, the labor movements surging from the Japanese mainland was harshly suppressed by local authorities under the political climate of the Cold War.

Rinsho Kadekaru's *Jidai no Nagare* (The Flow of Time) genuinely portraits this sense of forlornness, which is Kadekaru's identity as a survivor. The veteran soldier from the Southeast Asian battlefield during the Pacific War is welcomed by the death of family members upon his return, which best reverberates with the desolate sound of *sanshin* (Okinawan three-stringed lute). *Jidai no Nagare* begins as follows:

> *From the Chinese era to the Japanese era*
> *From the Japanese era to American era*
> *This Okinawa sure does change a lot.*

Isao Nakazato, one of the leading film scholars in Okinawa, once described the complex of the screen culture of Okinawa by referring to Kadekaru's *Jidai no Nagare*.[13] In a sense, the cinematic representation of Okinawa is as exploited as the archipelago itself. Let's take *Himeyuri no To* (Tower of the Lilies, 1953), produced by Toei Company, and *The Teahouse of the August Moon* (1956), produced by Metro-Goldwyn-Mayer (MGM), as examples; the former was directed by Japanese director Imai Tadashi following a script about a group of girl students sacrificed during the Battle of Okinawa, and the latter was a musical drama featuring Marlon Brando as an Okinawan interpreter joyfully serving the American base. The former ignores the crimes of *Gyokusai*, which forced thousands of inno-

13 Isao Nakazato, "'Liuqiu Dianying' De Shihijie—Riben He Meiguo De Jiafeng Zhi Jian" (the World of "Ryukyu Film"—in the Crevice between Japan and America)." *Directions*, 2012, pp.103-111.

267

cent Okinawa residents to commit suicide, and the latter neglected the ongoing sex crimes committed by the American military personals. Both films were not shot in the Okinawa archipelagoes.

V.

Regarding the relationship between oblivion and remembrance, French anthropologist Marc Augé once said, "Memories are crafted by oblivion as the outlines of the shore are created by the sea."[14] In other words, the existence of human beings not only has to do with their custodianship of memory's definitions but also has to take forgottenness into account when making these definitions. Such responsibility is about not only examining the causality of oblivion but also considering oblivion as a form of remembrance. According to Augé, "...oblivion is the life force of memory and remembrance is its product."[15] By re-approaching the construction of the first island chain—Japan, Okinawa, and Taiwan—through Augé's definition of oblivion, could there be a different way to reconstruct the correlation between the archive and "the others who already died" as driven by the life force of memory? If one sees oblivion as an ethical motivation of archival practices that unlock the potentiality of historical consciousness, could a different form of knowledge production fundamentally reconfigure Cold War geopolitics, especially in the modes of epistemological hegemony? From Takayama and Port B's urban theatre work *Sunshine 62* to Jen Wen's arrangement animating the already-vanished martial law urbanscape of Taipei via Ko's footsteps and Iri and Toshi Maruki's preparation of painting *Battle of Okinawa* via a decade-long project of listening to its survivors, artists' works are grounded on a shared concern regarding the sensibilities of oblivion. By establishing their works as an archive of sensibility with regard to forgottenness, these artists' projects unlock the deaths imprisoned by inscriptions upon political monuments and allow them to be used as a guide to the contemporary. By doing so, death is no longer merely about the existence of consciousness in a nonliving condition. It is also a historical perspective that enables us to recognize the dynamic relationship between the past and the present.

14 See Marc Augé, *Oblivion*. (University of Minnesota Press, 2004), p.20.

15 *Ibid*. p.21.

泛亞主義與「什麼是亞洲?」

洪子健

* 本文英文版原發表於《After Year Zero: Geographies of Collaboration》,華沙現代美術館出版,2015。

泛亞主義的故事,與日本從十九世紀末到二戰戰敗之間的作為,二者的關係難分難解。泛亞主義在當時為日本帝國採取,作為官方認定的神聖使命,使它有了規範性政治的意涵。若沒有日本出面提倡「東亞新秩序」,那麼泛亞主義作為一種反動意識型態,至多是天真浪漫,最糟不過是邏輯不通。泛亞主義的夢想在最早被提出之時,其根本缺陷恰恰在於「亞洲」是個模糊的概念。其次且致命的問題,是泛亞主義信條的每一根骨頭都銘刻著大量屠殺與死亡的日本優越論。

什麼是亞洲?

「亞細亞」作為地理名詞,最早可能源自古希臘,接著被羅馬沿用,後來專指在概念上與歐洲大陸不相連的一個大陸陸塊。像南極與澳洲這類大陸的邊界,即使小學生也能輕易明白,但歐洲與亞洲之間的邊界卻隨著時間挪移,爭議持續存在,同時許多學者完全不認為歐亞之間存在任何有意義的地理區隔。最早將「亞洲」視為獨一實體的是歐洲人,這種看法之所以廣被接受,正如海德格所認為的「把地球和人類徹底歐洲化」[1]。

1　Martin Heidegger, *On the Way to Language*, trans. Peter D. Hertz (New York: Harper & Row, 1982), p.15.

耶穌會學者在十六世紀末首次把「亞細亞」這個概念帶進中國。1602年,利瑪竇——最早認真學習古典漢語的的耶穌會士之一——印了一張中文地圖,帶進了「亞細亞」這個詞。現在所謂的東亞,在當時的文化上,是由中國的「前現代」朝貢關係系統所主宰。從階層上來說,這個朝貢體系把中國(或某個中國的朝代)置於政治文化的中心,可稱為「中華秩序」(Sinocentric Order)。帝制時期的中國知識分子並不將自己看成只是某區域中的一部分。對他們來說,人類最基本的區別只有文明和野蠻。

過了好幾個世紀,「亞洲」才成為一種身分認同,如今甚至能夠與其他認同型態競爭,如民族、種族,以及最常見的國族。換句話

世界地圖中的「亞細亞」，利瑪竇於 1602 年繪製。[2]

說，具獨特性的「亞洲認同」一直是難以捉摸且混亂的。舉例來說，印度 (India) 曾被認定為亞洲 —— 美洲的原住民現今仍被稱為 Indians (印地安人 / 印度人) —— 但經過數次「亞洲價值」為何的辯論之後，印度已不再與亞洲聯想在一起，或至少與 1990 年代的亞洲經濟崛起沒什麼關係。而俄羅斯表面上位於亞洲大陸，卻大多視自己為歐洲人。

此外，中華秩序核心裡的人沒有理由質疑自身的文化認同，只有亞洲外圍的國家，例如日本，才會提出亞洲認同作為概念的問題，並以其作為擺脫僵固的中華秩序之手段。即使在今天，許多日本人還認為自己是「西方人」，拒絕被視為「亞洲人」，甚至有些日本人自視為「白人」。

由於亞洲地理、文化與民族的明確邊界從未恰當地建立起來，即使對歐洲人來說，亞洲的概念差不多意味著「非歐洲人」。「亞洲」代表地表上的黑洞，它超出歐洲人所能理解的範圍之外，因此也在歐洲人所能掌握之外。如果有一個單數的歐洲存在，居住於其中的人可以說：「我們是歐洲人」，那麼就必須有一個論證上的「他者」，而其中一個「他者」就被假設為「亞洲」。或者用卡爾·雅斯培 (Karl Japsers) 的話說：「亞洲變成一個神話本體，當我們客觀地用歷史現實來分析時，它分崩離析。」[3]

什麼是泛亞主義？

經過帝國主義時代的一連串歷史事件，亞洲開始被重新定位。英國征服了印度，並在兩次鴉片戰爭中侵略中國滿清；馬修·培理 (Matthew Perry) 的「黑船」迫使日本開放貿易，而法國與荷蘭殖民了東南亞，諸如此類。印度、中國和日本的知識分子被迫接受歐洲人和 / 或美國人的科技優勢，繼而尋求改進自己的國家缺陷，開始討論亞洲團結和區域合作。

2 與許多中國古物一樣，這份中國地圖的原作已佚失。(參見 http://en.wikipedia.org/wiki/Matteo_Ricci#mediaviewer/File:Kunyu_Wanguo_ Quantu_by_Matteo_Ricci_Plate_1-3.jpg)

3 Karl Jaspers, *The Origin and Goal of History*, trans. Michael Bullock (New Haven, Connecticut: Yale University Press, 1953), p.70. 同時參見 Wang Hui, *The Politics of Imagining Asia*, ed. Theodore Huters (Cambridge: Harvard University Press, 2011), pp.13-14.

「亞洲一體」

亞洲團結的概念，經過十九世紀末的演化與突變，被稱為「亞洲主義」，但直到 1930 年代之前，它還不是當今認知的「泛亞主義」。在堀田江理寫的《泛亞主義與日本的戰爭 1931–1945》中，她詳細區分出三種泛亞主義：茶道式（Teaist）、中國式（Sinic）與盟主式（Meishuron，日語「領導者」）[4]。第一種，她所謂的「茶道泛亞主義」，是以岡倉天心（1862–1913）為例，他曾寫過著名的《東洋的理想》（1903）：

> 亞洲是一體的。喜馬拉雅山區隔了 —— 但也強化了 —— 兩個強大的文明：中國有孔子式的共產主義，印度有吠陀式的個人主義。但即使雪天屏障也無法在任何時刻阻礙對終極與普世思想的廣泛熱愛。終極與普世的共通思想是所有亞洲人種的遺產，使他們得以在世界上創造出偉大的宗教，使他們不同於地中海與波羅的海的海洋人民，後者關心的是殊相，追求的是生命的意義而非目的。[5]

岡倉以著作《茶之書》而聞名，他為了西方與印度的讀者而以英文寫作。岡倉的目的是要為想像的亞洲建立獨一無二的精神性，而日本則是捍衛者。他旅行到印度，結識了泰戈爾（1861–1941）[6]，共同推廣合縱亞洲的思維，不僅僅包含印度，還要囊括中東。在他初萌的泛亞概念裡，日本在其中扮演了特別的角色：

> 然而，日本有絕大的榮幸得以明確地實現萬流歸一。這個民族擁有印度－韃靼人的血統，得到兩種血緣特質的遺傳，因而反映了整個亞洲的意識。有著萬世一系的政權，自立自強、不受駕馭的民族性，並且孤立於島，雖無法擴張但也因而保護了祖宗的思想與天性得以傳承，這些都使日本成為儲藏亞洲思想與文化的寶庫。[7]

要將岡倉的泛亞主義重新組織為有條理的主張不太容易，因為他的說法沒有根據、不明確，或根本是錯的。再者，岡倉即有可能反對使用西方邏輯來詮釋他的亞洲哲學之道。不過，儘管一副形上學的身段，他還是為讀者端出論據：

1. 有一個獨特的、地理的、精神上的主體存在，名為亞洲，它包涵了許多不同的民族、文化與宗教。
2. 這些民族、文化與宗教是只屬於亞洲，並且可稱為「亞洲性」。
3. 亞洲性最終流傳至日本與其他亞洲國家。
4. 其他亞洲國家在政治上皆不穩定，且／或被西方征服。
5. 被征服且／或不穩定的國家無法適當地表現出固有的亞洲性。
6. 日本的政治穩定且未曾被征服。
7. 因此，只有日本能夠表現固有的亞洲性，或以他的話來說：「日本是亞洲文明的博物館。」[8]

4 Eri Hotta, *Pan-Asianism and Japan's War 1931–1945* (New York: Palgrave Macmillan, 2007).

5 Okakura Kakuzo, *Ideals of the East: The Spirit of Japanese Art* (Mineola, New York: Dover Publications, 2005), p.1

6 不同於盲從的杜波依斯（W. E. B. Du Bois），泰戈爾後來強烈批判日本的國家主義與其在中國的暴行。（參見 http://www.japanfocus.org/-Zeljko-Cipris/2577）

7 Okakura., p.2.

8 同前註，p.3。

依此看來，我們可以瞭解到岡倉看似溫和又激昂的亞洲主義，實際上卻不甚精巧地評比了日本形而上的卓越與亞洲的無助狀態。然而，岡倉從未明確定義「亞洲」，並且，他所說的亞洲宗教，例如佛教，從未超越東方主義者對於東方的陳腐概念，而這個迂腐概念，他更加之宣揚。再者，岡倉認可的「美學」泛亞主義從未提出推廣的行動方案。我們只能假設，如果日本是卓越的亞洲博物館，那麼作為博物館，它應該被保存在原處，而不是在其他較為不幸的亞洲國家再造一個。如此一來，在爾後的泛亞主義表述中，岡倉對於日本優越性的說法，才會變得較具明確性與說明性。

「同文即同種」

十九世紀末，日本知識分子以「同文即同種」這個口號作為例證，提出中日結盟的想法。在中華秩序之內，日本在名義上是朝貢國，幾乎像大盤商似地大量吸納中國文化，包括文字、服裝、料理和建築。當時許多讀過書的中國人因此而認為日本文化是沒什麼創造力的低階文化。這就是為什麼日軍侵華曾被認為（現在有些人仍然這麼想）是特別地屈辱。

作為瓦解中華秩序的手段，中日合作的亞洲主義所想像的願景 —— 堀田江理稱之為「中國泛亞主義」—— 是由卓越的日本來控制並保護落後的中國。不過，如果我們把這樣的事態看成是泛亞主義的一個版本，那過去的中華秩序顯然也是一種泛亞主義。對日本的泛亞主義者來說 —— 如犬養毅（1855–1932）和澤柳政太郎（1865–1927）—— 所謂的「中國泛亞主義」只是整個泛亞主義計畫的初始階段：其最終目的是統治全亞洲。[9]

9　「大亞細亞主義將未來的歷史區分為四個階段。第一階段，黃種人 —— 最強大的蒙古血統國家，日本；與領土最大的國家，中國 —— 必須在大亞細亞的旗幟下團結起來。」Sawayanagi Masataro, "Asianism" (1919) in *Pan-Asianism: A Documentary History, Volume 1: 1850–1920*, ed. Sven Saaler and Christopher W. Szpilman (Lanham, Maryland: Rowman & Littlefield, 2011), p.262.

10　本文作者攝於 2013 年。

歐洲強權入侵圖，展示於靖國神社中的遊就館。[10]

孫中山（1866–1925）在流亡日本期間結識了不少泛亞主義者，如同其他同道人一樣，他也有自己的國族主義綱領，即推翻清朝，建立共和的中國。為達此目的，他是個務實的政治機會主義者，向包括日本在內的全世界有錢人與權勢者爭取支持。1924 年，清朝被推翻的十三年後，孫中山在神戶發表了泛亞主義演講。

> 現在亞洲只有兩個頂大的獨立國家：東邊是日本，西邊是土耳其。日本和土耳其，就是亞洲東西兩個大屏障。現在波斯、阿富汗、阿拉伯也起來學歐洲，也經營了很好的武備。歐洲人也是不敢輕視那些民族的。中國現在有很多的武備，一統一之後，便極有勢力。我們要講大亞洲主義，恢復亞洲民族的地位，只用仁義道德做基礎，聯合各部的民族，亞洲全部民族便很有勢力。[11]

琢磨了岡倉對於合縱亞洲的想法，孫中山對這塊大陸明確地勾勒出泛亞主義概念的遼闊邊界。跟岡倉相似，歐洲對於亞洲的模糊觀念影響了孫中山 —— 亞洲位於歐洲的東邊，有著「仁義」文化與「道德」文明的神秘區域。孫中山判斷亞洲性的標準，可以簡化為一個小小想法：在亞洲大陸上的任何民族國家都屬於亞洲，當然，俄羅斯除外。

經常造訪日本的孫中山很清楚日本對滿州的算計，也明白泛亞主義會走的終極路徑。1924 年，中國陷入軍閥割據，孫中山死前還看不到共和政體下的中國。儘管承認日本軍事上的優越，孫中山仍然呼籲日本帝國維持亞洲合作的價值觀，而不是獨自主宰全亞洲：

> 你們日本民族既得到了歐美的霸道的文化，又有亞洲王道文化的本質，從今以後對於世界文化的前途，究竟是做西方霸道的鷹犬，或是做東方王道的干城，就待你們日本國民去詳審慎擇。[12]

那麼韓國呢？

對安重根（1879–1910）這類的韓國國族主義來說，中國與韓國曾信賴日本宣稱的亞洲主義使命，但日本在日俄戰爭（1904–1905）之後的舉動卻辜負了他們。亞洲主義者和全球許多非白人的知識分子曾為日本戰勝歐洲帝國而歡欣鼓舞，反之，白人霸權則視其為一個未來的警訊。雖然日本帝國聲稱日俄戰爭是為保衛韓國而戰，但日本在1905 年強迫韓國成為保護國，且隨後在 1910 年將其納入日本帝國。就如安重根在他未完成的論文中所說：

11　孫中山，〈孫中山在日本神戶的演講全文〉。（見 http://lishi.kantsuu.com/200912/20091215103401_167785.shtml）

12　同前註。

如果日本無法改變政治策略，如果反抗與日俱增，那中國人與韓
國人將不會再忍受同種人的羞辱對待，反而寧願它被其他人種擊
敗。這個後果不容置疑。被壓迫的中國與韓國人民將共同而自發
地與白人合作。[13]

安重根對日本的失望導致他著名的行動：於 1909 年刺殺日本駐朝
鮮第一任統監與日本的第一位首相伊藤博文。韓國與中國的國族主
義者，包括孫中山，將安重根奉為英雄，韓國與中國為他立起紀念
館與紀念碑，最近的一座建立在他起事的地點 —— 哈爾濱。2014
年，日本為安重根紀念館的開幕而向中國提出抗議，並稱他為「恐
怖分子」。[14]

泛亞主義成為「大日本主義」

堀田江理所說的「盟主泛亞主義」是最接近戰後東京審判所認知的意
識型態泛亞主義。「盟主」這個詞來自漢字「盟主論」，意義類似於
「領導者理論」。雖然孫中山與安重根的亞洲主義願景是不同權力之間
的平等合作 —— 中國與日本，或中國、韓國與日本 —— 但泛亞主義
最成熟的形式卻助長了日本霸權。

1930 年代之前，亞洲主義意識型態對日本國際主義外交政策幾乎沒
有影響。日本地下的極端民族主義團體和知識分子曾花了數十年一
直在號召日本擴張主義。[15] 從明治維新（1868–1912）開始，日本
領導人就已致力於讓日本帝國在新興的國際主義秩序中成為強權。
變動的世界局勢與國際聯盟拒絕承認日本的滿州傀儡政權，導致日
本重回泛亞主義意識型態。這就使得泛亞主義順理成章地作為一個
載具，承載著將帝國擴張主義政策合法化為解放亞洲的神聖使命。
一旦政府開始為泛亞主義的教條背書，知識分子與政治家便開始把
十九世紀以降流傳的那些模糊的，甚至有點沒邏輯的泛亞主義論題
編成規章。

泛亞主義作為實質的外交政策，最知名的表述是 1940 年提出的「大
東亞共榮圈」。被起訴的戰爭罪犯東條英機（1884–1948）曾回憶談
到這項政策的來源：

> 大東亞政策的重點是大東亞的建設。至於這項政策的形成，日本政府
> 在當時有下列基本觀點。維持世界和平的根本先決條件是全世界每個
> 國家都處於適當的地位，大家都能夠在與所有其他國家相互依賴與合
> 作之下，享受幸福與繁榮。[16]

13 Ahn Jung-geun, "A Discourse on Peace in East Asia" in *Pan-Asianism: A Documentary History, Volume 1: 1850–1920*, p.209.

14 參見 http://time.com/2609/104-years-later-a-chinese-train-station-platform- is-still-the-site-of-anti-japanese-rancor/

15 日本秘密社團「玄洋社」在 1887 年主張：「身為有色人種，我們必須有軍事建設與裝備以抵抗歐洲人與美國人。尤其是我們這個即將迎頭趕上的新興亞洲國家，我們期待有一天成為亞洲的領導者，此刻正是實施軍國主義的時機。」竹內好（Takeuchi Yoshimi）〈日本與亞細亞主義〉，擷自 Faye Yuan Kleeman, "Pan-Asian Romantic Nationalism: Revolutionary, Literati, and Popular Oral Tradition and the Case of Miyazaki Tōten," in *Sino-Japanese Transculturation: From the Late Nineteenth Century to the End of the Pacific War*, ed. Richard King and others (Lanham, Maryland: Lexington Books, 2012), p.50.

16 Tojo Hideki, *Affidavit to the International Military Tribunal for the Far East*, p.6.

其中的關鍵詞是「適當的地位」。日本對於「東亞新秩序」的概念有預設階級。傀儡政權滿州國的政治宣傳充滿了家庭式的——特別是家長的——形象與隱喻，在其中，仁義而進步的日本將領導並保護脆弱與落後的亞洲小孩。對日本泛亞主義者來說，日本所負背的教化使命與「白人的負擔」沒有什麼不同。如同澤柳政太郎於 1916 年所說：

> 人們認為，日本與中國是孿生兄弟，屬於同一個國家。按此特殊關係，日本有特別的義務去推動東亞和平，並保護中國——但也有權利要求特殊的地位……。[17]

明示或暗示，泛亞主義作為一種日本的思維產物，總是始終得維護日本的優越性。用最好聽的話解釋：日本人在亞洲處於優勢，只因為他們最早現代化。但日本最初的成功，後來便成為本質。快速的工業化、擴張的殖民帝國，戰勝中華秩序與俄羅斯，於是他們便沖昏了頭。日本之所以比其他亞洲國家優越，並不是因為現代化，而是日本本來就很優越，所以才會比其他競爭的亞洲國家早一步走向現代化。這些根深蒂固的迷思不容置疑。

17 Sawayanagi Masataro, in *Pan-Asianism: A Documentary History, Volume 1: 1850–1920*, 262.

18 來自本文作者的蒐藏。

1941 年的日本地圖上所標示的「大東亞共榮圈」。[18]

岡倉天心那神秘的泛亞主義從未主張所有亞洲國家都是平等的。日本已經在亞洲培養出一種獨特的「監護」功能。這種由日本帝國政府實現的功能，後來表現為政治的恐怖行為、壓迫、剝削，以及大規模強暴與屠殺——與歐洲帝國主義沒什麼兩樣。日本擴張主義的受害者很快就明白了，所謂的解放看來就等於侵略。中國共產黨創始人李大釗（1888–1927）在 1919 年講得非常清楚：

第一，須知「大亞細亞主義」是併吞中國主義的隱語。[…] 第二，須知「大亞細亞主義」是大日本主義的變名。[…] 在亞細亞的民族，都聽日本人指揮，亞細亞的問題，都由日本人解決，日本作亞細亞的盟主，亞細亞是日本人的舞台。到那時亞細亞不是歐、美人的亞細亞，也不是亞細亞人的亞細亞，簡直就是日本人的亞細亞。[19]

李大釗不是第一個把泛亞主義與「大日本主義」劃上等號的人。早在兩年之前，著名的日本國族主義知識分子與政治家北昤吉（1885–1961）就已將其作為等式：「是以，以『亞洲屬於亞洲人』為口號的所謂亞洲主義，若有任何意義，其本質就必須是大日本主義。」[20]

日本國族主義、帝國崇拜、好戰的國家神道，以及民族與種族沙文主義將泛亞主義翻修為有條理的政治論證。既然同在日本帝國「一個屋簷下」的亞洲國家，無論過去與未來都不可能平等，那麼宣揚和相信泛亞主義就不會導致認知失調。再者，強勢的泛亞主義計畫，也回答了一個相關問題：什麼是亞洲？

1. 只要日本認為是亞洲的土地，就是亞洲。
2. 除了日本，所有亞洲國家都是衰弱且／或曾被歐洲勢力殖民。
3. 衰弱的，或被非亞洲強權殖民的亞洲國家，無能解放所有的亞洲國家 —— 即亞洲。
4. 日本是強大的亞洲國家。
5. 只有強大的亞洲國家可以解放亞洲。
6. 因此，只有日本可以解放亞洲。

所以什麼是亞洲？它如何能為一體？用泛亞主義者的話來說，亞洲就是 —— 或可能是 —— 日本帝國。不可否認，哪塊土地屬於亞洲由日本人說了算，聽來有些奇怪。[21] 但想想東南亞，1941 年遭日本侵略，在此之前，這塊區域俗稱「南洋」、「熱帶」或「東印度群島」。而日本的行動將東南亞牢牢地放進亞洲 —— 或更明確地說，放進「大東亞」 —— 的領域。日本帝國不單單是要瓦解歐洲佔領的殖民地，還要重塑大多數人的空間想像。歐洲長久以來喜孜孜地為全球各地分類和命名，而日本的「新秩序」篡奪了這個權力。假如日本有能力更加滲透亞洲，尤其是印度 ——「東亞」的概念也會一併擴張。一份 1943 年的日本秘密文件概述了日本擴張的步驟：

第一步，日本、滿州、蒙古、華北、中國沿海主要島嶼、汪精衛政權下的華中與華南。

第二步，中國其他區域、法屬印度支那、泰國、英屬馬來西亞、緬甸、荷屬東印度群島、新幾內亞、英屬婆羅洲、新喀里多尼亞島、澳洲、紐西蘭、菲律賓除外的南海島嶼。

19 李大釗，〈大亞細亞主義與新亞細亞主義〉。（原文參見 https://zh.wikisource.org/zh-hant/ 大亞細亞主義與新亞細亞主義）

20 同前註。

21 想想泛伊斯蘭主義領土的決定方式。任何有足夠穆斯林人數的地方，或哈里發認為屬於伊斯蘭的地方，即為伊斯蘭領土。

第三步，貝加爾湖以東的蘇聯領土、中國周邊地區、菲律賓、印度與其沿岸島嶼。

第四步，亞述、土耳其、伊朗、伊拉克、阿富汗與其他中亞國家、西亞、東南亞。[22]

泛亞主義的失敗

日本的戰敗結束了作為政治使命的大東亞共榮圈與泛亞主義。日本的泛亞主義政治綱領造成大量死亡，單是中國就有數千萬。在「大東亞戰爭」的最後幾周裡，估計每天大約一萬人死於日本帝國的政策。[23] 昭和天皇投降後，各類型的泛亞主義者紛紛宣佈放棄泛亞主義的目標，其中有人宣稱，唯有戰敗後，日本人才真正地「重回亞洲」。[24] 美國政府仿照在德國實施的去納粹化，對戰敗的日本實施相同的作法，意圖將其轉化為模範的美國傀儡國。立場堅定的日本政客與理論家都從原官方職位上拔除（至少是暫時），或被以戰爭罪拘捕。

然而，不肯悔改的泛亞主義者在東南亞與印度戰後事件中感到振奮，該地區於戰時受日本支援的反殖國家主義運動，開始為獨立而奮戰。日本的修正主義者、極端民族主義者（ultranationalist）與泛亞主義者指稱，這些獨立運動證明了泛亞主義並非全為一己之私，它其實也激勵了數個被奴役的亞洲國家的解放運動。這是遊就館戰爭博物館所供奉的觀點，它位於東京極端民族主義的靖國神社。

雖然部份日本知識分子與軍事官員的確支持過亞洲解放運動，但他們的動機並非一直都那麼單純。[25] 當日本向歐洲強權宣戰時，理所當然會支持同仇敵愾的同盟者。就算不是全部，大部份同盟國與軸心國的政府都遵從這句格言：「敵人的敵人就是朋友」。

22 From *An Investigation of Global Policy with the Yamato Race as Nucleus*, quoted in John Dower, *War Without Mercy* (New York: Pantheon Books, 1986), p.273.

23 See Werner Gruhl, *Imperial Japan's World War Two: 1931–1945* (New Brunswick, New Jersey: Transaction Publishers, 2007).

24 *Pan-Asianism: A Documentary History, Volume 1: 1850–1920*, p.28. See also Oguma Eiji, "The postwar intellectuals' view of 'Asia'," in *Pan-Asianism in Modern Japanese Hsitory*, ed. Sven Saaler and J. Victor Koschmann (London: Routledge, 2002), p.200.

25 日本從二戰前數十年到戰時，收留了不少來自中國、印度與其他國家的流亡國家主義者與獨立運動領袖。參見 Cemil Aydin, *The Politics of Anti-Westernism in Asia: Visions of World Order in Pan-Islamic and Pan-Asian Thought* (New York: Columbia University Press, 2007).

26 擷自本文作者於 2013 年拍攝的影片。

極端民族主義者於靖國神社舉行的「大東亞戰爭」紀念儀式。[26]

靖國神社／遊就館戰爭博物館所採取的歷史觀，省略了伴隨泛亞主義使命而來的大屠殺、強暴、濫刑、細菌戰、奴役與斬首。日本帝國的受害者大多沒有留下姓名並且被歷史遺忘，而我們可以合理地推論，誰都不會願意為了推動日本泛亞主義所主張的解放亞洲而被屠殺、強暴或折磨。

「什麼是亞洲？」日本的答案已被證明是屠殺與不堪，但區域合作的可能性並未完全抹滅。亞洲組織 —— 如東協（ASEAN） —— 與依然強勢的美國世界秩序，以及中國和印度等崛起中的國家，都試圖在未來繼續回答這個問題。

Pan-Asianism and the Question "What is Asia?"

James T. Hong

* This article was originally published in *After Year Zero: Geographies of Collaboration*, Museum of Modern Art in Warsaw, 2015.

The story of Pan-Asianism is indelibly linked to the actions of Japan from the late nineteenth century until its defeat in WWII. It was Imperial Japan that gave Pan-Asianism a prescriptive political meaning by employing the idea as a government-sanctioned, holy mission. Without Japan's championing of a "New Order in East Asia," Pan-Asianism as a reactionary ideology is naive at best and incoherent at worst. The fundamental weakness of the early, inchoate Pan-Asianist dream is precisely the vagueness of the concept of "Asia." The second and fatal Pan-Asianist flaw is the inscription of Japanese superiority into the very fabric of Pan-Asianist dogma, which resulted in the murder and unnecessary deaths of millions.

What is Asia?

"Asia" as a geographical term purportedly comes from the Ancient Greeks; it was later adapted by the Romans, and then eventually defined as a continental landmass conceptually detached from the European continent. The geographical borders of continents such as Antarctica or Australia are clear even to primary school students, but the border between Europe and Asia has shifted throughout time and continues to be contentious, with a number of scholars denying any meaningful geographical break between Europe and Asia at all. Since the notion of a unitary and distinct entity called "Asia" is of European origin, its widespread acceptance is just one example of what Martin Heidegger deemed "the complete Europeanization of the earth and man."[1]

1 Martin Heidegger, *On the Way to Language*, trans. Peter D. Hertz (New York: Harper & Row, 1982), p.15.

Jesuit scholars first introduced the concept of "Asia" to China in the late sixteenth century. In 1602, Matteo Ricci, one of the first Jesuits to seriously take up the study of classical Chinese, printed a map in the Chinese language that introduced the term "亞細亞" (Asia). What is now East Asia was then culturally dominated by China in a "pre-modern" system of tributary relations. Hierarchical, this tributary system placed China (or specifically a dynasty within China) at the politico-cultural center and can be called the "Sinocentric Order." Educated Chinese during dynastic rule did not see themselves as just one part of a regional bloc. For them, the most basic differentiation between peoples was that between civilization and barbarism.

"Asia" in Matteo Ricci's 1602 world map.[2]

2 Like many ancient Chinese treasures, there are no known original prints of this map in China. (See http://en.wikipedia.org/wiki/Matteo_Ricci#mediaviewer/File:Kunyu_Wanguo_ Quantu_by_Matteo_Ricci_Plate_1-3.jpg)

It took centuries before "Asia" became an identity, and even now it competes with ethnic, racial, and most frequently nationalist identity formations. In other words, the idea of a distinctive "Asian identity" is elusive and still unsettled. India, for instance, was once identified with Asia, with the natives in the Americas still being called "Indians" today. But after the debates concerning "Asian values," India no longer came to be associated with Asia, or at least with the Asian economic successes of the 1990's. And the Russians, ostensibly located on the continent of Asia, have, for the most part, seen themselves as European.

Moreover, those at the center of the Sinocentric Order had no reason to question their cultural identities, and it was only on the periphery of Asia, such as Japan, where the question of Asian identity arose as a conceptual problem and as a means of displacing the stagnating Sinocentric

Order. Even today, many Japanese consider themselves "Westerners" as opposed to "Asians," with some of them even identifying as "white."

Since the precise geographical, cultural, and ethnic borders of Asia have never been duly established, even to Europeans, the concept of Asia made more sense as a term signifying "non-European." "Asia" represented a terrestrial black hole that was beyond the comprehension and therefore the control of Europeans. If a singular Europe exists, within which people can say, "we are European," then there needs to be a discursive "Other," and one of these "Others" was posited as "Asia." Or to put it in Karl Jaspers words: "Asia is turned into a mythical principle, that falls apart when it is analyzed objectively as an historical reality."[3]

What is Pan-Asianism?

A series of historical events during the Age of Imperialism would begin to remap Asia. The British had subdued India and invaded Qing Dynasty China during the first and second Opium Wars; Commodore Perry's "black ships" had forced Japan open to trade, while the French and Dutch colonialized Southeast Asia, and so on. Intellectuals in India, China, and Japan were forced to accept the technological superiority of the Europeans and/or the Americans, and seeking a way to allay their own national vulnerabilities, began to speak of Asian solidarity and regional cooperation.

"Asia is One"

The concept of Asian solidarity known as "Asianism" evolved and mutated through the late nineteenth century, but did not come to be what is now known as "Pan-Asianism" until the 1930's. In her detailed *Pan-Asianism and Japan's War, 1931–1945*, Eri Hotta distinguishes between three types of Pan-Asianism: Teaist, Sinic, and *Meishuron* (Japan as leader).[4] The first, what she calls "Teaist Pan-Asianism," is exemplified by Okakura Kakuzo (1862–1913), who famously wrote in his *Ideals of the East* (1903):

3 Karl Jaspers, *The Origin and Goal of History*, trans. Michael Bullock (New Haven, Connecticut: Yale University Press, 1953), p. 70. See also Wang Hui, *The Politics of Imagining Asia*, ed. Theodore Huters (Cambridge: Harvard University Press, 2011), pp.13-14.

4 Eri Hotta, *Pan-Asianism and Japan's War 1931–1945* (New York: Palgrave Macmillan, 2007).

Asia is one. The Himalayas divide, only to accentuate, two mighty civilizations, the Chinese with its communism of Confucius, and the Indian with its individualism of the Vedas. But not even the snowy barriers can interrupt for one moment that broad expanse of love for the Ultimate and Universal, which is the common thought- inheritance of every Asiatic race, enabling them to produce all the great religions of the world, and distinguishing them from those maritime peoples of the Mediterranean and the Baltic, who love to dwell on the Particular, and to search out the means, not the end, of life.[5]

Okakura, better known as the author of *The Book of Tea*, wrote in English for a Western and Indian audience. His aim was to establish the inimitable spirituality of an imagined Asia of which Japan was the custodian. He travelled to India, and as an associate of Rabindranath Tagore (1861–1941) [6], promoted the idea of a comprehensive Asia, which not only included India, but also much of the Middle East. Within his nascent Pan-Asianist conception, Japan had a special role to play:

It has been, however, the great privilege of Japan to realize this unity-in-complexity with a special clearness. The Indo-Tartaric blood of this race was in itself a heritage which qualified it to imbibe from the two sources, and so mirror the whole of Asiatic consciousness. The unique blessing of unbroken sovereignty, the proud self-reliance of an unconquered race, and the insular isolation which protected ancestral ideas and instincts at the cost of expansion, made Japan the real repository of the trust of Asiatic thought and culture.[7]

Reformulating Okakara's Pan-Asianism into a coherent argument is difficult, as much of what he claims is unsubstantiated, vague, or simply wrong. Moreover, Okakura would most likely be opposed to using Western logic to interpret his philosophical, Asiatic sermon. However, despite his metaphysical posturing, Okakura is presenting an argument to his readers:

1. There exists a singular, geographical, and spiritual entity called Asia, which includes a number of different ethnicities, cultures, and religions.

5 Okakura Kakuzo, *Ideals of the East: The Spirit of Japanese Art* (Mineola, New York: Dover Publications, 2005), p.1.

6 Unlike a duped W. E. B. Du Bois, Tagore would become a fierce critic of Japanese nationalism and atrocities in China. (See http://www.japanfocus.org/-Zeljko-Cipris/2577)

7 Okakura, p.2.

2. These ethnicities, cultures and religions are exclusive to Asia and can be called "Asianness."
3. Asianness eventually traveled to Japan and other Asian nations.
4. All of these other Asian nations are politically unstable and/or have been conquered by the West.
5. Conquered and/or unstable nations cannot adequately express their inherent Asianness.
6. Japan is stable and has not been conquered.
7. Therefore, only Japan can express inherent Asianness, or, in his own words, "Japan is the museum of Asiatic civilization."[8]

8 *Ibid.*, p.3.

Put in this way, we can see how Okakura's seemingly benign and uplifting Asianism is actually an unsubtle claim of Japanese metaphysical preeminence vis-á-vis Asia's helplessness. However, Okakura's "Asia" is never clearly defined and most of his descriptions of Asiatic religions such as Buddhism never elevate themselves above hackneyed Orientalist conceptions of the East, which of course he himself popularized. Furthermore, Okakura's admittedly "aesthetic" Pan-Asianist agenda never pushes a prescriptive plan of action. We may only assume that if Japan is the museum of Asia *par excellence*, then as a museum, it should be preserved but not necessarily recreated in other less fortunate Asian nations. Okakura's claim of Japanese superiority would become more explicit and prescriptive in later formulations of Pan-Asianism.

"The Same Letters, The Same Race."

In the late nineteenth century, Japanese intellectuals were presenting the idea of a Sino-Japanese alliance exemplified in the slogan "the same letters, the same race." During the Sinocentric Order, Japan as a nominal tributary state absorbed much of Chinese culture almost wholesale, including written language, customs, cuisine, and architecture. Hence many educated Chinese saw Japan as a less creative and inferior culture. This is one of the reasons why the Japanese invasions of China were considered (and still are considered by some) particularly offensive.

As a subversion of the Sinocentric Order, this Asianist vision for Sino-Japanese cooperation, what Hotta terms "Sinic Pan-Asianism," imagines a superior Japan manipulating and safeguarding a primitive China. However, if we consider this state of affairs a version of Pan-Asianism, then surely the historical Sinocentric Order is also a type of Pan-Asianism. For Japanese Pan-Asianists such as Inukai Tsuyoshi (1855–1932) and Sawayanagi Masataro (1865–1927), so-called "Sinic Pan-Asianism" is just the initial phase of a total Pan-Asianist project: the domination of all of Asia.[9]

9 "The future history of Greater Asianism will be divided into four stages. In the first stage, the Yellow race—the strongest country of Mongol ethnicity, Japan, and the largest country, China—must be united under the banner of Greater Asianism." Sawayanagi Masataro, "Asianism" (1919) in *Pan-Asianism: A Documentary History, Volume 1: 1850–1920*, ed. Sven Saaler and Christopher W. Szpilman (Lanham, Maryland: Rowman & Littlefield, 2011), p.262.

A display showing the encroaching European powers at the Yushukan Museum on the grounds of Yasukuni Shrine.[10]

10 Photo taken by author in 2013.

While in exile in Japan, Sun Yat-Sen (1866–1925) befriended a number of Pan-Asianists, and like any other, Sun had his own nationalist agenda, namely overthrowing the Qing Dynasty and founding a republic in China. To this end, he was a practiced political opportunist and courted rich and powerful people around the world including the Japanese. In 1924, thirteen years after the fall of the Qing Dynasty, Sun delivered a speech on Pan-Asianism in Kobe, Japan.

At present Asia has only two independent countries, Japan in the East and Turkey in the West. In other words, Japan and Turkey are the Eastern and Western barricades of Asia. Now Persia, Afghanistan, and Arabia are also following the European example in arming themselves, with the result that the Western peoples dare not look down on them. China at present also possesses considerable armaments, and when her unification is

accomplished she too will become a great Power. We advocate Pan-Asianism in order to restore the status of Asia. Only by the unification of all the peoples in Asia on the foundation of benevolence and virtue can they become strong and powerful.[11]

11 Sun Yat-Sen, "Speech on Pan-Asianism". (Found at http://en.wikisource.org/wiki/Sun_Yat-sen%27s_speech_on_Pan-Asianism)

12 *Ibid.*

Elaborating upon Okakura's comprehensive notion of Asia, Sun's Pan-Asianism explicitly delineated the far-flung borders of his Pan-Asianist conception of the continent. And like Okakura's, Sun's concept of Asia relies upon the vague European conception—a mystical realm of "benevolent" cultures and "virtuous" civilizations that originated to the east of Europe. Sun's criterion for Asianness can be reduced to the trivial notion that any ethnic nation on the entire Asian landmass is Asian, except of course Russia.

A frequent guest of Japan, Sun was well aware of Japanese designs on Manchuria and cognizant of the ultimate path Pan-Asianism might take. By 1924, China had descended into warlordism, and Sun wouldn't live to see a China at least nominally united under the republicans. While acknowledging the military superiority of Japan, Sun calls on the empire to uphold the values of Asian cooperation, rather than dominating Asia for herself:

Japan today has become acquainted with the Western civilization of the rule of Might, but retains the characteristics of the Oriental civilization of the rule of Right. Now the question remains whether Japan will be the hawk of the Western civilization of the rule of Might, or the tower of strength of the Orient. This is the choice which lies before the people of Japan.[12]

What Happened to Korea?

For Korean nationalists such as Ahn Jung-Geun (1879–1910), Japan's actions after the Russo-Japanese War (1904–1905) betrayed Chinese and Korean trust in Japan's purported Asianist mission. Asianists and many intellectuals of color around the world had celebrated Japan's victory over a European empire, whereas white supremacists saw it as a bad sign of things to come. Despite the Japanese Emperor's claim that the Russo-Japanese War was fought to defend Korea, by 1905 Japan had forced Korea into becoming a

Japanese protectorate and would later annex it completely into the Japanese empire in 1910. As Ahn puts it in his unfinished treatise:

> *If Japan fails to change its political strategy and if oppression continues to increase daily, then the Chinese and Koreans will no longer endure the humiliations inflicted upon them by the people of the same race, but will prefer defeat at the hands of another race. The consequences are clear. The oppressed inhabitants of China and Korea will jointly and voluntarily collaborate with the white people.*[13]

Ahn's frustration with Japan led to his most famous act: assassinating the Resident-General of Korea and Japan's first Prime Minister, Ito Hirobumi, in 1909. To Korean and Chinese nationalists, including Sun Yat-Sen, Ahn was lionized as a hero. Memorials and monuments in his honor have since been erected in Korea and China, the most recent in Harbin where Ito was assassinated. In 2014, the Japanese government protested China's newly opened Ahn Jung-Geun Memorial Hall and called Ahn a "terrorist."[14]

Pan-Asianism as "Greater Japanism"

What Hotta dubs "Meishuron Pan-Asianism" is closest to the postwar Tokyo Trial interpretation of ideological Pan-Asianism. The term "Meishuron" is the romanization of the Japanese pronunciation of the Chinese characters "盟主論," which mean something like "leader theory." Whereas, Sun Yat-Sen and Ahn Jung-Geun's Asianist visions presented an equitable collaboration between multiple powers—Chinese and Japanese or Chinese, Korean, and Japanese—Pan-Asianism at its most mature concretizes Japanese supremacy.

Before the 1930's, Asianist ideologies had little bearing on Japan's internationalist foreign policy. Underground Japanese ultranationalist groups and intellectuals had been calling for Japanese expansionism for decades.[15] Ever since the Meiji Restoration (1868–1912), Japanese leaders had striven to make the Empire of Japan a great power within the emerging internationalist order. Changing world conditions and the League of Nations' 1933 refusal to accept

13 Ahn Jung-Geun, "A Discourse on Peace in East Asia" in *Pan-Asianism: A Documentary History, Volume 1: 1850–1920*, p.209.

14 See http://time.com/2609/104-years-later-a-chinese-train-station-platform- is-still-the-site-of-anti-japanese-rancor/

15 In 1887, the Japanese secret society, Genyosha or "Black Ocean Society," claimed: "As a colored race, it is imperative for us to have military facilities and equipment to counter the Europeans and the Americans. Especially, for our country, as a prosperous new up-and-coming nation in Asia, and with our hope to one day become the leader of Asia, this is the right time for state militarism." Takeuchi Yoshimi, "Nihon no Ajia shugi" (Japan and Asianism), quoted in and translated by Faye Yuan Kleeman, "Pan-Asian Romantic Nationalism: Revolutionary, Literati, and Popular Oral Tradition and the Case of Miyazaki Tōten," in *Sino-Japanese Transculturation: From the Late Nineteenth Century to the End of the Pacific War*, ed. Richard King and others (Lanham, Maryland: Lexington Books, 2012), p.50.

Japan's puppet state in Manchuria led Japanese leaders back to Pan-Asianist ideology. It made perfect sense to use Pan-Asianism as a vehicle for legitimizing the empire's expansionist policies as a moral and honorable mission of Asian liberation. Once the government began officially endorsing a Pan-Asianist doctrine, intellectuals and politicians went to work codifying the vague and sometimes incoherent Pan-Asianist themes that had been circulating since the nineteenth century.

Pan-Asianism as tangible foreign policy would be most famously articulated in 1940 as the "Greater East Asia Co-Prosperity Sphere." Looking back on the origins of the policy, the indicted war criminal Tojo Hideki (1884–1948) would claim:

> *The key points of the Greater East Asia policy was the establishment of a Greater East Asia. Regarding the formulation of this policy, the Japanese Government at the time held the following fundamental views. The underlying prerequisite for the lasting peace of the world is that each and every nation in the world should be placed in its proper place, and that it should enjoy happiness and prosperity by depending on and cooperating with every other nation.*[16]

16 Tojo Hideki, *Affidavit to the International Military Tribunal for the Far East*, p. 6.

17 Sawayanagi Masataro, in *Pan-Asianism: A Documentary History, Volume 1: 1850–1920*, p.262.

The crucial phrase is "proper place." The Japanese conception of a "New Order in East Asia" was hierarchical by design. The propaganda surrounding the puppet state of Manchukuo was dominated by familial, particularly patriarchal, images and metaphors, in which a benevolent and advanced Japan would guide and protect its vulnerable and backward Asian children. For Japanese Pan-Asianists, Japan was tasked with a civilizing mission not unlike that of the "white man's burden." As Sawayanagi Masataro put it in 1916:

> *One can say that the Japanese state and the Chinese state are the twin sons of one and the same nation. In accordance with this special relationship, Japan has a special duty to promote peace in the Far East and to protect China—but it also has the right to claim a special position....*[17]

Implicitly or explicitly, Pan-Asianism, as a Japanese con-struct, always maintained the superiority of Japan. In its most benign expressions, the Japanese were dominant in Asia only because they had modernized first. But Japan's initial successes would become essentialized. Rapid indus-trialization, a growing colonial empire, and victories against the Sinocentric Order and then Russia would go to their heads. It wasn't modernization that made Japan superior to other Asian nations; Japan already was superior, so it was destined to modernize before any other competing Asian nation could. Foundation myths leave no room for accident.

The rising Greater East Asia Co-Prosperity Sphere according to a 1941 Japanese map.[18]

18 From the author's collection.

Okakura's mystical Pan-Asianism never claimed that each and every Asian nation was equal to the other. Japan had nurtured a unique "custodial" function in Asia. This function, as realized by the Imperial Japanese government, would come to be expressed as political terror, oppression, exploitation, and mass rape and murder—not so different from the imperialism practiced by the Europeans. Victims of Japanese expansionism would learn very quickly that liberation looked a lot like invasion. Li Da-Zhao (1888–1927), considered a co-founder of the Chinese Communist Party, put it very clearly in 1919:

> *First, one should know that the term "Greater Asianism" con-ceals the doctrine of China's annexation.... Second, one should be*

aware that "Greater Asianism" is just another name for Greater Japanism…. All the Asian nations listen to orders from Japan; the problems of Asia are all being solved by the Japanese; Japan is the leading power in Asia, and Asia has become a stage for the Japanese. So Asia is not the Asia of the Europeans or Americans, and neither is it the Asia of the Asians—it is simply the Asia of the Japanese.[19]

Li was not the first to equate Pan-Asianism with "Greater Japanism." Just two years earlier Kita Reikichi (1885–1961), a prominent Japanese nationalist intellectual and politician, made the same equation: "So, if the so-called Asianism with its slogan of 'Asia for the Asians' has any significance, it must essentially be Greater Japanism." [20]

Japanese nationalism, Emperor worship, militant State Shinto, and ethnic and racial chauvinism would renovate Pan-Asianism into a consistent political argument. Since Asian nations were not and would not be equal "under one roof" of the Japanese empire, promoting and believing in Pan-Asianism did not necessarily entail any type of cognitive dissonance. Furthermore, the program of strong Pan-Asianism would also answer one relevant question: what is Asia?

1. Any territory that is determined by Japan to be Asian is thus Asian.
2. With the exception of Japan, every Asian nation is weak and/or colonized by European powers.
3. A weak Asian nation or one colonized by non-Asian powers cannot liberate all Asian nations, i.e., Asia.
4. Japan is a strong Asian nation.
5. Only a strong Asian nation can liberate Asia.
6. Therefore, only Japan can liberate Asia.

So what is Asia, and how is it one? Asia is, to put it in Pan-Asian terms, a real or potential Japanese empire. It admittedly sounds strange to claim that a territory is Asian, if the Japanese decide that it is.[21] But consider the example of Southeast Asia, which the Japanese invaded in 1941. Before the war, the area was known colloquially as the "South Seas," "the Tropics," or the "East Indies." Japan's actions placed Southeast Asia firmly within the realm of Asia or

19 Li Dazhao, "Greater Asianism and New Asianism," in *Pan-Asianism: A Documentary History, Volume 1: 1850–1920*, pp.220-221.

20 *Ibid.*, p.301.

21 Consider the determination of Pan-Islamic territory. An Islamic territory is any territory that happens to have a sufficient number of Muslims or is deemed to be Islamic by the Caliphate.

specifically in "Greater East Asia." The Empire of Japan was not only disrupting European colonial possessions, it was also reshaping the dominant spatial imagination. Europeans had long enjoyed the power of cataloging and naming various parts of the Earth, and the Japanese "New Order" aimed to usurp that power. Had the Japanese been able to penetrate more deeply into Asia, especially India, the notion of "East Asia" would have expanded as well. A secret Japanese document from 1943 outlines the stages of Japanese expansion:

Stage 1. Japan, Manchuria, Mongolia, North China, major islands of the China coast, Central and South China under the Wang Ching-Wei regime.

Stage 2. Remaining areas of China, French Indochina, Thailand, British Malaya, Burma, Dutch East Indies, New Guinea, British Borneo, New Caledonia, Australia, New Zealand, South Sea Islands with the exception of the Philippines.

Stage 3. Soviet territory east of Lake Baikal, peripheral regions of China, the Philippines, India and its coastal islands.

Stage 4. Assyria, Turkey, Iran, Iraq, Afghanistan and other central Asian countries, West Asia, Southwest Asia.[22]

The Failure of Pan-Asianism

Japan's defeat in World War II ended the Greater East Asia Co-Prosperity Sphere and Pan-Asianism as a political mission. Japan's Pan-Asianist agenda had resulted in the deaths of millions, with tens of millions in China alone. In the last weeks of the "Greater East Asia War" an estimated 10,000 people per day were murdered or died as a direct result of Imperial Japanese policies.[23] After Hirohito's surrender, former Japanese Pan-Asianists of all stripes renounced the aims of Pan-Asianism, with some claiming that only in defeat did the Japanese really "return to Asia."[24] Mimicking its denazification efforts in postwar Germany, the American government made concerted efforts to transform a defeated Japan into a model American puppet state. Japanese politicians and ideologues of the strong

22 From *An Investigation of Global Policy with the Yamato Race as Nucleus*, quoted in John Dower, *War Without Mercy* (New York: Pantheon Books, 1986), p.273.

23 See Werner Gruhl, *Imperial Japan's World War Two: 1931–1945* (New Brunswick, New Jersey: Transaction Publishers, 2007).

24 *Pan-Asianism: A Documentary History, Volume 1: 1850–1920*, p.28. See also Oguma Eiji, "The postwar intellectuals' view of 'Asia'," in *Pan-Asianism in Modern Japanese Hsitory*, ed. Sven Saaler and J. Victor Koschmann (London: Routledge, 2002), p.200.

Pan-Asianist persuasion were purged from any official capacities (at least temporarily) or arrested for war crimes.

However, unrepentant Pan-Asianists would take heart in the postwar events of Southeast Asia and India, where anticolonial nationalist movements that had been supported by Japan during the war, began fighting for their own independence. Japanese revisionists, ultranationalists, and Pan-Asianists point to these independence movements as evidence that the Pan-Asianist mission was not entirely self-serving and that it actually did give rise to the liberation of various subjugated Asian nations. This is the view that is enshrined at the Yushukan War Museum on the grounds of the ultranationalist Yasukuni Shrine in Tokyo.

While it is true that some Japanese intellectuals and military officers supported Asian liberation movements, it is not always clear what their motivations were.[25]

As Japan had declared war on a number of European powers, it made perfect sense for the Japanese government to support co-belligerents fighting common enemies. Most governments, if not all of the Allied and Axis powers, adhered to the proverb "the enemy of my enemy is my friend."

The Yasukuni Shrine/Yushukan War Museum version of history omits the massacres, rapes, indiscriminate

25 Japan hosted a number of exiled nationalists and independence leaders from China, India, and other nations in the decades leading up to and during WWII. See Cemil Aydin, *The Politics of Anti-Westernism in Asia: Visions of World Order in Pan-Islamic and Pan-Asian Thought* (New York: Columbia University Press, 2007).

26 Video still taken by author in 2013.

Ultranationalists commemorating "The Greater East Asia War" at Yasukuni Shrine.[26]

torture, biological warfare, enslavement, and beheadings that accompanied the Pan-Asianist mission. Most of the victims of the Empire of Japan remain anonymous and forgotten to history, and it is reasonable to conclude that none of them wanted to be killed, raped, or tortured to further the Japanese Pan-Asianist cause of Asian liberation.

The Japanese answer to the question "What is Asia?" proved to be homicidal and intolerable, but the possibilities for regional cooperation were not totally dashed. Asiatic organizations, such as ASEAN, the still dominant American World Order, and rising states such as China and India will attempt to answer that question in the future.

掠 影
GLIMPSES

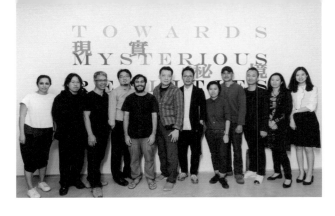

「現實秘境」於台北TGK⁺ 與立方計劃空間，2016–2017
Towards Mysterious Realities at TKG⁺ and
TheCube Project Space in Taipei, 2016–2017

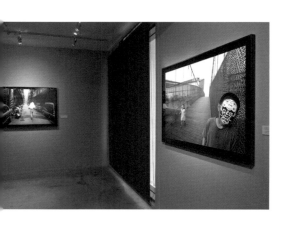

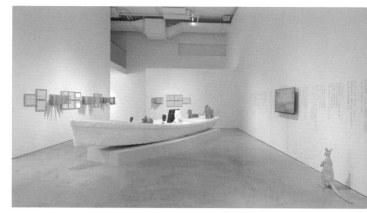

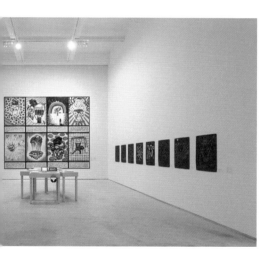

「雙束現實─歷史潛流中的感覺能指」國際論壇於吉隆坡，2017

The symposium *Reality in Its Double Bind: Emotional Signifiers in the Undercurrents of History* in Kuala Lumpur, 2017

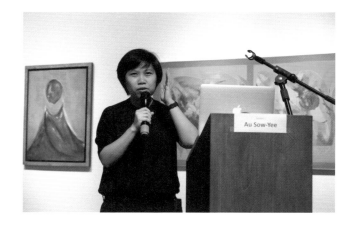

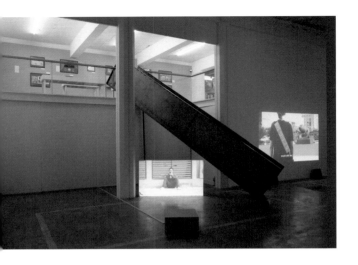

「現實秘境」於首爾總體當代美術館及Space55，2018

Towards Mysterious Realities at Total Museum of
Contemporary Art and Space55 in Seoul, 2018

簡歷
BIOGRAPHIES

藝術家

區秀詒 1978 年出生於馬來西亞，居住和工作於台北。畢業自文化大學戲劇系，舊金山藝術學院電影研究所、國立台北藝術大學新媒體藝術研究所。區秀詒的創作實踐以擴延影像與影像製造，以及和歷史、政治、權力之間的關係為核心概念。作品曾在東京森美術館、柏林 HKW、曼谷文化與藝術中心（BACC）、上海外灘美術館、新加坡國際電影節、韓國首爾國際實驗電影節、牯嶺街國際小劇場藝術節等展覽與電影節發表。她同時也是《數位荒原》特約作者、「亞答屋 84 號圖書館」共同創辦人之一。

巴尼·海卡爾 出生於 1985 年，居住和工作於新加坡，是一位文本與音樂實驗者。作為一位獨奏者，他的作品主要使用原音樂器，包括傳統的及改造的。他的研究圍繞於敘事、結構即興以及話語。他是「OFF-CUFF」及「b- 四重奏」的成員，也是團體「The Substation」的聯合藝術家。作為藝術家與音樂家，海卡爾參加過 Media/Art Kitchen、da:ns 等藝術節和新加坡 M1 藝穗節。他同時也是新加坡前衛搖滾樂團「觀測台」（The Observatory）的成員，這個樂團曾巡迴挪威（2012）和義大利（2013）。海卡爾於 2013 年獲得新加坡青年藝術家獎，2015 年入選「總統青年藝術家獎」。海卡爾研究爵士樂風潮和文化冷戰的關係、影響與歷史，揭露其潛藏於社會政治、經濟和文化敘事中關於自由及民主概念的政治意涵。他以此和新加坡當下對音樂與藝術的興趣傾向做出參照。海卡爾視文化擴張和自由的迷思為政治與觀念的污染，並且需要被重新思考和想像。作為一位具有批判力的藝術家和思想者，海卡爾的作品檢視感知、關聯性、聲音和音樂文化。通過與不同領域的藝術家合作為方法挖掘新的音樂形式，這些樂曲可被詮釋為用以瞭解更廣泛政治作用的語言。

法蘭西斯柯·卡馬丘 1979 年出生於哥倫比亞的波哥大，居住和工作於阿姆斯特丹。曾在 2008 至 2009 年間於阿姆斯特丹的皇家國際藝術村擔任研究員。卡馬丘的社會與政治參與計畫 —— 可視為一種行動主義或社會論述 —— 曾在國際的多場個展與聯展中展出，其中包括 2007 年魁北克雙年展，和 2012 年台北雙年展。他曾於 2009 年在阿姆斯特丹的 SKOR 公共藝術基金會的「表現史賓諾沙」計畫裡表演他持續進行的計畫「集體結婚」。在 2010 年於盧森堡的卡西諾當代藝術中心駐村時，他發表了個展「Entkustung de

l'art」。2011 年，他在「十二種手勢」計畫裡完成了一項介入行為，這項計畫是由洛杉磯的「公共學校」和巴黎的卡蒂斯基金會所發起。同年，他在荷蘭的范艾比現代美術館創作了一項與社區有關的計畫。他目前正執行一項社交媒體網站計畫 www.fulltopia.com。

張乾琦 1961 年生於台灣台中，居住並工作於奧地利格拉茲，是一位攝影記者，在 1991 至 1994 年間曾先後加入《西雅圖時報》、《巴爾的摩太陽報》。1995 年加入馬格蘭通訊社（Magnum Photos）。攝影作品散見於《紐約客》、《國家地理雜誌》、《時代雜誌》、《新聞週刊》、《紐約時報》、《GEO》等多家國際出版社。張乾琦的作品主要呈現疏離和牽繫的抽象概念。他移居美國多年後至奧地利居住，從自身深刻而分歧的移民經歷探索人與人之間的束縛關係。他投入二十四年時間拍攝紐約唐人街中國移民的生活，以及他們在中國福建的妻子和家人。目前仍在進行中的〈唐人街〉攝影計畫，曾於新加坡國家博物館（2009）、紐約國際攝影中心（2012）展出。張乾琦參加的展覽包括 2001 年威尼斯雙年展和 2011 年巴塞爾文化博物館展出作品〈鍊〉；2014 年於雪梨國家藝術學校畫廊、雪曼當代基金會（Sherman Contemporary Foundation）及釜山雙年展展出〈家〉。他獲得許多獎項，包括美國國家新聞攝影家協會年度攝影獎（1998、1999）、荷蘭世界新聞攝影獎（1998、1999）、法國影像 Visa 國際紀實攝影獎（1999）和尤金·史密斯紀念基金會所創立的人道主義攝影獎（1999）。

秦政德 出生於 1971 年，居住並工作於台北。朋友們叫他「阿德」，當年「文化大學美術系事件」的關鍵人物。1994 年秦政德於文化大學成立團體「藝術法西斯」諷刺美術系老師對學生言論的壓制而遭到退學，美術系學生於是發起抗議行動以及一個多月的罷課。最後秦政德復學，而美術系主任被停職。罷課期間，學生自行成立「小草藝術學院」，邀請校外藝術家、老師與校友於學校廣場舉辦體制外的講座，這個短暫的學院，讓此事件多了另一個層次的意義。也因文大事件，秦政德與同學共同創立「小草藝術學院」，自許為永遠的「小草 N 號志工」，小草藝術學院長年持續以在台灣歷史文物中發現的圖像為載體製作明信片。除了台灣歷史文件的蒐藏，他在藝術創作的方法學上發展出極具個人特色的地理學田野工法，透過「立碑」的行動揭示及再現被人忽略及被宏大敘事遺忘的重要台灣歷史片段。

洪子健 出生於 1970 年，居住和工作於台北，美籍亞裔電影製作人及藝術家。他已有二十多年的影片與錄像製作經驗，作品主題涵括海德格、史賓諾莎、日本生物戰、鴉片戰爭與種族主義。近年他完成了一部關於國族主義和中國東海領土爭議的紀錄片，該片曾於 2016 柏林影展及紐約古根漢美術館放映。他曾研究東亞的道德概念，並於 2016 台北雙年展中發表了一件多媒體的實驗作品〈尼采轉世為一位中國女性與他們共享的生命〉。其文章散見於《e-flux Journal》和其他出版物。洪子健的電影及錄像作品包括〈Behold the Asian: How One Becomes What One Is〉、〈Condor: A Film from California〉、〈資本主義萬萬歲〉及有關德國哲學家海德格的作品〈The Denazification of MH〉。有關日本七三一部隊的得獎紀錄片作品〈731: Two Versions of Hell〉於 2007 年完成，此主題於 2010 年由作品〈歷史血痕〉延續。其 2012 年的電影作品〈The Turner Film Diaries〉，根據臭名昭著的美國種族主義小說《透納日記》而創作。他參加的展覽與影展包括 2016 台北雙年展、南韓光州亞洲文化中心 ACT Center 所舉辦的「Interrupted Survey: Fractured Modern Mythologies」、香港 Para Site 藝術空間的「土尾世界——抵抗的轉喻和中華國家想像」、2016 年柏林影展，以及菲律賓馬尼拉當代藝術與設計博物館所舉辦的展覽「土與石，靈與歌」。

侯俊明（六腳侯氏） 1963 年出生於台灣嘉義縣六腳鄉，居住和工作於台北和苗栗。他慣以「六腳侯氏」署名，畢業於國立藝術學院（現改制為國立台北藝術大學）美術系第一屆。1990 年代以裝置、版畫形式進行創作，大膽挑戰禁忌、富儀式性，作品常與當下台灣政治環境和社會現況有密切關聯，曾於 1995 年及 2013 年受邀威尼斯雙年展等國際展。近年創作轉向心靈探索的隨手書、自由書寫和以文字形音義為發想並結合台灣民俗信仰之漢字創作；並於 2008 年起陸續於橫濱、台北、台中、曼谷、嘉義及香港等城市進行「亞洲人的父親」訪談創作計畫，其最新的創作系列〈身體圖〉創作也以訪談模式進行對身體慾望的意象探索。著有《搜神記》（時報文化，1994）、《三十六歲求愛遺書》（大塊文化，2002）、《穀雨‧不倫》（華藝文化，2007）、《鏡之戒》（心靈工坊，2007）、《侯俊明的罪與罰》（田園城市，2008）及《跟慾望搏鬥是一種病：侯俊明的塗鴉片》（心靈工坊，2013）。

許家維 出生於 1983 年，居住和工作於台北。畢業於法國國立當代藝術工作室，在藝術的實踐方式上，特別著力於影像創作背後的行動性，並透過建立鏡頭以外的事件，連結正規歷史描述所未及的人、物質與地方的關係。曾經舉辦的個展包括台北尊彩藝術中心「台灣總督府工業研究所」（2017）、台北鳳甲美術館「回莫村」（2016，獲第 15 屆台新藝術獎年度大獎）、香港巴塞爾藝術展「回莫村計畫」（2016）、荷蘭凡艾比美術館「Position 2」（2015）等。參與過的展覽包括柏林世界文化中心「2 or 3 Tigers」（2017）、台北市立美術館「台北雙年展——當下檔案‧未來系譜：雙年展新語」（2016）、上海外灘美術館「HUGO BOSS 亞洲藝術大獎」（2013）、五十五屆威尼斯雙年展台灣館「這不是台灣館」（2013）、法國網球場美術館「Faux Amis / An Ephemeral Video Library」（2010）等。他同時也與一群藝術家共同經營一個在台北的藝術空間「打開－當代藝術工作站」，一個同時具有策展、創作、論述、跨領域交流，以及藝術教育推廣多功能之組織，持續地致力於當代藝術中的每一種創造溝通的可能。他身兼策展人所策劃的展覽包括台北鳳甲美術館第六屆台灣國際錄像藝術展「離線瀏覽」（2018）、曼谷文化藝術中心「理解的尺度——台泰當代藝術交流展」（2012）等。

黃大旺 出生於 1975 年，居住和工作於台北。先天性表演者。在網際網路開始於台灣興盛時，以「㊣黑暗校園民歌之狼」晦澀混跡於網路留言板。2001 年自主發行《宅錄十年選集》，2002 年與 Cold Burn 樂團合作，在「聖界」翻唱濁水溪公社代表作，是為第一次公開表演。同年起以多個計畫名義在台北、台中、高雄演出。2004 至 2010 年旅日期間，與日本及其他國家多位樂手、樂團合作。返台後以即興演奏與日文翻譯為活動與工作重心。2011 年與張又升、陳藝堂等人組成環境即興與聲音採集團體「民國百年」，獲 2012 奧地利林茲電子藝術節聲音藝術類榮譽獎。2012 至 2014 年間參與林婉玉導演紀錄片〈台北抽搐〉的拍攝，獲 2015 年台北電影獎評審團特別獎。曾於香港、澳門、新加坡、東京、大阪、柏林、林茲、紐約等地開唱，參與多檔聯展，翻譯多本日文書，於平面媒體發表評論及隨筆，並演出多部學生短片。

任興淳 出生於 1969 年，居住和工作於首爾，是首爾的藝術家兼電影導演。在他早期以自身工人階級家庭為主題的作品中，就已開始探索被社會、政治、資本與國家所邊緣化的人民的生活。他同時具有政治性、詩性與感性的作品使用了多種視覺媒材，包括攝影、裝置、電影、公共藝術與社群藝術。他的第二部專題電影〈工業園區〉（2014）曾於 2014 年釜山影展的「廣

角紀錄片單元」裡首映，並於 2015 年第五十六屆威尼斯雙年展獲得銀獅獎，之後多次放映於世界各地。他的作品曾在世界各地展出，其中包括首爾的國立現代美術館（MMCA）（2017、2018）、柏林的世界文化中心（2017）、巴黎的龐畢度中心（2016）、紐約的林肯中心（2016）、台北雙年展（2016）、倫敦的泰特現代藝術館（2015）、東京的國立新美術館（2015）、沙迦雙年展（2015）與紐約的 PS1 當代美術館（2015）。

曹海準、李京洙、曹東煥 曹海準生於 1972 年，李京洙生於 1974 年，兩人居住和工作於斯圖加特和首爾；曹東煥生於 1935 年，工作和生活於全州。曹海準與李京洙從 2005 年參與關於韓國民眾藝術的展覽「設想之戰」起，兩人開始共同創作。他們曾收集南韓及阿拉伯國家民主化過程所發生的事件、故事，將其轉化成素描、裝置和由口述歷史所拍攝的影像。他們的主要計畫包括〈偉大的父親〉（2005）、〈阿拉伯之春：阿拉伯世界之外的反思〉（2013）。曹海準與李京洙也共同創作了〈之間的場景〉（2013），並參與伊斯坦堡雙年展（2009）、「自由！」（埃爾蘭根，德國，2013）、SeMA 首爾媒體城市雙年展（2014）、「告訴我一個故事」（外灘美術館，上海，2015 / 杜林，2018）和「Prospectif Cinema」（龐畢度藝術中心，巴黎，2016）等。

李燎 1982 年出生於湖北，居住和工作於深圳，是一位中國的行為藝術家。2005 年畢業於湖北美術學院，並在 2013 年獲得 HUGO BOSS 亞洲新銳藝術家大獎提名。李燎的創作形式多元，以行為表演為主，他往往將自己置身於公共社會場域，雖不帶有特定批判意識，但能以一些荒誕和微小的行為，來反映隱藏在社會規範下的普遍認知。他通過轉換自身經歷來提問藝術與社會之間的關係，或是針對如藝術體系、展覽機制等問題。李燎的行為藝術深深根植於他的日常生活與情感需求。他的意圖不僅在於培養一種基於親密關係的藝術風格，而是在日常情感和公共空間之間創造一種令人意想不到的強烈碰撞。

李士傑 出生於 1973 年，跨領域的數位文化思考與行動者。畢業於台灣大學心理學系，東華大學族群關係與文化研究所。早期論文從見證（witness）角度，切入人類社會遭逢科技群所產生的巨大撞擊與轉變，認為網路媒介創造現實社會之外的「不可能的見證」，導入且重新建構了新的「他者性」（alterity）；並關注從詩意與人文學科面向，觸及當代社會公民 / 使用者的感知能力，並審視網絡科學（network science）的可能性。曾任台灣自由軟體鑄造場創始計畫經理、數位典藏國家型計畫辦公室專案經理與國際合作計畫執行顧問、清華大學社會學研究所博士班研究（2007–2012）。目前參與項目包括：社群媒體資料分析創業團隊（2015 起）、宏華環境保護與數位未來基金會執行長（2016 起），以及杭州中國美院網絡社會研究所客座研究員（2015 迄今）。曾以藝術家身分參與上海雙年展（2016）、「現實秘境」展覽計畫（2016，台北；2017，吉隆坡）等。

玉仁集體 成立於 2009 年的藝術家團體，由李庭旼（Joungmin Yi）、金華用（Hwayong Kim）和陳是有（Shiu Jin）組成。團體名是以首爾市鐘路區的玉仁公寓大樓 —— 同時也是他們第一個計畫的發生地點 —— 來命名。 玉仁集體的第一個計畫「玉仁公寓計畫」，肇始於拜訪一位曾住在集合式建築玉仁公寓（當時預定 2009 年 7 月拆除）中的藝術家成員。公寓的重建發展決策來得非常突然，因此居住其中的租戶們沒有足夠的時間進行搬遷。「玉仁公寓計畫」的現地研究包括訪查住戶在過程中被迫搬遷的不幸遭遇、追溯昔日居民留下來的種種痕跡、探討現代主義建築的象徵價值，以及周邊環境的歷史性。 玉仁集體透過挪用、仿製、對場所的再挖掘、借用語言的碎片等不同的實踐方法來創造混合的情境。對玉仁集體而言，藝術在社會中的角色是為現實提供新的觀點，在其藝術實踐中，「即興」特質創造了一種以合作和尊重差異為基礎的另類工作方式，並且在他們的創作結構中，直接體現合作生產所需的靈活性。 玉仁集體自成立以來已經進行過多種計畫、表演和展覽，包括 2010 年於首爾玉仁公寓舉辦「玉仁：開放場址」個展，參與釜山美術館的「人生，永無平靜，只有冒險」（2010）、「開放庫房」（西班牙，2012）、「有形真相」（奧地利，2012）、總體當代美術館舉辦的「發聲行動」（2013）、「Festival Bo:m 2014」、光州雙年展（2014、2018）、「人造物藝術節」（比利時，2015）、「Rien ne va plus? Faites vos jeux!」（de Appel 藝術中心，2016）等展出。自 2010 年 9 月起，玉仁集體網路廣播電台[STUDIO+82]（http://okin.cc）正式開播。 2018 年，獲首爾國立現代美術館（MMCA）年度藝術家獎。

普拉賈克塔・波特尼斯 出生於 1980 年，居住和工作於孟買。她的作品所呈現的內涵，處於個人的私密世界與外部世界之間，二者有時候僅被一道「牆」所區隔。她把牆視為內嵌藏著棲居的痕跡，見證了歷史的紀錄。她試著將一般中產階級家庭中的「牆」，到形成各種制度的無形的「牆」放在一起思考，視它們為各種細微分子所能穿透的「膜」，也隱喻由上而下的政策規訓影響

個人的方式。「牆」成了一個起點，她從這裡出發，探討社會的與個人的焦慮。波特尼斯的創作包括繪畫、現地雕塑裝置和公共藝術等不同形式，巧妙地將自身的複雜情緒和這個時代的真相交織在一起。自 2001 年起，波特尼斯的作品即在印度和國際上頻繁展出。2017 至 2018 年，她參加了由鄭慧華策展的「現實祕境」展覽（台北、首爾）；由 Julia Sarisetiati 和 Renan Laru-An 策展的「O.K video 印度尼西亞媒體藝術節」；由 Arshiya Lokhandwala 策展，具標誌性的展覽「India Re-Worlded: Seventy Years of Investigating a Nation」；2016 年她受邀參與由瑪麗亞・琳德（Maria Lind）策劃的第十一屆光州雙年展；2015 年參加紐約皇后美術館所舉辦的聯展「After Midnight」。

作者

鄭慧華 獨立策展人，台北立方計劃空間成立者之一。立方計劃空間以研究導向的實踐關注「拓展策展」的可能性，致力於深耕在地文化、與創作者的長期合作和推動台灣與國際之間的對話連結。鄭慧華近年的策展包括：2011 威尼斯雙年展台灣館「聽見，以及那些未被聽見的 —— 台灣社會聲音圖景」、「重建／見社會」系列（2011–2013，台北）、「巫士與異見」（2013，香港）、「現實秘境」（2016–2018，台北、吉隆坡、首爾）等；共同策劃的展覽包括：第三屆台灣國際錄像藝術展「憂鬱的進步」（2012，台北）、「造音翻土 —— 戰後台灣聲響文化的探索」（2014，台北、高雄）、「文明幻魅」（2015，盧森堡）以及「告訴我一個故事 —— 地方性與敘事」（2016、2018，上海、杜林）等。2017 年，她擔任威尼斯雙年展大會評審團委員。

阿崔伊・古普塔 加州大學伯克萊分校藝術史學系助理教授，教授全球現代藝術。目前她正在撰寫一本專論，關於南亞地區在兩次大戰間與戰後的抽象繪畫、雕塑、攝影和影片，以及與奧奎・恩威佐（Okwui Enwezor）共同編輯著作《二戰之後：全球藝術史，1945–1965》。她的評論文章刊登於書籍、展覽手冊、雜誌，包括《Art Journal》、《Third Text》、《Yishu》等。

許芳慈 獨立研究者暨策展人，美國芝加哥藝術學院藝術策展學碩士，目前為新加坡國立大學社會科學所的亞洲文化研究課程博士候選人、沖繩大學地方文化研究中心特別研究員。研究興趣為冷戰美學的現代性視覺考研，以及記憶政治之於動態影像的關

聯性。近期策劃的展覽包括於國立台灣美術館展出的「在現場：卡帕百年回顧展」（2013）；於立方計劃空間舉行的「透工 —— 萬迪拉塔那與他所捨棄的影像」（2016），以及由鳳甲美術館主辦的第六屆台灣國際錄像藝術展「負地平線」（2016）。

金炫進 策展人兼作家，目前擔任卡蒂斯藝術基金會的亞洲區首席策展人，策劃 2019 年威尼斯雙年展南韓國家館。他曾是第七屆光州雙年展（2008）的共同策展人之一，並且於首爾 Arko 藝術中心擔任總監（2014–2015）。他的策展實踐包括「2 or 3 Tigers」，世界文化中心（柏林，2017）；「Two Hours」，Tina Kim 畫廊（紐約，2016）；「Tradition (Un)Realized」，Arko 藝術中心（首爾，2014）；「Plug-In#3-Undeclared Crowd」，凡艾比當代美術館（恩荷芬，2006）等。金炫進也曾為藝術家尼娜・卡內爾（Nina Canell）、Nam Hwayeon、梁慧圭、Jewyo Rhii、Seoyoung Chung 撰文和策展，並委託藝術家 Sung-Hwan Kim、鄭恩瑛、Jewyo Rhii 等人製作表演及劇場。金炫進曾是柏林世界文化中心的顧問之一（2014–2016）以及柏林 DAAD 藝術家駐村計畫的評審委員（2017–2018）。

李庸宇 媒體史學家及文化研究學者，目前生活和工作於紐約、首爾。他在紐約大學教授現代韓國媒體與文化研究、電影理論、東亞大眾文化、戰時日本與戰後韓國思想史、當代藝術以及後／殖民史學。

魏月萍 馬來西亞蘇丹依德理斯教育大學中文系副教授。研究關懷為思想史、新馬歷史與文學，尤其關注文學公民、新馬華文左翼文學以及馬來馬共論述等議題。近年來強調「重返馬來亞」作為方法論述，以亞際書院（新馬）為平台，在吉隆坡（2014）和印尼日惹（2016）舉辦相關議題的學術討論會。同時在《亞際文化研究》和台灣《人間思想》擔任《重返馬來亞》和《馬來亞和印尼》中英文專號的客座主編。

覃炳鑫 英國牛津大學東南亞跨領域研究中心的「東南亞計畫」發起人及計畫主席。羅德獎學金與英聯邦獎學金獲獎學者、奧運選手和唯一泳渡英吉利海峽的新加坡人，他的研究工作專注於處理東南亞政治治理與政治學。他最近的著作包括：《在新加坡與神話共生》（Ethos：2017，與 Loh Kah Seng 及 Jack Chia 共同編輯），他同時也是播客（podcast）「新加坡的歷史」的創始人，可以在 www.thehistoryofsingapore.com 或 iTunes 找到。

Artists

AU Sow-Yee Born in 1978 in Malaysia. Lives and works in Taipei. Her practice revolves around moving images, historical narrative, representational politics and power. She completed her M.F.A. from San Francisco Art Institute on experimental filmmaking and graduate school of New Media Arts at the Taipei National University of the Arts. Sow-Yee's works were exhibited in Mori Art Museum (Tokyo), HKW (Berlin), BACC (Bangkok), Shanghai Rockbund Art Museum, Singapore Film Festival, official selection of *Experimental Film and Video Festival in Seoul* (ExiS) and various other exhibitions and screenings. She is currently a guest writer for online magazine *No Man's Land* and co-founded Kuala Lumpur's Rumah Attap Library and Collective in 2017.

BANI Haykal Born in 1985. Lives and works in Singapore. Bani Haykal experiments with text and music. As a soloist, he works primarily with acoustic instruments, both traditional and/or hacked, and his studies revolve around narratives, structured improvisation and spoken word. He is a member of OFFCUFF and b-quartet. An associate artist with The Substation, Haykal has collaborated, exhibited, performed and toured internationally, as an artist and a musician, participating in festivals including *Media/Art Kitchen* (Indonesia, Malaysia, Philippines and Japan), *da:ns Festival* and *The M1 Fringe Festival* (Singapore) among others. Haykal was also a member of the Singaporean avant rock band The Observatory, with whom he has toured Norway (2012) and Italy (2013). Haykal was a recipient for the Young Artists' Award (2013) and has been selected for the 2015 President's Young Talents. Haykal's research looks into the history and affect of the cultural cold war through the movement of Jazz music; identifying the political baggage associated with freedom and democracy as unpacked concepts locked in to the sociopolitical, economic and cultural narrative. Mirroring it to the narrative of Singapore's present interest in music and the arts, Haykal posits the myths of freedom and cultural expansion as political and conceptual pollution that needs to be rethought and reimagined. As a critically reflective artist and thinker, Haykal's work examines the perceptions, relevance and culture of sound and music. This is often materialized through collaborations with artists across all fields as a means to discover new musical forms. These compositions can be interpreted as language in which to understand wider politics at play.

Francisco CAMACHO Born in 1979. Lives and works in Amsterdam. Francisco Camacho was born in Bogota, Colombia. He was a research fellow at the Rijksakademie in Amsterdam in 2008–2009. Camacho's social and politically engaged projects, which can be viewed as forms of activism or social discourse, have been presented in numerous solo and group exhibitions internationally, notably at the 2007 Biennale de Québec, the 2012 Taipei Biennale and the 2018 Biennale of Sydney. In 2009 Camacho performed his ongoing project *Group Marriage* at SKOR in Amsterdam as part of *Manifestatie Spinoza*. His solo exhibition *Entkustung de l'art* was presented at Casino Luxembourg – Forum d'art contemporain, where he was a resident artist in 2010. In 2011, Camacho completed an intervention as part of *12 Gestures*, a project initiated by The Public School, Los Angeles, and the Kadist Art Foundation, Paris. Also in 2011, he created a community-based project for the Van Abbemuseum, Eindhoven. Currently he is working on a web social media project www.fulltopia.com.

CHANG Chien-Chi Born in Taichung, Taiwan, 1961. Lives and works in Graz, Austria. Chang was a photojournalist for the *Seattle Times* and later the *Baltimore Sun* between 1991–1994. In 1995, Chang was elected to join Magnum Photos. His work has been published by *New Yorker*, *National Geographic Magazine*, *TIME*, *Newsweek*, *The New York Times Magazine*, *GEO* (France and Germany) and many other leading international publications. In his work, Chang makes manifest the abstract concepts of alienation and connection. Chang's investigation of the ties that bind one person to another was drawn on his own deeply divided immigrant experience first in the United States and later in Austria. For 24 years, Chang has photographed the bifurcated lives of the Chinese immigrants in New York's Chinatown, along with those of their wives and families back home in Fujian, China. Still a work in progress, *China Town* was hung at the National Museum of Singapore in 2008 as part of a mid-career survey and at La Biennale di Venezia, 2009 as well as at International Center of Photography, New York, 2012. Chang has had steady solo and group exhibitions including *The Chain*, La Biennale di Venezia, 2001, Museum der Kulturen Basel, 2011 and recently, *Home*, at National Art School Gallery/Sherman Contemporary Foundation, Sydney, 2014, Busan Biennale 2014, Chang has received numerous awards from National Press Photographers Association, Picture of Year (1998 & 1999, USA), World Press Photo (the Netherlands, 1998 & 1999) Visa d'Or at Visa Pour L'image (1999, France) and was the recipient of the W. Eugene Smith Memorial Fund on Humanistic Photography in 1999.

CHIN Cheng-Te Born in 1971. Lives and works in Taipei. "A-Te," as his friends call him, was a pivotal figure in the historical incident of the Department of Fine Art at the Chinese Culture University occurred in 1994 in Taiwan. As a university student in 1994, Chin Cheng-Te founded the artistic group "Art Fascism" as an ironic reply to the professors who threatened their freedom of speech. This action unfortunately resulted in Chin's involuntary withdrawal, and the students in the department organized a demonstration and a one-month strike. This incident ended with Chin's re-enrolling and the dean's suspension from duties. The student-founded "Spring Grass Arts Academy" was born during the strike, when it actively invited external artists, teachers and alumni to deliver public, informal lectures. This Academy might be ephemeral, but it gave a deeper meaning to this incident. The event prompted him to establish the "the Spring Grass Arts Academy" in collaboration with his classmates, after which he styles himself as the lifetime "Grass Volunteer Worker No. N". Over the past decades, the Academy has kept producing postcards carrying the images appropriated from Taiwanese historical artefacts and documents. In addition to his collection of Taiwanese historical documents, the artist also developed *sui generis* geographical fieldwork techniques as part of his artistic methodology. By virtue of his actions of erecting steles, he managed to re-explore and represent those forgotten and neglected landmark events or fragments in the grand narrative of the Taiwanese history.

James T. HONG Born in 1970. Lives and works in Taipei. James T. Hong is a filmmaker and artist who has been producing films and videos for over twenty years. He has produced works about Heidegger, Spinoza, Japanese biological warfare, the Opium Wars, and racism and recently completed a documentary about nationalism and disputed territory in the East China Sea which was screened at the 2016 Berlin Film Festival and the Guggenheim Museum in New York. He is currently researching the concept

of morality in East Asia and presented a new experimental, multimedia work about Nietzsche and metempsychosis at the 2016 Taipei Biennial. Hong also occasionally writes articles for *e-flux Journal* and other publications. Hong's films and videos include *Behold the Asian: How One Becomes What One Is, Condor: A Film from California, Suprematist Kapital*, and *The Denazification of MH* about Martin Heidegger, which is analyzed in the journal *Film-Philosophy*. Hong produced the award-winning documentary *731: Two Versions of Hell* about Japan's Unit 731 in 2007, which was followed by *Lessons of the Blood* in 2010. His 2012 short film *The Turner Film Diaries* is based on the infamous, racist American novel, *The Turner Diaries*.Hong has participated in numerous international exhibitions and film festivals and his most recent include: *Interrupted Survey: Fractured Modern Mythologies* at ACT Center, Asia Culture Center in Gwangju, South Korea; *A Hundred Years of Shame – Songs of Resistance and Scenarios for Chinese Nations* and *Creative Operational Solutions* at Para Site Art Space in Hong Kong; *2 or 3 Tigers* at the Haus der Kulturen der Welt in Berlin, Germany; *Tito's Bunker* at the Württembergischer Kunstverein, Stuttgart, Germany; and *Soil and Stones, Souls and Songs* at the Museum of Contemporary Art and Design in Manila, Philippines and the JT Art Center in Bangkok, Thailand.

HOU Chun-Ming a.k.a. **Legend Hou/Hou of Liuchiao Township** Born in Liuchiao Township, Chiayi County, Taiwan in 1963. Lives and works in Taipei and Miaoli. Hou Chun-Ming graduated from the National Arts Academy (now Taipei National University of the Arts) and styles himself as Hou of Liuchiao Township. He engaged in taboo-breaking installations and woodcut prints as early as in the 1990s, and his uncanny and ritualistic artworks always

faithfully reflect the political and social status quo of Taiwan. Hou has been invited to participate in many international art exhibitions including the Venice Biennale, Taiwan Pavilion in 1995. In recent years, he has re-orientated his artistic practice towards freehand drawing in which he finds inner sustenance, *écriture automatique*, and Chinese characters that represent an aesthetically pleasing mix of configuration, pronunciation, meaning and Taiwanese folk beliefs. Since 2008, Hou has embarked on *The Asian Father Interview Project*, an interview-based art series created successively in Asian cities including Yokohama, Taipei, Taichung, Bangkok, Chiayi, Hong Kong and Seoul. His latest work *Body Images* once again uses interview-based techniques and methodologies to transform bodily desires into artistic expressions. He is the author of several books, including *Anecdotes about Spirits and Immortals* (China Times Publishing, 1994), *A Suicide Message of Dying on Love at Age 36* (Locus Publishing, 2002), Grain Rain. *Amorous Affair* (Cans Art, 2007), *The Caution in Mirror* (Psygarden Publishing, 2007), *Legend Hou's Sin & Punishment* (Garden City Publishers, 2008) and *Suffer from Desires: Hou Chun Ming's Free Drawing* (Psygarden Publishing, 2013).

HSU Chia-Wei Born in 1983. Lives and works in Taipei. Graduated from Le Fresnoy - Studio national des arts contemporains, France, Hsu stresses specifically on the actionability underneath image creation when comes to the practice of art, while linking up the relationships of humans, materials, and places omitted in the narrative of the conventional history through establishing the incidents beyond camera. Hsu has thrown solo exhibitions including *Industrial Research Institute of Taiwan Governor-General's Office* at Liang Gallery, Taipei, Taiwan (2017), *Huai Mo Village* at Hong-Gah Museum, Taipei, Taiwan (2016) that was recognized by the

Annual Grand Prize of The 15th Taishin Arts Award, *Huai Mo Village Project* at Art Basel, Hong Kong Convention and Exhibition Centre, Hong Kong, China (2016), and *Position 2* at Van Abbemuseum, Eindhoven, Netherlands (2015). The artist has participated in exhibitions such as *2 or 3 Tigers* at Haus der Kulturen der Welt, Berlin, Germany (2017), 2016 Taipei Biennial—*Gestures and Archives of the Present, Genealogies of the Future* at Taipei Fine Arts Museum, Taipei, Taiwan (2016), *HUGO BOSS ASIA ART Award* at Rockbund Art Museum, Shanghai, China (2013), The 55th International Art Exhibition—la Biennale di Venezia: *This is not a Taiwan Pavilion*, Venice, Italy (2013) and *Faux Amis / An Ephemeral Video Library* at JEU DE PAUME, Paris, France (2010). He and a group of artists also run an art space in Taipei: Open-Contemporary Art Center, an organization with functions of curation, creation, narrative, inter-disciplinary exchange, education as well as promotion of art that strives to seek every possibility to create communication in contemporary art. He is also the curator of the 6th Taiwan International Video Art Exhibition—*Offline Browser* at Hong-Gah Museum, Taipei, Taiwan (2018) and *THAITAI: A Measure of Understanding* at Bangkok Art and Culture Centre, Bangkok, Thailand (2012).

HUANG Da-Wang Born in 1975. Lives and works in Taipei. Born to be a performer, Huang used to hang out at the Bulletin Board System (BBS) with the user-name "the wolf of dark campus folksongs" during the time when Taiwan saw the dawn of the Internet age. He self-released his *Audio Graffiti Compilation* in 2001, and covered the magnum opuses of Loh Tsui Kweh Commune in collaboration with the band Cold Burn at Zeitgeist Live House in 2002, which was his stage debut, followed by a series of his performances delivered in Taiwan. Huang had collaborated with several Japanese musicians and bands during his stay in Japan between 2004 and 2010. He re-orientated himself towards improvisation and Japanese translation/interpreting profession after returning home in 2010. Huang organized the improvised soundscape band Minkoku Hyakunen in collaboration with Zhang You-Sheng, Chen Etang and the others in 2011, and awarded honorary mention at the 2012 Ars Electronica in Linz, Austria. He had attended the production with Jessica Lin Wan-Yu, the director of the documentary *TPE-Tics*, and won the Special Jury Award at the 2015 Taipei Film Festival. He has delivered performances in Hong Kong, Macau, Singapore, Tokyo, Osaka, Berlin, Linz and New York, as well as participated in many exhibitions. Apart from translating Japanese books, Huang has also published reviews and notes in print media and acted in student films.

IM Heung-Soon Born in 1969. Lives and works in Seoul. IM Heung-Soon is an artist and filmmaker based in Seoul. Since his early works on his working-class family, he has explored the lives of people who are marginalized in social, political, capitalist, and national contexts. His political yet emotional works are embodied through different visual mediums such as photography, installations, cinema and public art and community art. His second feature film, *Factory Complex* (2014), was premiered at the Wide Angle Feature Documentary section of 2014 Busan International Film Festival and many others after having been awarded the Silver Lion Award at the 56th Venice Biennale 2015. His works have been exhibited, among others, at the MMCA, Seoul (2017, 2018), HKW, Berlin (2017), Pompidou Centre, Paris (2016), Lincoln Center, NY (2016), Taipei Biennale (2016), Tate Modern, London (2015), The National Art Center, Tokyo (2015), Sharjah Biennale (2015) and MoMA PS1, New York (2015).

JO Haejun, LEE Kyeongsoo & JO Donghwan Jo Haejun, born in 1972; Lee Kyeongsoo, born in 1974. They live and work in Stuttgart and Seoul. Jo Donghwan, born in Korea in 1935, lives and works in Jeonju.

Jo Haejun and Lee Kyeongsoo started working together from 2005 when they participated in the exhibition *The Battle of Visions*. Jo and Lee have been collecting incidents and stories from the democratization process of South Korea and the Arabic countries, transforming them into drawings, installations, and videos based on oral memory. Their major projects include *Amazing Father* (2005) and *Arab Spring: The Arab World Reflected From Without* (2013). Jo and Lee also worked as collaborated to produce *Scenes of Between* (2013), They participated in the Istanbul Biennale (2009), *Freiheit!* (Kunstpalais Erlangen, 2013), SeMA Biennale Mediacity Seoul (2014), *Tell Me a Story* (Rockbund Art Museum, Shanghai, China, 2015; Torino, Italy, 2018) and *Prospectif Cinema* (Centre Pompidou, Paris, 2016) among others.

LI Liao Born in 1982. Lives and works in Shenzhen. Graduated from the Hubei Institute of Fine Arts in 2005, Chinese performance artist Li Liao was nominated for the HUGO BOSS Asia Art Award in 2013. His oeuvre takes on multifarious forms with a large body of performance art. Adopting no critical attitude, he tends to situate himself in public places, carrying out absurd and low-profile acts to reveal the stereotypes masked by social regulations and norms. By reference to his personal experiences, Li undertakes an enquiry into the relationships between the arts and the society, as well as questions the art system and exhibition mechanism. His performance has been deeply rooted in his quotidian existence and emotional needs. He intends not only to form an intimacy-based art style but also to provoke an unanticipated head-on clash between quotidian sentiments and public spaces.

Shih-Chieh Ilya LI Born in 1973, a transdisciplinary thinker and activist. Graduated from the Department of Psychology, National Taiwan University and earning his master's degree from the Department of Ethnic Relations and Cultures, National Dong Hwa University. Treating "witnessing" as the entry point, Li's thesis primarily addressed the drastic changes of human society ensued from the profound impacts of innovative technologies, arguing that online media make the "impossible witnessing" beyond our society possible. He introduced and reconstructed in his thesis a new "alterity", not only discussing the awareness of contemporary citizen-users from the poetic and humanistic aspects, but also examining the possibility of the network science. He is the founding program manager of Open Source Software Foundry in Academia Sinica, and used to be the program office project manager of Taiwan e-Learning and Digital Archives Program and an executive consultant on international cooperation. He was enrolled in the doctoral program at the Institute of Sociology, National Tsing-Hua University (2007–2012). Li has devoted himself specifically to the field of digital culture development. He has been occupied with several positions, including a start-up company of social media data analysis (since 2015), the CEO of Honghua Foundation for Environmental Protection and Digital Future (since 2016), and a guest researcher at the Institute of Network Society, China Academy of Art (since 2015). As an artist, he participated in *Towards Mysterious Realities*. (2016, Taipei; 2017, Kuala Lumpur) and Shanghai Biennial (2016).

Okin Collective is an artists' group, which consists of Yi Joungmin, Kim Hwayong, Jin Shiu, named after Okin Apartment complex

in Jongnogu, Seoul, where in which the first group project was held. The inaugural project, *Okin Apartments Project*, was stemmed from a visit to one of the artist members who lived in the complex where was to be demolished in July, 2009. The decision of redevelopment was abrupt so the tenants did not have enough time to prepare their move out. The project composed of researches the stories on the site including: the tenants' unfortunate situation during the eviction process for the redevelopment project, traces left by the former residents, symbolic values of the modernist buildings and historicity of the surroundings. According to Okin Collective, art's role in society is to offer new perspectives on reality. They create hybrid situations through complex matrix of appropriation, pastiche, discovery of sites, borrowed linguistic fragments and different methods of practice. The improvisational quality of their practice offers an alternative way of working defined by cooperation and respect for difference, and the flexibility required for collaborative production is directly demonstrated in the structure of their works. The group has organized various projects, performances and exhibitions since its inception, including its solo show entitled *Okin OPEN SITE* at Okin apartments, Seoul(2010). It has participated in *Life, No Peace, Only Adventure* at Busan National Museum of Art(2011), *Open Hangar*(Spain, 2012), *Truth is Concrete*(Austria, 2012), *Acts of Voicing* at Total Museum(2013), *Festival Bo:m 2014, 10th Gwangju Biennale(2014)*, *ARTEFACT FESTIVAL 15*,(STUK, Belgium, 2015), *Rien ne va plus? Faites vos jeux!,*(de Appel art centre, 2016) and more. They have been running Okin Collective Internet radio station [STUDIO+82](http://okin.cc) since September 2010.

Prajakta POTNIS Born in 1980. Lives and works in Mumbai. Potnis' work dwells between the intimate world of an individual and the world outside which is separated sometimes only by a wall. She refers to the wall as a witness to history that has traces of inhabitance embedded within. She tries to contextualize the wall from middle class home to the walls that build institutions with a membrane through which imperceptible elements pass, how resolutions passed by top down policies affect an individual. The wall becomes a starting point through which she addresses social and individual anxieties. Potnis effortlessly weaves complexities of emotions and the veracity of today's times through her practice. Her practice sails through paintings, site-specific sculptural installations to public art interventions. She has extensively shown her works since 2001 nationally and internationally. Potnis' work was included in the OK. Video—Indonesia Media Arts Festival curated by Julia Sarisetiati and Renan Laru-An. She was part of an iconic exhibition *India Re-Worlded: Seventy Years of Investigating a Nation*, curated by Arshiya Lokhandwala, marking 70th years of independence. In 2016 she was invited to participate at the 11th Gwangju Biennale, curated by Maria Lind and *Towards Mysterious Realities* curated by Amy Cheng in Taipei. In 2015 she was part of the group exhibition, *After Midnight* at Queens Museum in New York.

Contributors

Amy CHENG is a curator and writer based in Taipei. She co-founded TheCube Project Space with Jeph Lo in 2010, which serves as an independent art space devoted to the research, production and presentation of contemporary art in Taipei. She has curated various exhibitions including *The Heard and the Unheard: Soundscape Taiwan*, Taiwan Pavilion at the 54th International Art Exhibition—La Biennale di Venezia (2011),

the exhibition series *Re-envisioning Society* (Taipei, 2011–2013), *Shamans and Dissent* (Hong Kong, 2013) and *Towards Mysterious Realities* (Taipei, Kuala Lumpur, Seoul, 2016–2018). She also co-curated these exhibitions: The 3rd Taiwan International Video Art Exhibition —*Melancholy in Progress*(2012), *ALTERing NATIVism—Sound Cultures in Post War Taiwan* (2014), *Phantom of Civilization* (Luxembourg, 2015) and *Tell Me a Story—Locality and Narrative* (Shanghai, Torino, 2016/2018). Cheng has been appointed the jury member of the 57th Biennale di Venezia (2017).

Atreyee GUPTA is an Assistant Professor of Global Modern Art in the History of Art Department at the University of California, Berkeley. Currently, she is completing a monograph on abstraction in interwar and postwar painting, sculpture, photography, and experimental film in South Asia and *Postwar: A Global Art History, 1945–1965* (co-edited with Okwui Enwezor). Her essays have appeared in books, exhibition catalogs, and journals such as *Art Journal, Third Text*, and *Yishu*.

HSU Fang-Tze An independent curator and a Ph.D. candidate in the Cultural Studies in Asia programme of the National University of Singapore. Her dissertation research, *Cold War Acousmêtre: Artists' Film and Videos from Okinawa, Taiwan, and the Philippines*, has been supported by the President's Graduate Fellowship and the FASS Promising Graduate Scholar Award. Her research interests include contemporary knowledge formation, Cold War aesthetics, memory, philosophies of technology, and the embodiment of artistic praxis in everyday life. Hsu is the co-curator of the 5th Taiwan International Video Art Exhibition—*Negative Horizon* (2016) and her writings can be found in *ARTCO Magazine* (Taiwan) and *LEAP* (China).

KIM Hyunjin is a curator and writer, currently the KADIST Lead Curator for Asia and the curator for 2019 Korean Pavilion, Venice Biennale. She was a co-curator of the 7th Gwangju Biennale (2008) and worked as Director for Arko Art Center, Seoul (2014–2015). Her curation includes *2 or 3 Tigers*, HKW (Berlin 2017); *Two Hours*, Tina Kim Gallery (New York 2016); *Tradition (Un) Realized*, Arko Art Center (Seoul 2014); *Plug-In#3-Undeclared Crowd*, Van abbemuseum (Eindhoven, 2006) and so on. Kim also curated and wrote for the artists like Nina Canell, Nam Hwayeon, Haegue Yang, Jewyo Rhii and Seoyoung Chung, and commissioned performance/theater works by the artists like Sung Hwan Kim, siren eun young jung, Jewyo Rhii and so on. Kim was one of advisory for Haus der Kulturen der Welt, Berlin (2014–2016) and a jury member for DAAD artist residency, Berlin (2017–2018).

LEE Yongwoo is a media historian and cultural studies scholar based in New York and Seoul. He teaches media and cultural studies of modern Korea, film theory and popular culture in East Asia, intellectual history of wartime Japan and postwar Korea, Korean contemporary art and post-colonial historiography at New York University.

NGOI Guat-Peng Associate Professor, Sultan Idris Education University, Malaysia. Her research interests involve literature, intellectual history, and the history of Singapore and Malaysia, with a particular focus on literary citizenship, Chinese left-wing literature in Singapore and Malaysia, and the discourses of the Communist Party of Malaya. Adopting "revisiting Malaya" as a methodological approach and the Inter-Asia School (MAT Singapore and Malaysia Office) as a platform, she has organized symposiums in recent years on related issues in Kuala Lumpur (2014) and Yogyakarta (2016). She also works as a guest editor for *Inter-Asia Cultural Studies*

and Renjian Thought Review in charge of the bilingual special issues on *Revisiting Malaya* and *Malaya and Indonesia*.

THUM Ping-Tjin Founding director of Project Southeast Asia, an interdisciplinary research centre on Southeast Asia at the University of Oxford. A Rhodes Scholar, Commonwealth Scholar, Olympic athlete, and the only Singaporean to swim the English Channel, his work centres on Southeast Asian governance and politics. His most recent work is *Living with Myths in Singapore* (Ethos: 2017, co-edited with Loh Kah Seng and Jack Chia). He is creator of *The History of Singapore* podcast, available at www.thehistoryofsingapore.com or on iTunes.

現實秘境 Towards Mysterious Realities

策展人
鄭慧華

藝術家
區秀詒、巴尼・海卡爾、法蘭西斯柯・卡馬丘、張乾琦、秦政德、洪子健、侯俊明、許家維、黃大旺、任興淳、曹海準、曹東煥、李士傑、李燎、李京洙、玉仁集體、普拉賈克塔・波特尼斯

台北展覽
聯合主辦｜立方計劃空間、財團法人耿藝術文化基金會
日期｜2016.12.10–2017. 1. 26
地點｜耿畫廊
技術統籌｜藝術戰爭公司
美術設計｜章芷珩
翻譯｜王聖智、區秀詒、楊爾寧
媒體協力｜關鍵評論、典藏・今藝術、藝術家雜誌、數位荒原

吉隆坡國際論壇
策劃｜許芳慈
主辦｜立方計劃空間
日期｜2017. 12. 8–12.10
合作｜Lostgens' 當代藝術空間、亞答屋 84 號圖書館
支持｜ILHAM
特別放映｜約翰・托雷斯〈人民力量重磅彈：越南玫瑰日記〉（2017. 12. 9）

首爾展覽
共同策展人｜申寶瑟
聯合主辦｜立方計劃空間、總體當代美術館
日期｜2018.4.26–6. 24
地點｜總體當代美術館、Space55
技術、展場統籌｜藝術戰爭公司、Zero LAB、Hanall Design
美術設計｜章芷珩、Hein Son
翻譯｜王聖智、區秀詒、楊爾寧、Choi Sooyoung
藝術家駐地｜區秀詒（2017. 9）、侯俊明（2018. 2.28–4.28）
特別放映｜任興淳〈工業園區〉（2018. 9. 8）

Curator
Amy Cheng

Artist
Au Sow-Yee, Bani Haykal, Francisco Camacho, Chang Chien-Chi, Chin Cheng-Te, James T. Hong, Hou Chun-Ming, Hsu Chia-Wei, Huang Da-Wang, Im Heung-Soon, Jo Haejun, Jo Donghwan, Shih-Chieh Ilya Li, Li Liao, Lee Kyeongsoo, Okin Collective, Prajakta Potnis

Taipei Edition
Organizer | TheCube Project Space, TKG Foundation for Arts & Culture
Date | 2016.12.10–2017. 1. 26
Venue | TKG+
Technical Support | Art War Company
Graphic Designer | Shauba Chang
Translator | Au Sow-Yee, Wang Sheng-Chih, Ernie Yang
Media collaborator | The News Lens, ARTCO magazine, Artist magazine, No Man's Land

International Symposium in Kuala Lumpur
Convener | Hsu Fang-Tze
Organizer | TheCube Project Space
Date | 2017. 12. 8–12.10
Partner | Lostgens' Contemporary Art Space, Rumah Attap Library & Collective
Support | ILHAM
Special Screening | John Torres, *People Power Bombshell: The Diary of Vietnam Rose* (2017. 12. 9)

Seoul Edition
Co-curator | Nathalie Boseul Shin
Organizer | TheCube Project Space, Total Museum of Contemporary Art
Date | 2018.4.26–6. 24
Venue | Total Museum of Contemporary Art, Space55
Technical Support and Space Construction | Art War Company, Zero LAB, Hanall Design
Graphic Designer | Shauba Chang, Hein Son
Translator | Au Sow-Yee, Choi Sooyoung, Wang Sheng-Chih, Ernie Yang
Residency Artist | Au Sow-Yee (2017. 9), Hou Chun-Ming (2018. 2.28–4.28)
Special Screening | Im Heung-Soon, *Factory Complex* (2018. 9. 8)

專輯 / 讀本出版資訊

專文作者 | 區秀詒、鄭慧華、阿崔伊・古普塔、洪子健、許芳慈、金炫進、李庸宇、李士傑、魏月萍、覃炳鑫等
發行 | 立方計劃空間
主編 | 鄭慧華
執行編輯 | 羅悅全、孫以臻
翻譯 | 丘琦欣、Josh Hong、Lin Chia-Hsuan、王聖智、味王、楊爾寧、Yu Jiwon
攝影 | 陳懋璋、陳藝堂、張國耀
美術設計 | 章芷珩、胡逸貞
印刷 | 經緯印藝實業有限公司
出版日期 | 2019 年 1 月

Publication Information

Author | Au Sow-Yee, Amy Cheng, Atreyee Gupta, James T. Hong, Hsu Fang-Tze, Kim Hyunjin, Lee Yongwoo, Shih Chieh Iiya Li, Ngoi Guat-Peng, Thum Ping-Tjin
Publisher | TheCube Project Space
Chief Editor | Amy Cheng
Editor | Jeph Lo, Sun Yi-Cheng
Translator | Brian Hioe, Josh Hong, Lin Chia-Hsuan, Wang Sheng-Chih, Wèi Wáng, Ernie Yang, Yu Jiwon
Photographer | Chen Mao-Chang, Chen ETang, Chong Kok-Yew
Graphic Designer | Shauba Chang, Johnny Hu
Printer | Jing Wei Printing Co., Ltd.
Publishing Date | 2019. 01

贊助 Sponsor

國藝會 2015 視覺藝術策展專案

RC 文化藝術基金會

首爾市政府

韓國文化藝術委員會

特別感謝

陳佳鈴、陳界仁、陳星穎、陳瀅如、鄭莉貞、程立名、陳思伶、Chi Too、周育正、謝豐嶸、許芳慈、黃蘭茵（故宮器物處助理研究員）、侯昱寬、吳敬賢、劉家明、李傑、廖寶秀（故宮器物處研究員）、林炳炎、李永定、陸仲雁、盧紀帆、呂岱如、彭安水、拉赫爾·約瑟夫、蘇穎欣、孫先勇、宋兆霖（故宮圖書文獻處處長）、宋杰、唐千雅、寶藏巖藝術村、王彥蘋、楊兩興、余政達、俞小明（故宮圖書文獻處科長）、余泓緯、余佩瑾（故宮器物處處長）

Special Thanks

Angel Chen, Chen Chieh-Jen, Chen Hsing-Ying, Chen Yin-Ju, Cheng Li-Chen, Cheng Li-Ming, Tanya Chen, Chi Too, Chou Yu-Cheng, Hsieh Feng-Rong, Hsu Fang-Tze, Huang Lan-Yin (Department of Antiquities Assistant Research Fellow, National Palace Museum), Ho Yu-Kuan, Jj Ng Zing-Shein, Alan Lau, Lee Kit, Liao Pao-Show (Department of Antiquities Researcher, National Palace Museum), Lin Pin-Yen, Li Yong-Ding, Lisette Lou, Lu Chi-Fan, Esther Lu, Peng An-Shui, Rahel Joseph, Show Ying-Xin, Simon Soon, Daniel C. Sung (Chief Curator of Rare Books and Historical Documents, National Palace Museum), Sung Jieh, Satie Tang, Treasure Hill Artist Village, Hussard Wang, Yeoh Lian-Heng, Yu Cheng-Ta, Yu Hsiao-Ming (Librarian of Department of Rare Books and Historical Documents, National Palace Museum), Yu Hong-Wei, Yu Pei-Chin (Director of Department of Antiquities, National Palace Museum)